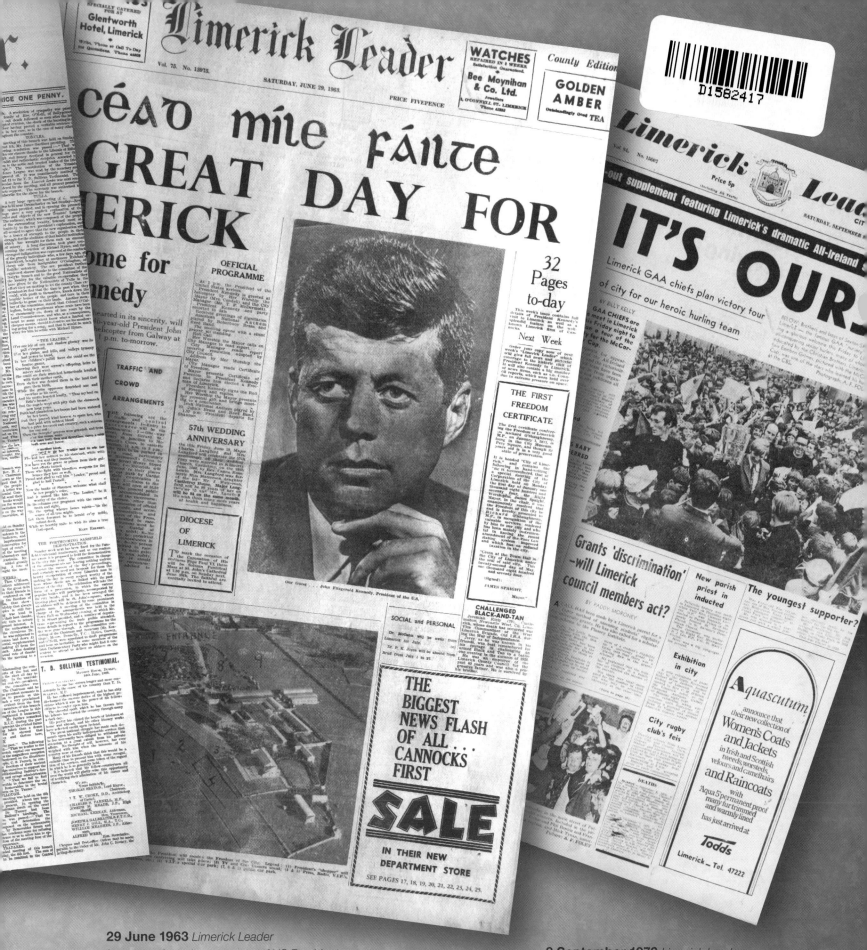

29 June 1963 *Limerick Leader*
front page featuring coverage of US President
John F. Kennedy's historic visit to Limerick.

8 September 1973 *Limerick Leader*
front page celebrating Limerick's victory
in the All-Ireland Senior Hurling Final.

LIMERICK
THROUGH THE LENS

Pictures from the **LIMERICK LEADER** Archive

If you would like to own any of these photographs . . .

We hope you enjoy the images in this book, all of which are available to order from the *Limerick Leader*. To purchase any of these photographs, please contact the *Limerick Leader*, on 061-121531, write to Photo Sales, Limerick Leader, 54 O'Connell Street, Limerick, or email photos@limerickleader.ie, quoting the caption and unique reference code (e.g. To order the photo of the crowd scene at the Limerick Show on page 11, quote: *1957 Faces in the crowd at the Limerick Show, as captured by the* Leader *photographer. LL11)*

LIMERICK
THROUGH THE LENS

Pictures from the **LIMERICK LEADER** Archive

The Collins Press

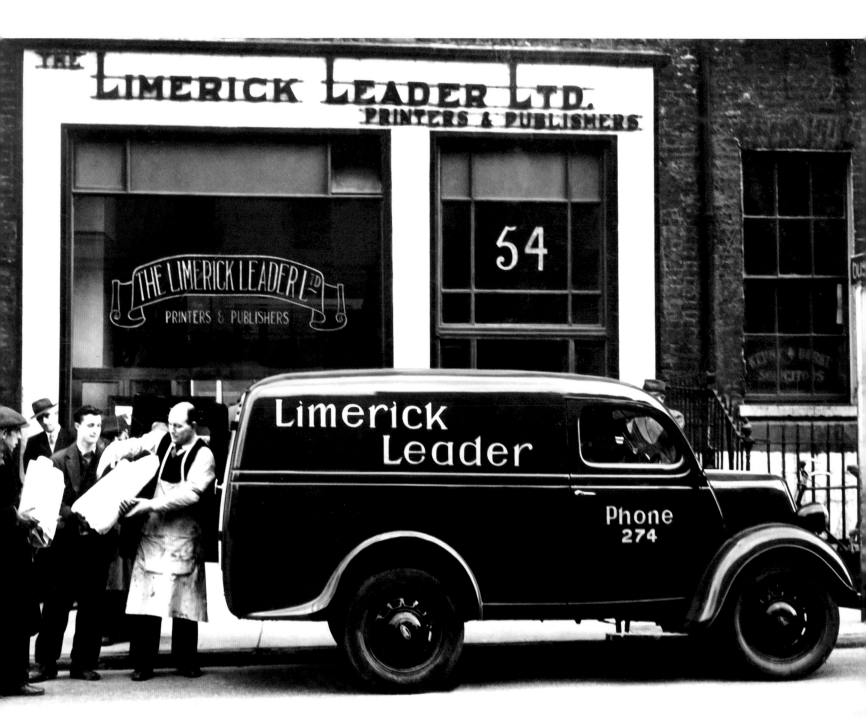

1955 View of *Limerick Leader* premises at 54 O'Connell Street, with van and staff including Leo McInerney, the van driver, Jimmy Kenyon and Mick Casey loading the van. *LL4*

INTRODUCTION

It was only in the early 1950s that the *Limerick Leader* began putting news stories on its front page, after more than six decades during which advertisements held sway. Perhaps it was no coincidence that the *Leader*'s photographic department was set up around the same time by the truly legendary Donal MacMonagle, who instantly established a level of photographic excellence that more than stands the test of time today.

In fact, one of the great joys of this book for me is that justice can finally be done to Donal's wonderful pictures from the 1950s and 1960s. At the time, newspaper printing methods were nothing like as advanced as today. Thus, the newsprint of the era did not do justice to the clarity of Donal's beautifully composed photographs, taken with a Hasselblad camera. Now, however, in this strikingly handsome book, these photographs finally have the showcase they always deserved.

After Donal departed Limerick for his native Kerry, the *Leader*'s photographic department was taken over by the youthful John F. Wright, a member of the Buckley family who owned the paper for more than a century. Another very fine photographer, John succeeded in upholding the high standards set by Donal, and many of his excellent pictures can be seen in this book too.

Unlike many local newspapers in Ireland, the *Leader* continued to employ staff photographers, who became well known throughout the city and county as the paper set about capturing local life on film week after week, thus building an archive that is by far the most comprehensive local collection in existence today. Terrific pictures taken by A.F. ('Foncie') Foley, Dermot Lynch and Owen South from the early 1970s through to the early 1990s complement the earlier photographs beautifully and will bring back memories for many. This book is a tribute to their talents.

In this hugely eventful black-and-white era, every aspect of Limerick life was photographed and we can be grateful that the vast collection – hundreds of thousands of images – has largely survived intact in negatives and glass plates, which we are digitising and bringing back to life, following on from the good work done by long-time *Leader* employee Sean Curtin. In 2014, the *Leader*'s 125th anniversary year, a fruitful collaboration with Limerick Museum & Archives resulted in tens of thousands of images from the 1970s being scanned and uploaded to a new website, for the enjoyment of Limerick people everywhere.

Around three years ago, we began in earnest the task of getting to grips with the riches that had been gathering dust in filing cabinets for decades. Thousands of long-forgotten pictures were scanned, Photoshopped and republished in a new section of the paper: 'All Our Yesterdays'. The more we printed, the more readers contacted us to say how much they enjoyed them. Some, on recognising family members in pictures they had never seen before, became quite emotional.

A series of magazines encompassing 30 years of *Limerick Leader* coverage proved enormously popular. Then, on the street, people came up and asked, 'What about a book?' The 125th anniversary provided the impetus and for me the best thing about *Limerick Through The Lens* is that, thanks to the handsome production you are holding now, these pictures will live on, long after their first appearance in newsprint.

With such a huge collection to choose from, selecting the 300-odd photographs for the book has been one of the bigger challenges of my time as editor, but also one of the greatest pleasures. Some of these pictures are being published for the first time and the book would never have come together without the dedication of our present-day photographers Adrian Butler and Michael Cowhey in helping to uncover many gems from the past. In our anniversary year, we were blessed with a wonderful archive team who went to great lengths in pursuit of potential photographs for the book and also spent many hours researching the information for the captions. A big thank-you to Stephen Lappin, Grainne Keays and Kelan Chadwick.

I hope you enjoy this trip down memory lane as much as we have.

Alan English
Limerick Leader editor

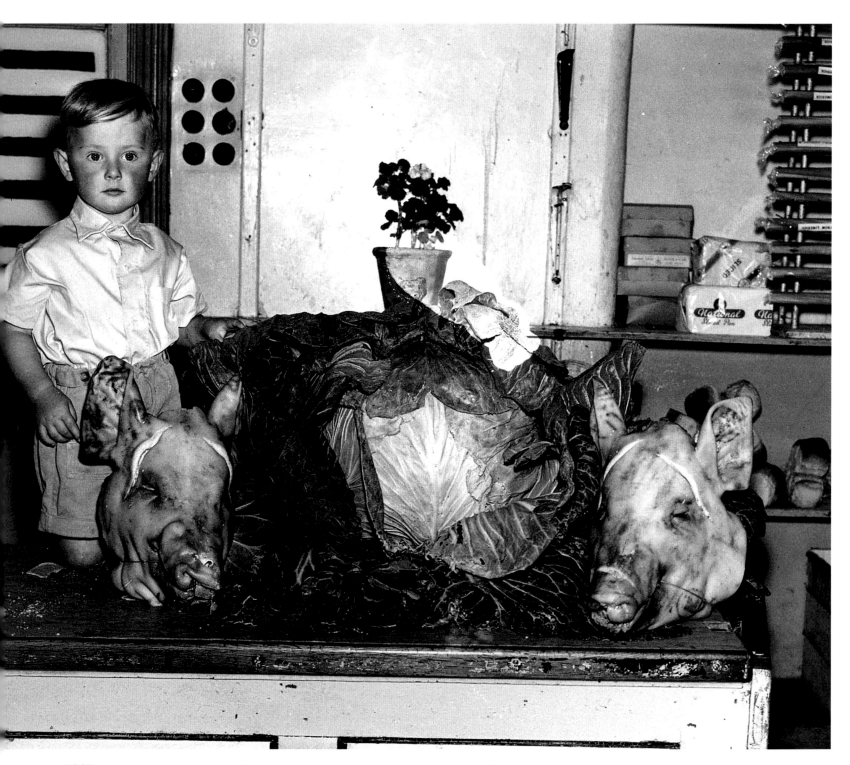

1960 Three-year-old Liam Doab with a huge head of cabbage, which his father, Patrick, grew on the family farm. The *Limerick Leader* of 3 September 1960 reported that it took two men to pull the cabbage from the ground. The caption writer for the photograph of young Liam added: 'With a pig's head on either side of the cabbage, the picture gives one that appetising feeling associated with this succulent dish.' *LL6*

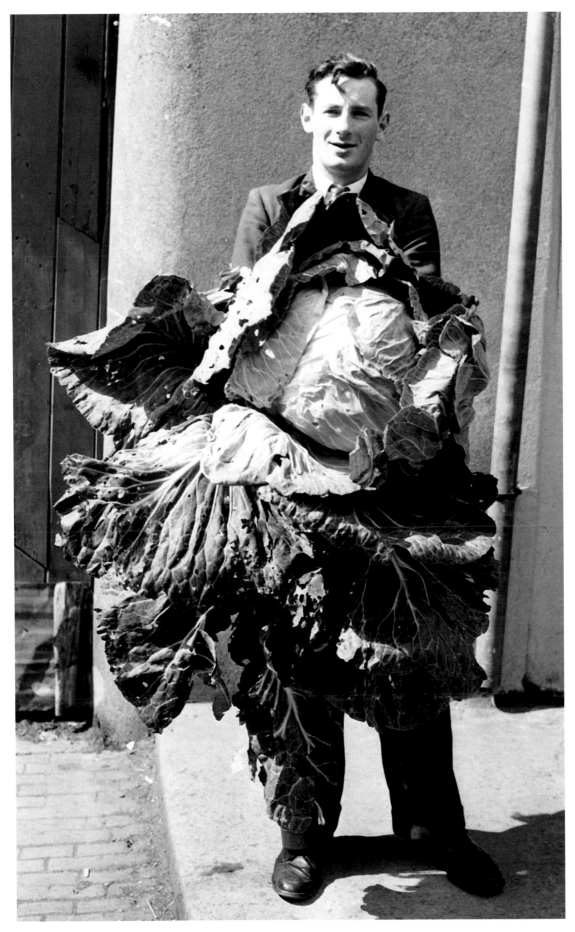

1960 Patrick Doab from Knockdromin, Croagh, County Limerick, with a giant head of cabbage. It weighed in at 33½ lb. *LL7*

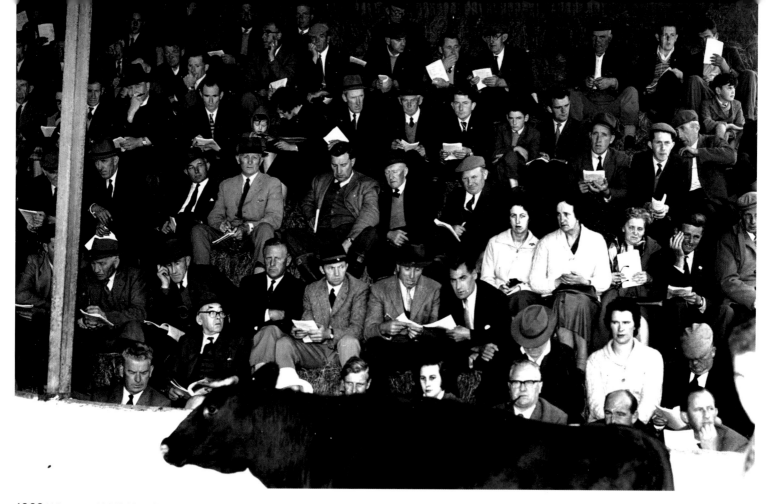

1963 What am I bid? Not all eyes are on the ring at Fitt's at the Paddocks, South Circular Road. Some potential buyers look singularly unimpressed! *LL8*

1955 A fine Aberdeen Angus bull in the ring at the Wm. B. Fitt premises at the Paddocks. The animal, called 'Pretence of Dooneen', is held by Alec Gabbett, whose family was synonymous with the sales. It sold for the princely sum of 152 guineas. *LL8B*

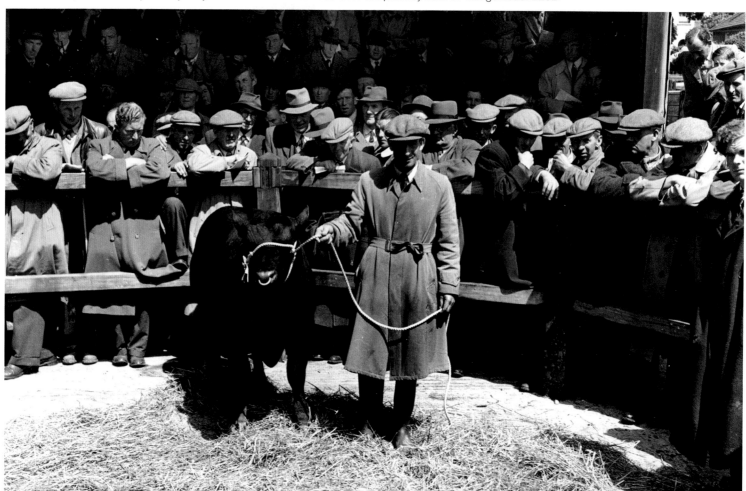

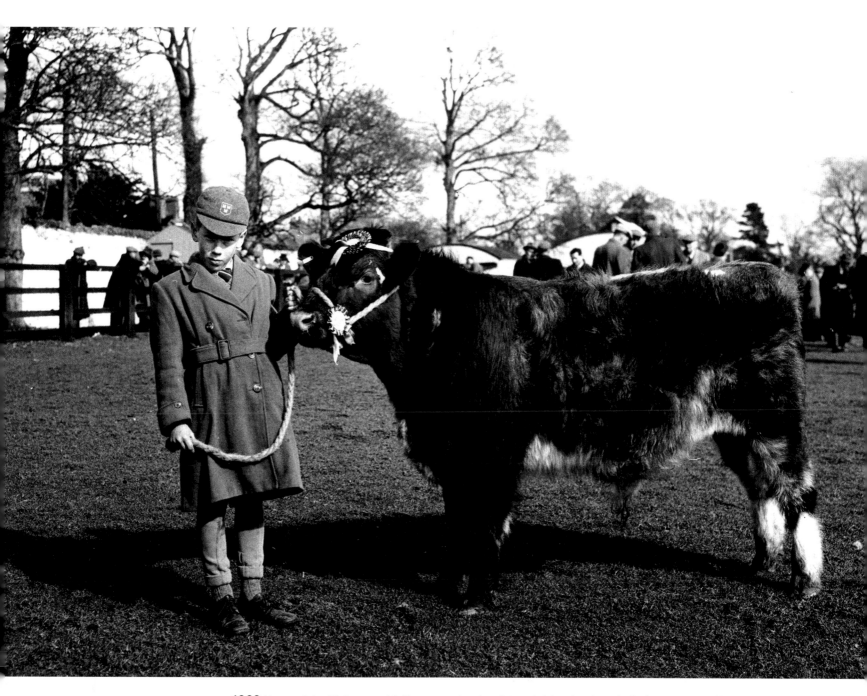

1960 Young John Moloney exhibiting a purebred registered dairy shorthorn bull, the property of his grandfather, Maurice Raleigh of Knocklong, and winner of the *Limerick Leader* Cup at the 36th annual show and sale of the County Limerick branch of the Irish Dairy Shorthorn Breeders Society held at the Paddocks, South Circular Road. *LL9*

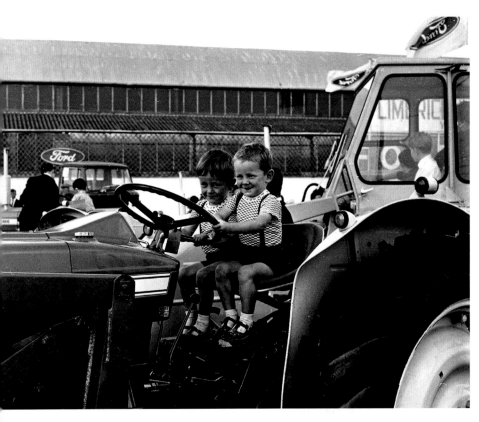

1970 Two little boys can't resist the chance to get behind the big wheel at the Limerick Show. *LL10*

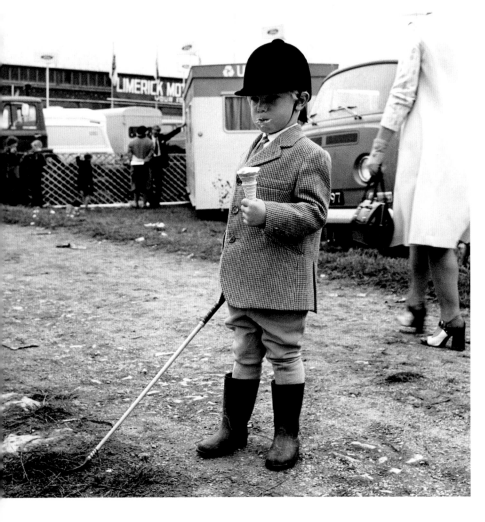

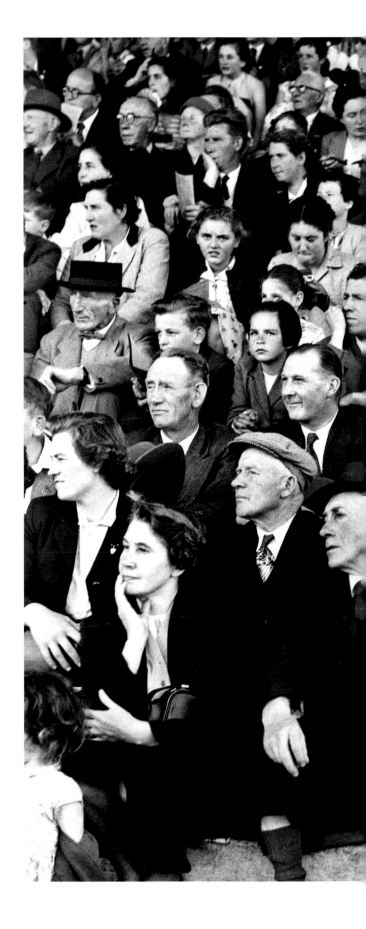

1971 Dressed for the occasion and cooling down with an ice cream at Limerick Show. *LL10B*

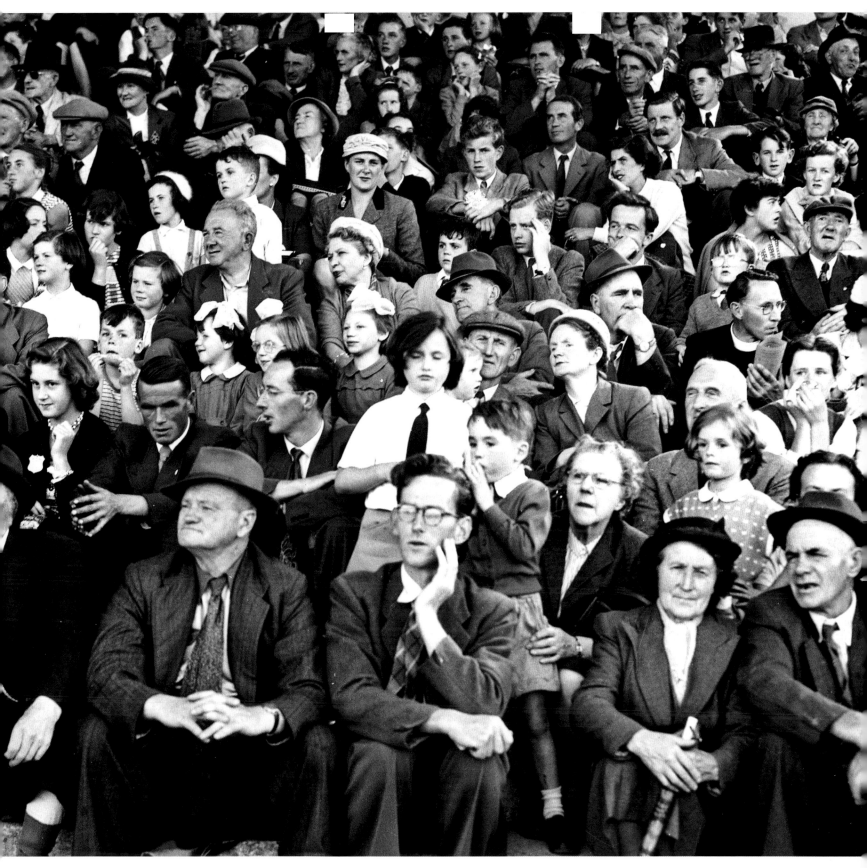

1957 Faces in the crowd at the Limerick Show, as captured by the *Leader* photographer. *LL11*

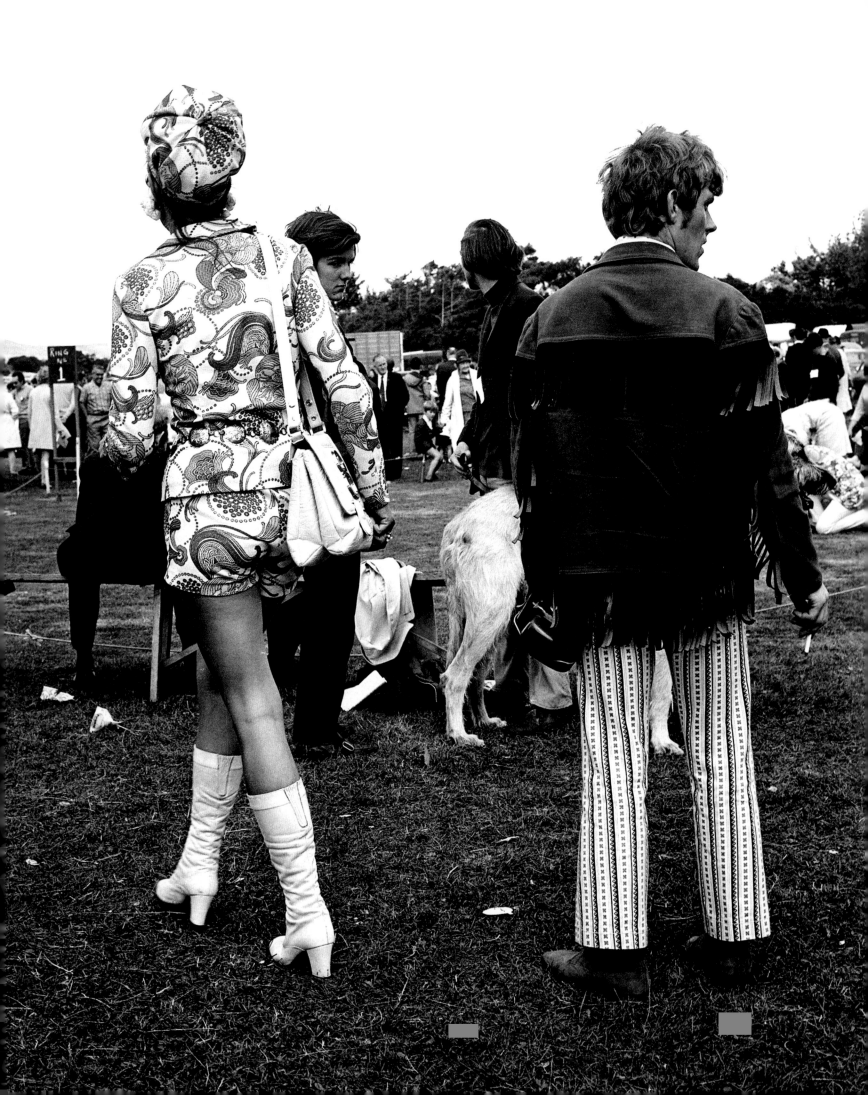

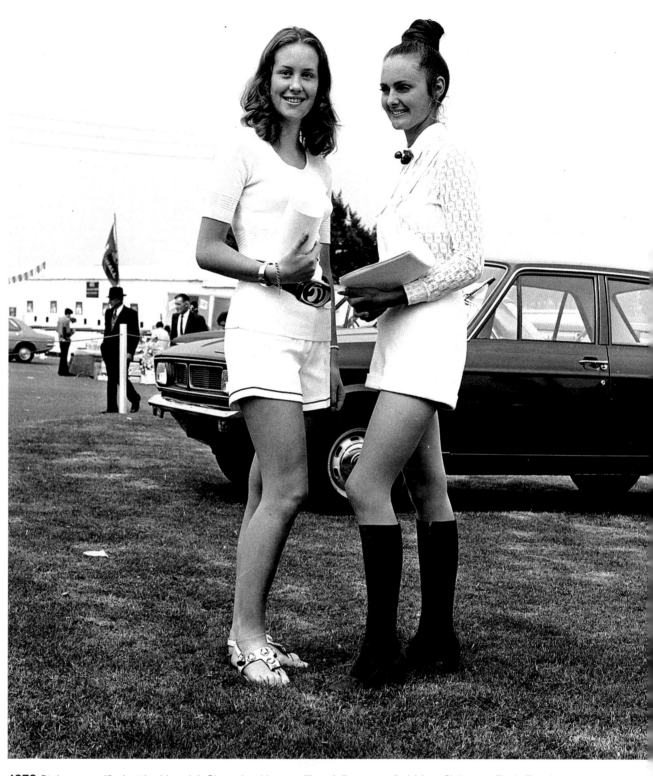

1972 Style personified at the Limerick Show. Looking a million dollars were (l–r) Mary Clohessy, Ennis Road, and Lillian Barry, Raheen. *LL13*

1971 Limerick ladies have always been at the cutting edge of fashion. This striking outfit caught our photographer's eye at Limerick Show. *LL12*

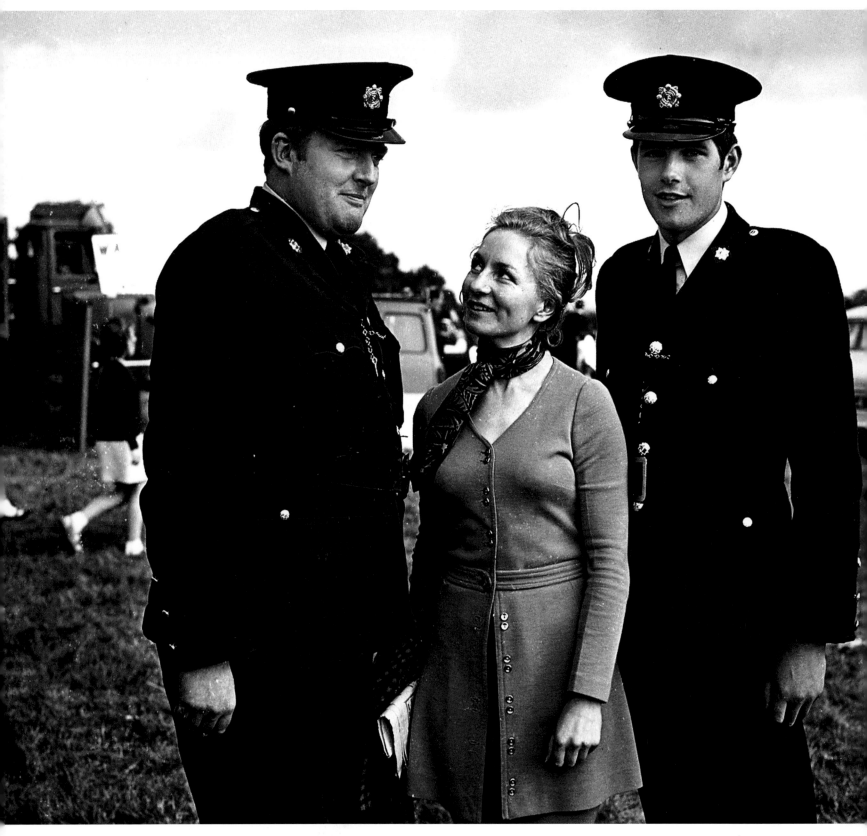

1970 Keeping a close eye on things at the Cappamore Show, one of the highlights of the Limerick summer for generations. Actress Áine Ní Mhuirí was photographed with local gardaí Dermot Fahey (left) and Seamus Doherty. Áine later went on to play Lily in the RTÉ soap opera *Fair City* and also starred in the TV series *Ballykissangel*. *LL14*

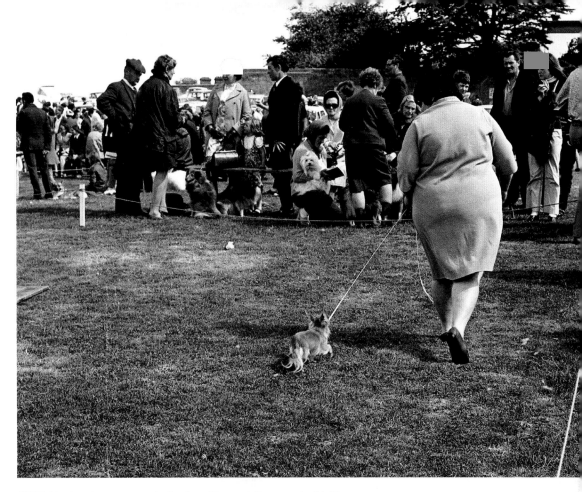

1971 Hoping for a rosette in the Dog Show at Greenpark. *LL15*

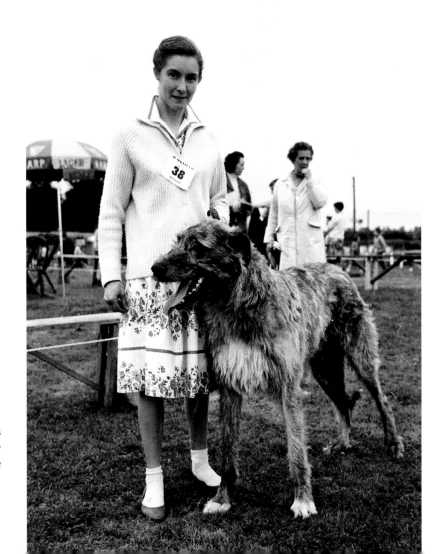

1964 An impressive wolfhound was one of the entrants in the ever-popular Dog Show at Greenpark. *LL15B*

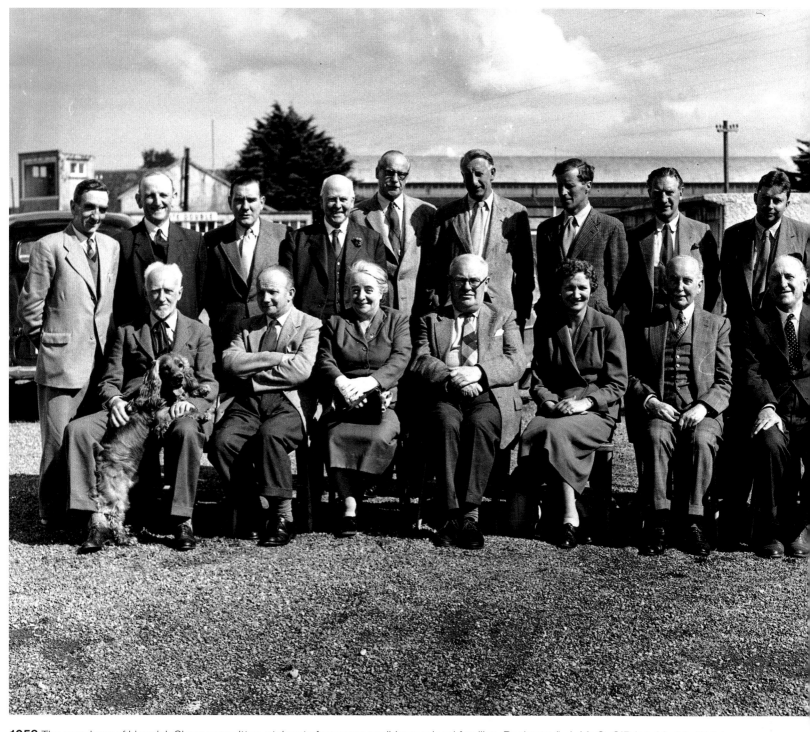

1958 The members of Limerick Show committee, stalwarts from many well-known local families. Back row (l–r): Mr G. O'Brien, Mr J.A. Walshe, Mr H. Russell, Mr P.F. Quinlan, Major Hastings, Commander P. Fitzgerald, Colonel O'Grady, Lord Inchiquin, Mr A.K. Gabbett, Mr D. Fitzgerald, Mr P. McNiece (secretary). Front row (l–r): Commander Monsell, Mr J.F. Sheehan, Dr Mary Roche-Kelly, Mr J.W. Canty (chairman), Mrs N. O'Shaughnessy, Mr S. J.K. Roycroft, Mr J.P. Frost, Mr D. Dwyer. *LL16*

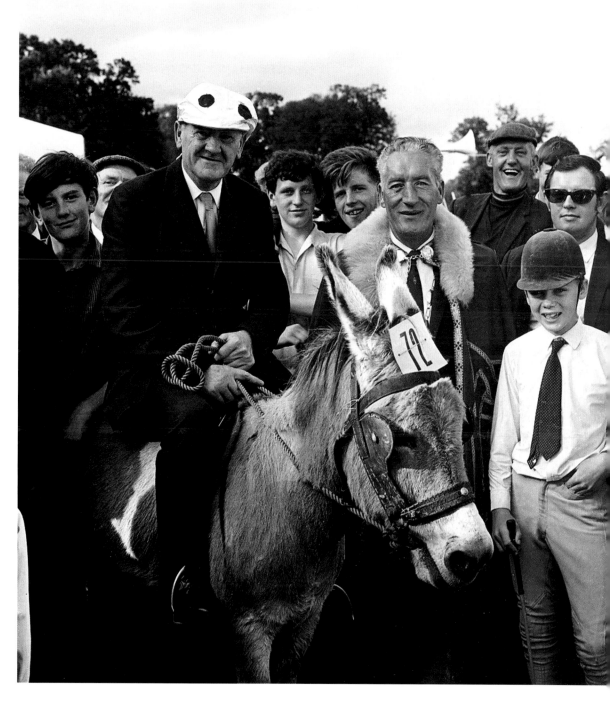

1970 Mayor Rory Liddy joining in the fun of the donkey derby at Newcastle West Gymkhana. *LL17*

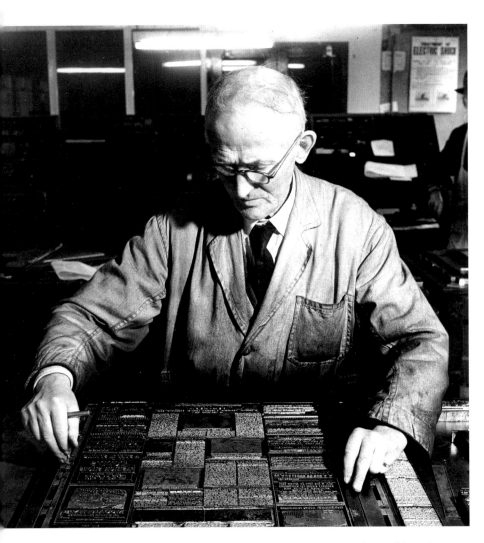

1955 Compositor 'Muffer' O'Halloran hard at work on another edition of the *Leader*. *LL18*

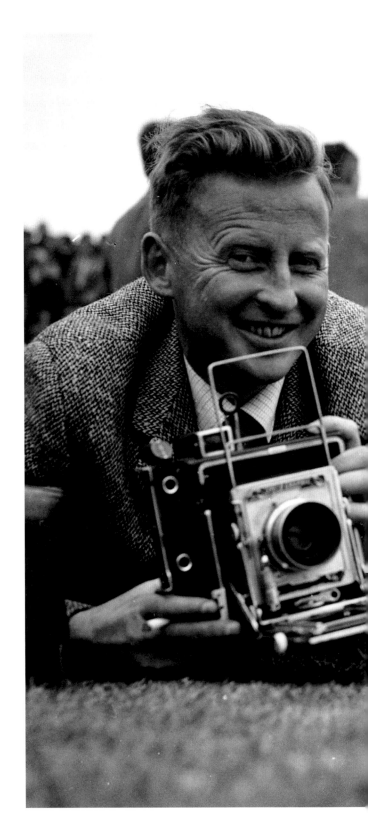

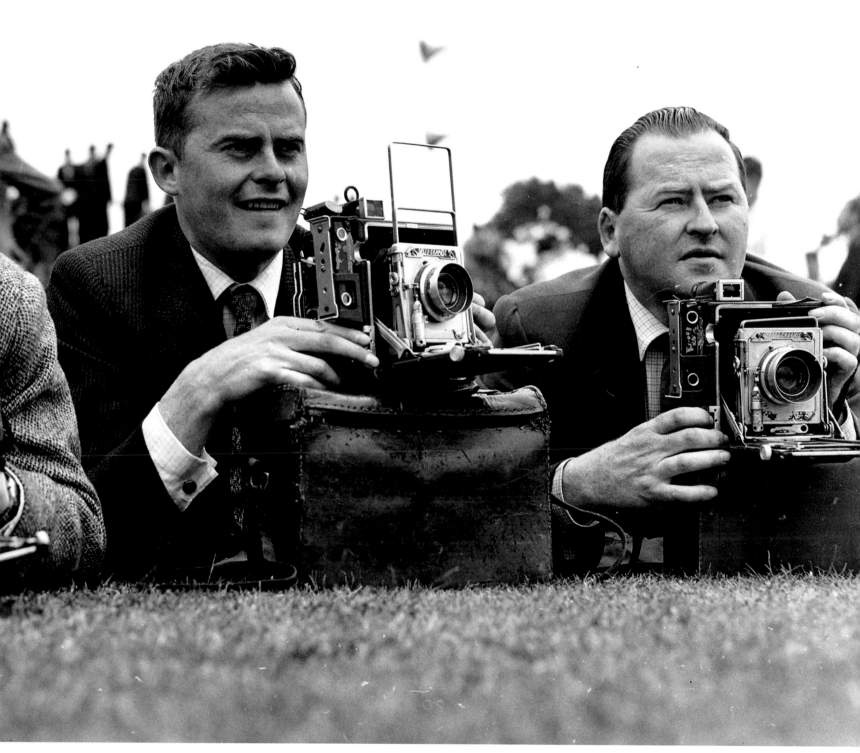

1961 The legendary Donal MacMonagle set up the *Limerick Leader* photography department in the early 1950s and took many of the pictures in this book. Here he is on the right with his brothers Harry (centre) and Louie. All three brothers were high-class photographers whose work appeared in a host of local and national newspapers. Donal is still fondly remembered in Limerick and thousands of his photographs are in the paper's archive. John F. Wright, a member of the Buckley family which owned the *Leader* for more than a century, headed up the photographic department for many years following Donal's return to his native Kerry later in the 1960s. *LL19*

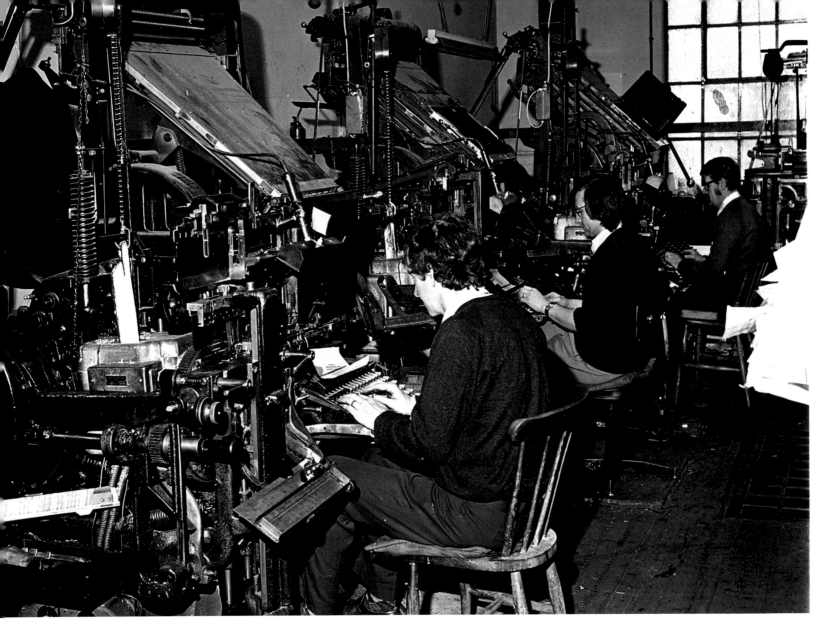

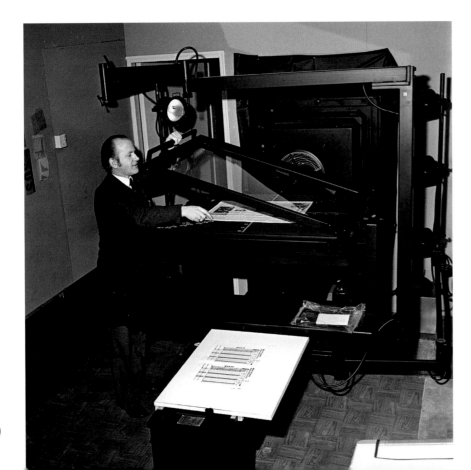

1978 Newspaper production has been driven by changing technology for centuries. These photographs capture a time when the *Limerick Leader* was produced by a highly skilled and experienced team based at the rear of the paper's headquarters in 54 O'Connell Street, before being printed just a few yards away in the 'Leader Lane'. While times have changed, memories of how the paper was skilfully put together to exacting standards remain strong.
Top (l–r): Aidan Corr, Sean Curtin and Micky O'Halloran concentrating hard.
Left: Billy Butler creating a plate for the press.
Opposite page, top (l–r): production staff Joe Naughton, Sean Curtin, Micky O'Halloran, Jack O'Connor and Tony Price; *bottom:* Paddy O'Byrne puts another front page together.

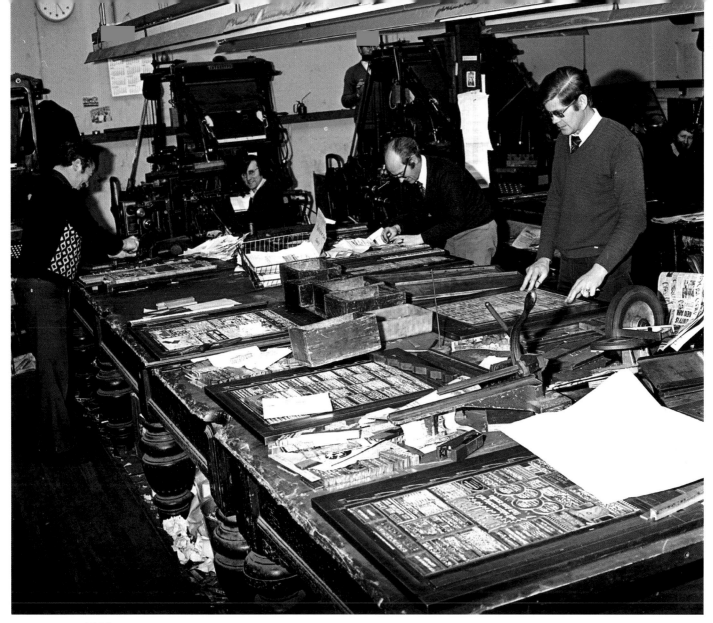

LL21

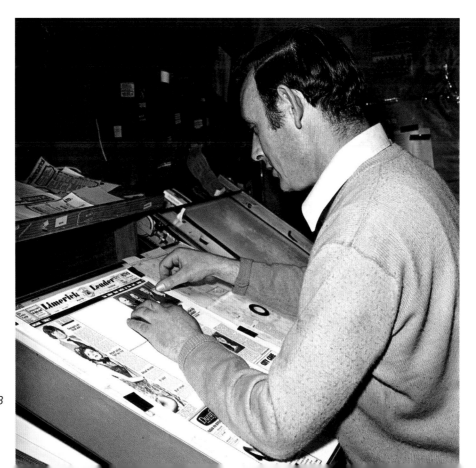

LL21B

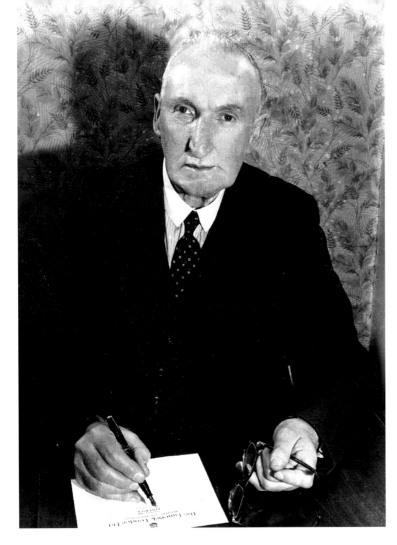

1955 Con Cregan had been editor of the *Limerick Leader* for 45 years when this picture was taken and went on to complete an astonishing 50 years in the chair before his well-earned retirement in 1960. *LL22*

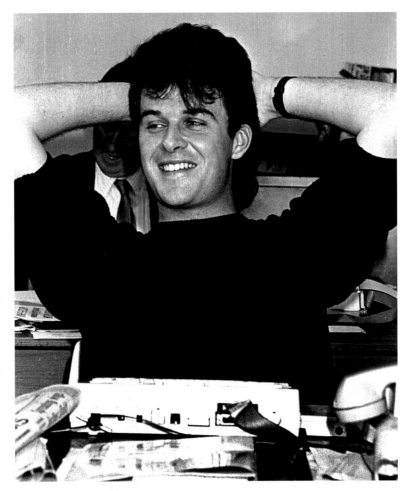

1988 Current *Leader* editor Alan English pictured a few months after starting as a junior reporter with the paper in 1988. Appointed in 2007, he is – after Con Cregan and Brendan Halligan – the third longest-serving editor in the paper's 125-year history. *LL22B*

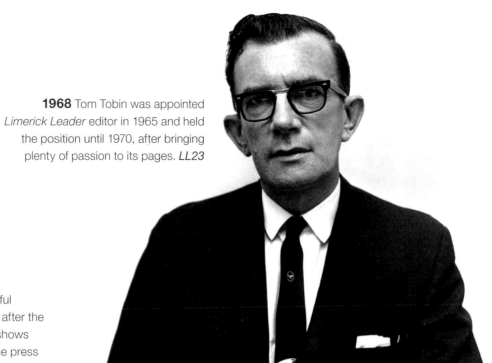

1968 Tom Tobin was appointed *Limerick Leader* editor in 1965 and held the position until 1970, after bringing plenty of passion to its pages. *LL23*

1991 Brendan Halligan edited the *Leader* for 36 eventful years, from 1970 to 2006. This picture was taken days after the fire which gutted large parts of the building in 1991. It shows Brendan emerging with the weekend edition, just off the press and on time, despite the huge difficulties faced by the *Leader* team that week. *LL23B*

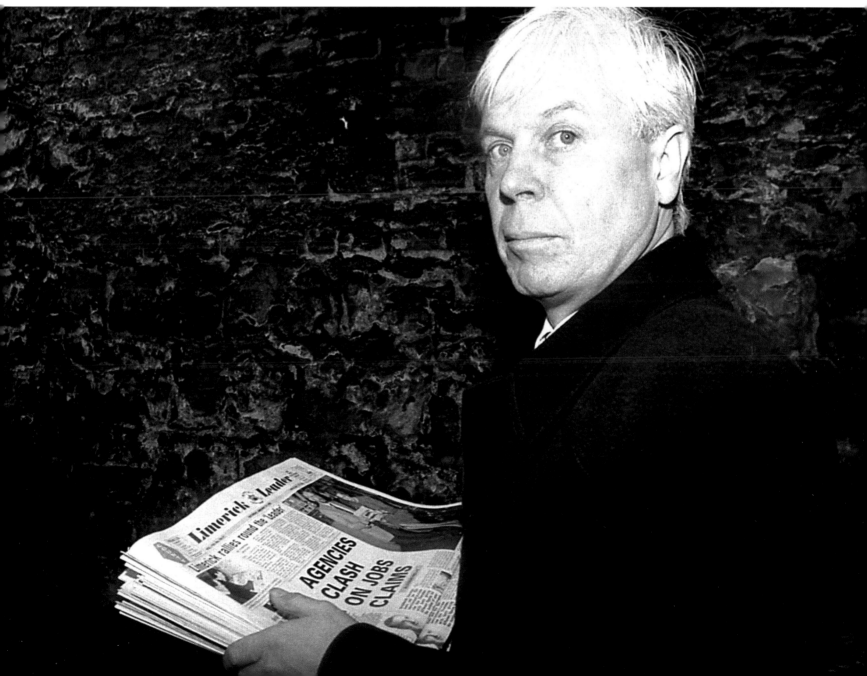

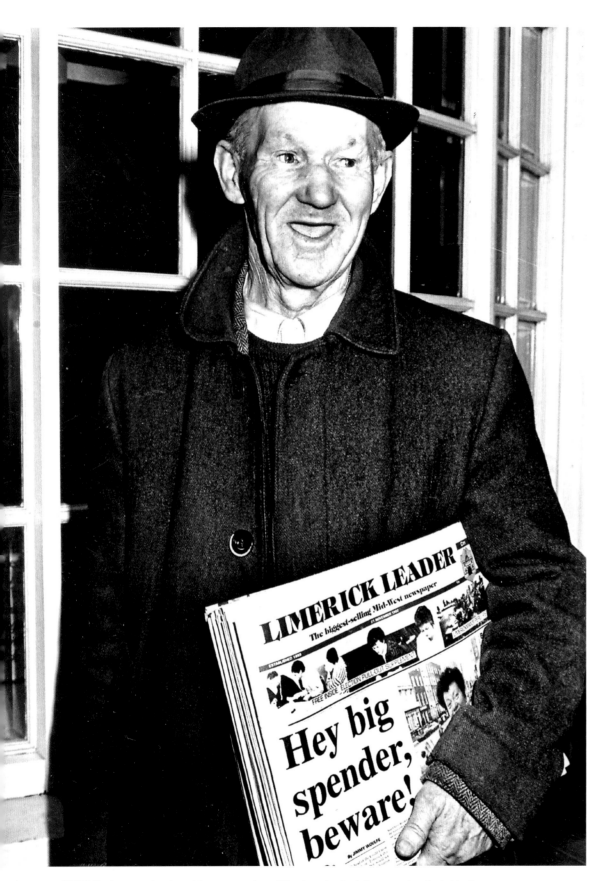

1992 Perhaps nobody sold more copies of the *Leader* that the popular Jack Nash, who was a regular fixture outside the office in O'Connell Street for many years. *LL24*

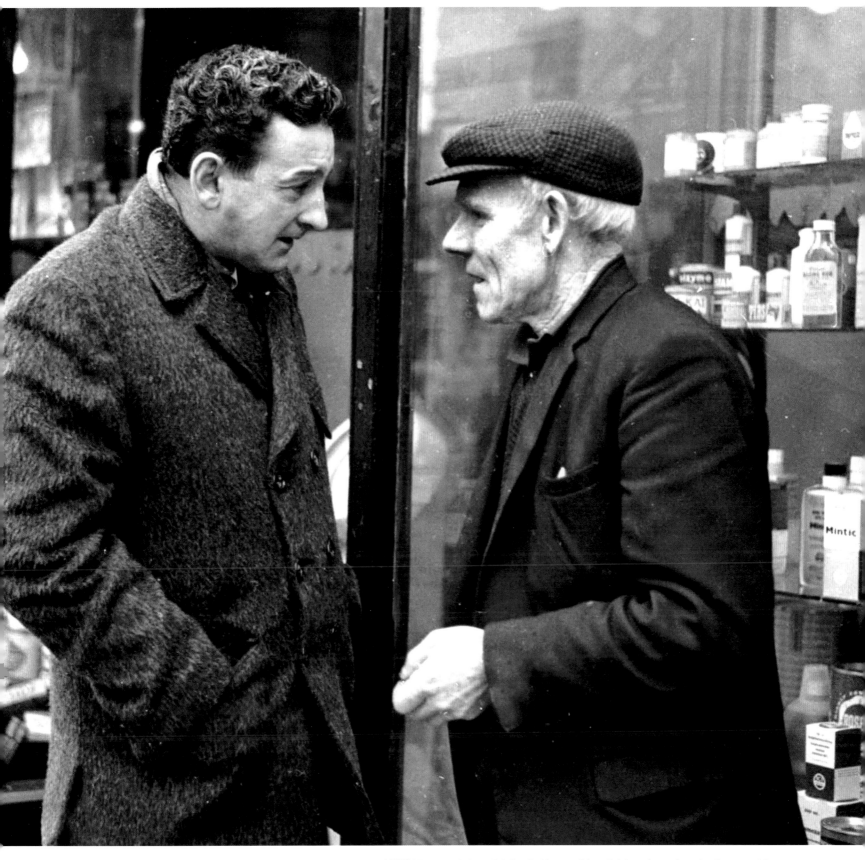

1971 The much-loved John B. Keane, *Limerick Leader* columnist for over 30 years, out and about in Listowel and perhaps picking up material for his next article. *LL25*

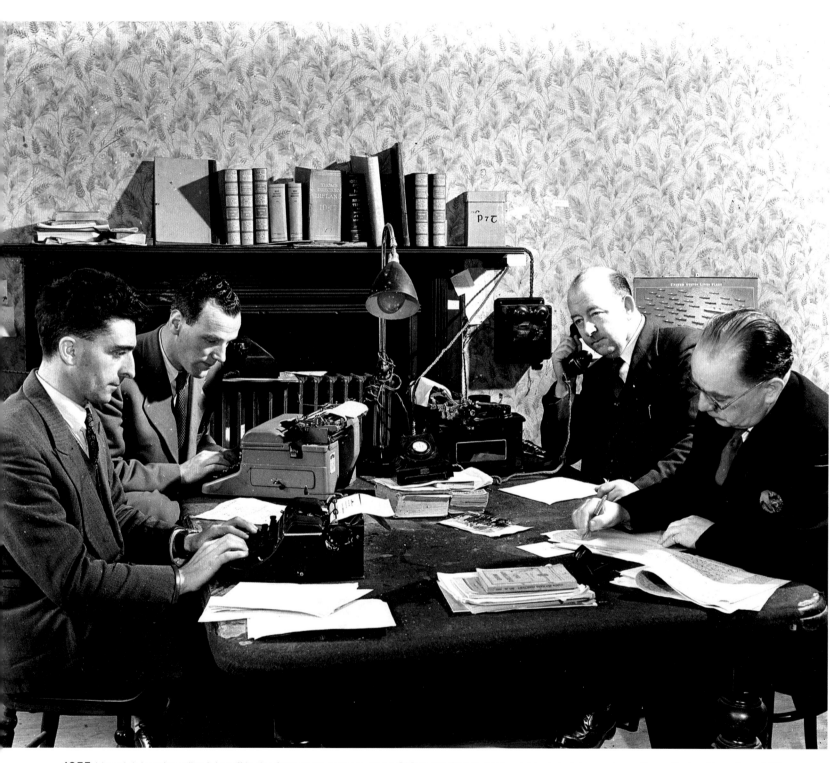

1955 *Limerick Leader* editorial staff in the former newsroom at 54 O'Connell Street. This wonderful picture adorns the editor's office almost 60 years later. Included are (l–r): Michael Barber, Bernard Carey, Gerry Ryan and Joe Mulqueen. *LL26*

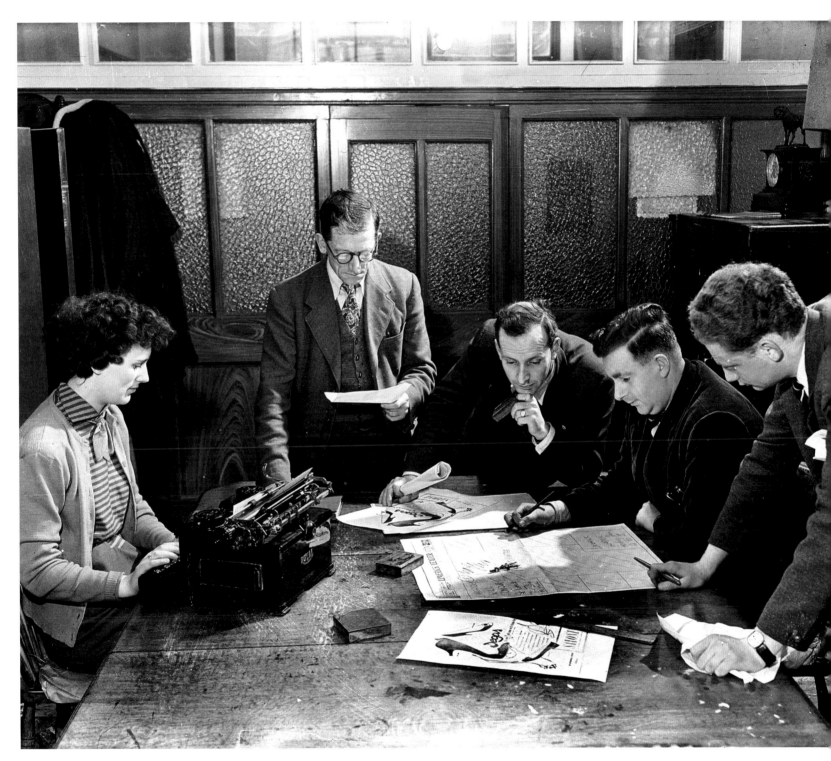

1955 *Limerick Leader* staff looking over a plan for one of Earl Connolly's entertainment pages. His popular section was the bible for those keen on a good night out in Limerick. (L–r): Anna Nestor, Willie Naughton, Jimmy Kelly, Earl Connolly and Gerry Saunders. *LL27*

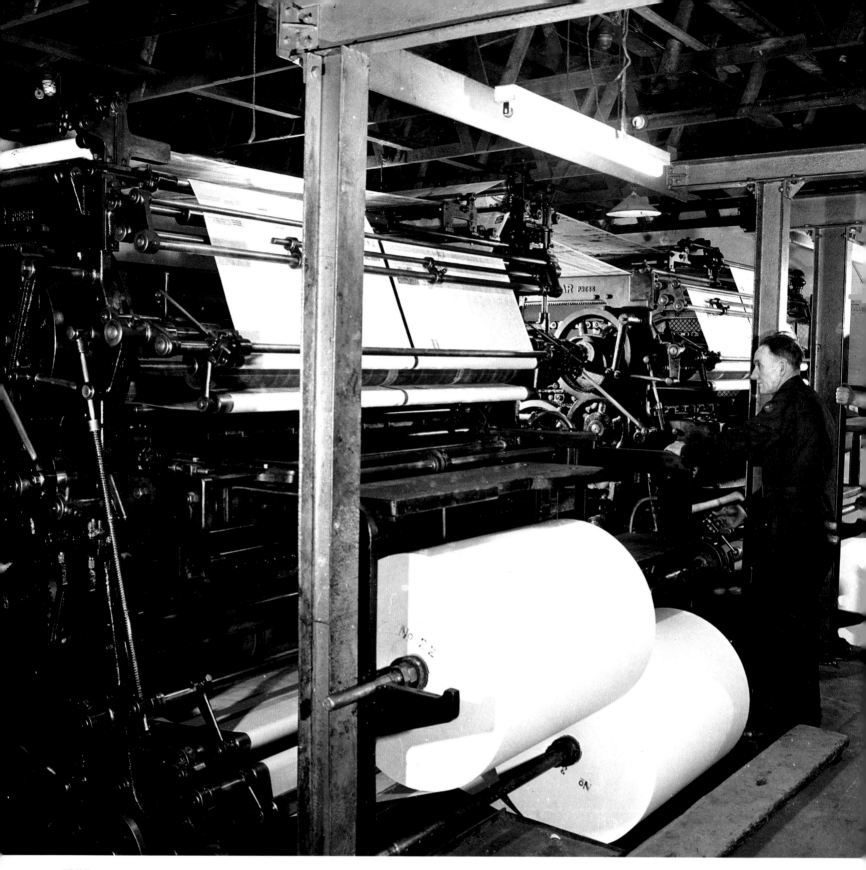

1955 The *Leader* printing press is prepared for another copy of the local paper of record with printer Murty O'Halloran keeping a close eye on the latest edition. *LL28*

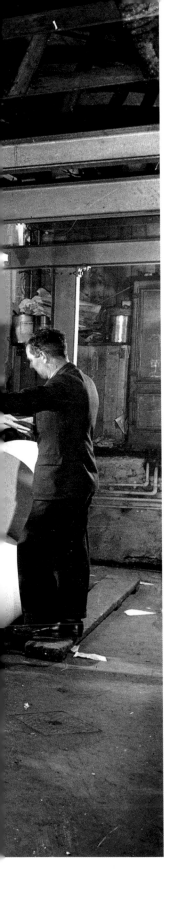

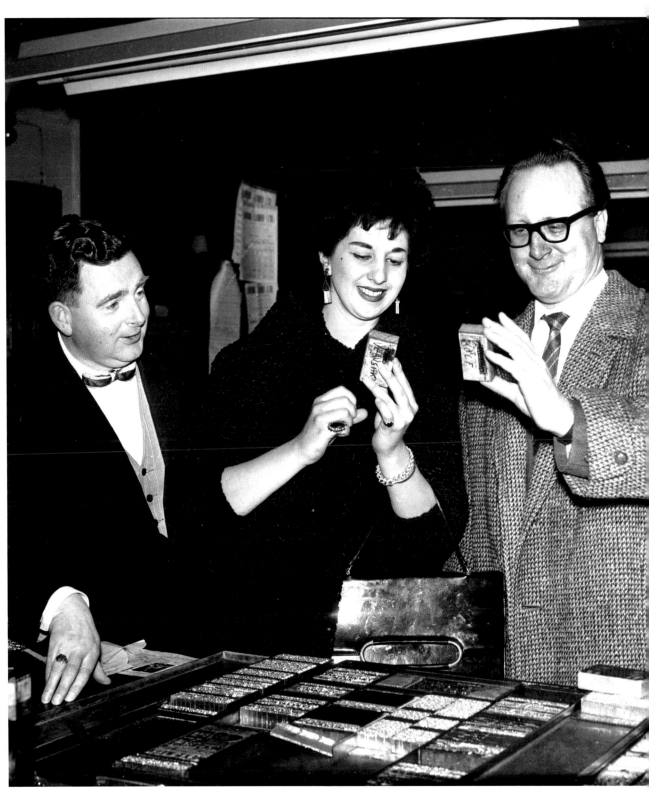

1960 Earl Connolly (left), the *Leader's* Mr Showbusiness, with some visiting opera stars. *LL29*

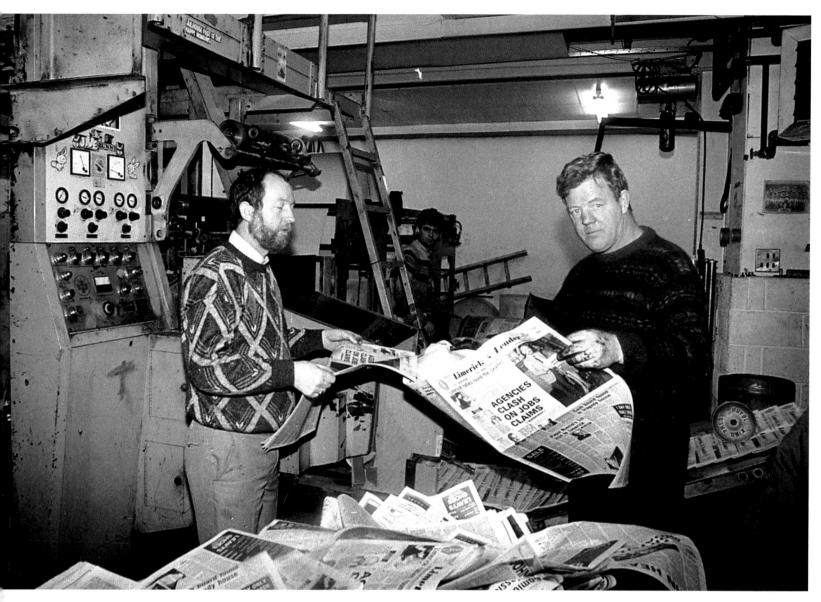

1990 Printers Johnny Costelloe (left) and Cyril McMahon with the first weekend edition of the *Leader* produced in the aftermath of the fire which destroyed parts of the building. The headline at the top of the front page reads 'Limerick rallies round the *Leader*'. *LL30*

1990 The editorial staff of the *Leader* were forced to relocate to the nearby Hanratty's hotel in Glentworth Street after the fire. Pictured with the first weekend edition hot off the press were news editor Jimmy Woulfe (left), news reporter Eugene Phelan (now deputy editor) and sports reporter John O'Shaughnessy. The lady nearest the camera is Helen Buckley, a member of the family that owned the paper for more than a century. *LL30B*

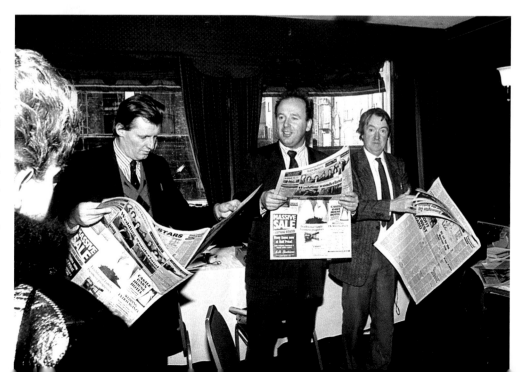

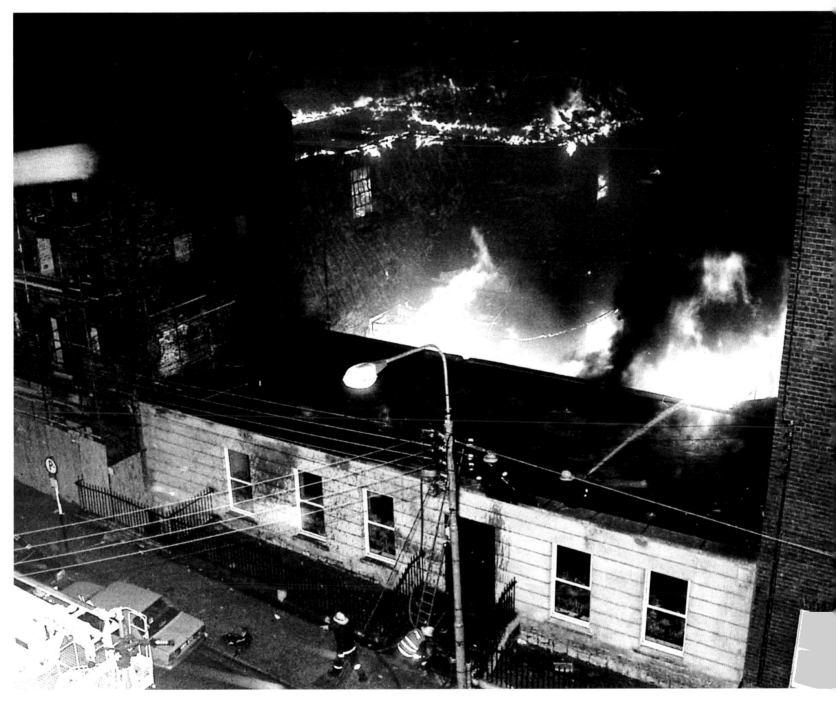

1991 The *Limerick Leader* building, seen from an aerial perspective, in Glentworth Street, as a fire raged on a January weekend. Huge damage was caused but the paper never missed an edition. *LL31*

1973 *Limerick Leader* newsboys waiting to collect the papers off the press three days before Christmas. (L–r): Pat Treyne, Stephen O'Connor, Gerard Collins, John Slattery, Jimmy McCarthy, Peter Fahey, Noel Ahern, and Butch the newshound. *LL32*

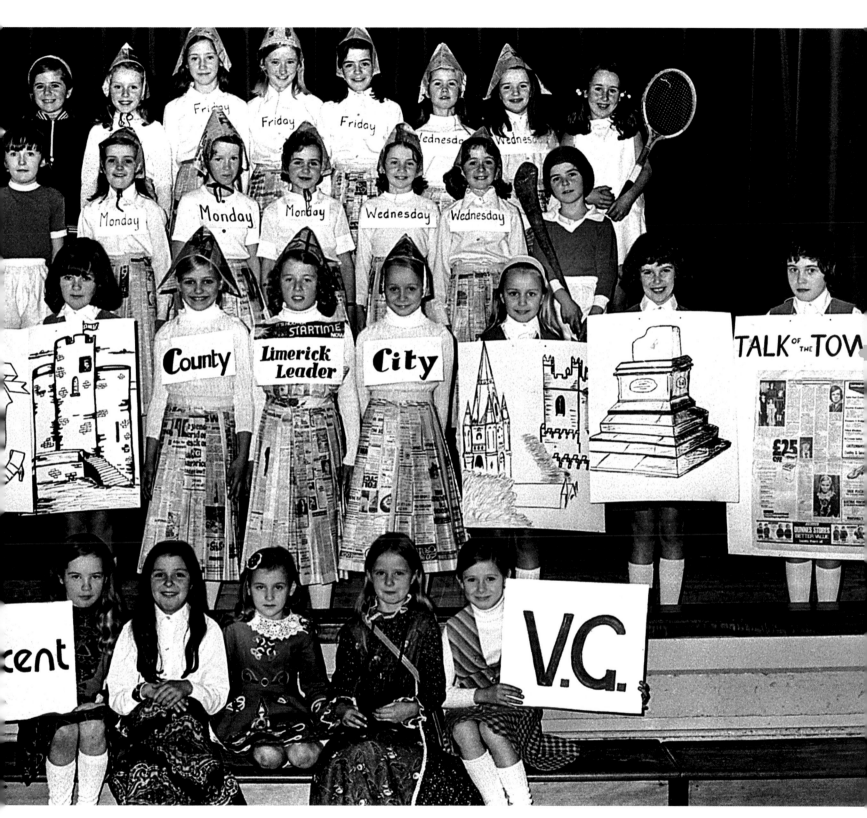

1975 The girls at the Salesians Convent, Fernbank, put on a great show with a strong *Limerick Leader* theme! *LL33*

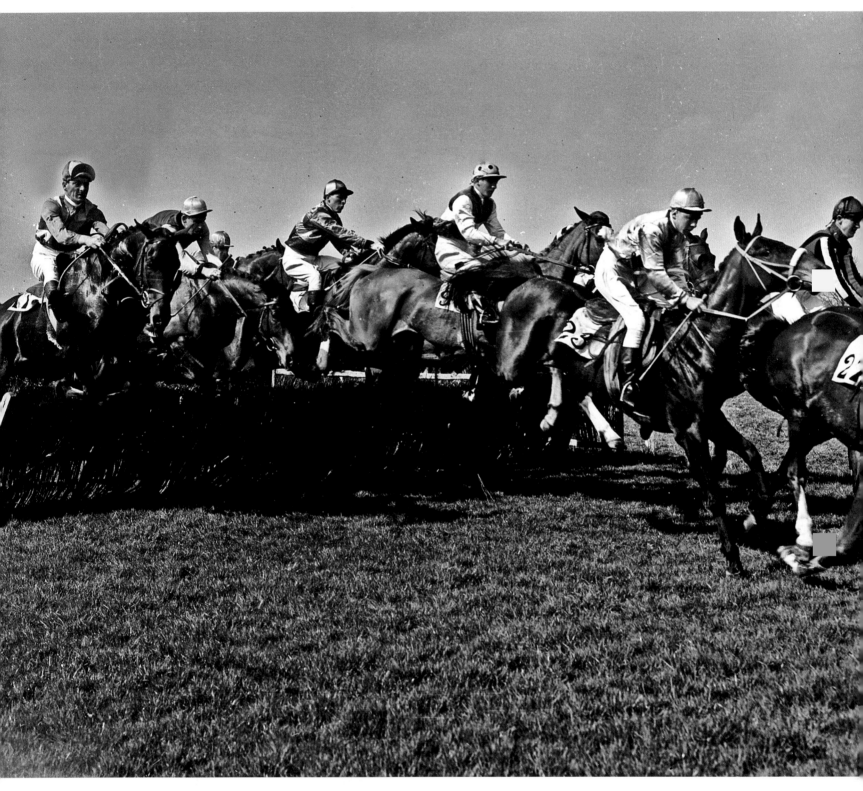

1955 Runners and riders at Limerick Junction on an April afternoon. *LL34*

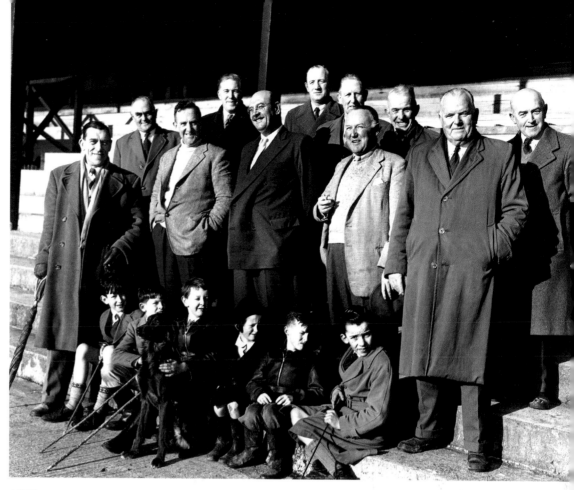

1957 A Clounanna coursing group featuring different generations pose for the *Leader*. *LL35*

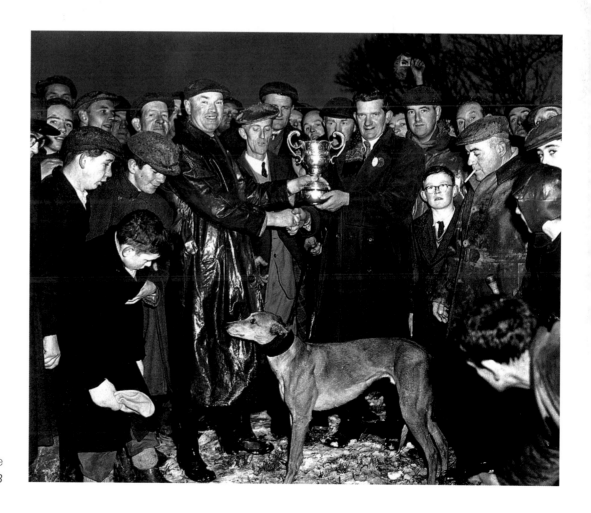

1959 Coursing enthusiasts in Newcastle West after a champion is crowned. *LL35B*

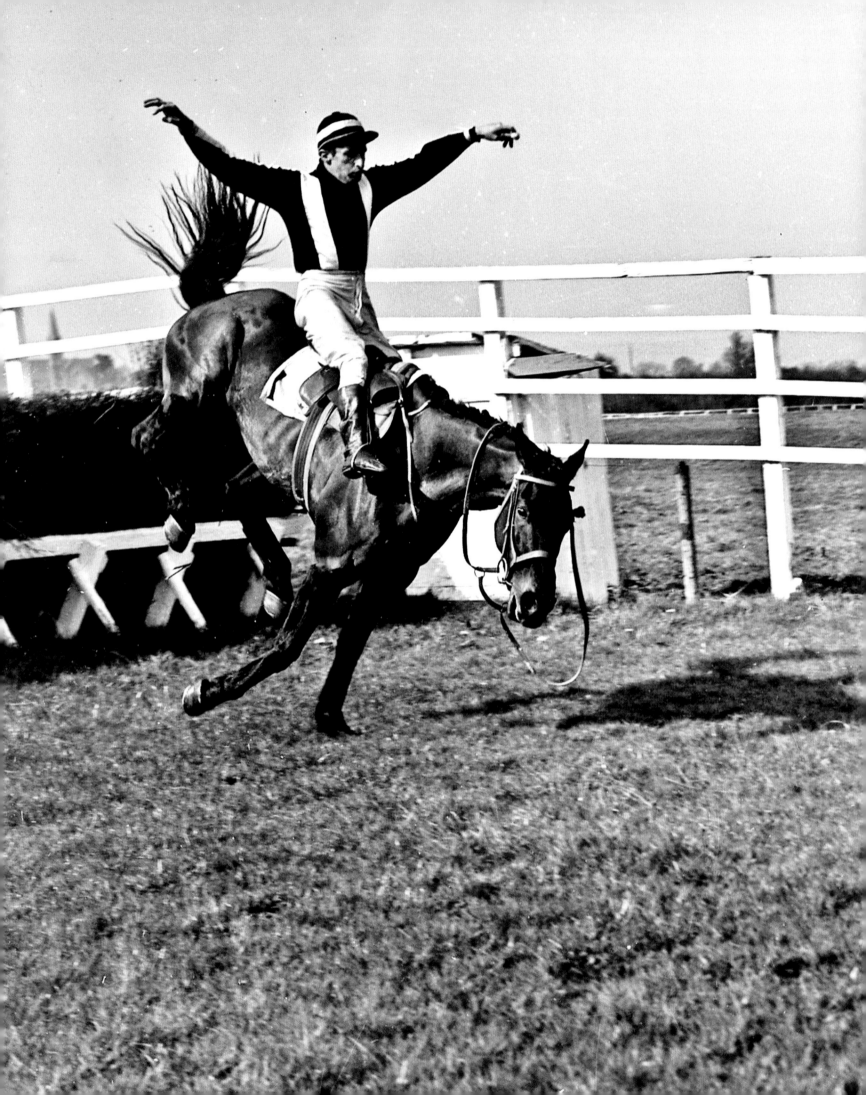

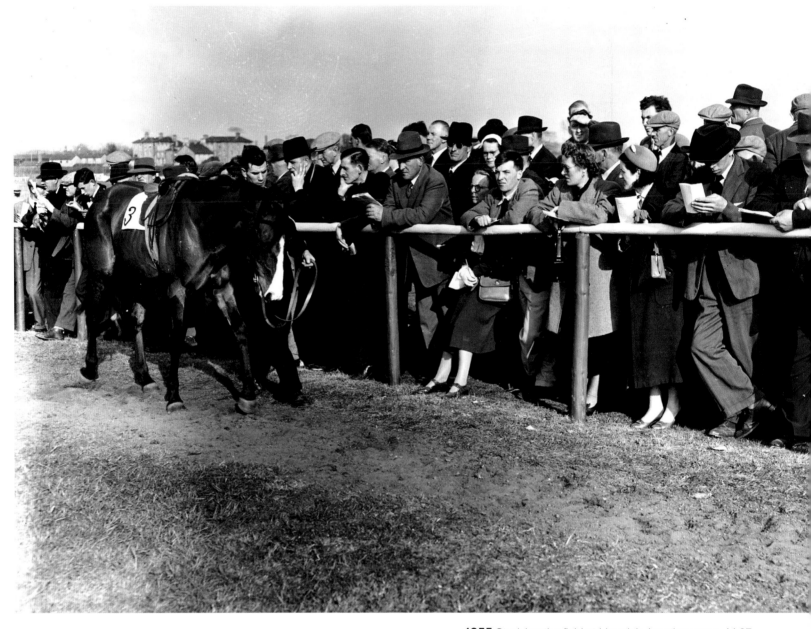

1955 Studying the field at Limerick Junction races. *LL37*

1955 This jockey needed a miracle to stay in the saddle after hitting a fence at Limerick Junction. *LL36*

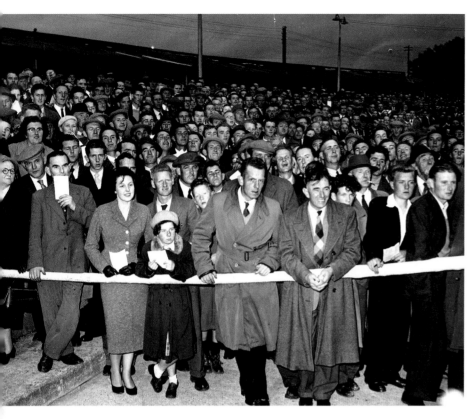

1957 A crowd scene from Limerick dog track finals at the Markets Field, Mulgrave Street. *LL38*

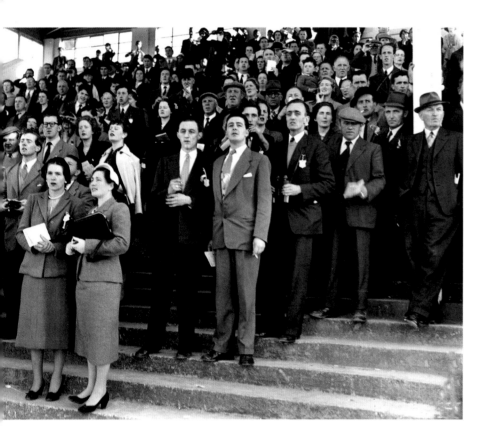

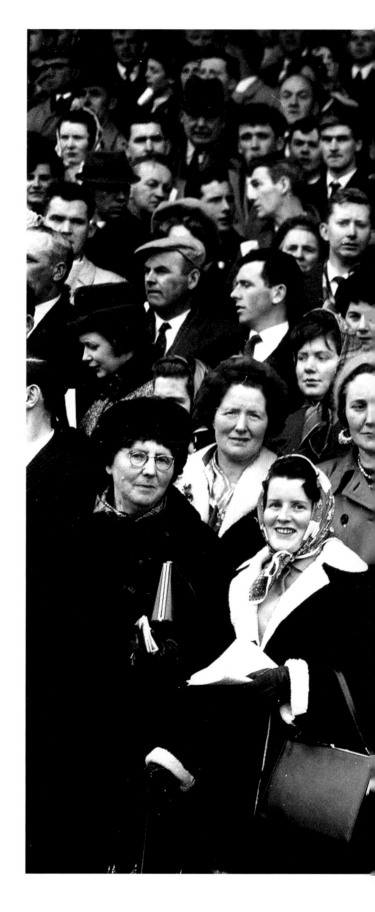

1955 A crowd scene from Limerick Races in April. Three-time future mayor Jack Bourke can be seen (front right) with his friend Tom English, then manager of the Savoy Theatre. *LL38B*

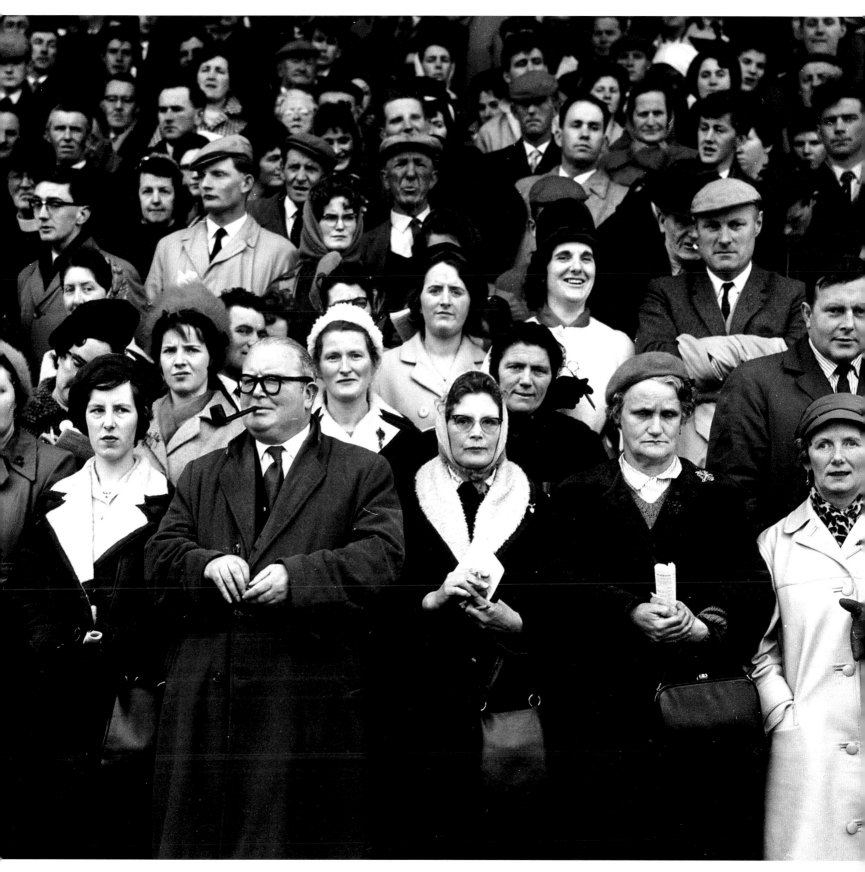

1964 Crowd scene from Limerick Races at Greenpark on St Patrick's Day. *LL39*

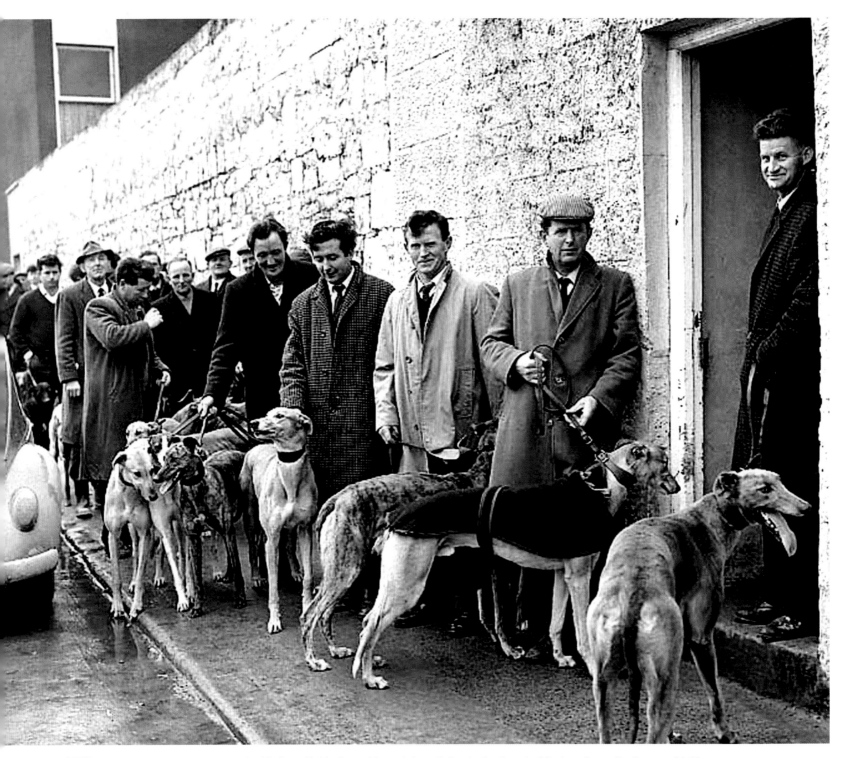

1970s Greyhound trials resume at the Markets Field after a 12-week lay-off due to the threat of foot-and-mouth disease. *LL40*

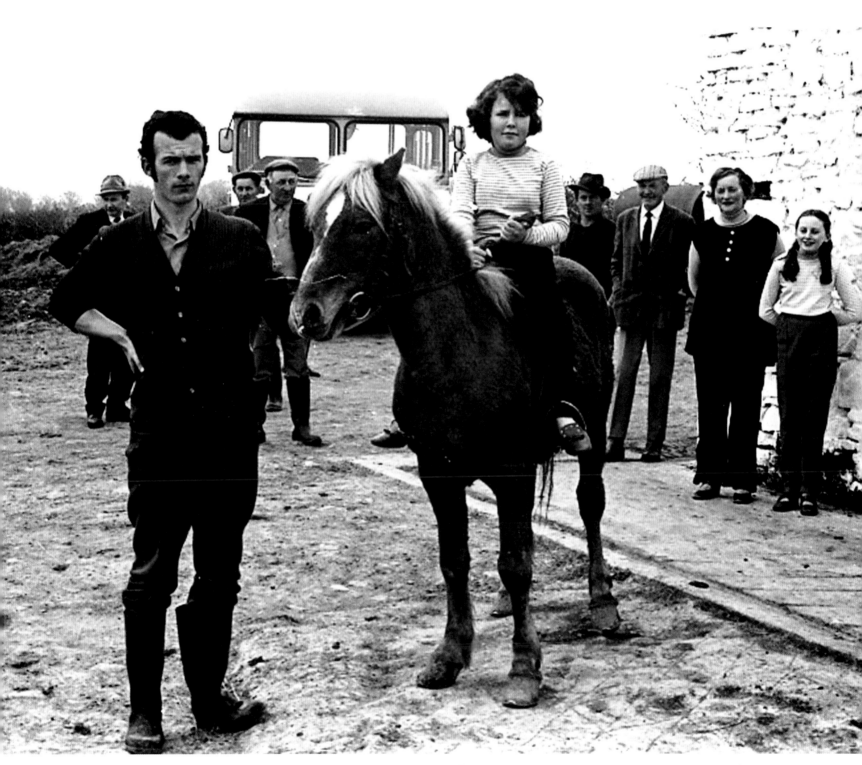

1971 Jock Leahy and friends at Banard Stud Farm, Abbeyfeale. *LL41*

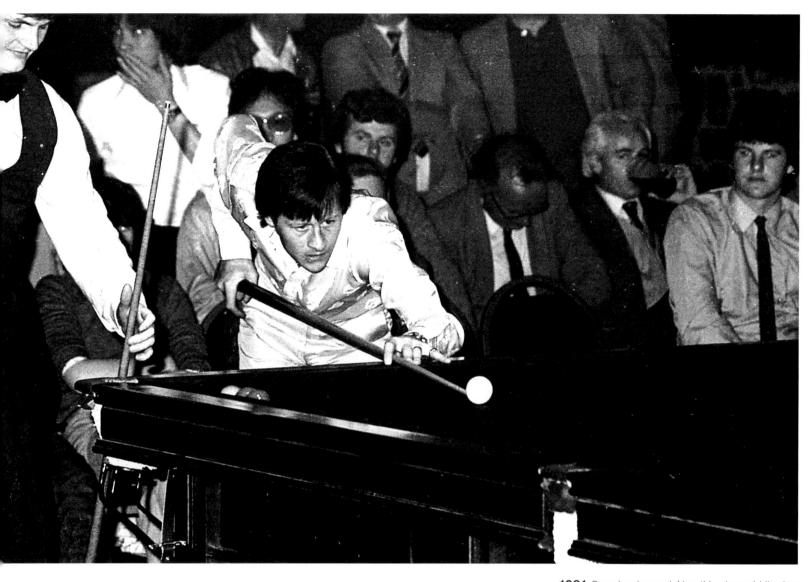

1981 Snooker legend Alex 'Hurricane' Higgins demonstrates his skills at the Parkway Motel. *LL42*

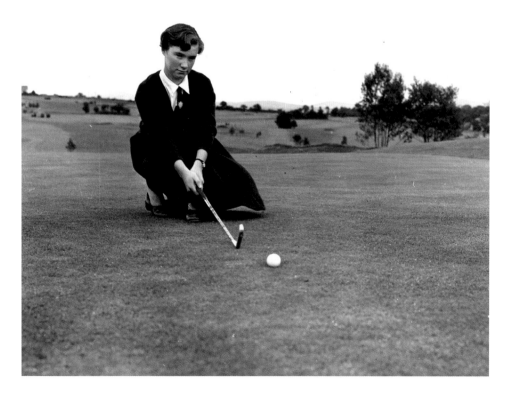

1955 Breda Hayes, winner of the Castletroy Lady Captain's Prize, lines up a putt on a course with far fewer trees than today. *LL42B*

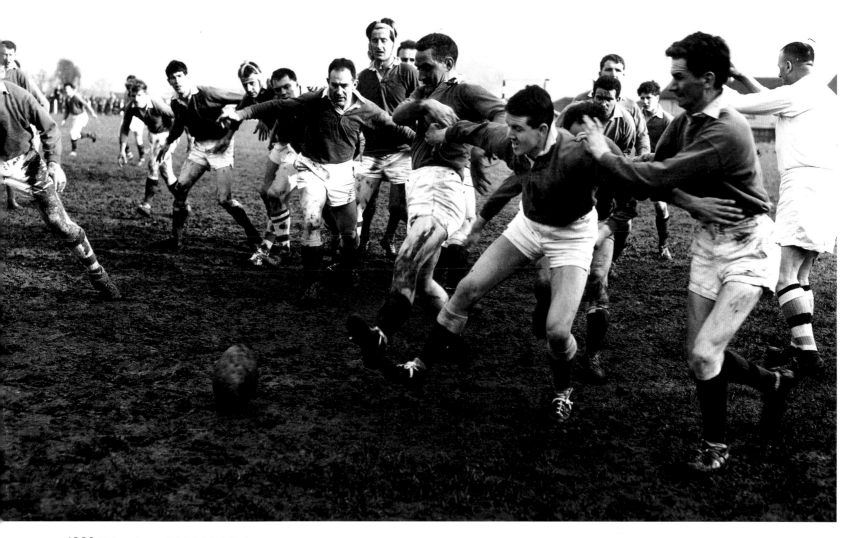

1966 Bohemians v Highfield of Cork on a muddy pitch at Thomond Park. *LL43*

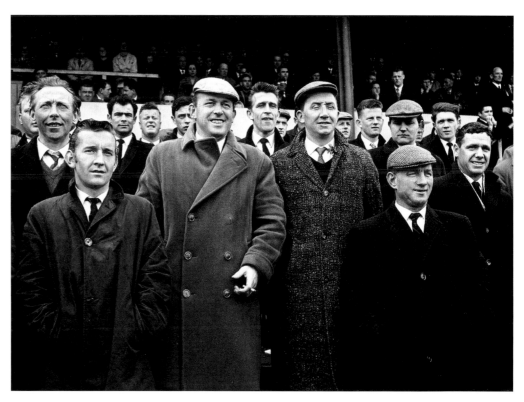

1965 A crowd scene at Thomond Park watching junior clubs Abbeyfeale v Thomond. *LL43B*

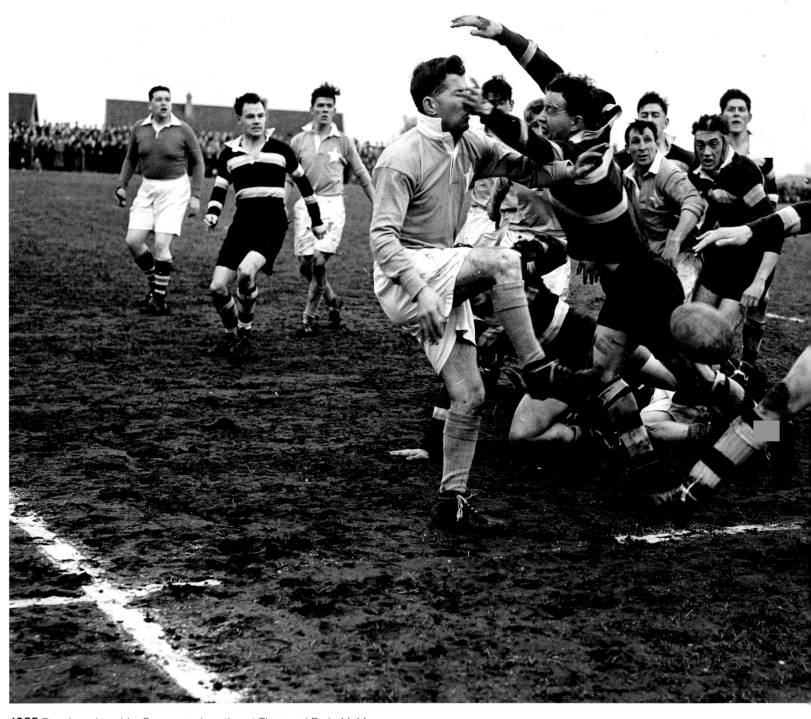

1955 Rough and tumble: Garryowen in action at Thomond Park. *LL44*

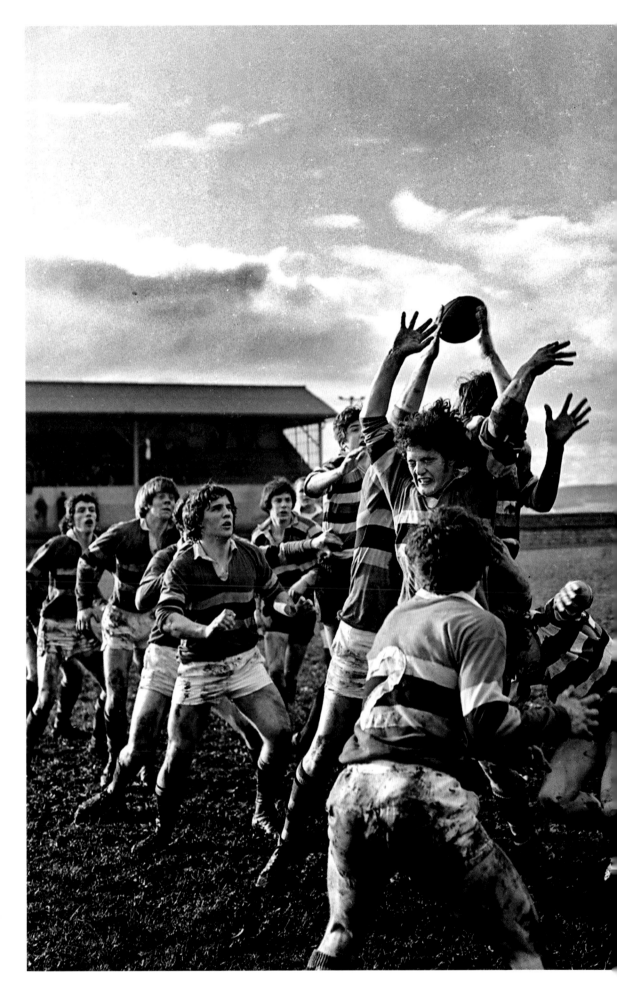

1978 Lineout leap: Limerick's Crescent College in action at Thomond Park against Christian Brothers College, Cork. *LL45*

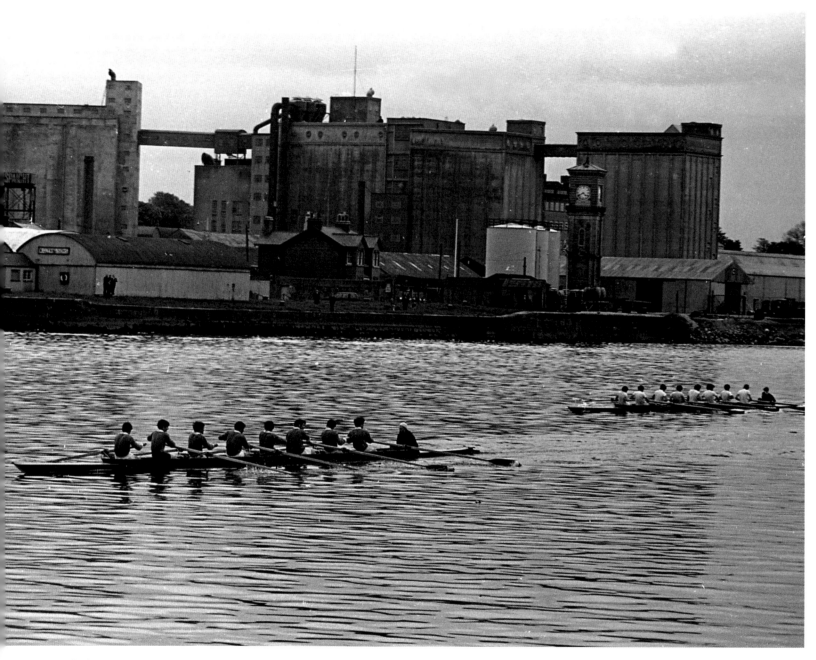

1979 Limerick Regatta on the Shannon with view of Dock Road and the Ranks building in the background. *LL46*

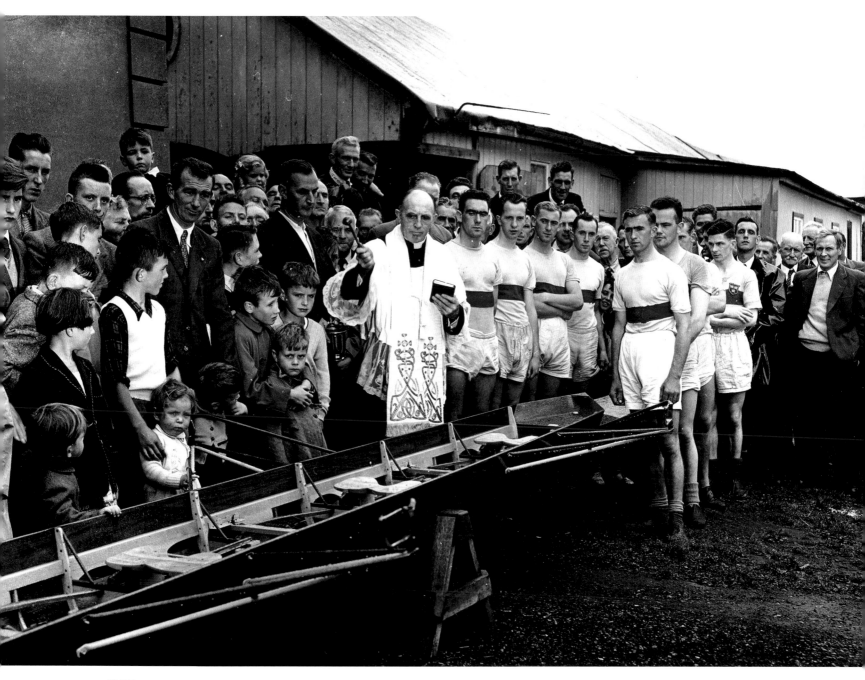

1955 At the blessing of a new boat at Athlunkard Boat Club, Corbally. Rather fittingly, the new 'Clinker Eight' is being blessed by the man it was named after, the Very Rev. Canon P.J. Lee, long-time parish priest of St Mary's. The boat was called, simply, 'P.J. Lee'. *LL47*

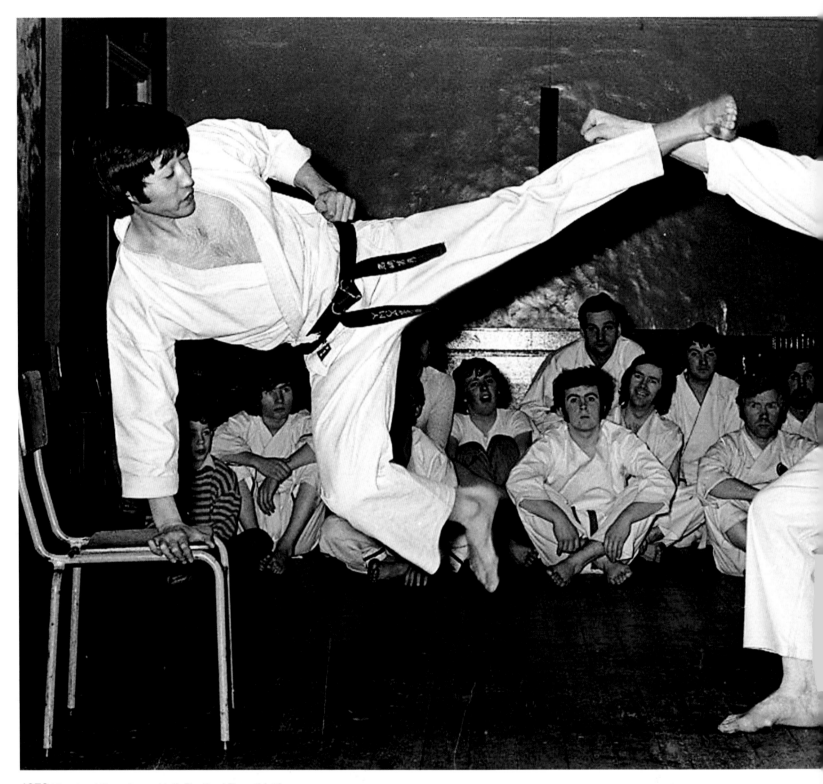

1973 Karate at Fransiscan Hall, Bedford Row. *LL48*

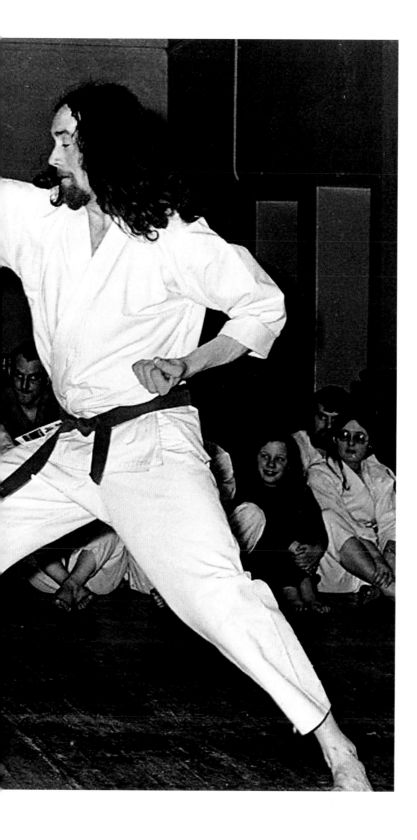

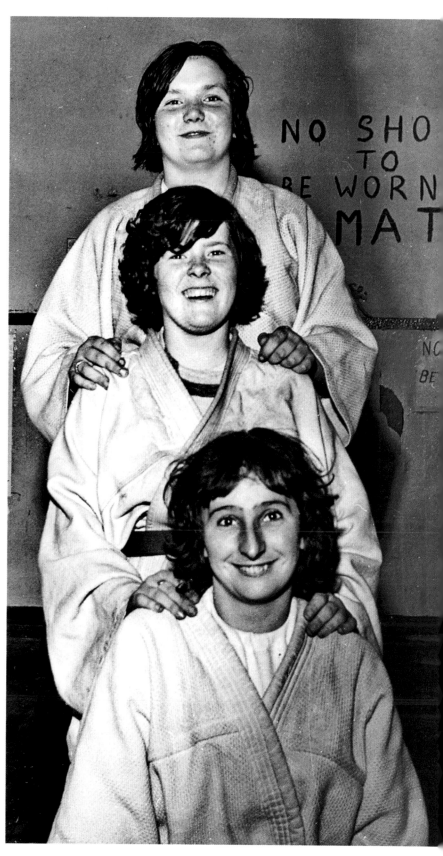

1964 Judo winners looking very pleased. *LL49*

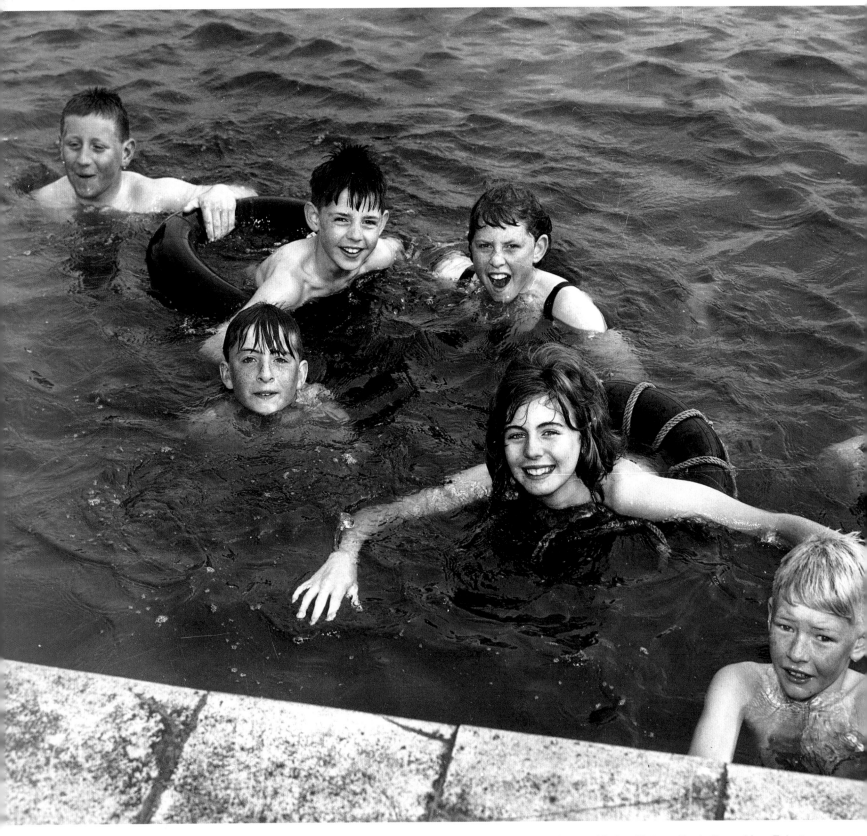

1964 Fun in the water at Corbally Baths on the last day of July. Smiling for the *Leader* photographer are Marion Slattery, Denis Ryan, Mary Egleston, Frank Slattery, Brian Morris, Ger Ryan and Niall O'Brien. *LL50*

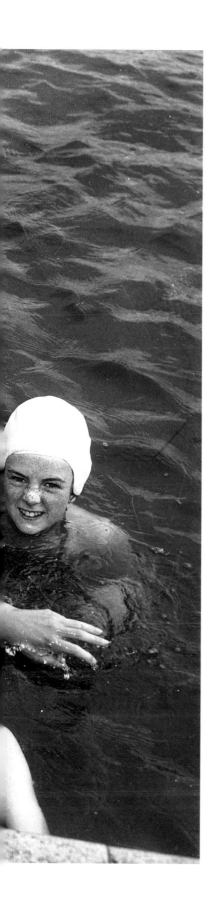

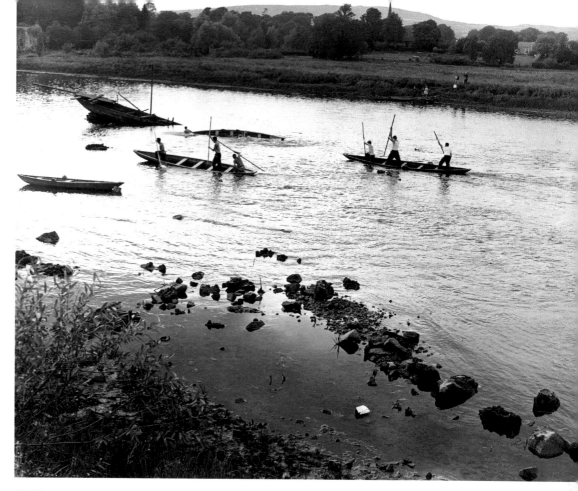

1955 Man overboard! Things not going according to plan for some at the Corbally Regatta. *LL51*

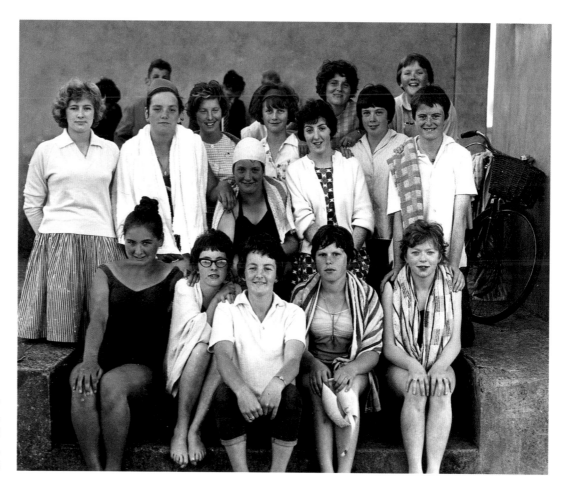

1964 Swimming at Corbally Baths. Front centre in this group is Mae Clancy, who went on to become a highly regarded writer under her married name, Leonard. *LL51B*

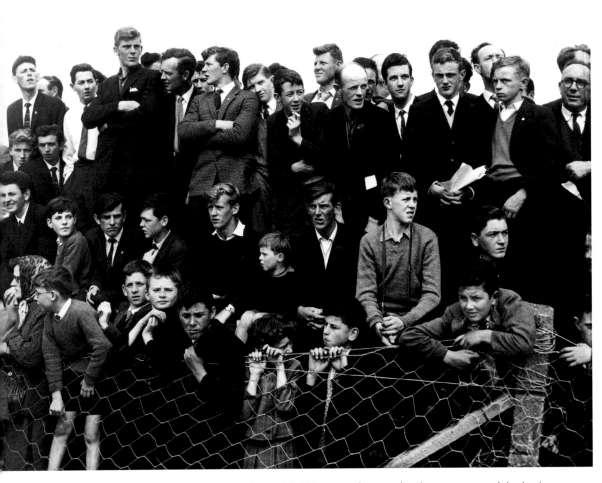

1964 The fence doesn't look up to the task in this scene from go-karting races on a July day in Kilcornan. *LL52*

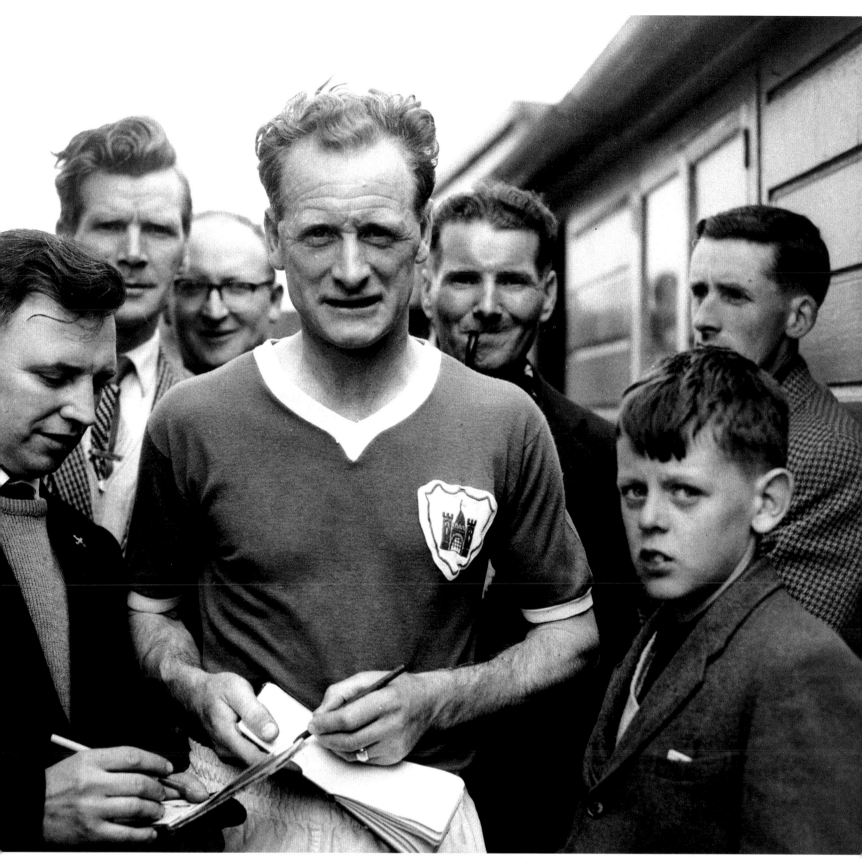

1962 England soccer international Tom Finney at the Markets Field for a charity match. Finney joined a Limerick representative team who beat a Cork selection 5-1 before a 3,000-strong crowd. *LL53*

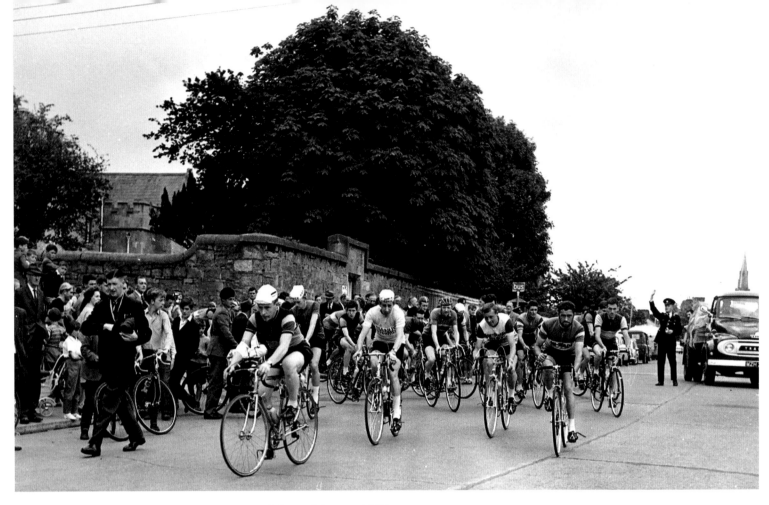

1965 The Tour of Ireland cycle race heads down O'Connell Avenue. *LL54*

1976 Victory is sweet! Donegal's Daniel McDaid, aka The Flying Postman, crossing the finish line of the Irish Marathon on the Dock Road. His winning time was 02:13:06. He won this race four times in all, also prevailing in 1970, 1974 and 1983. *LL54B*

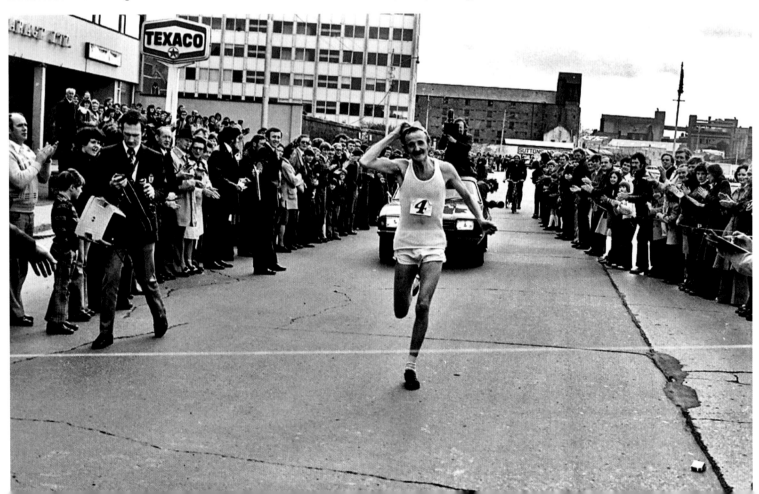

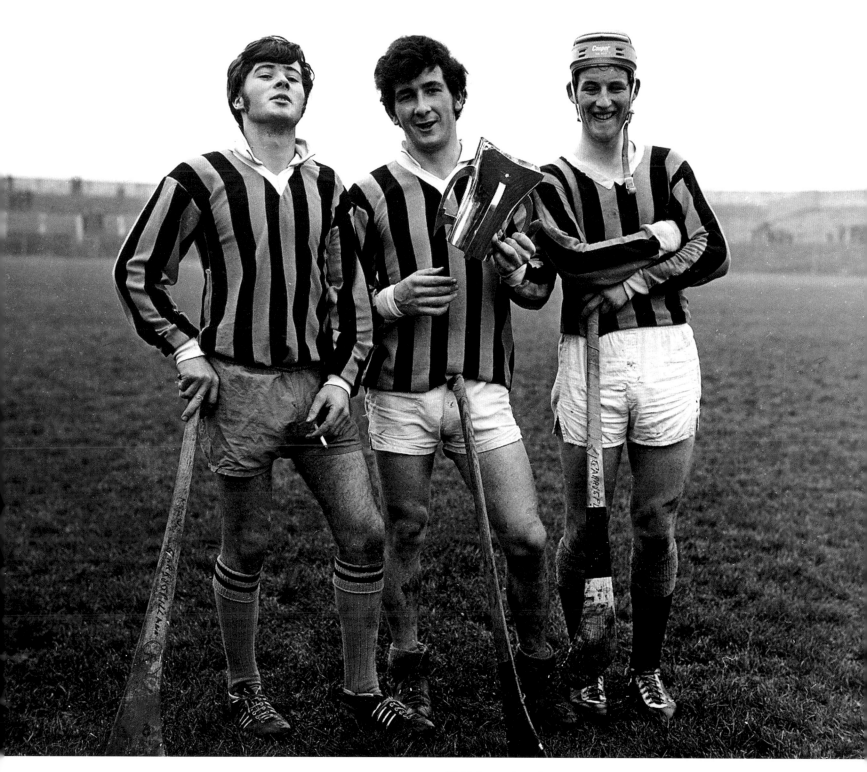

1970 James Carroll, Tommy Ryan and Kevin Walsh of the Garryspillane hurling club relishing their victory over Boher at the Gaelic Grounds. *LL55*

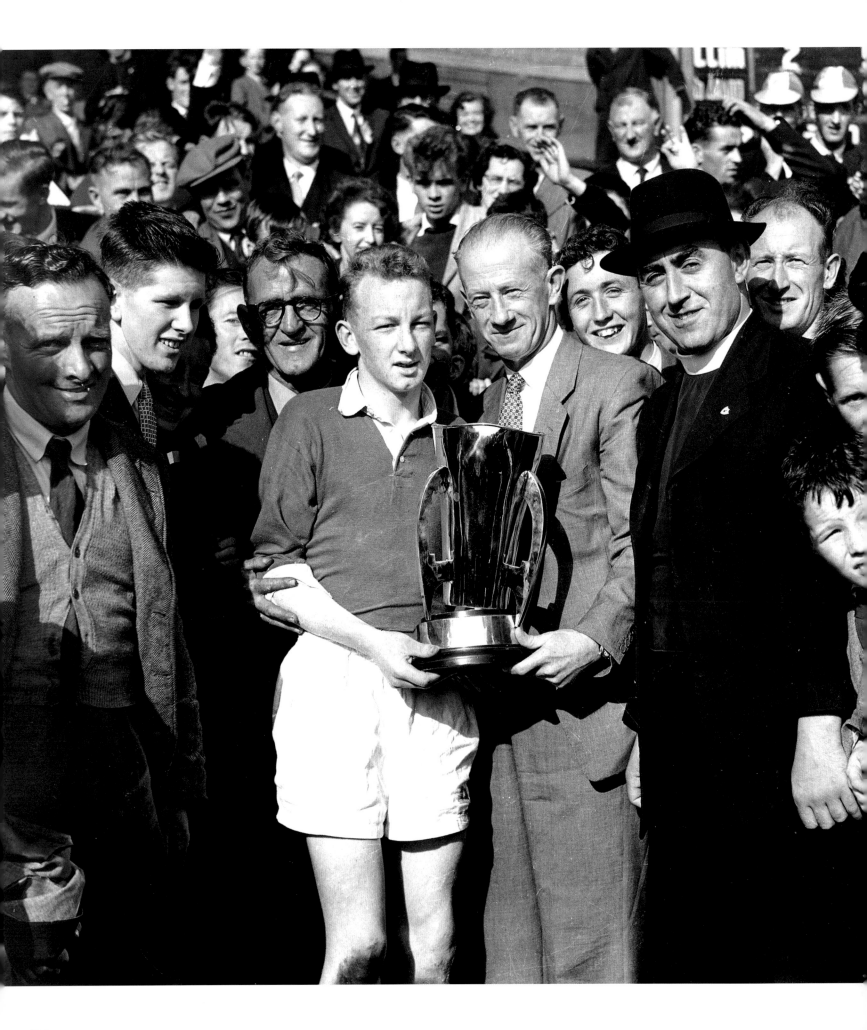

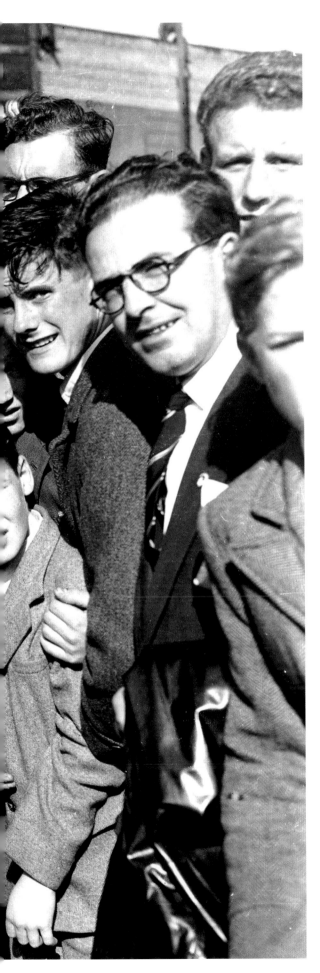

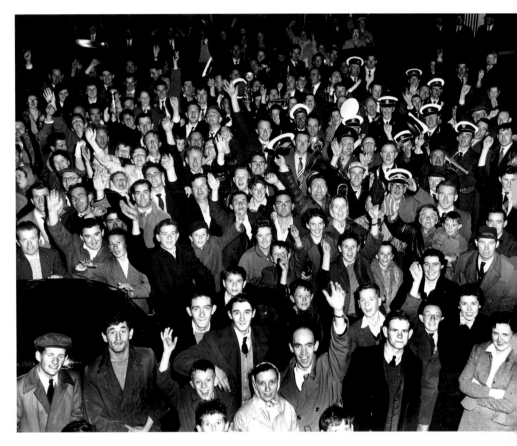

1958 Huge crowds celebrating Limerick's All-Ireland Minor Hurling Championship win. Little did they know they would star in a book 56 years later! *LL57*

1958 Limerick's All-Ireland Minor Hurling champions at Croke Park. Limerick defeated Galway 5-08 to 3-10. Captain Paddy Cobbe is surrounded by proud Limerick men as he receives the trophy. *LL56*

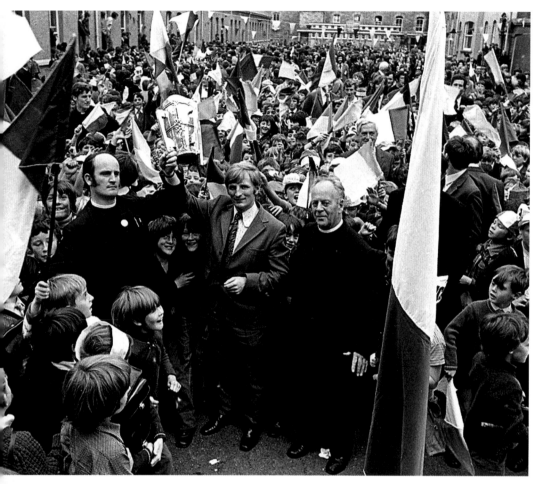

1973 Jubilation is everywhere at CBS Sexton Street, following Limerick's win in the All-Ireland Senior Hurling final, with skipper Eamon Grimes raising the trophy. *LL58*

1973 Patrickswell welcomed some local heroes shortly after Limerick were crowned All-Ireland Senior Hurling champions, beating Kilkenny to claim their first title since 1940. *LL59*

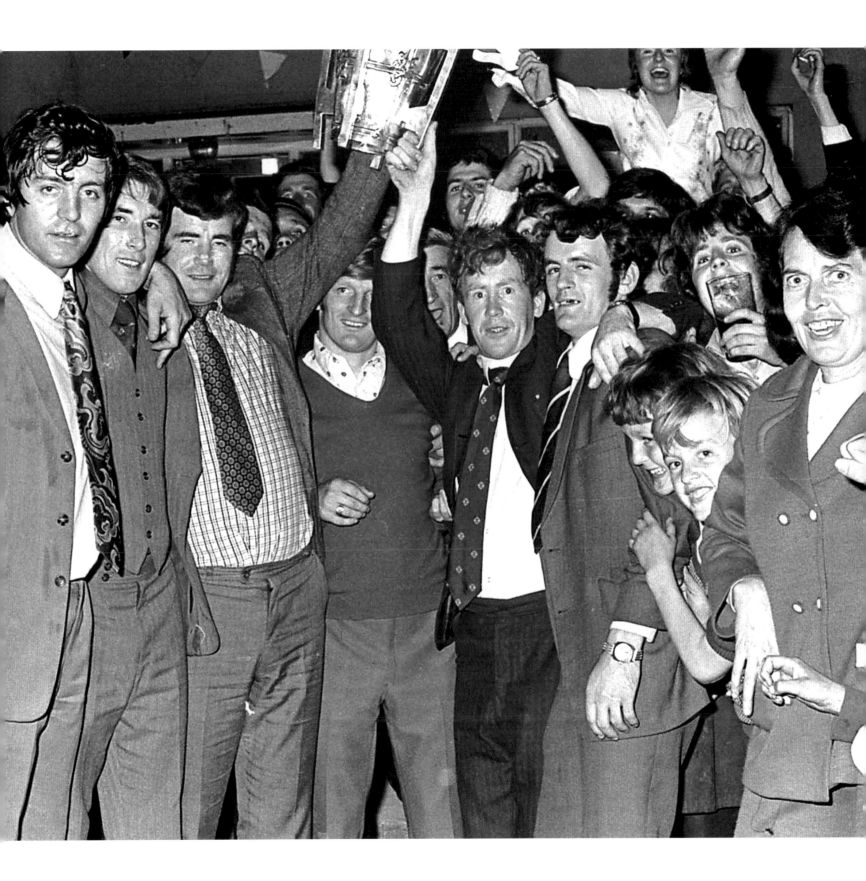

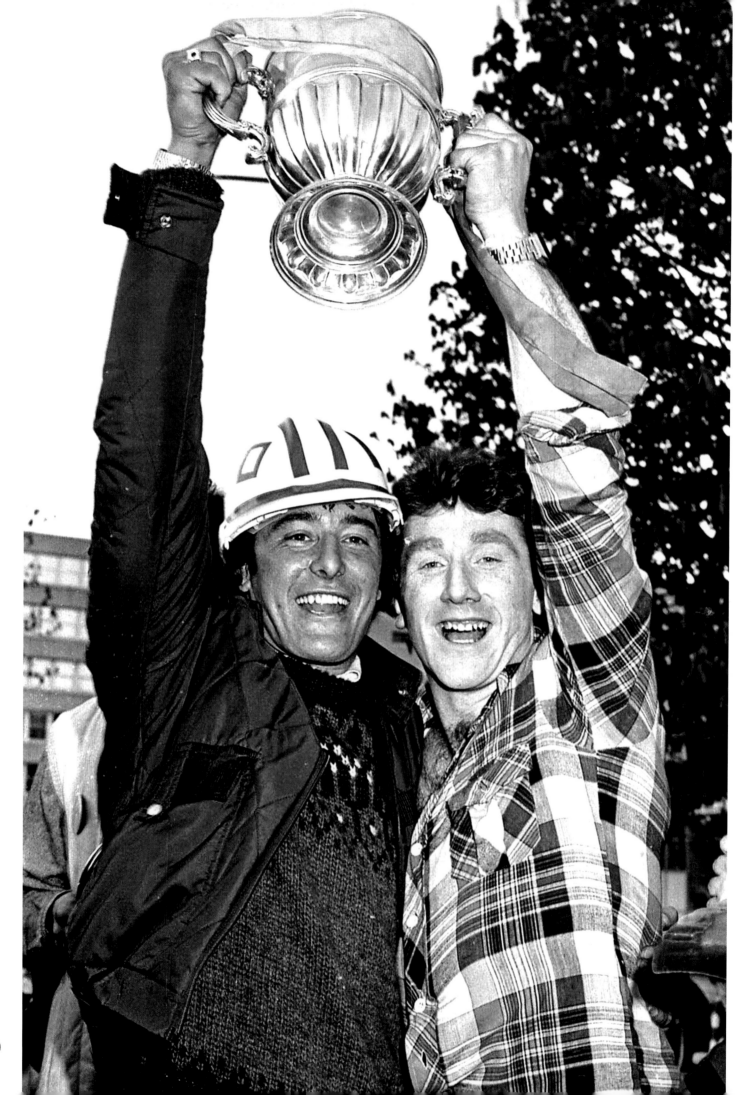

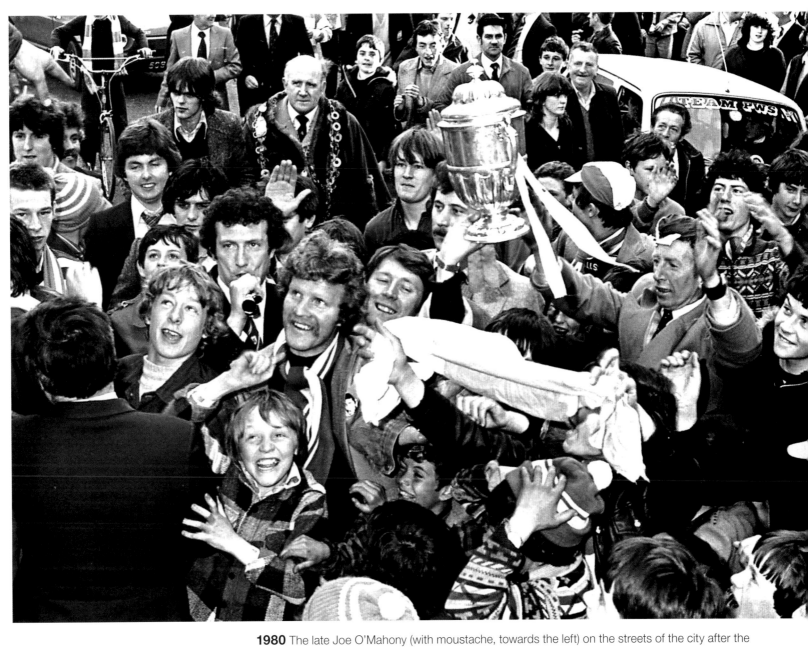

1980 The late Joe O'Mahony (with moustache, towards the left) on the streets of the city after the team he captained celebrated winning the League of Ireland title of 1979–80. *LL61*

1980 Cup of cheer: a star-studded Limerick United were crowned League of Ireland champions in 1980, clinching the title away to Athlone, and joy was unconfined in the city when the team arrived home. *LL60*

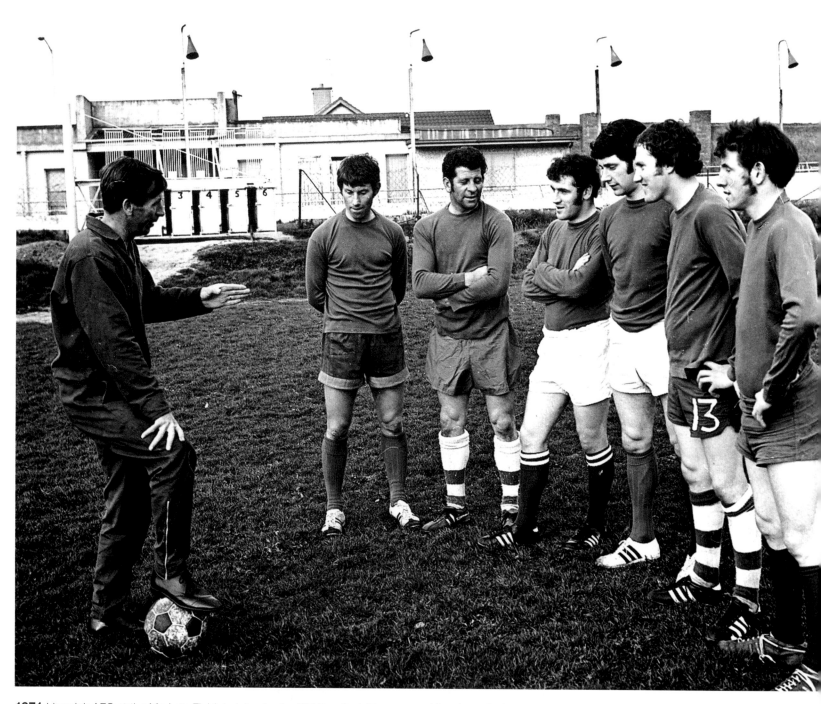

1971 Limerick AFC at the Markets Field, training for the FAI Cup final. The man making the point is manager Ewan Fenton, who set up a driving school in the city in the 1960s after starring for Blackpool in the 1953 FA Cup final at Wembley, perhaps the most famous final of them all. Eighteen years later, Fenton watched his Limerick charges triumph 3-0 in a replay against Drogheda. *LL62*

1965 Limerick v Cork in the Munster Senior Football semi-final. Limerick broke an almost 70-year losing spell in this match, winning by 2-5 to 0-6. They gave a good account of themselves against Kerry in the Munster final, but lost out. *LL63*

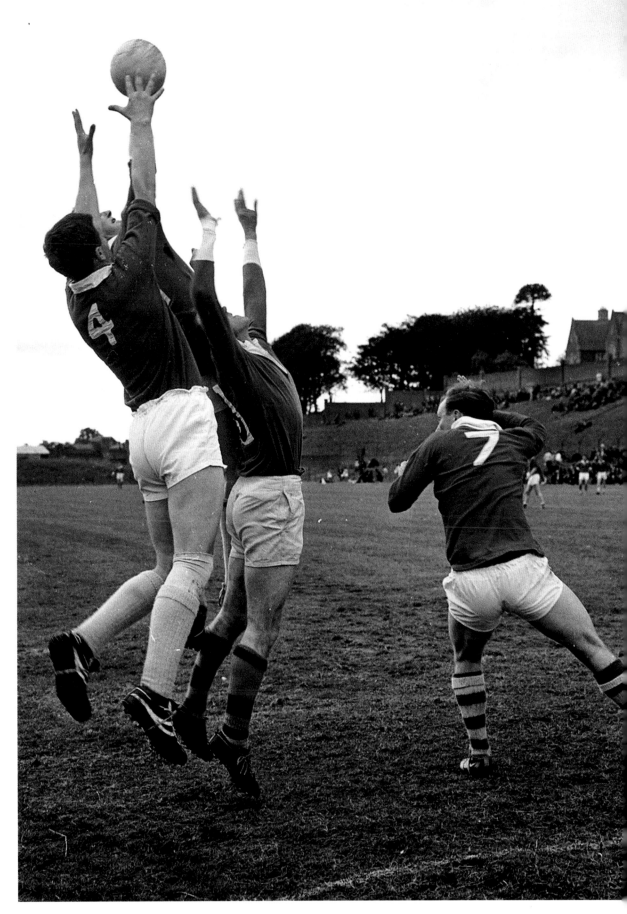

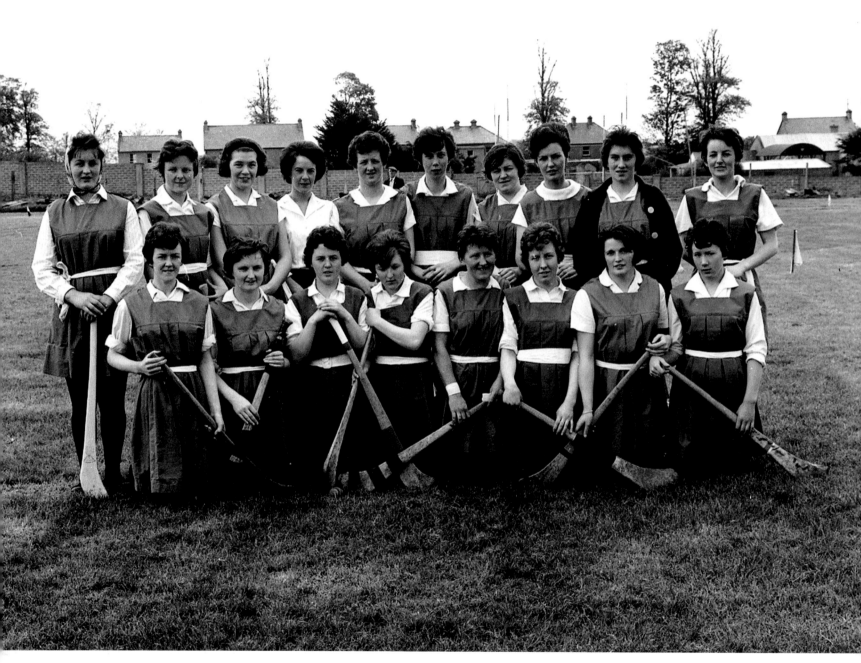

1965 The Limerick Camogie team which took on Kerry in the Munster Senior Championship at Newcastle West on a Sunday in May. With ten minutes to go, Limerick were ahead by seven goals but the match was then abandoned due to adverse weather conditions. *LL64*

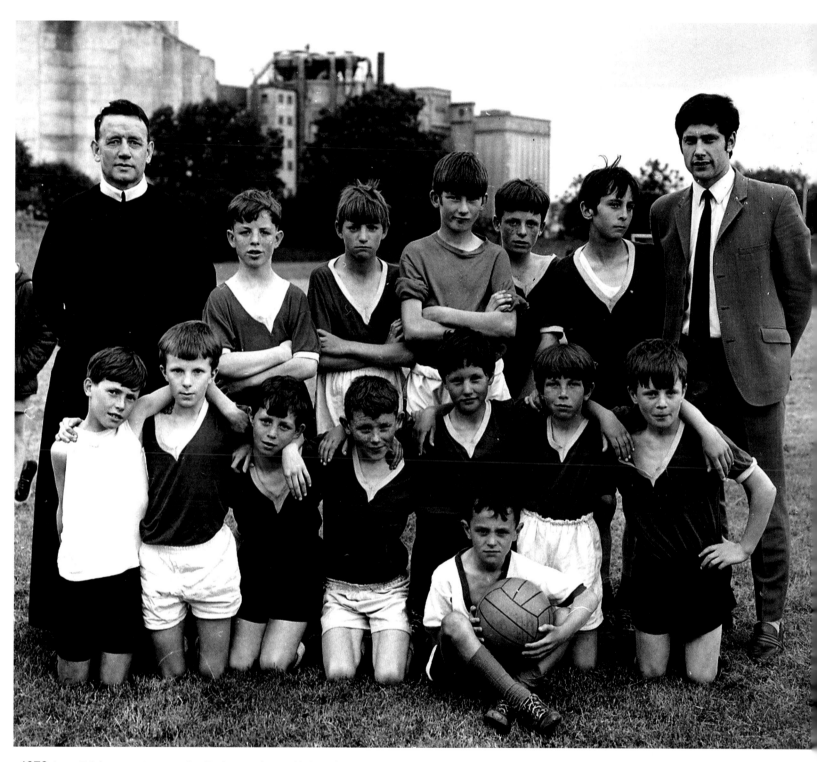

1970 A youthful soccer team at the Redemptorists, with local hero Al Finucane. The iconic Ranks building can be seen in the background. *LL65*

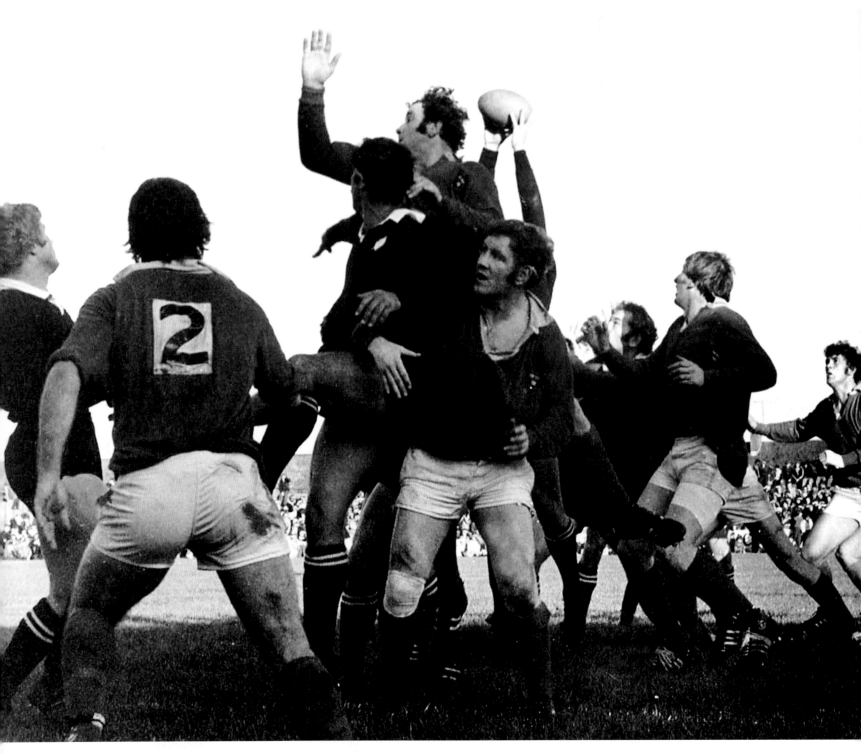

1978 Legendary victory: Munster beat the All Blacks 12-0 at Thomond Park, their first and still the only time to do it. Famously, around 100,000 claimed to have been there to witness history, even though Thomond's capacity at the time was only about 12,000. *LL66*

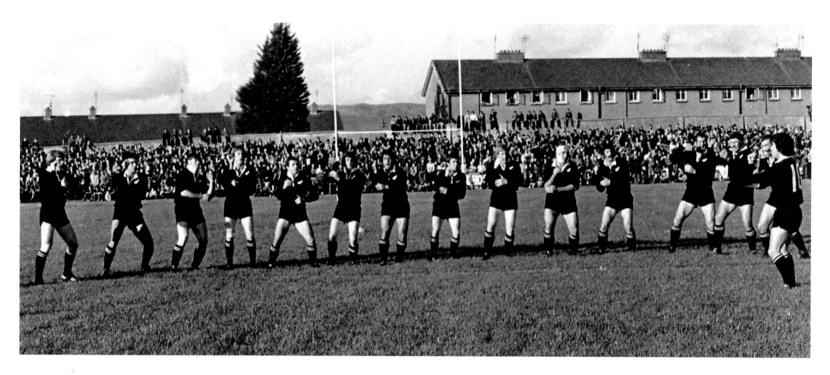

1978 The All Blacks performing the haka prior to their match against Munster at Thomond Park. A huge stand is now in place where the houses in the background once were. *LL67*

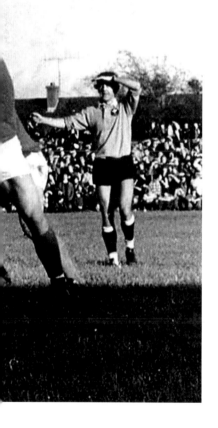

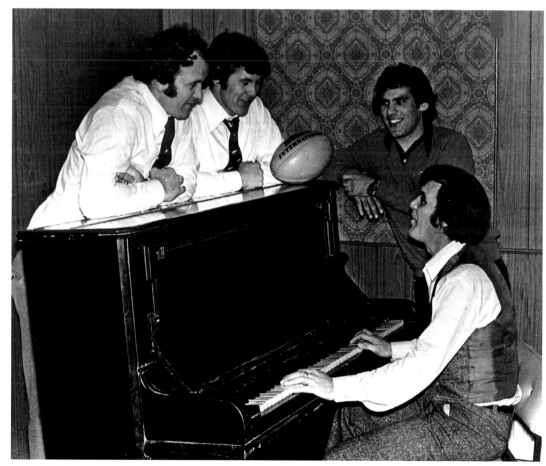

1978 Michael Cowhey took this picture the day after Munster's victory over the All Blacks at Thomond Park. (L–r): Brendan Foley, Colm Tucker and Tony Ward, with Ger Cusack tickling the ivories. *LL67B*

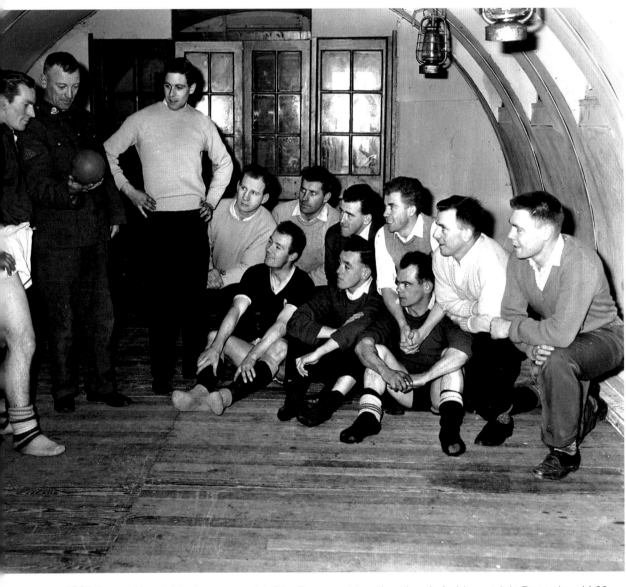

1961 Famed Limerick junior soccer club Pike Rovers get together ahead of a big match in December. *LL68*

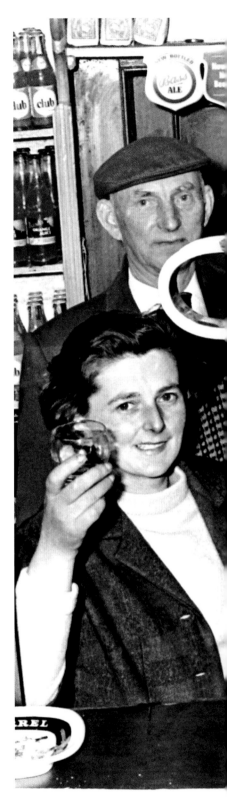

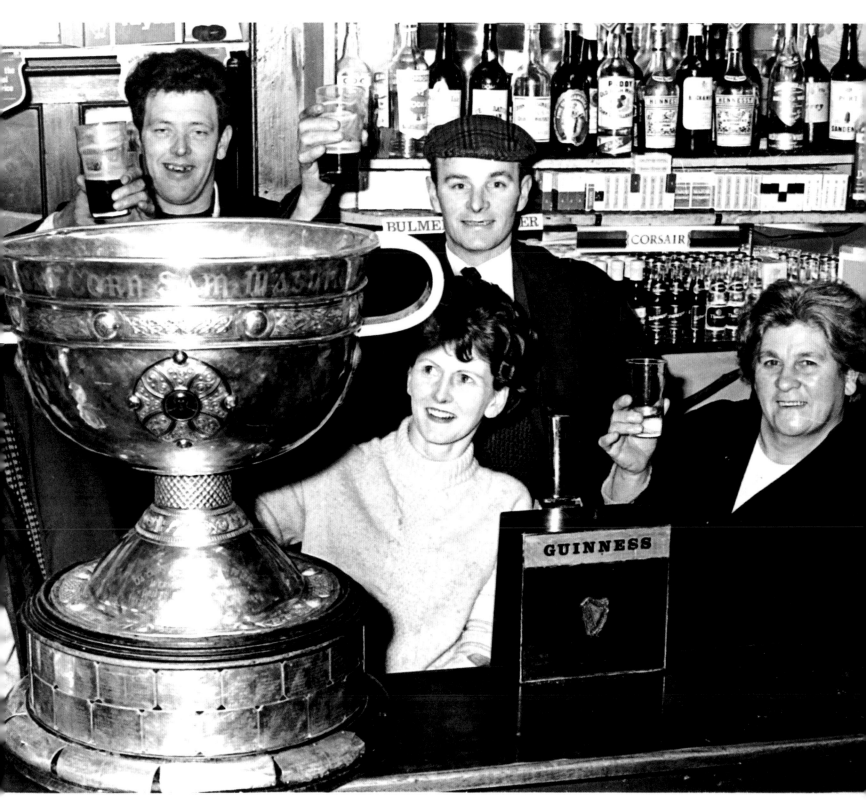

1970 The Sam Maguire cup at Collins pub, Askeaton. Kerry, not surprisingly, were the holders at the time, having beaten Offaly in the All-Ireland Senior Football. *LL69*

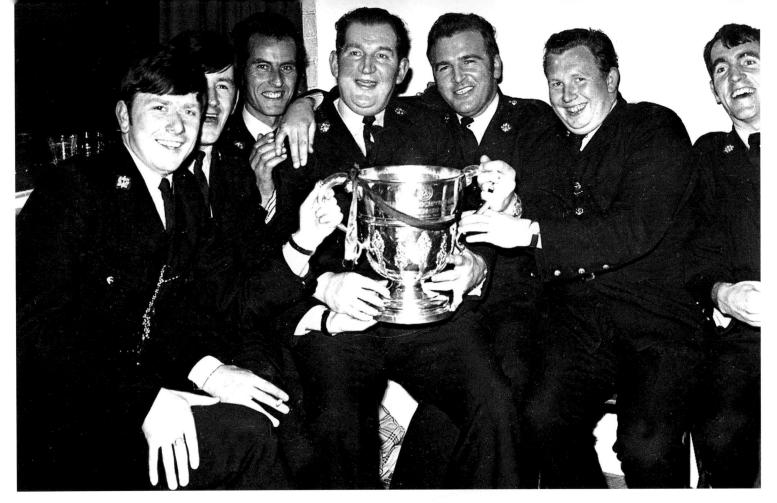

1971 Jim Browne, a long-time supporter of Limerick soccer, with some of his An Garda Síochána colleagues celebrating the 1971 FAI Cup triumph. *LL70*

1971 The victorious Limerick soccer team arrives back at Limerick's Colbert Station with the FAI Cup. Limerick beat Drogheda 3-0 in a replay at Dalymount Park following a 0-0 draw in the first match. *LL70B*

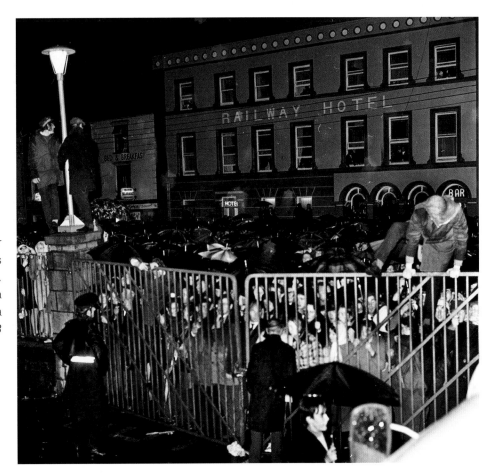

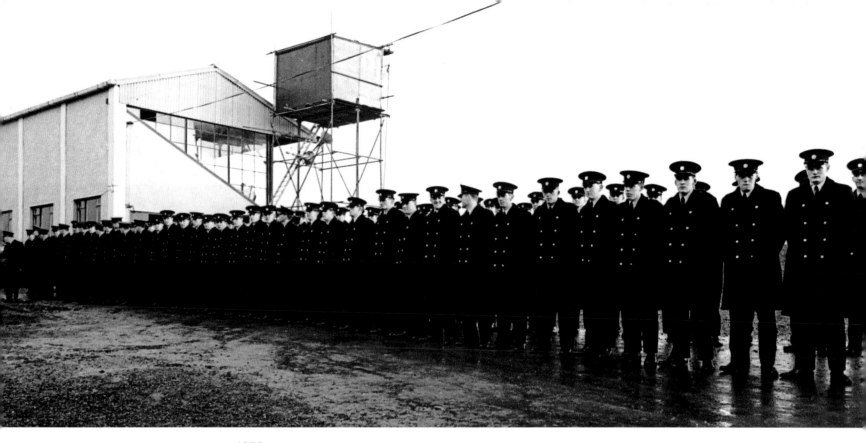

1970 There was a heavy Garda presence for the arrival of the controversial Springboks rugby team at Thomond Park, with 400 gardaí on duty on the day and protests against the touring all-white South African team because of the apartheid system. The event passed off peacefully and Springboks beat Munster 25-9. *LL71*

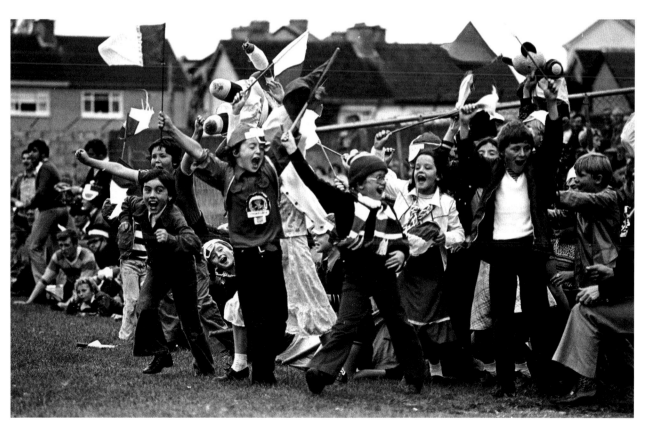

1978 Youthful Monaleen supporters invade the pitch at the Gaelic Grounds after watching their team beat St Kieran's in the county senior football final. *LL71B*

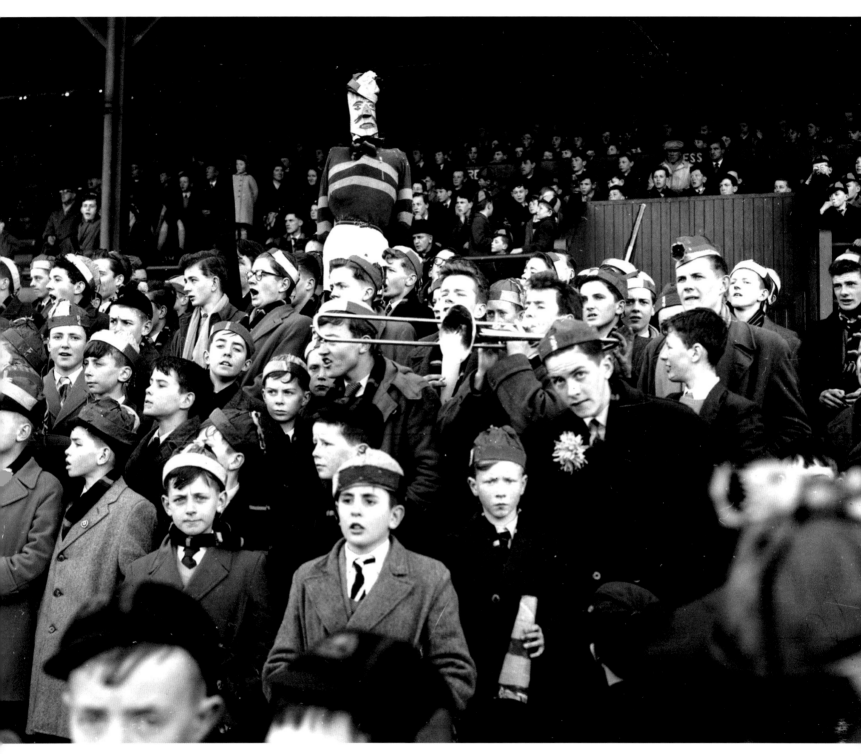

1958 Schools rugby on a March afternoon at Thomond Park. *LL72*

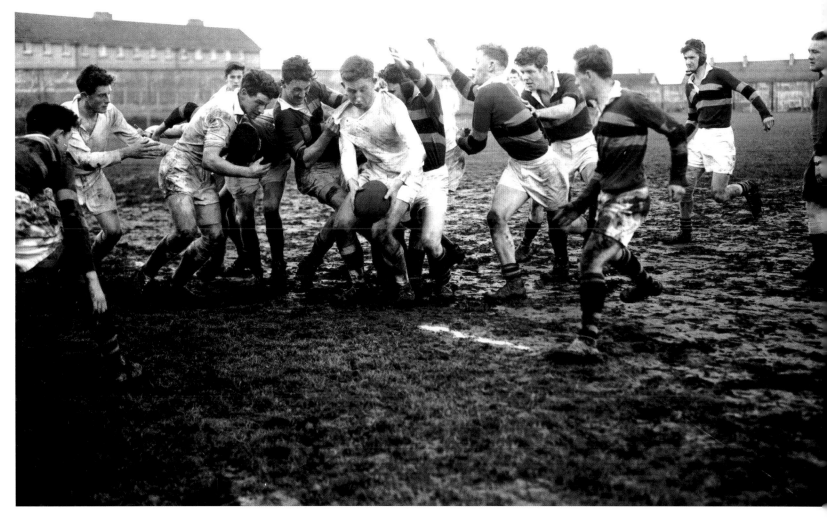

1958 These days the Thomond Park pitch usually looks manicured, but it was far from that during this Schools Cup rugby contest. *LL73*

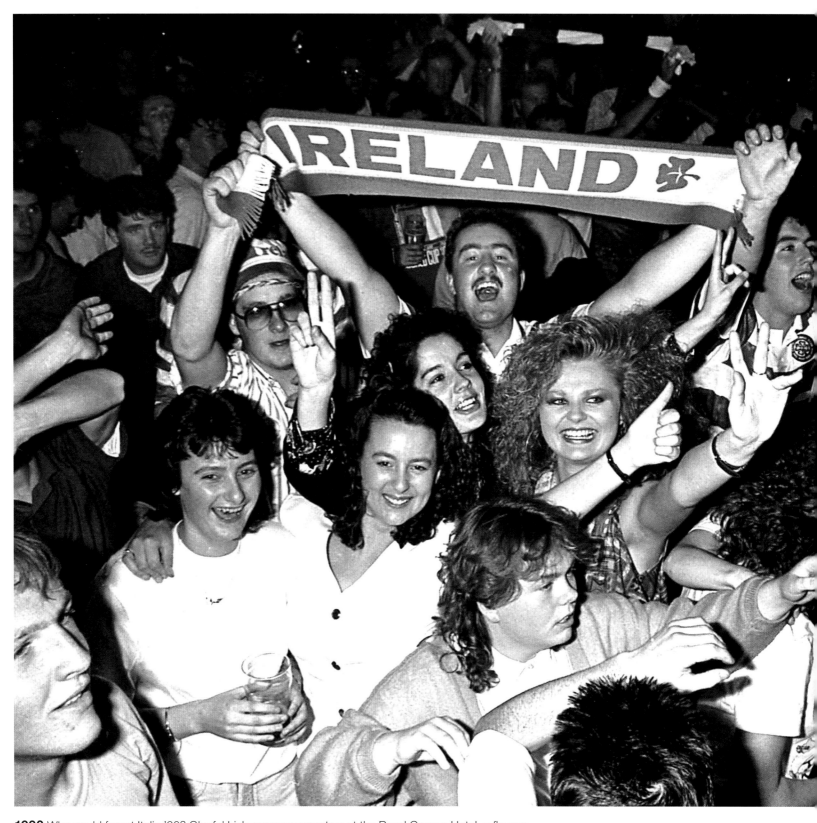

1990 Who could forget Italia '90? Gleeful Irish soccer supporters at the Royal George Hotel, a flavour of the national euphoria which greeted Ireland's appearance in the World Cup quarter-finals. *LL74*

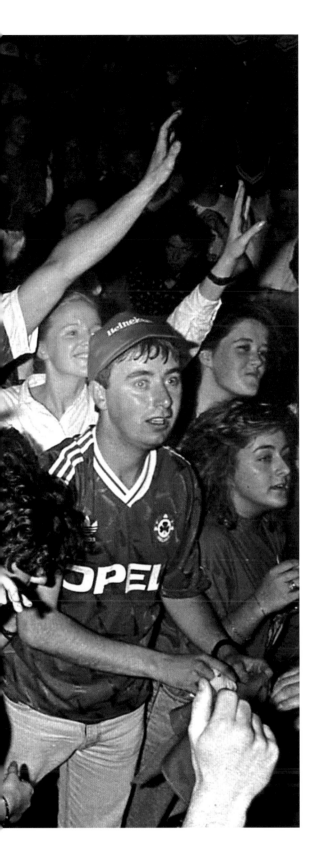

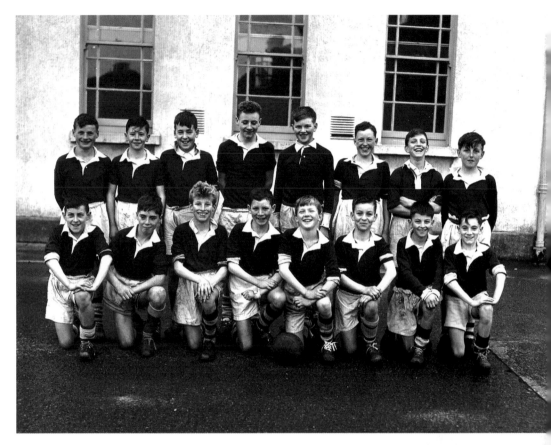

1961 St John's School GAA team. This school building, located in Garryowen, is now demolished. *LL75*

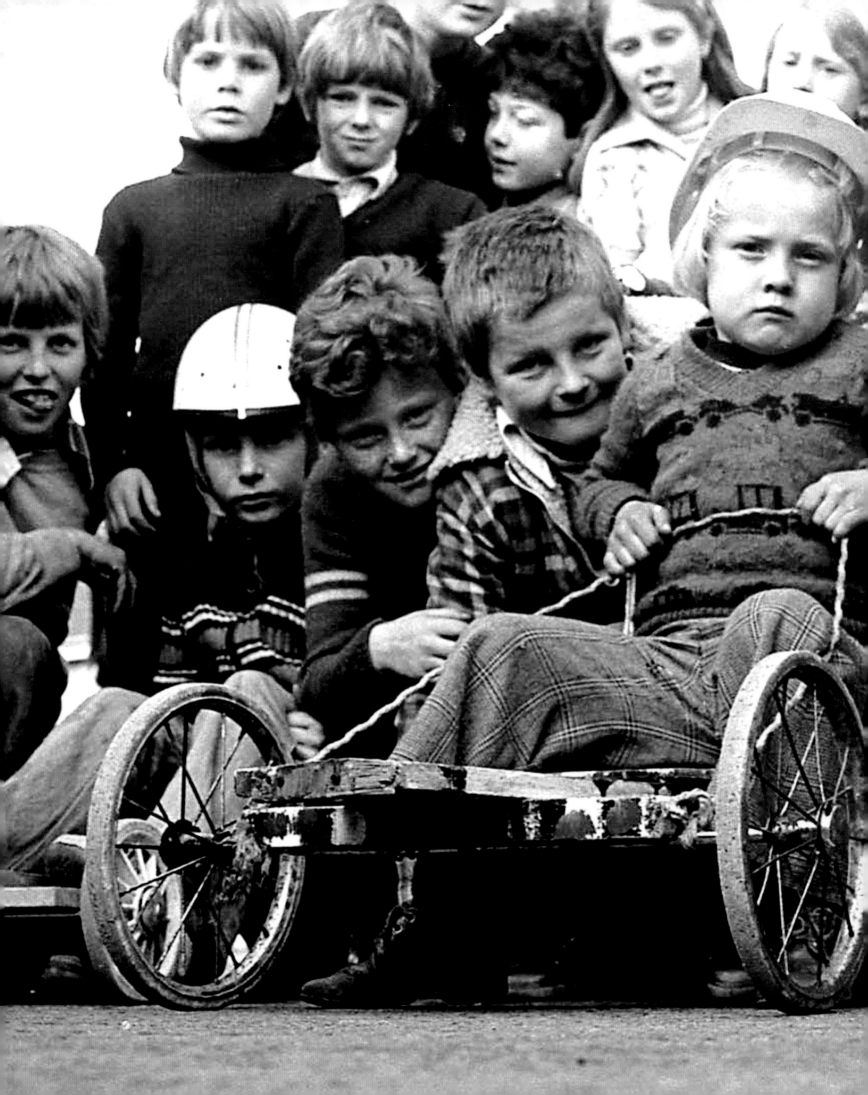

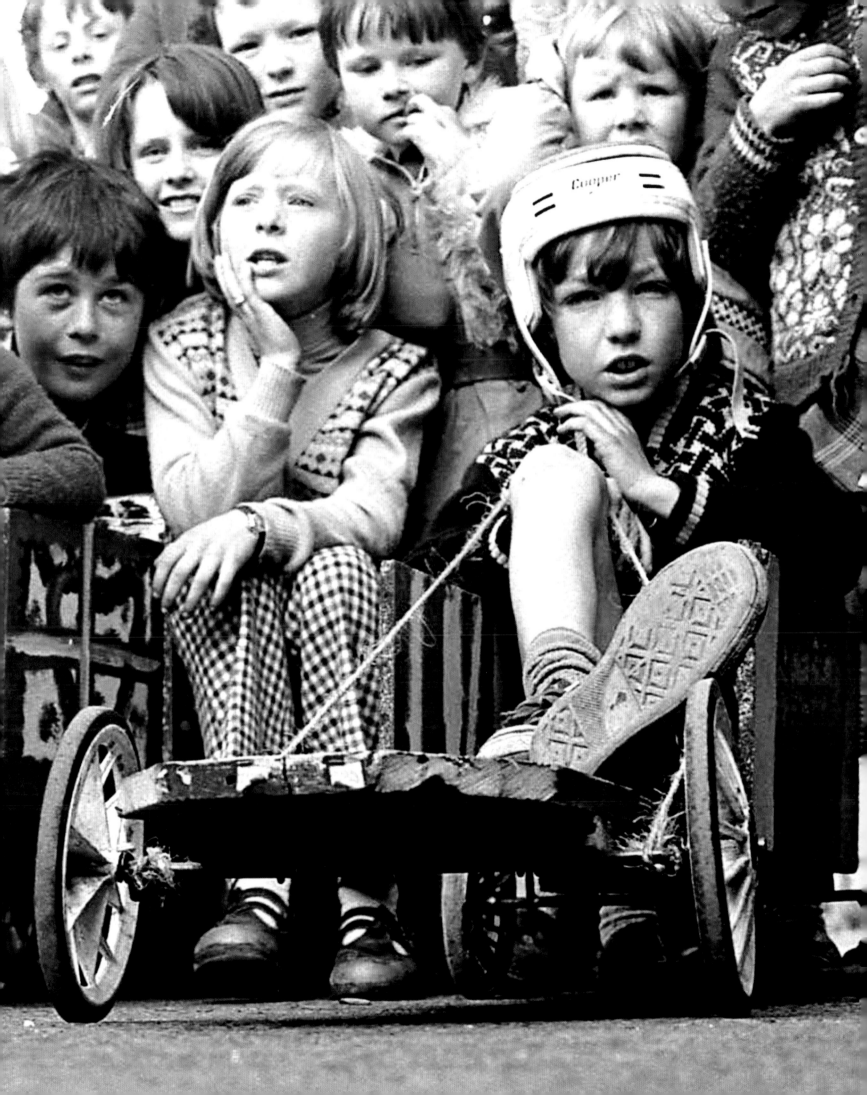

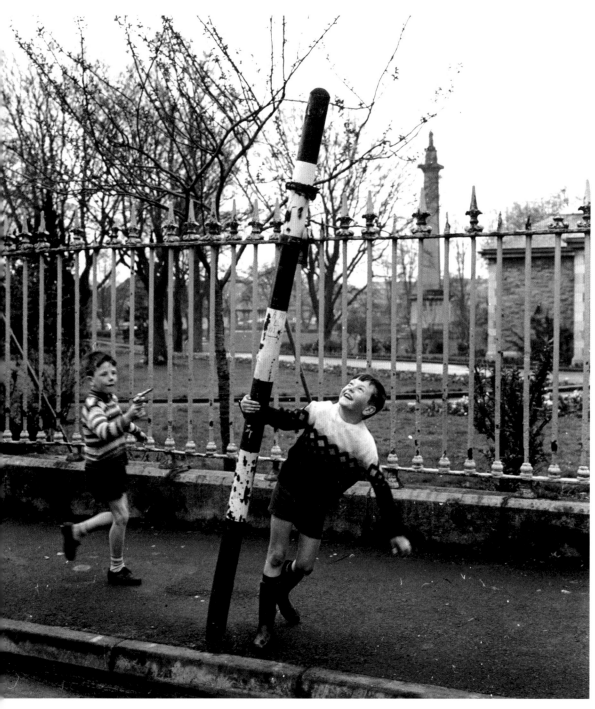

1969 Mr Muscle! Boy 'bends' pole at the People's Park. *LL78*

Previous pages: **1978** The very serious and competitive business of the Southill Soap Box Derby. *LL76*

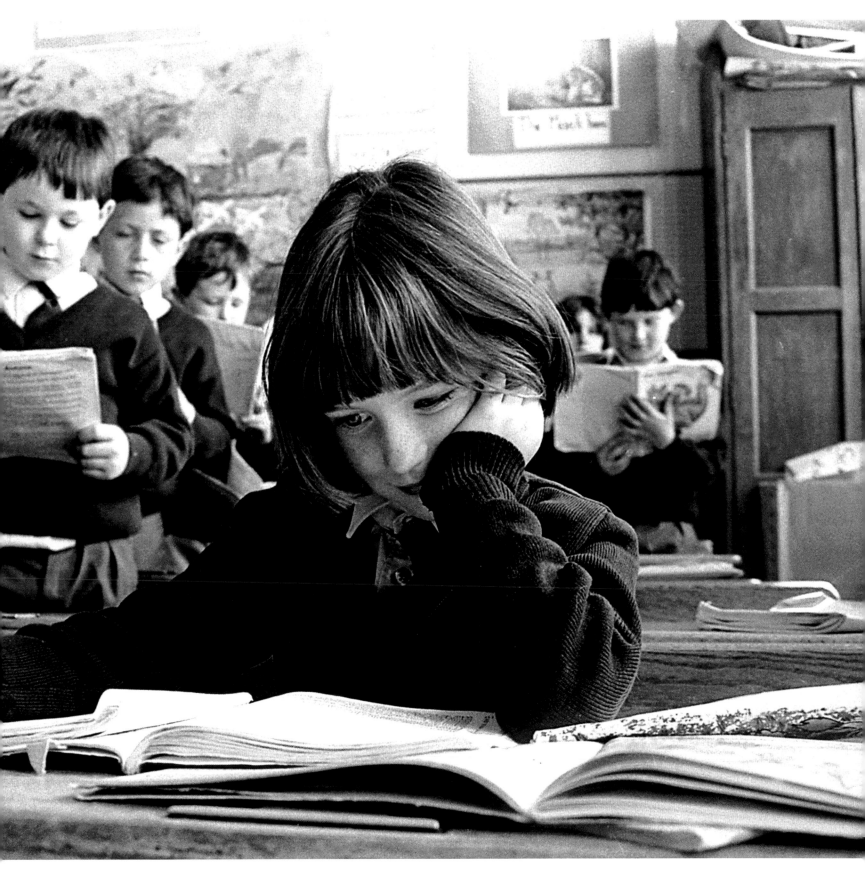

1993 Estella Harte was deep in thought at Askeaton National School when the *Leader* called out to illustrate a story about a book rental scheme. *LL79*

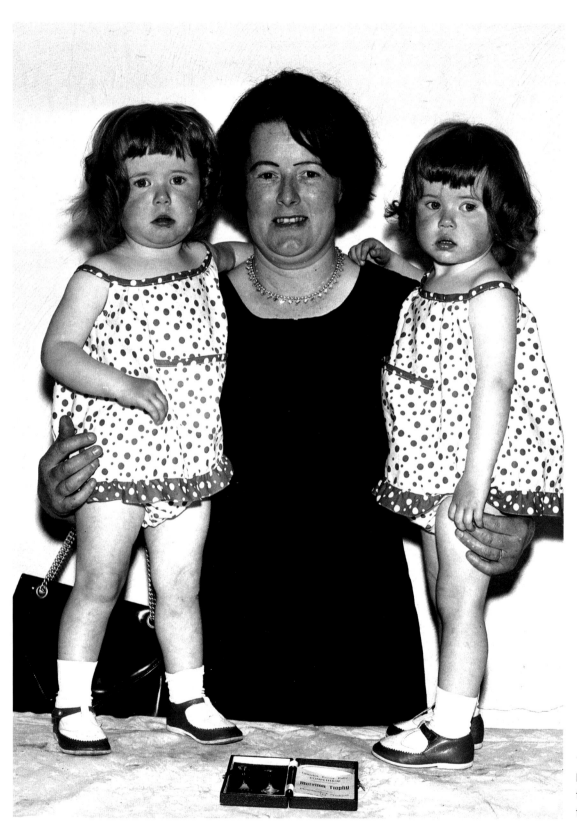

1964 Twins Helena (left) and Harrietta McCarthy, from Ballynanty in the city with their proud mother on the occasion of their second birthday. *LL80*

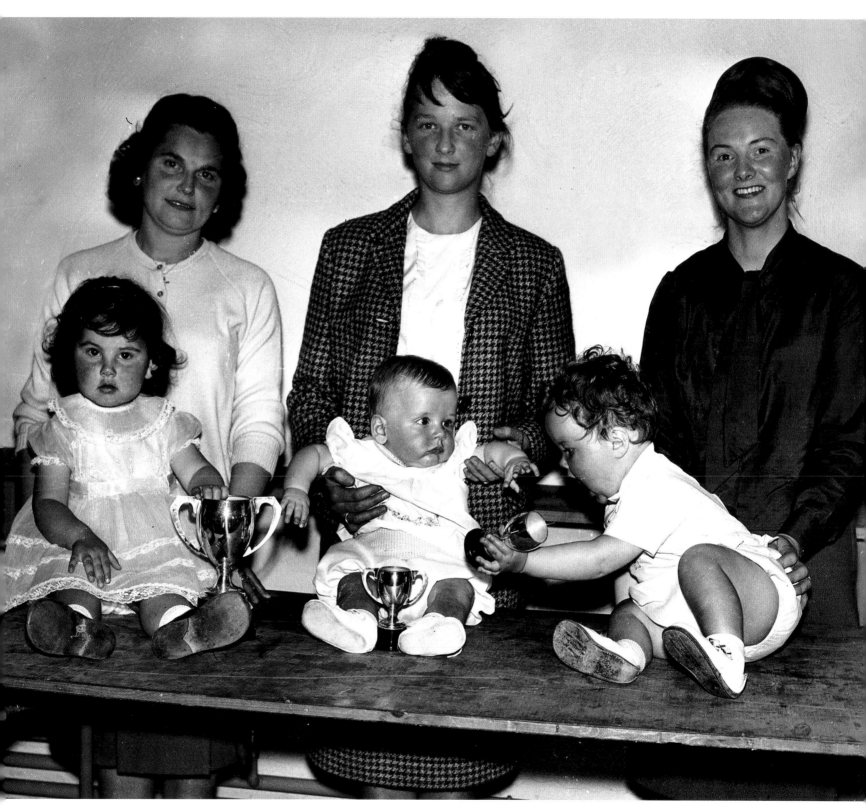

1966 Beautiful babies and their beaming mothers … one of the prizewinners was having fun with the cup just presented. *LL81*

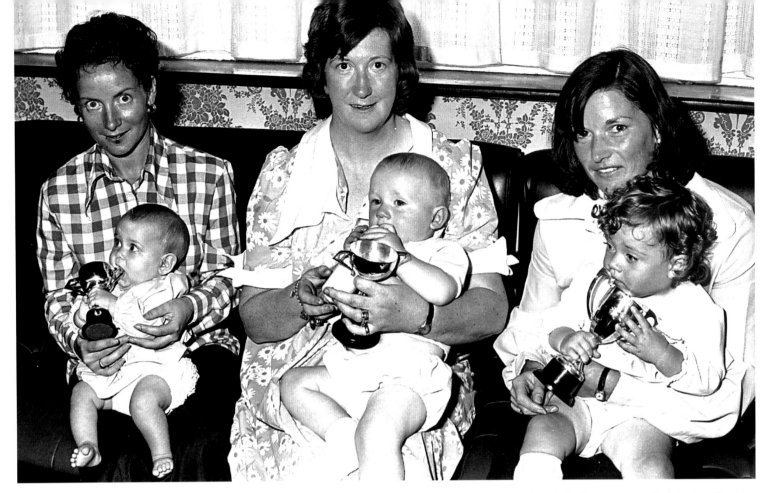

1975 Bonny Baby competition in July, Newcastle West. In the arms of their proud mothers, and clutching their silver cups are (l–r): Louise Cremin from Newcastle West, Castlemahon girl Maura Neville and Caroline Mulcahy from Ardagh. *LL82*

1975 Winning smiles: Féile Luimní successes from Salesian Convent, Fernbank. The girls completed a clean sweep in the Under 6 poetry section and were understandably pleased with their achievements! (L–r): Elizabeth Birdthistle (first), Mirinda Martin (second) and Isabel Donnellan (third). *LL82B*

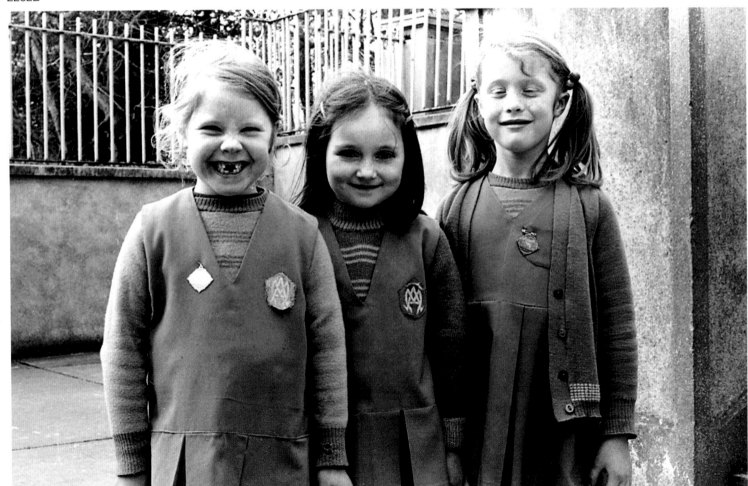

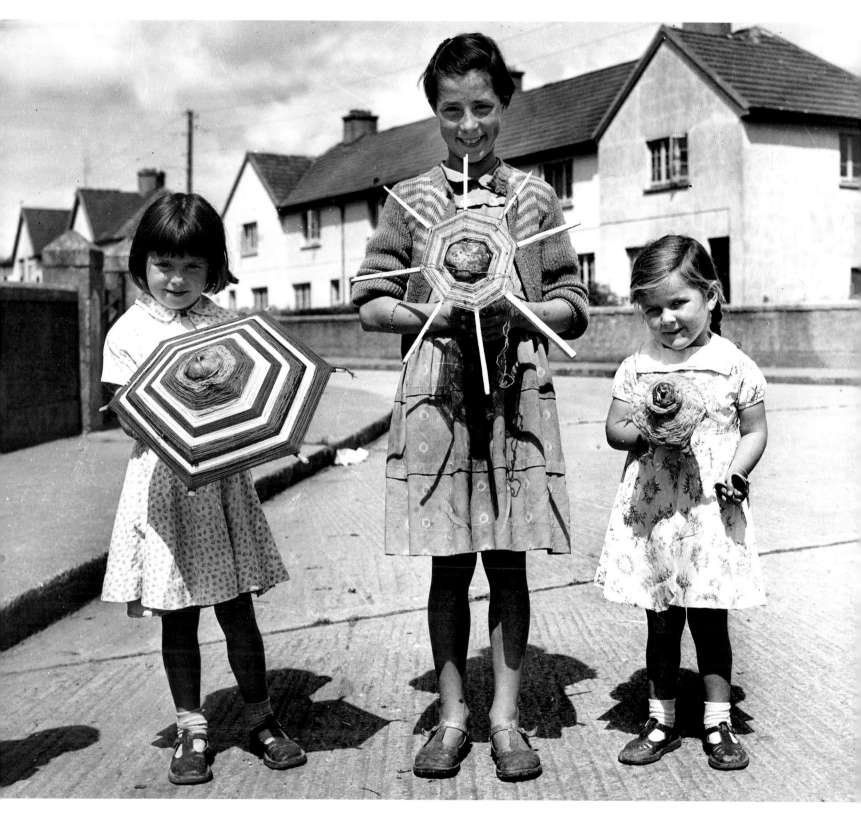

1959 Children in the city showing off their craft work. *LL83*

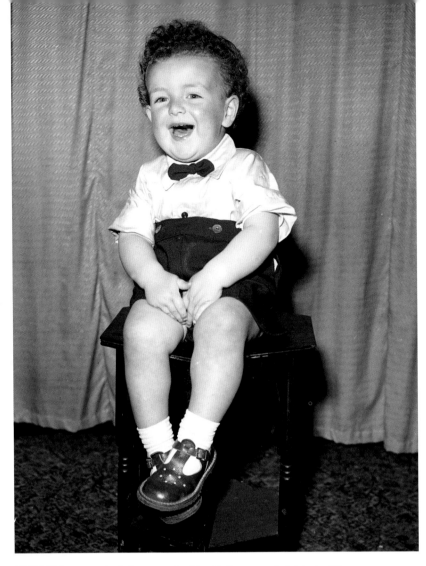

1956 This young lad, the son of a Mrs Butler, was delighted with himself when posing for the *Leader* photographer. *LL84*

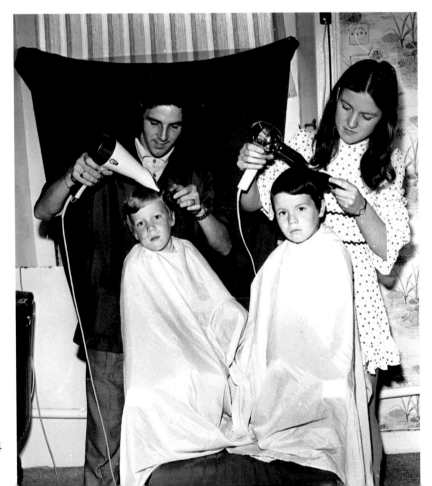

1971 Doing everything together – the McDonagh twins getting their hair cut. *LL84B*

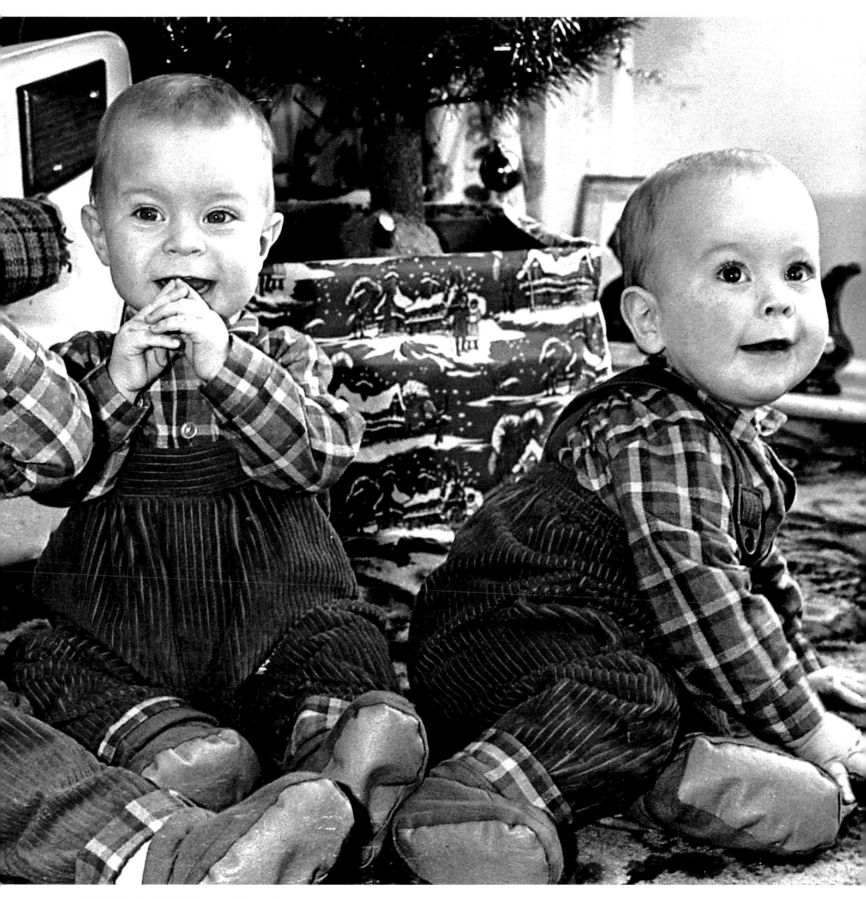

1988 Triplets Keith, Cian and Shane Connery from De Valera Park, Thomondgate, had a great time celebrating their first birthday in front of the family Christmas tree. Well, at least two of them seemed happy about having their picture taken! *LL85*

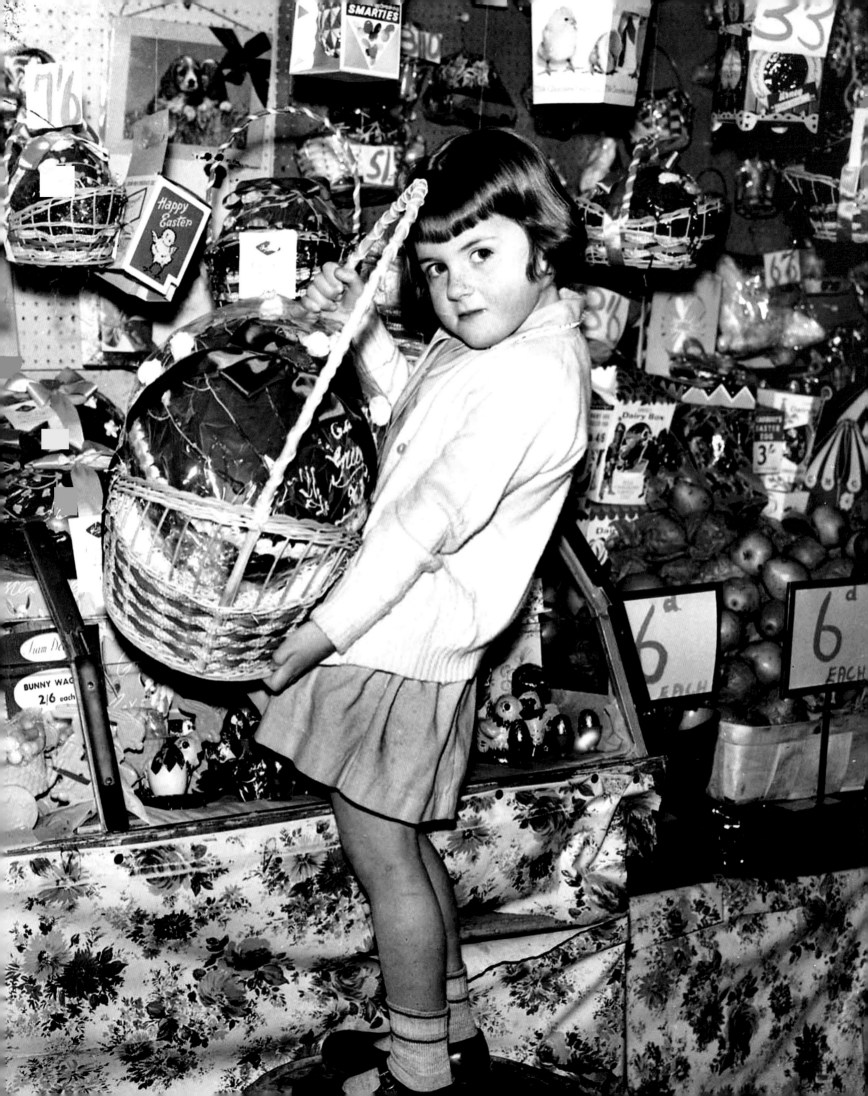

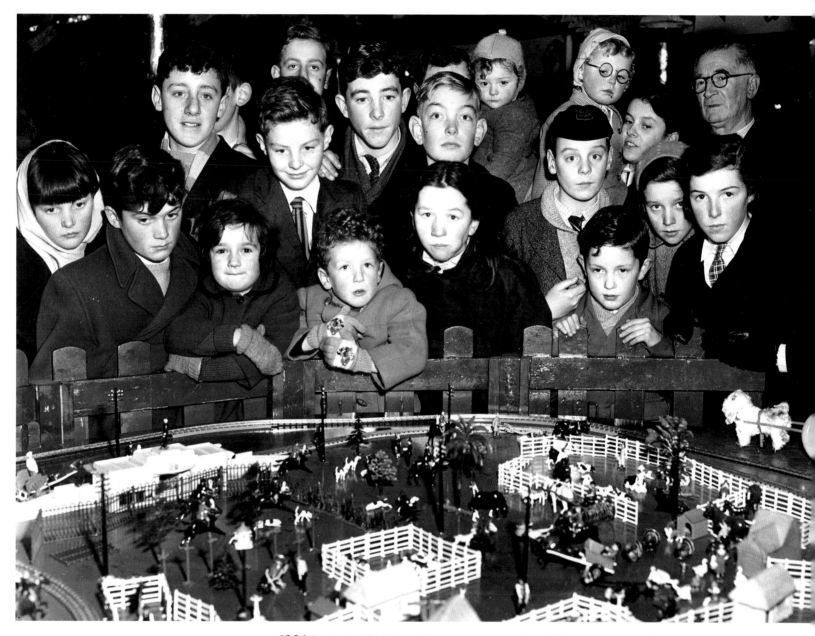

1964 Toyland at Todd's and there were any number of fascinated young Limerick faces. *LL87*

1963 A young girl struggles to hold a giant Easter egg at Paddy McKenna's Shop, Bedford Row. *LL86*

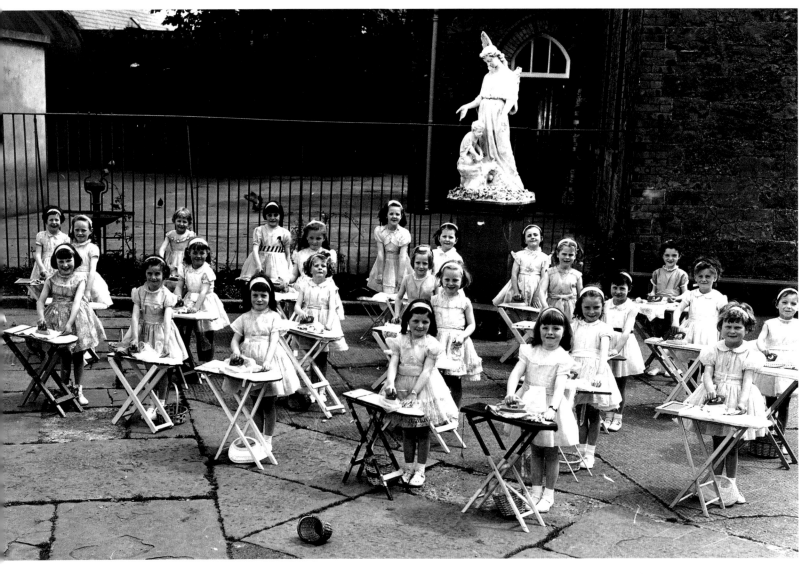

1963 Young girls from St John's School with ironing boards. *LL88*

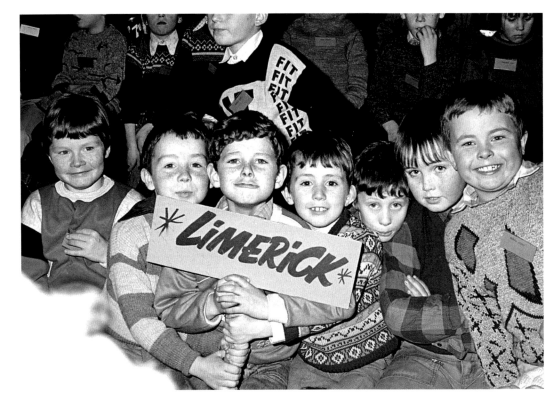

1985 Children from St Mary's parish at the RTÉ Christmas Party. *LL88B*

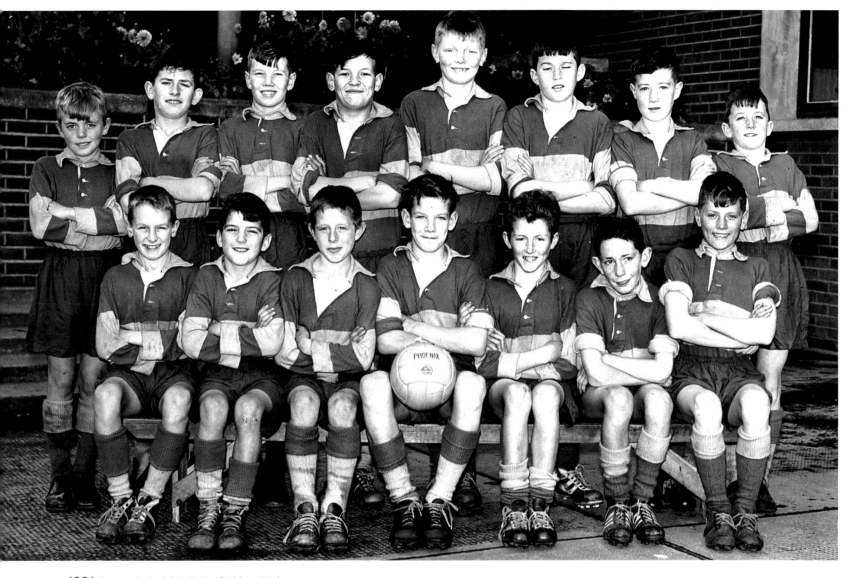

1961 Arms nicely folded, the St Munchin's CBS football team make a fine picture.
LL89

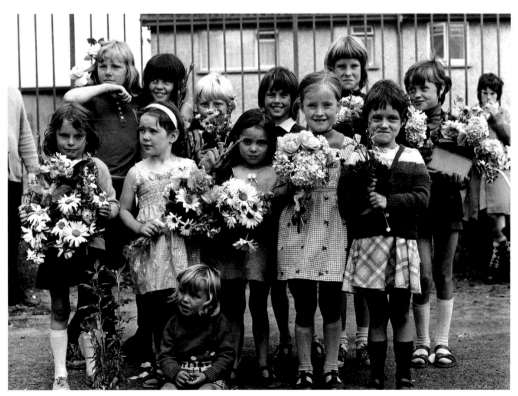

1977 The Weston/Prospect Dog and Flower show proved a big hit with these youngsters.
LL89B

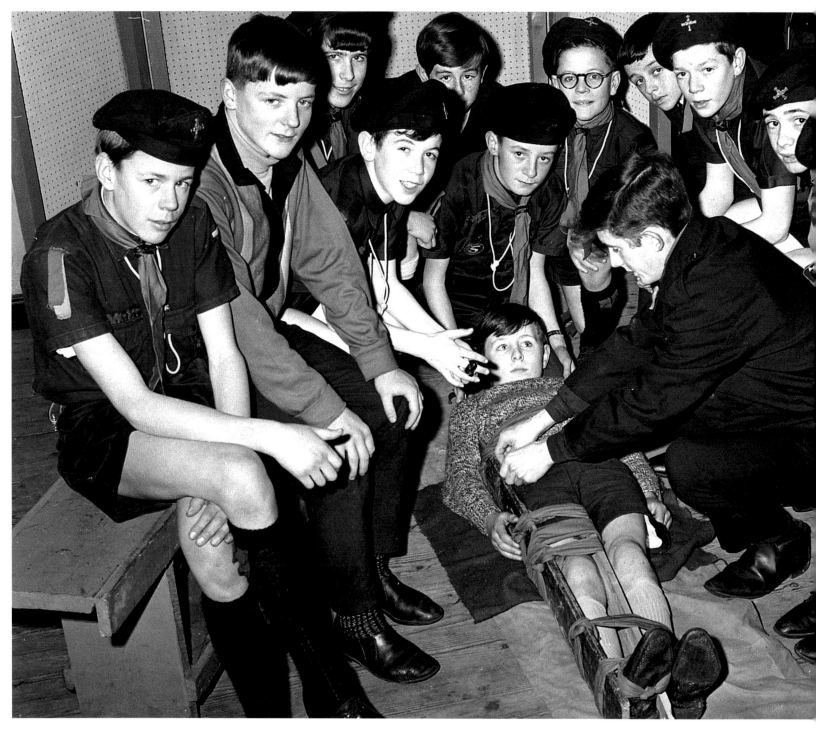

1968 Fully prepared: the St Mary's Scout Troop. *LL90*

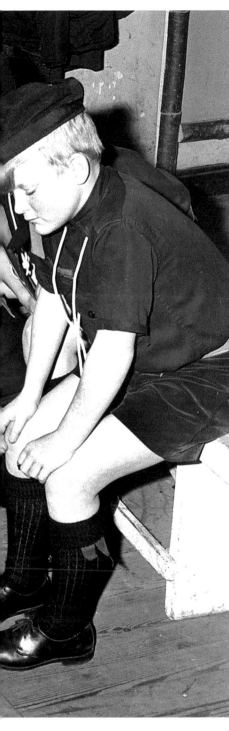

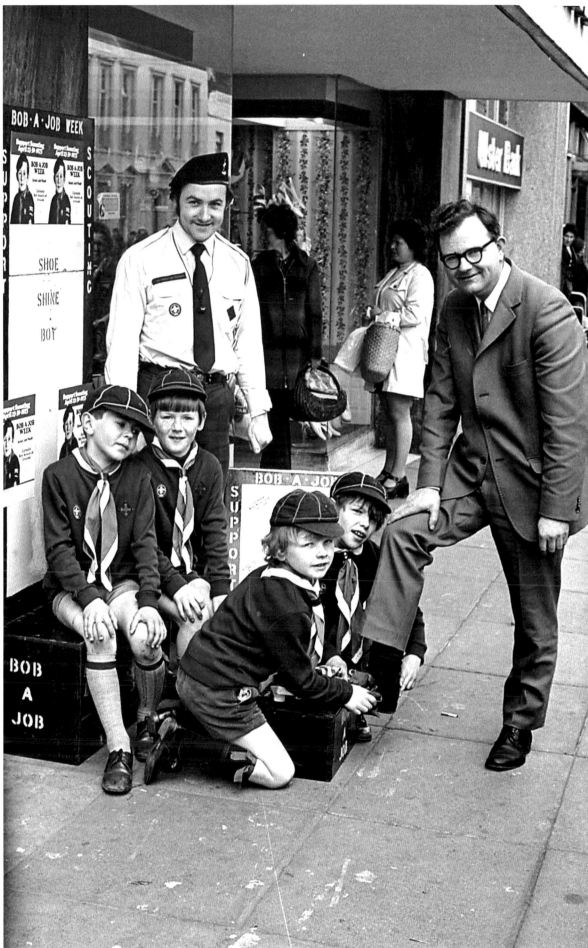

1973 Mayor of Limerick, Paddy Kiely, having his shoes shined by a Bob-a-Job team outside Todd's, O'Connell Street. The scouts are (l–r): Declan Woods, Paul O'Doherty, Shane Rooney and John O'Brien. At the back is unit leader Kieran O'Hanlon, who went on to become mayor himself in 1996. *LL91*

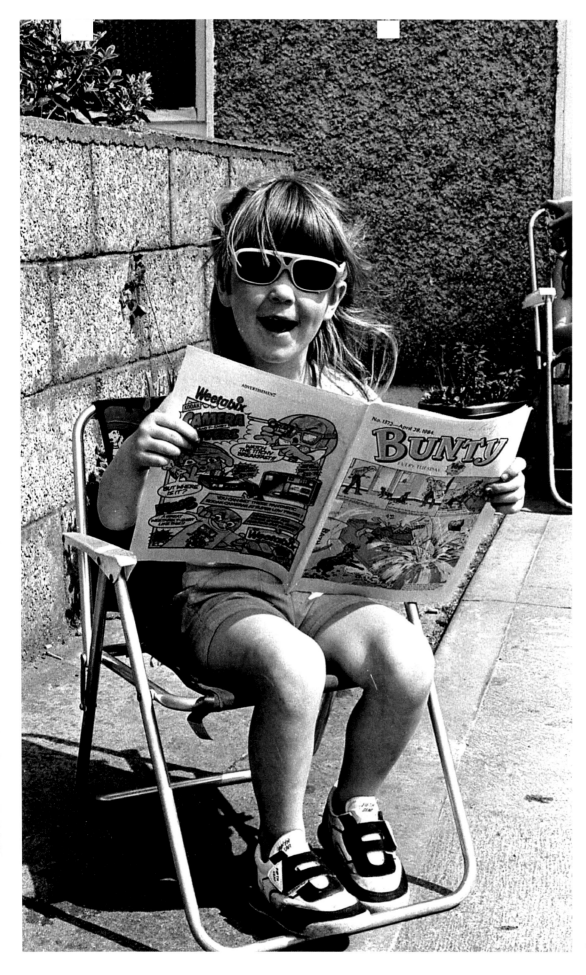

1984 Shirley Foley from Granville Park was enjoying an unseasonably sunny April day with the latest edition of the *Bunty*. Shirley's father, Foncie, a *Leader* staff photographer for many years, took this lovely picture. *LL92*

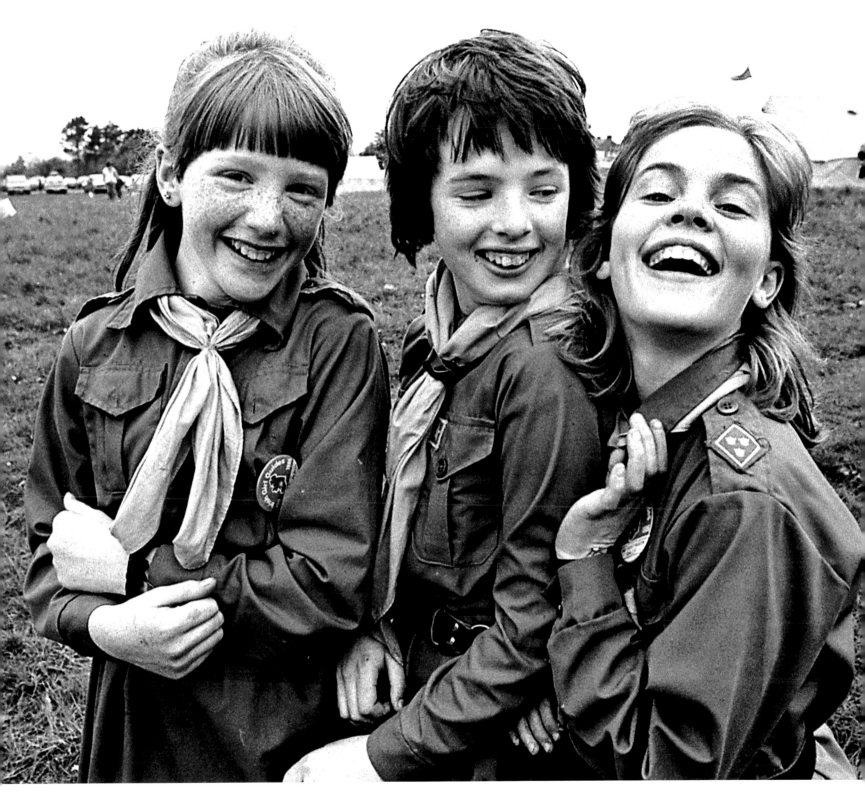

1986 Limerick Girl Guides gala day at Greenpark. *LL93*

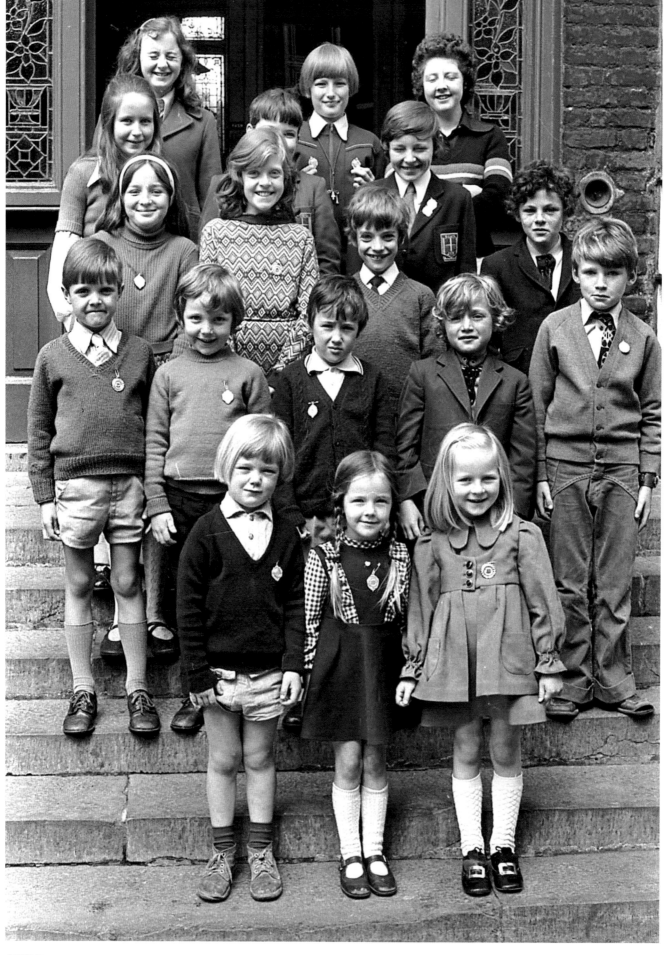

1974 Thomond Feis prizewinners, students of the Lansdowne School of Speech & Drama. *LL94*

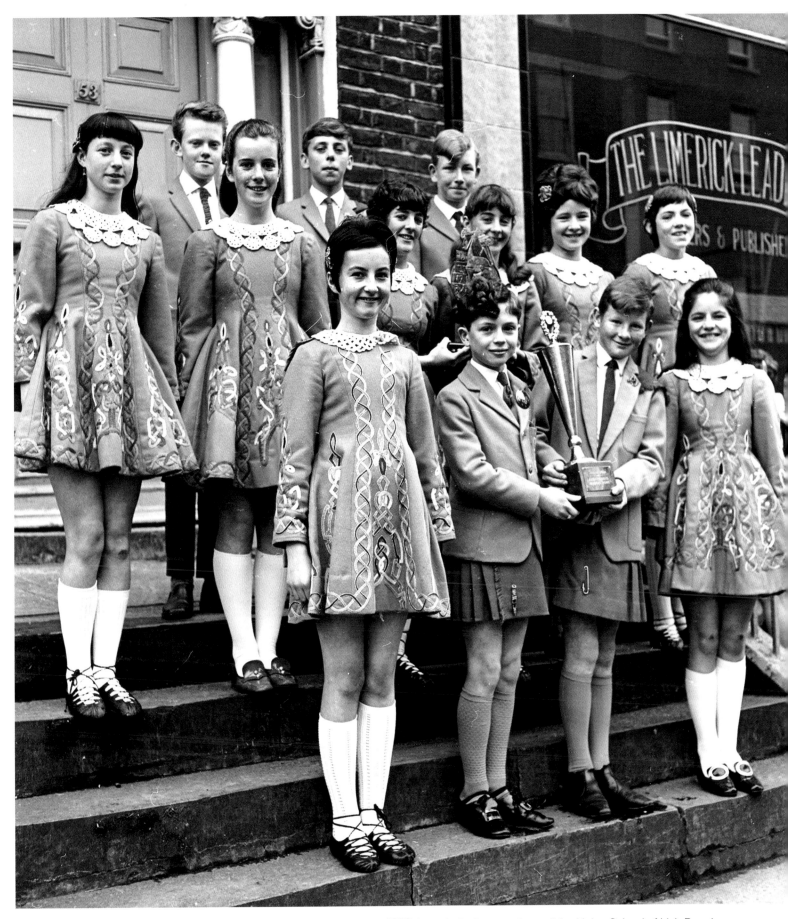

1970 Award-winning members of the Nolan School of Irish Dancing outside the *Limerick Leader* offices at 54 O'Connell Street. *LL95*

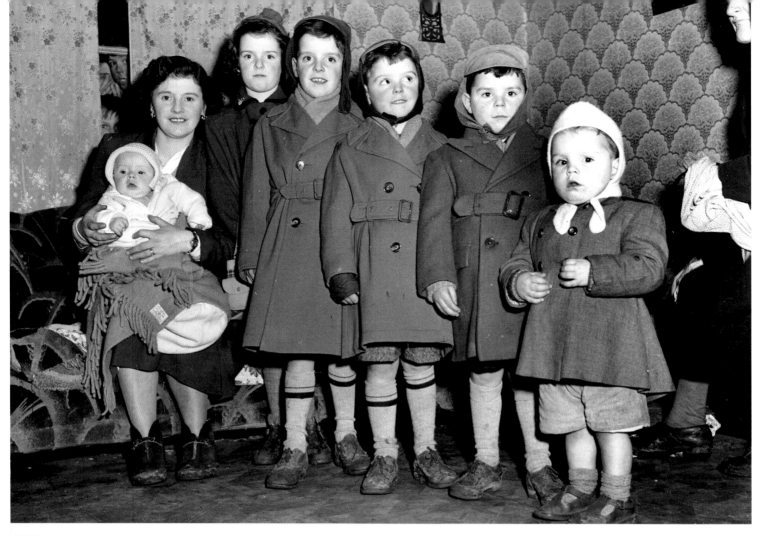

1954 The Gleeson family emigrates to Boston. (L–r): mother Maggie with Annette, Christy, Paddy, Martin, John and Noel. Note the curious faces at the back window as the *Leader* captured the moment. *LL96*

1972 Eleanor Wallace of Bengal Terrace with her pet dog, Bruno, and a giant head of cabbage. *LL96B*

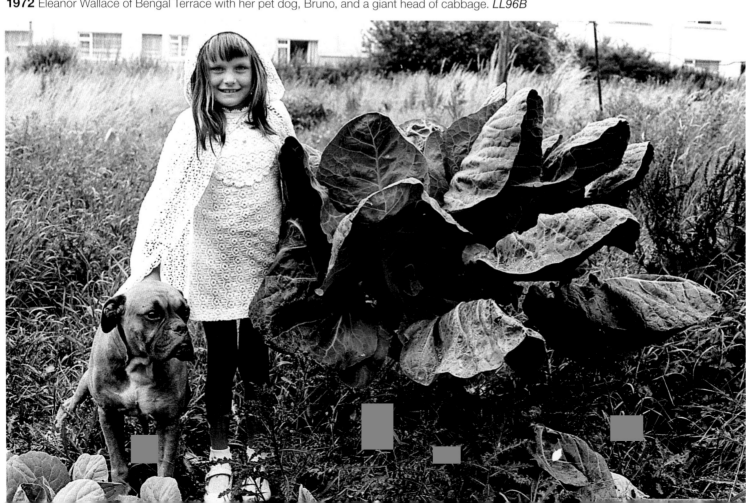

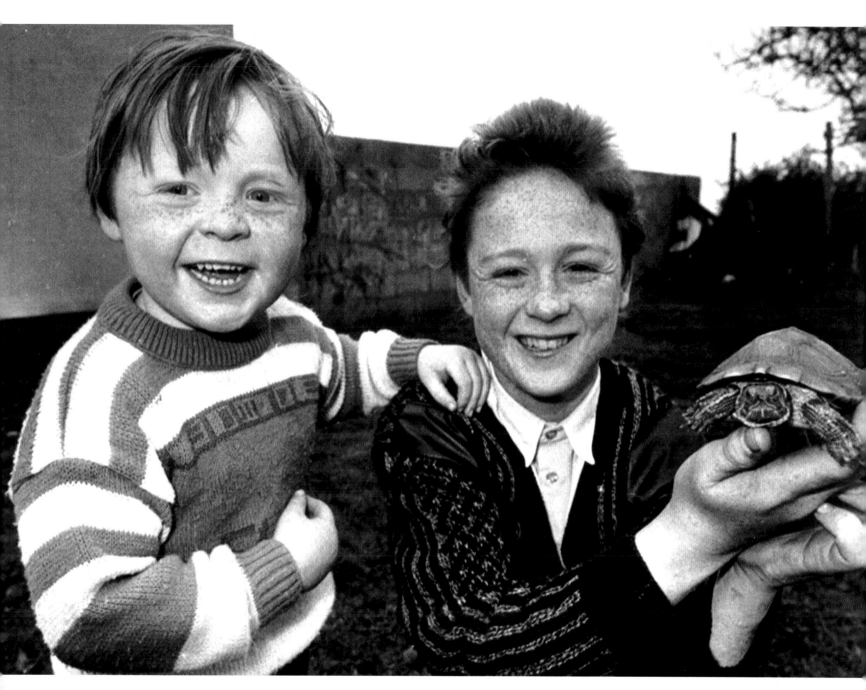

1989 Another year, another lost pet found. The paper captured the happy scene as Liam Fitzgerald and his brother Charlie, from Rathbane, were reunited with 'Joey'. *LL97*

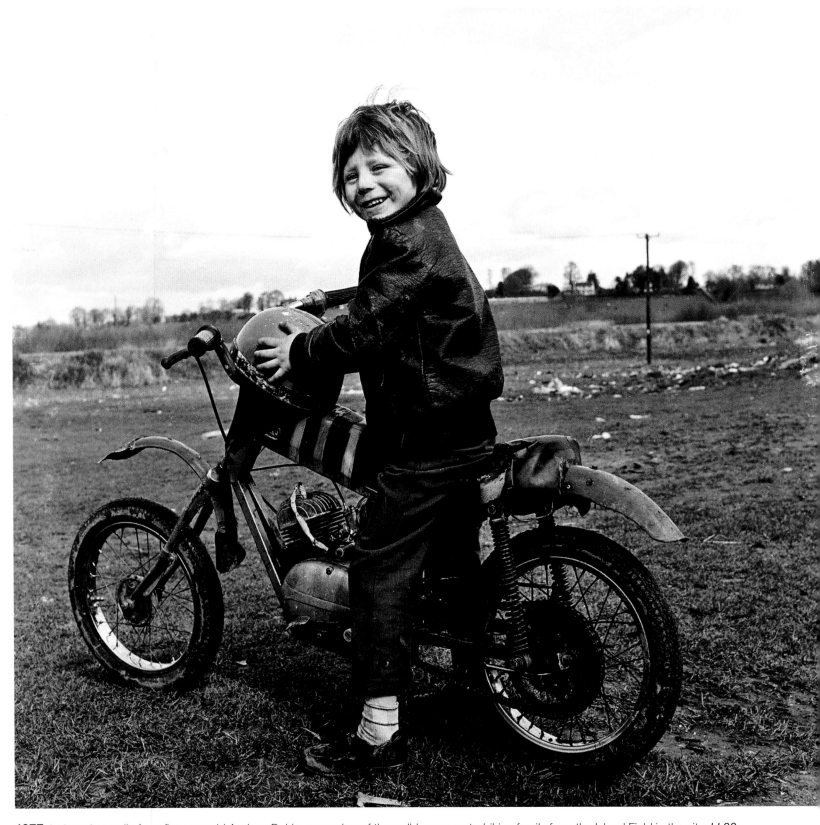

1977 A charming smile from five-year-old Andrew Duhig, a member of the well-known motorbiking family from the Island Field in the city. *LL98*

1979 Bonfire night in the city in the Watergate Flats/Mungret Street area.
LL99

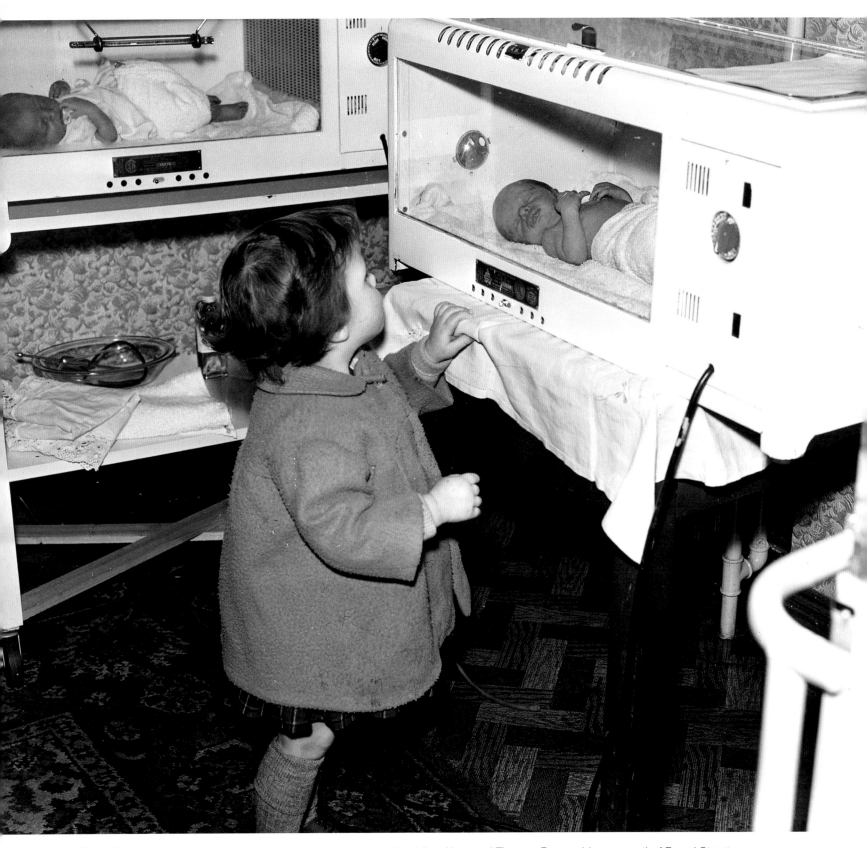

1962 The Peppard quads made news everywhere when born in Limerick to Nora and Thomas Peppard (newsagent) of Broad Street. The quads, three boys and a girl, were born at St Anthony's Nursing Home, Barrington Street, much to the fascination of their sibling. *LL100*

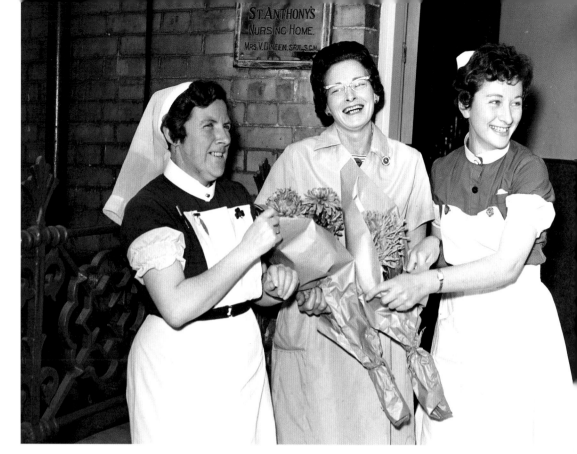

1962 Mrs Nora Peppard with delighted nurses following delivery of her quads. The births were attended by doctors John Holmes and Ann McMahon, with nursing staff Vera Dinneen, Tess Wallnutt, Nurse McCoy, Frances O'Connor and Josephine O'Connell. The babies were born a month premature. The first, a daughter named Mary, was born at 7.40 a.m. on 21 September, weighing 4 lb 4 oz. She was followed by brothers Donald, John and Anthony, with the last of the boys delivered at 12.50 p.m., more than four hours after Mary's arrival. Sadly, Donald died a few weeks later, having weighed just 2 lb at birth. With considerable interest in the Peppards, the *Leader* subsequently reported on birthdays celebrated by Mary, John and Anthony. *LL101*

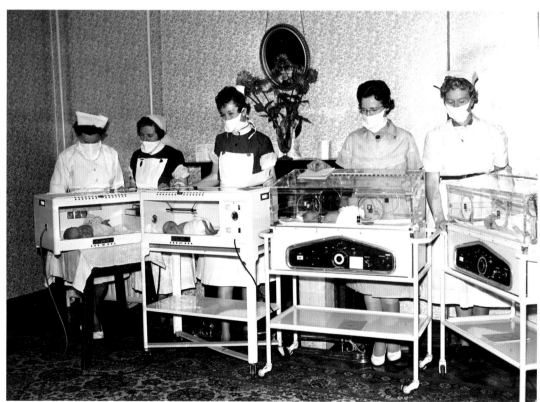

1962 Mrs Vera Dinneen and her staff watch over the Peppard quads at St Anthony's Nursing Home, Barrington Street. The babies were the first quads to be born in Ireland in half a century. *LL101B*

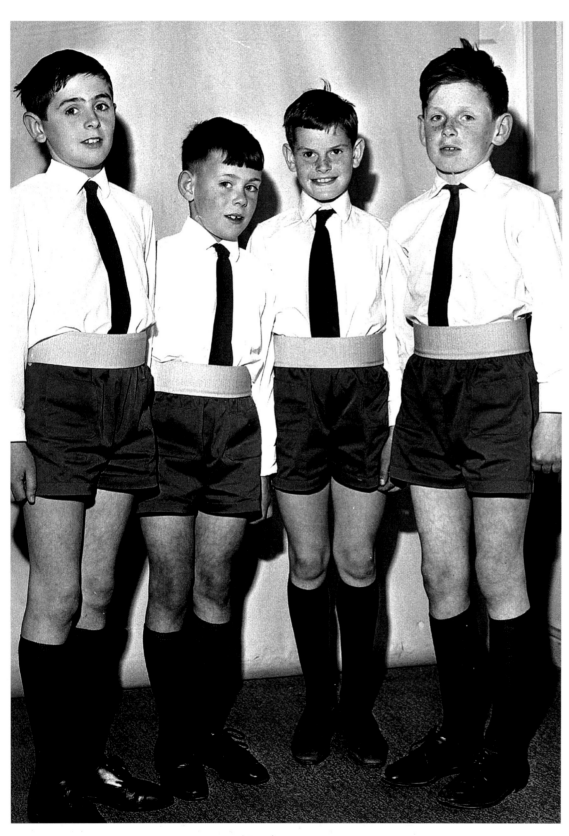

1969 Young students of the Dalton School of Dance. (L–r): John Kelly, Sean Ryan, Tom Dunne and Tom Noonan, all from Adare. When pictured they were fresh from their triumph of winning an All-Ireland medal for the four-hand reel. *LL102*

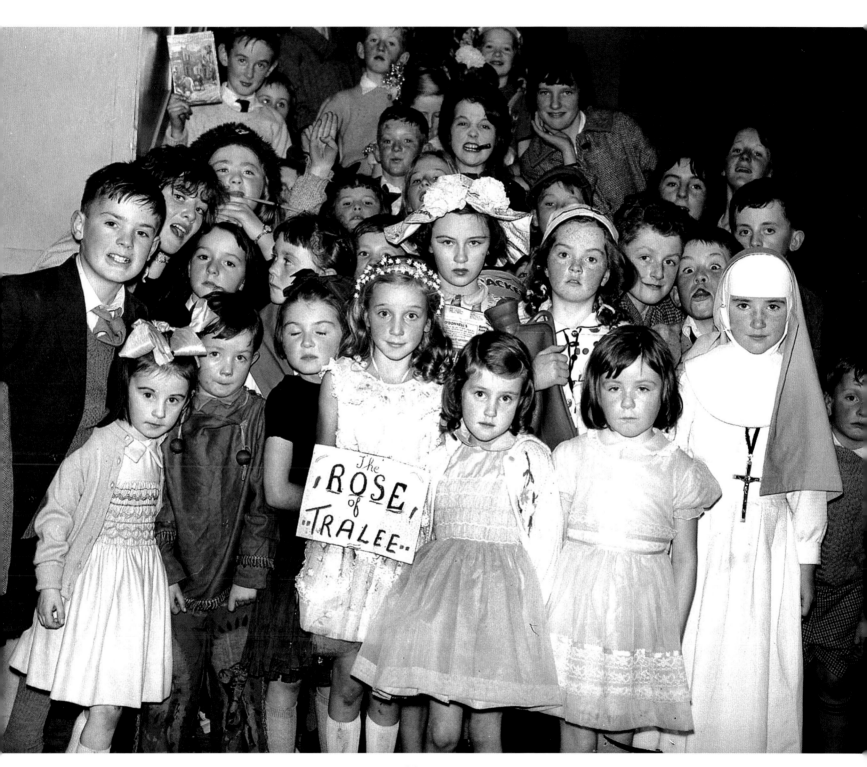

1961 This fancy dress parade attracted many young Limerick participants. *LL103*

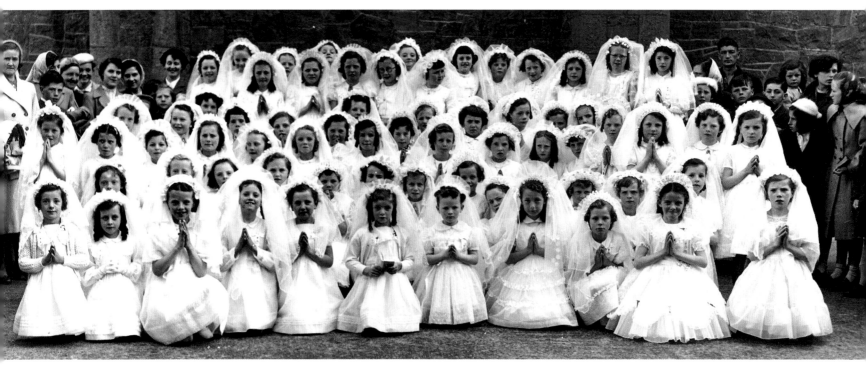

1956 The girls who received First Holy Communion at St John's Cathedral. *LL104*

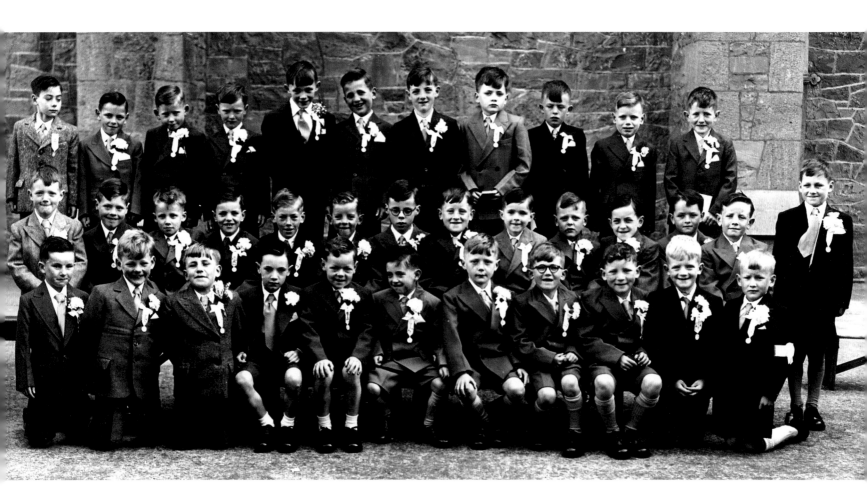

1956 Local boys who received First Holy Communion at St John's Cathedral. *LL104B*

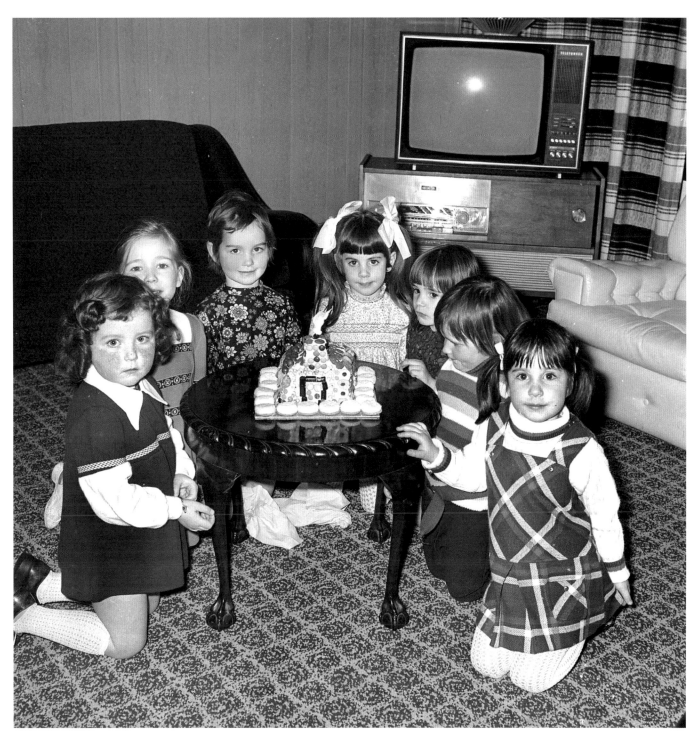

1973 Happy birthday, dear Jean! Fifth birthday party for Jean Bourke, Castletroy.
Thankfully, they were having too much fun to watch telly. *LL105*

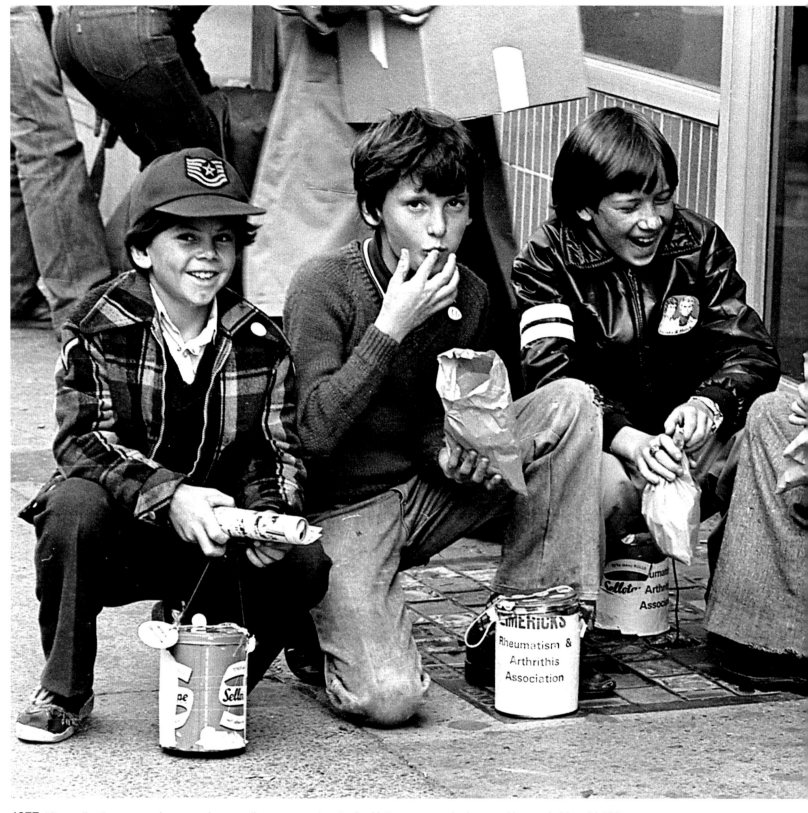

1977 After collecting money for a good cause, these youngsters tucked into some much deserved bags of chips. *LL106*

1979 Waiting for Pope John Paul II at Greenpark Racecourse. *LL107*

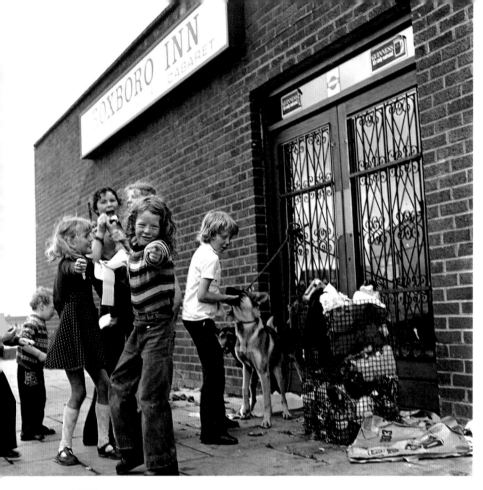

1978 Young Traveller children at Roxboro Road. *LL108*

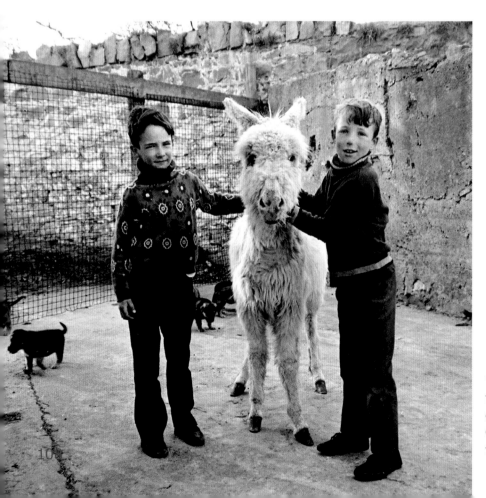

1971 Tiny Tim the donkey returns home and is photographed for the *Leader*. Tiny Tim had gone missing and was found grazing in a field in Southill, much to the relief of his owners Gerard Clancy (left) and his brother Noel, sons of the Limerick fruit vendor Paddy Clancy. *LL108B*

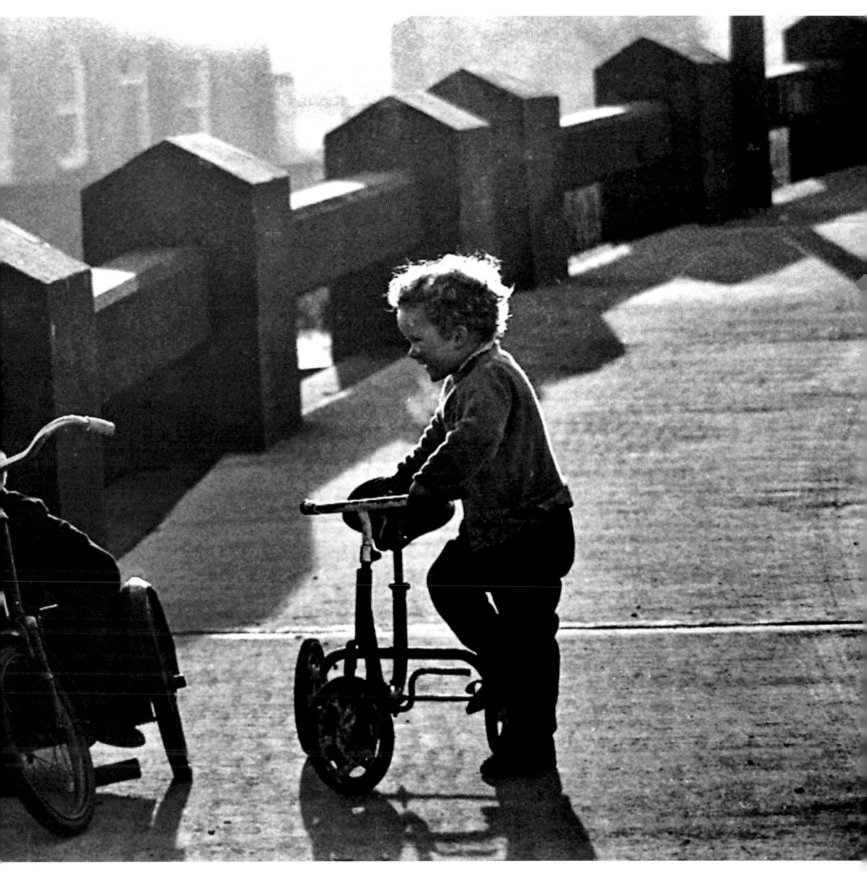

1972 So how's it going? Two boys having a chat amid shadows in the city at Corbally. *LL109*

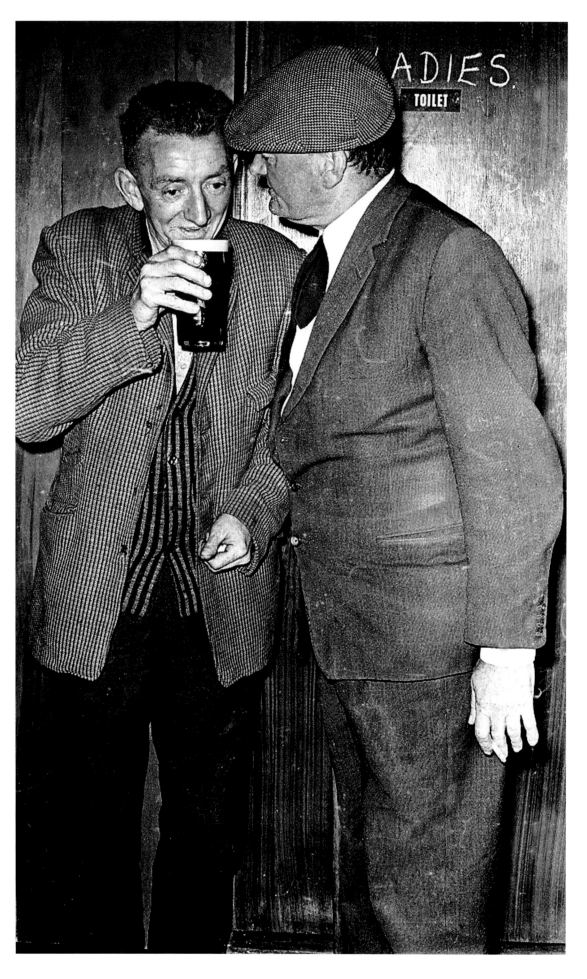

1972 A word in your ear: deep in conversation at a hostelry in Abbeyfeale. *LL110*

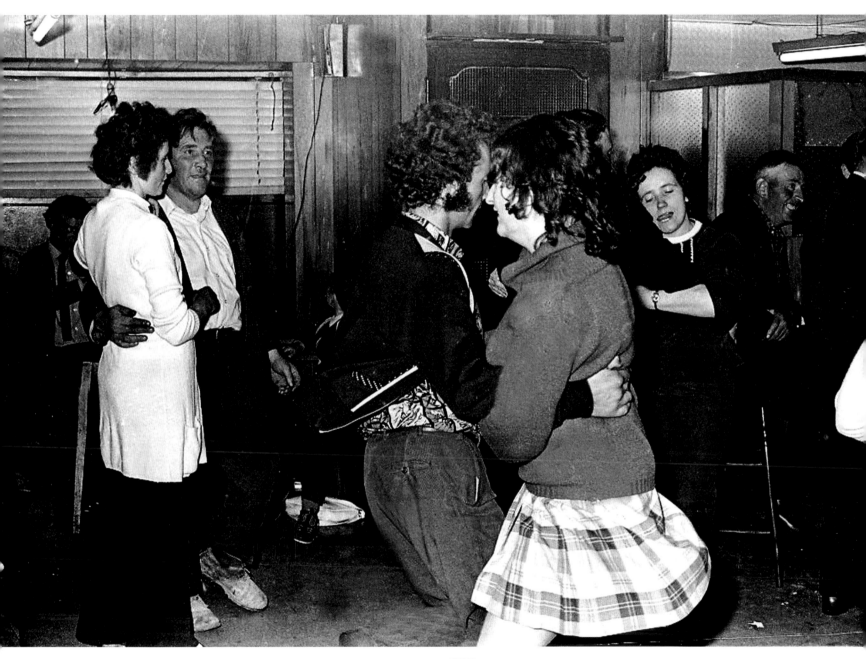

1972 Dancers moving to the rhythm at the Abbeyfeale festival. *LL111*

1979 'Jazmic' dancers pictured at the Zonta dinner in the Limerick Inn Hotel. (L–r): Lolanda Hogan, Judy O'Connor, Marie McNamara and Annette McCarthy. *LL112*

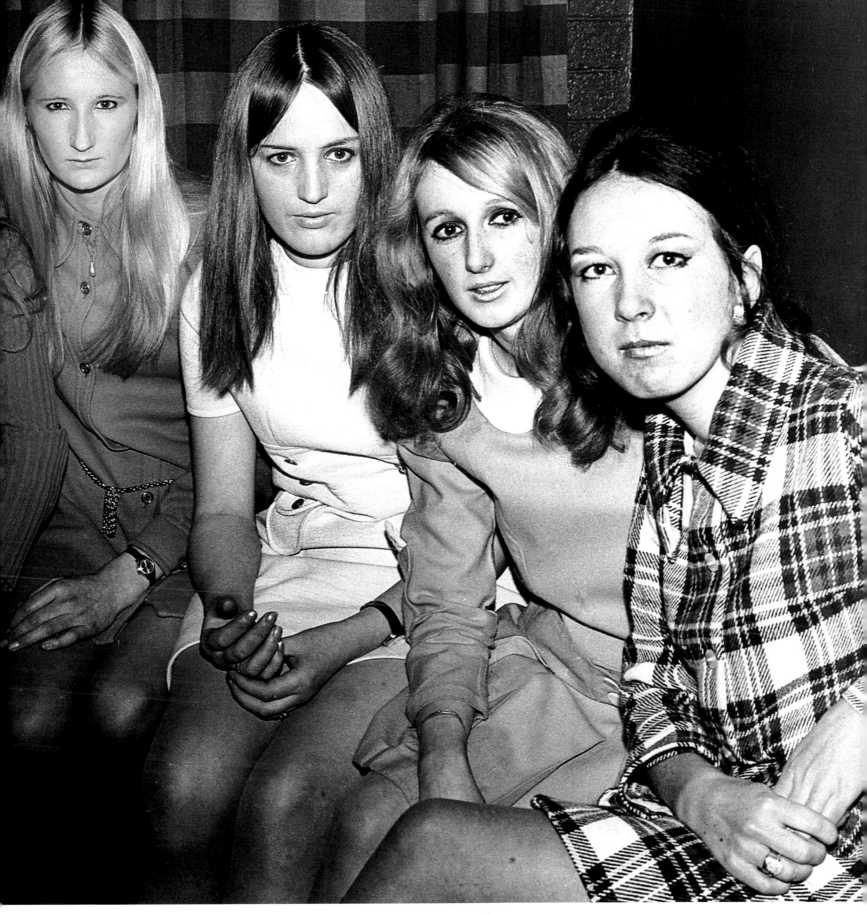

1970 Young women attending An Óige dance at the Royal George Hotel, O'Connell Street. *LL113*

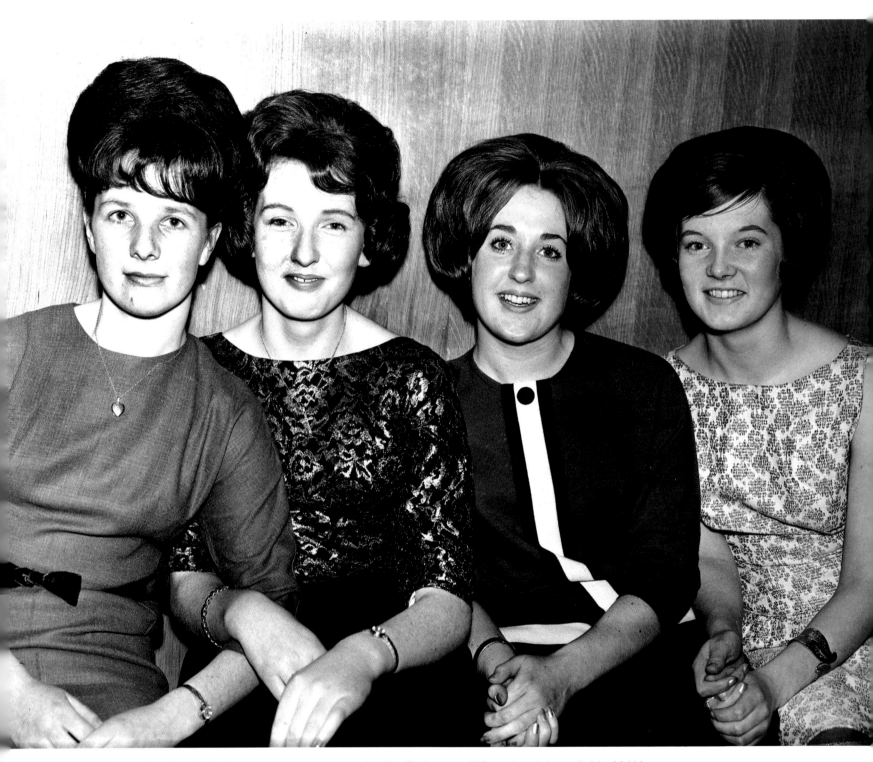

1958 Four stylish Limerick ladies at a dinner dance organised by Shelbourne AFC, on the city's northside. *LL114*

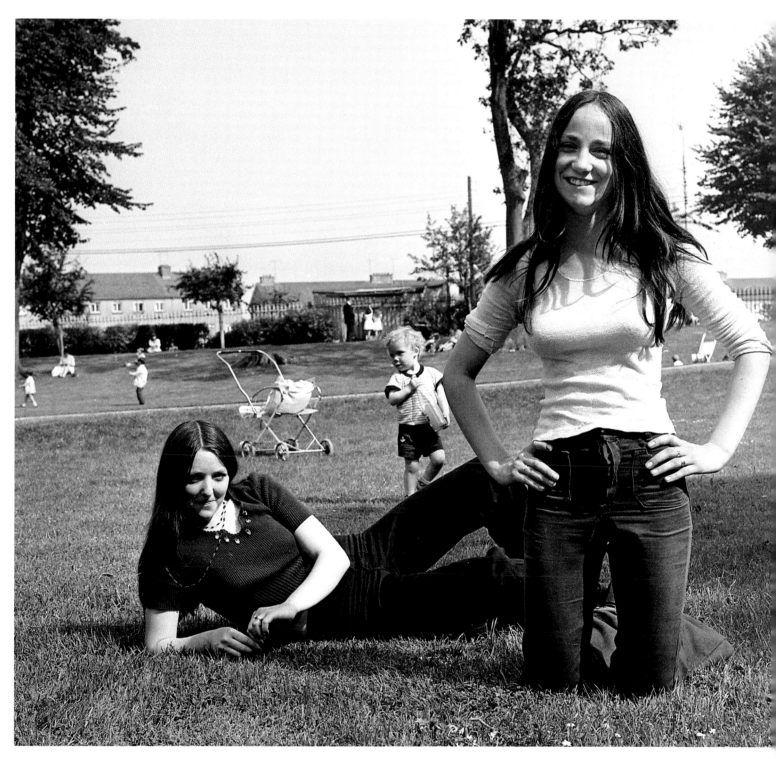

1973 Bridget Healy and Eileen O'Sullivan, Parnell Street, enjoying the sunshine in the People's Park. *LL115*

Following pages: **1965** 'All glammed up' at Shannon Rugby Football Club dinner dance. *LL116*

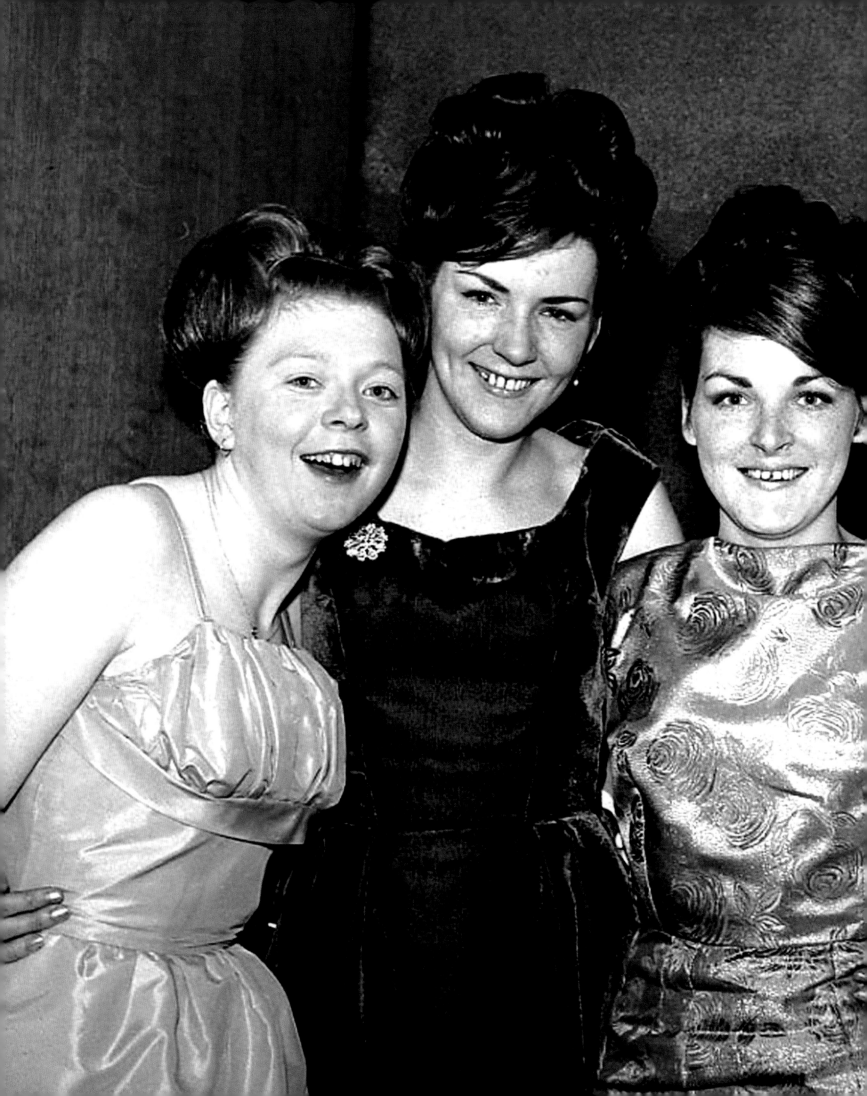

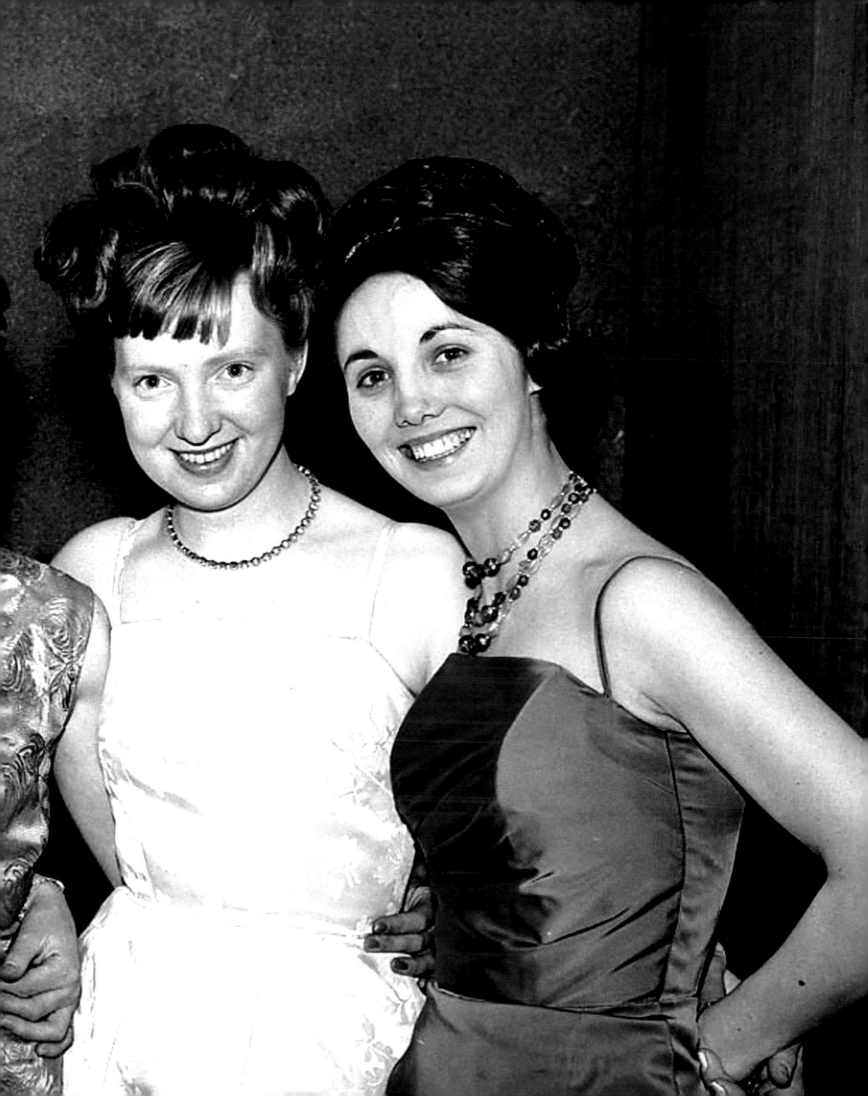

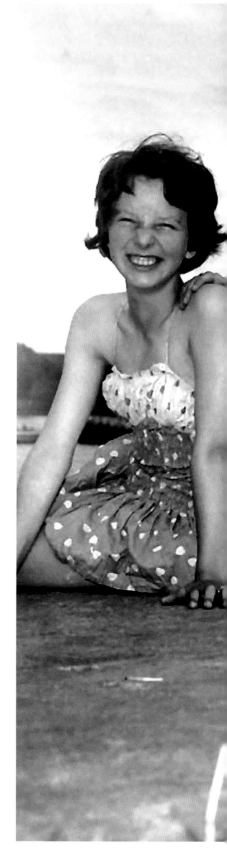

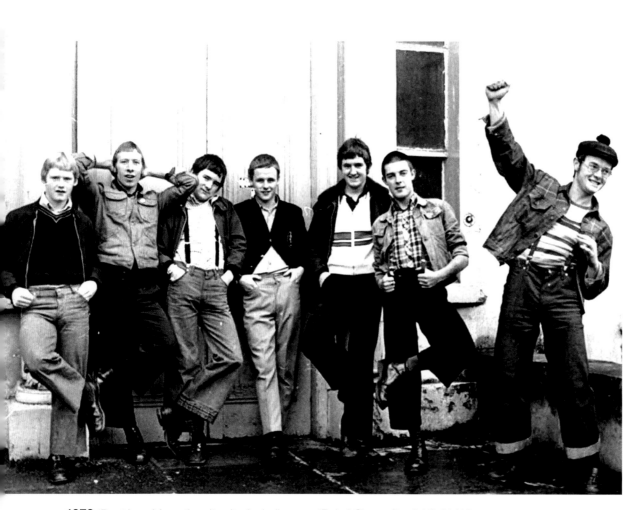

1973 'Boot boys' from the city city, including one 'Babs' Clancy (far right). *LL118*

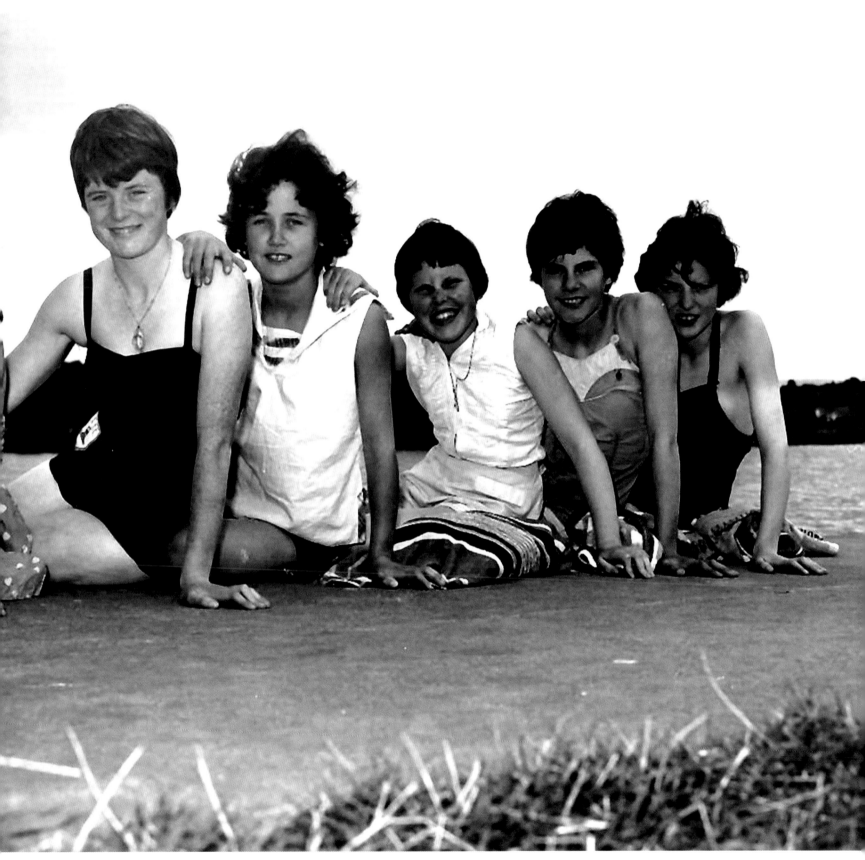

1961 A pretty group of bathers at Corbally Baths. *LL119*

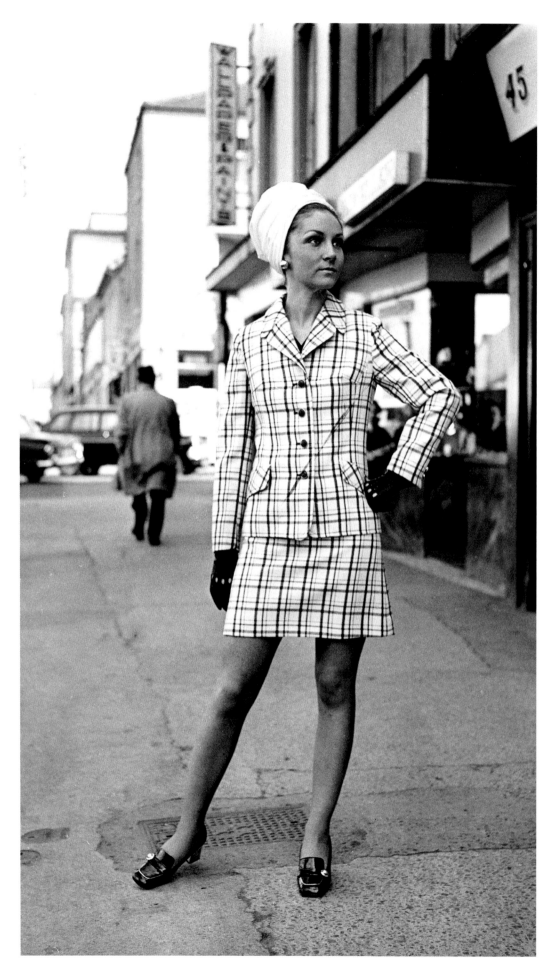

1970 Model Lorna Coffey showing an outfit from Helene Modes, Roches Street. *LL120*

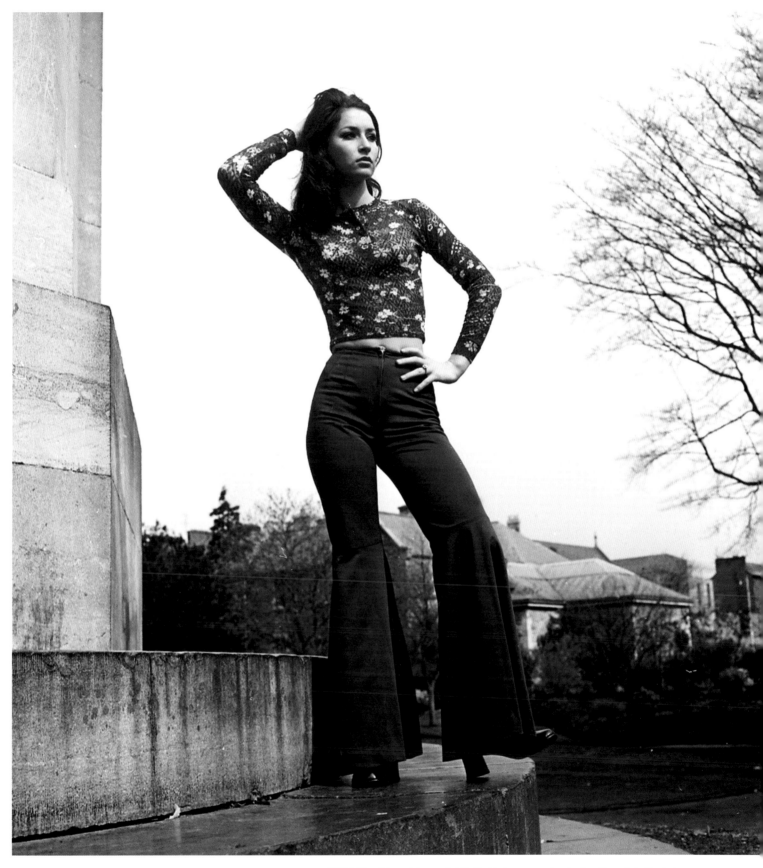

1971 Top Limerick model Celia Holman posing in the People's Park for an advertising feature in the *Limerick Leader* for Trudy's Boutique. *LL121*

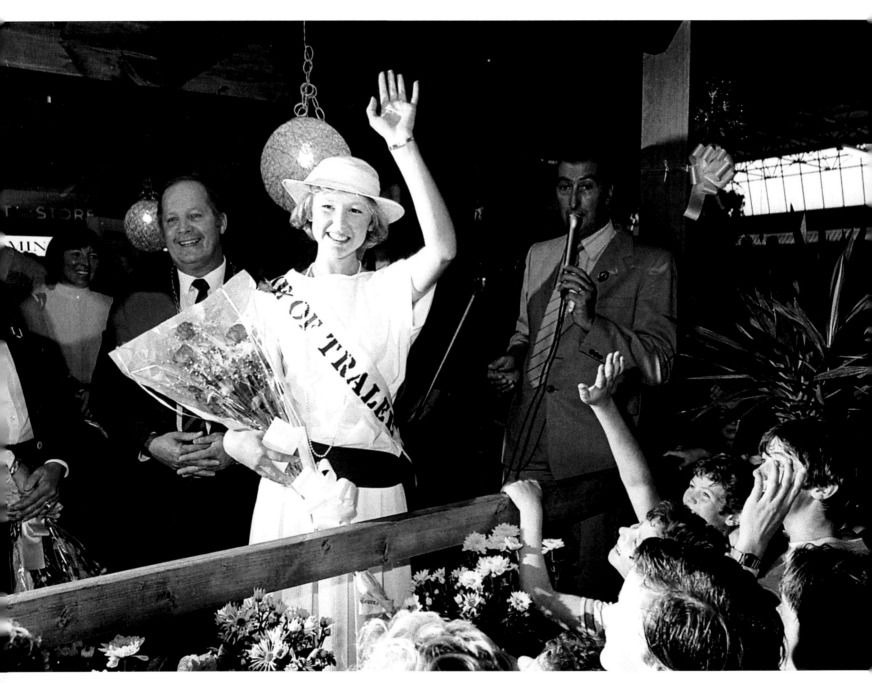

1984 Limerick's Diane Hannagen proved a hugely popular Rose of Tralee winner. She is pictured here at the Parkway Shopping Centre, fresh from her victory. Mayor Frank Prendergast is at her right shoulder. *LL122*

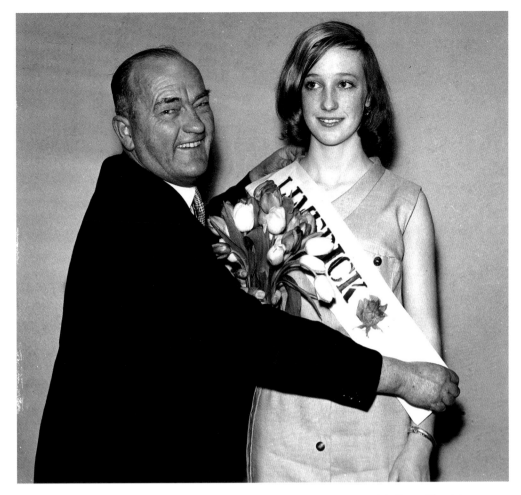

1965 Mayor Jack Danagher places the winning sash on the new Limerick Rose, Tina Moran, at the Jetland Ballroom. *LL123*

1994 Limerick's most recent Rose of Tralee winner, Muirne Hurley, with her proud parents Cormac and Peg on a visit to her father's place of work, Henry Street Garda Station. *LL123B*

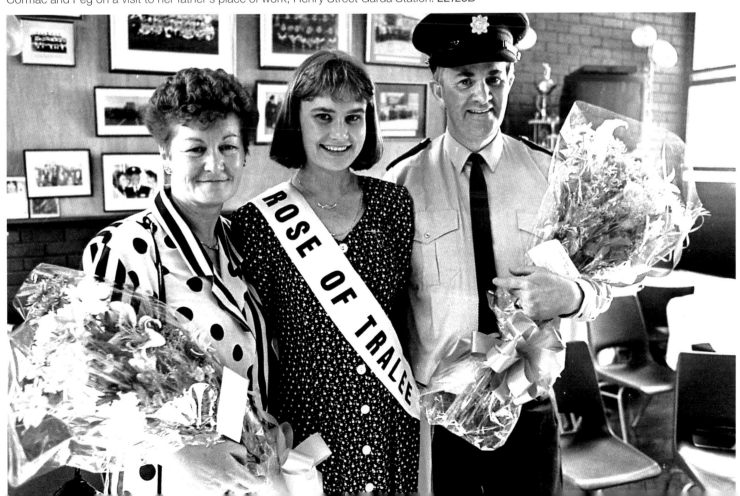

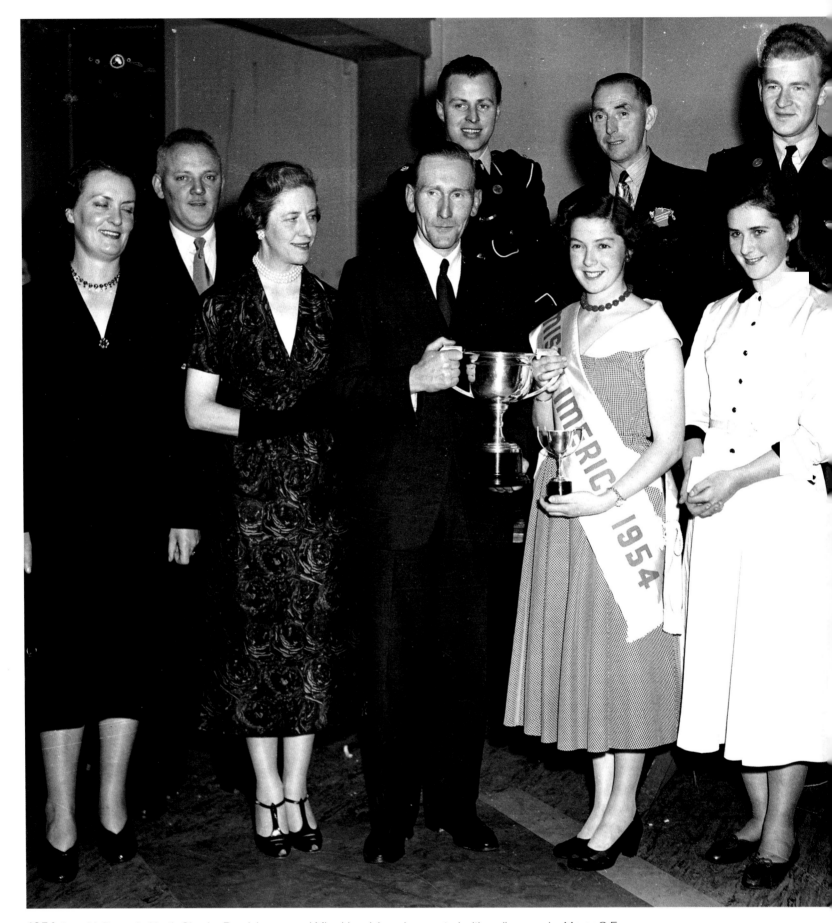

1954 Joan McDonagh, North Circular Road, is crowned Miss Limerick and presented with a silver cup by Mayor G.E. (Ted) Russell at the Stella Ballroom in early November. Alongside Joan is runner-up Mary Cronin from Adare. Wearing the gloves beside the mayor is Lady Dunraven, Nancy Wyndham-Quin. To her right is Ted Russell's wife, Derry. *LL124*

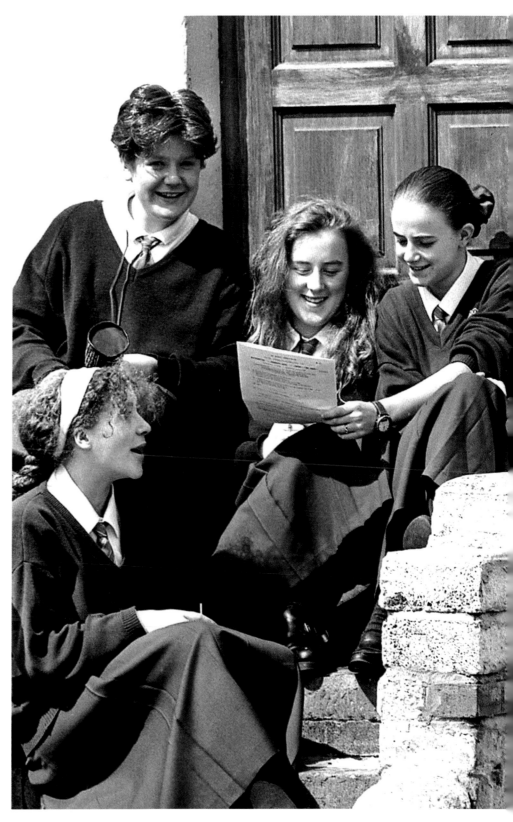

1992 Laurel Hill students during their Leaving Certificate. (L–r): Margaret Flannery, Melissa Sexton, Catriona Hayes and Lorainne Scanlon. *LL125*

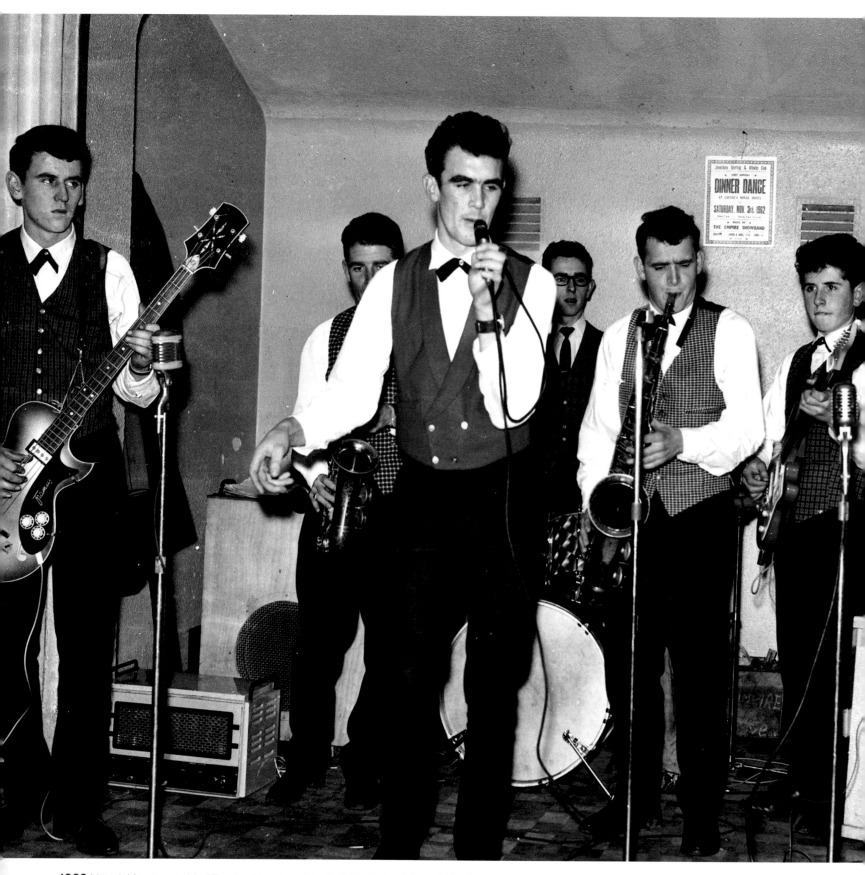

1962 Limerick's star-studded Empire Showband. (L–r): Pat O'Brien, Michael Hinchy, Ger Cusack, Harry Hockedy, Christy Falalee, Johnny Hockedy and Eric Ryan. *LL126*

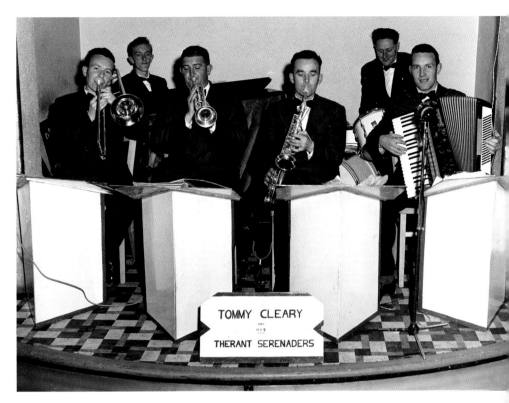

1956 Tommy Cleary and his band at Cruise's Royal Hotel, O'Connell Street. *LL127*

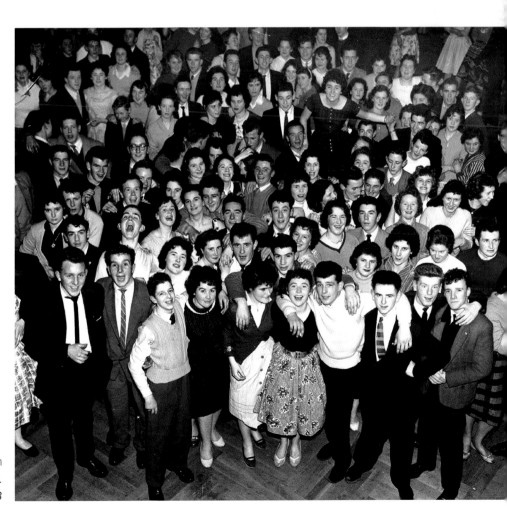

1955 This teenage dance at the Stella Ballroom drew a big crowd of happy Limerick youngsters.
LL127B

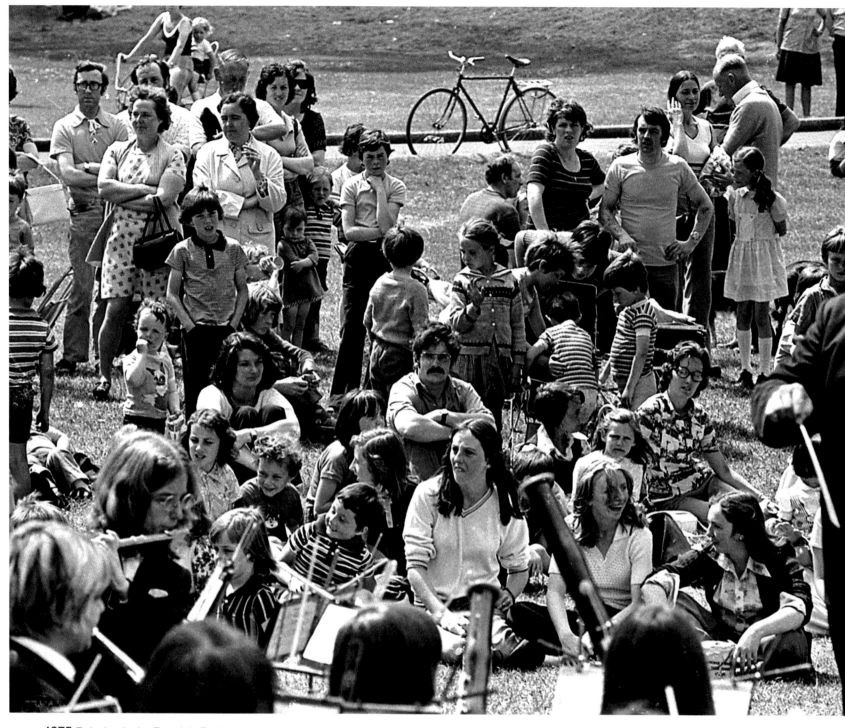

1975 Relaxing in the People's Park on a warm summer's day, watching a performance by the Bowling Green band from Kentucky, USA. *LL128*

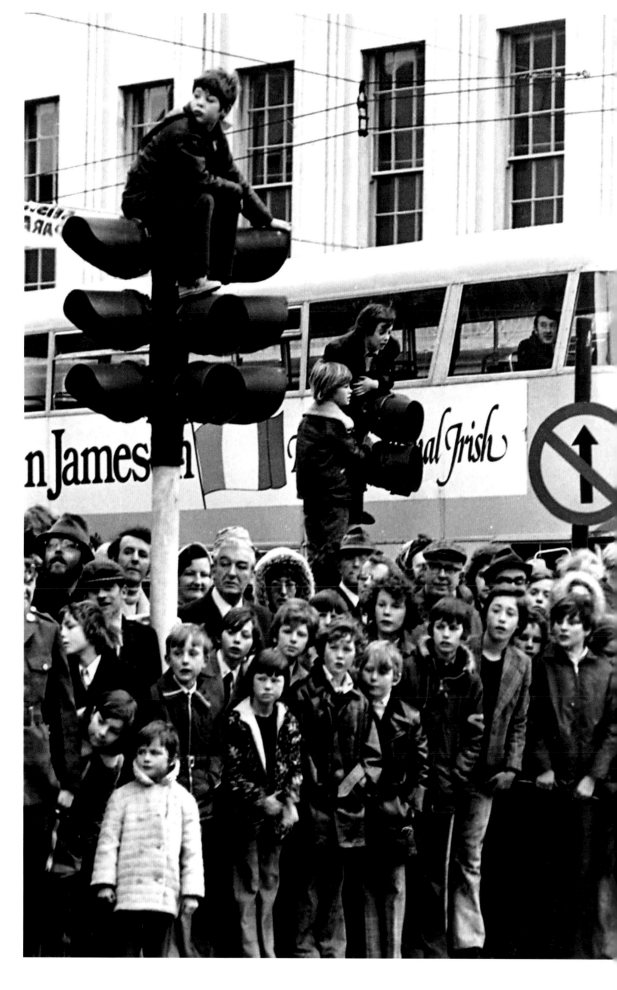

1976 Going to great lengths to get a prime view at the International Band Parade on O'Connell Street. Note the strategically parked bus in the background with the driver on the upper deck! *LL129*

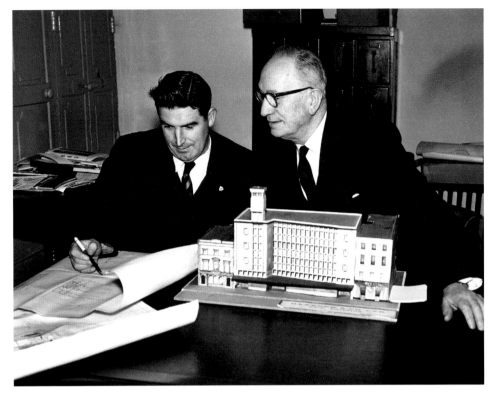

1963 Cannock's secretary Michael Harkin (left) with managing director John J. Fitzgerald, studying plans for the remodelling of the once popular O'Connell Street department store, which closed in March 1980. *LL130*

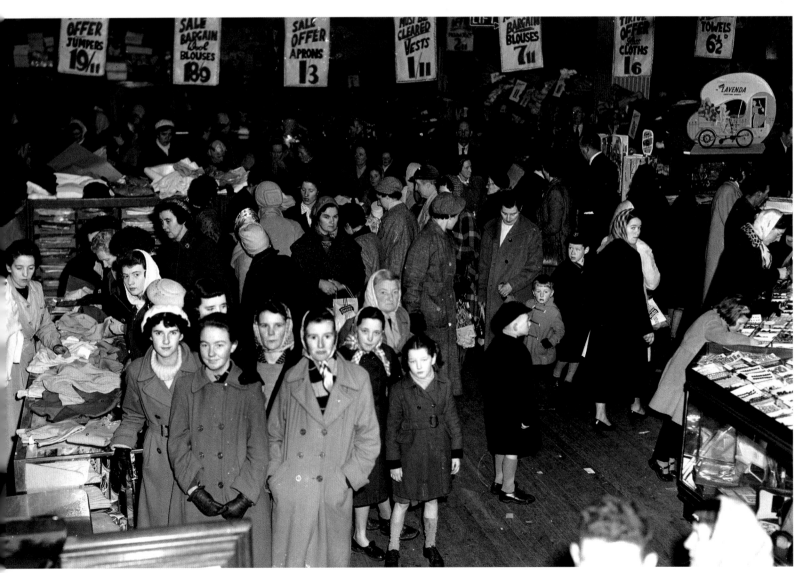

1958 January sales at Roches Stores, O'Connell Street. *LL130B*

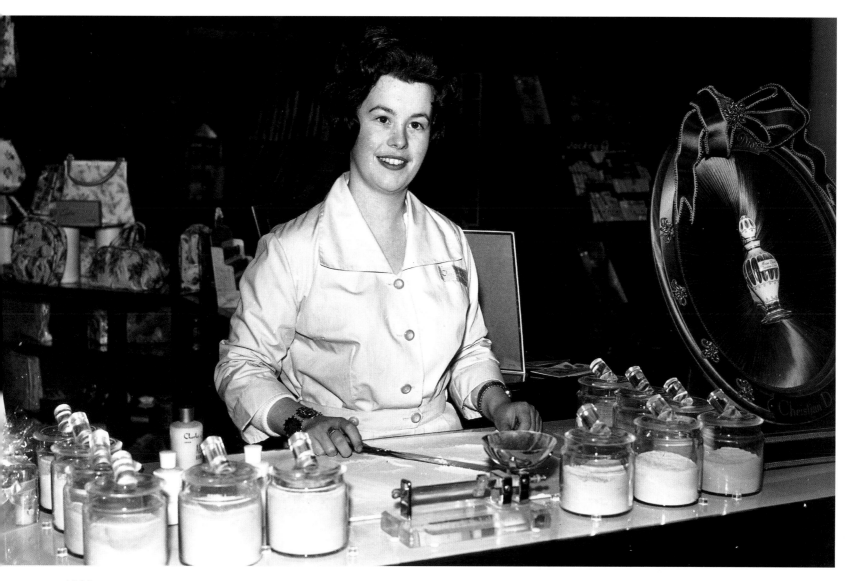

1962 Jacqueline McCarthy, sales assistant on the Cyclax cosmetics counter at Cannock's in March. In 1963, the famous Limerick store took out a nine-page advertising feature in the *Leader* to showcase its redesigned premises, which included the replacement of the legendary clock overhead. Alas, many felt that much of the old magic was lost in the change and amid much local sadness Cannock's closed its doors in 1980, to be replaced on the site by Penneys. *LL131*

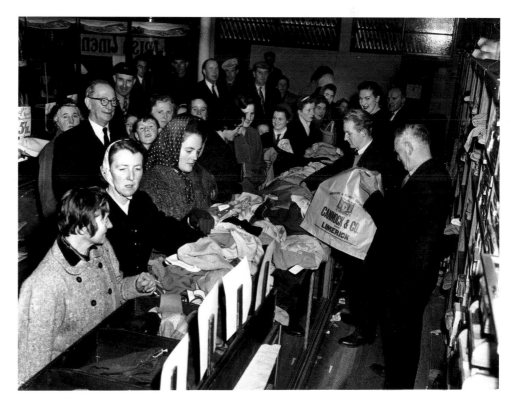

1958 Bargain hunters during the January sales at Cannock's department store, O'Connell Street. *LL131B*

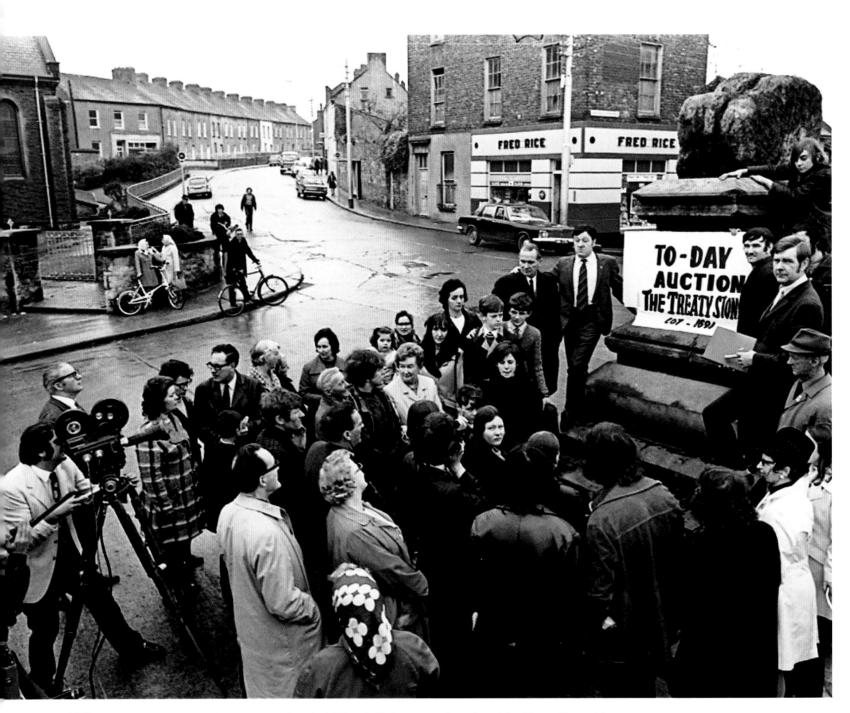

1972 Local comedians Tom O'Donnell and Paschal O'Grady filming a spoof auction of the Treaty Stone. The scenes were shown at the pair's popular *Christmas Crackers* show, which opened at the City Theatre that November. The storyline had it that the Treaty Stone, erected in 1865 at a cost of £65, fetched the gigantic sum of £90 million at auction. *LL132*

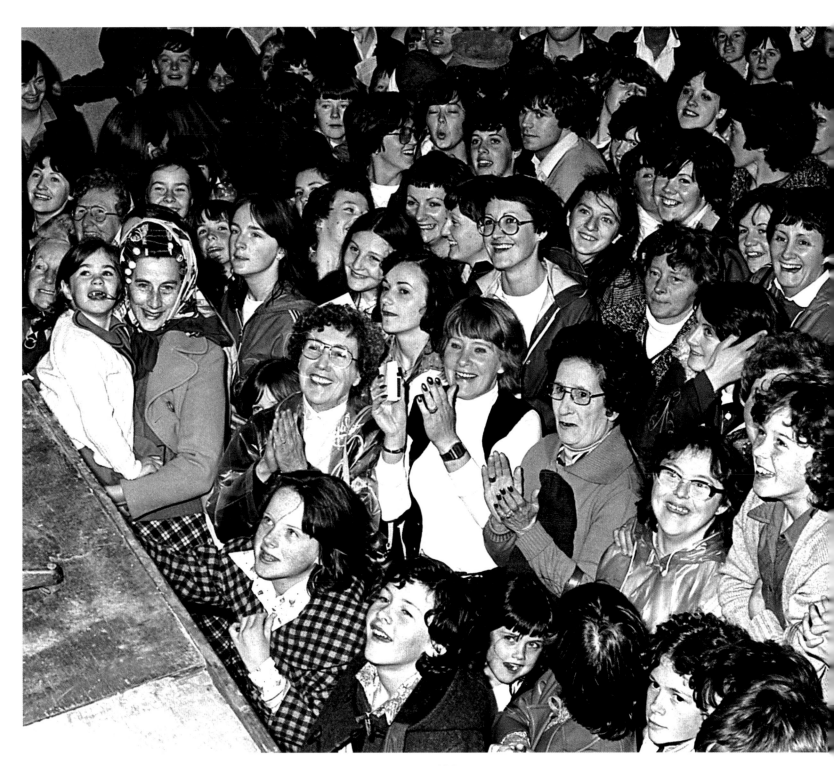

1980 Excited onlookers at the Ballybunion Bachelor Festival. *LL133*

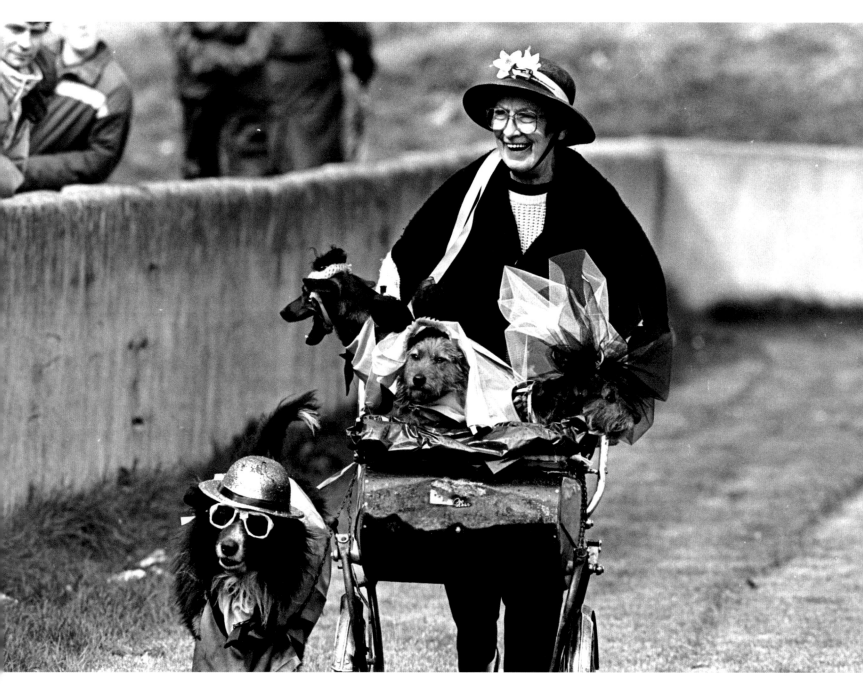

1980 Much-loved Limerick character DoDo Reddan (Mrs Nora Quirke) of Carey's Road, Young Munster's No. 1 fan, at Thomond Park to witness their victory of Bohemians in the Munster Senior Cup. *LL134*

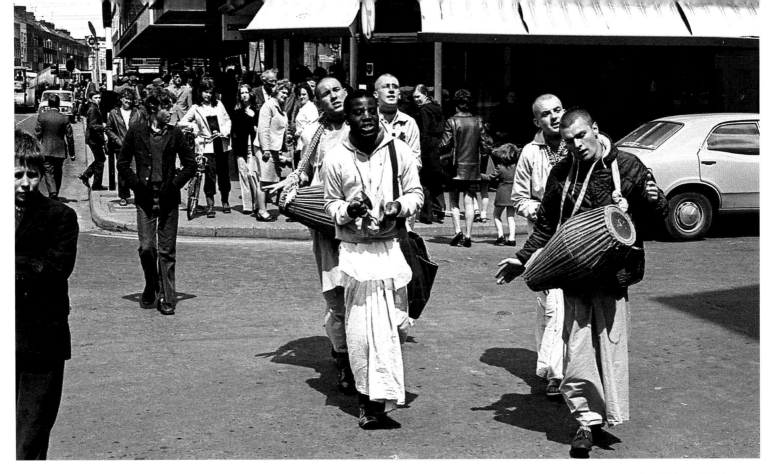

1973 Hare Krishnas evoking their mantra on O'Connell Street. They had arrived down from Dublin on the train earlier that day in May. *LL135*

1961 Bertram Mills Circus & Menagerie at the Fairgreen in late August. They stayed for a week and excited plenty of curiosity, promising 'the greatest show of all' for an admission fee that ranged from five shillings for the cheapest adult seats to 12s 6d for the most expensive. Reflecting the local excitement, CIÉ took out an advertisement in the *Leader* which provided the times for a huge number of special trains and buses from all parts of Limerick and beyond. The return fare from Abbeyfeale was 16 shillings for an adult, and 9s 3d for a child. Adults coming in from Castleconnell paid 9s 9d, with children charged 6s 3d. *LL135B*

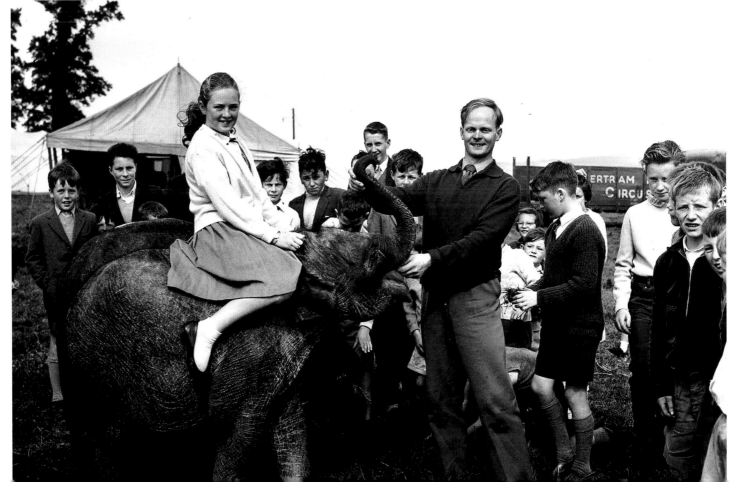

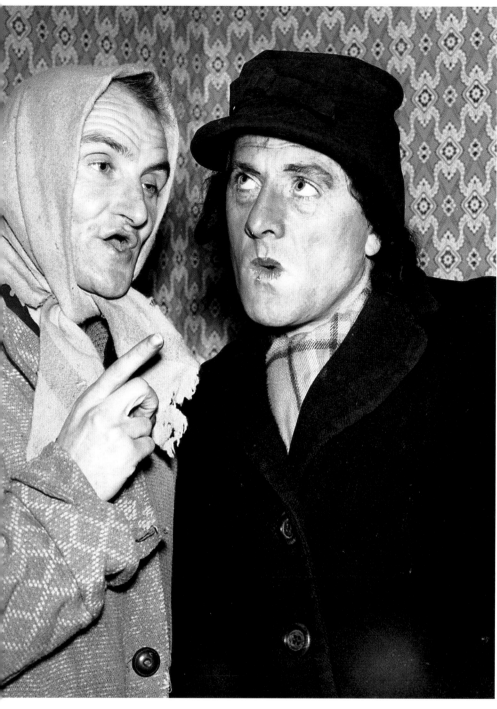

1961 Comedians Tom O'Donnell and Paschal O'Grady, known to all as Tom and Paschal, in character as Katty and Nonie. *LL136*

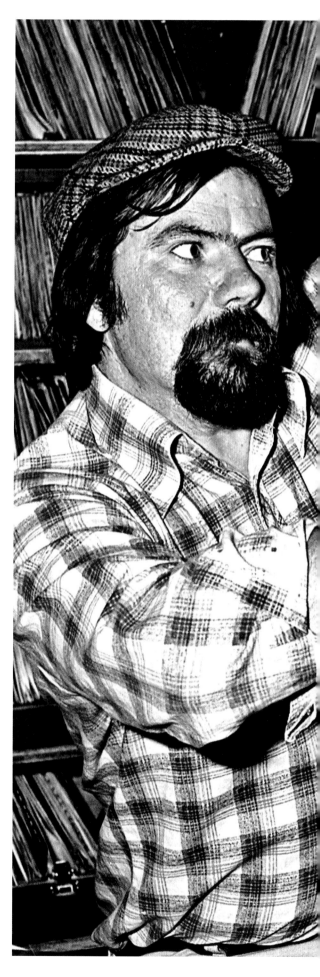

1978 A scene from the studio of Big L pirate radio station which was located on Ellen Street. *LL137*

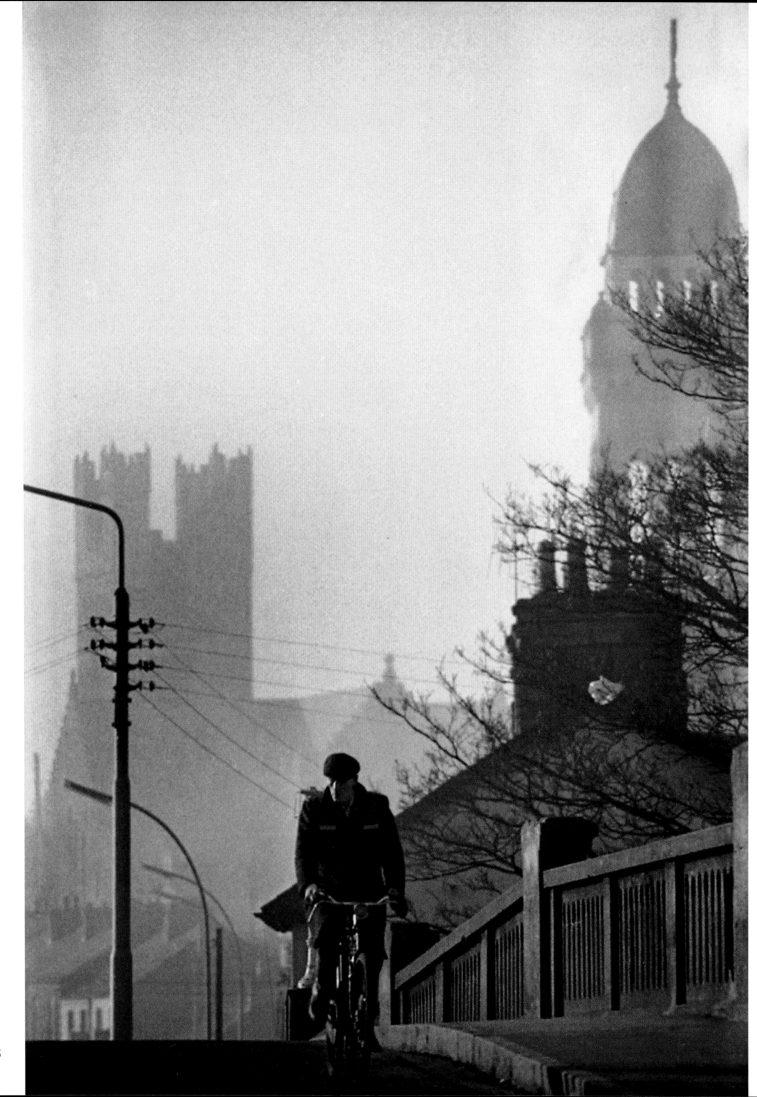

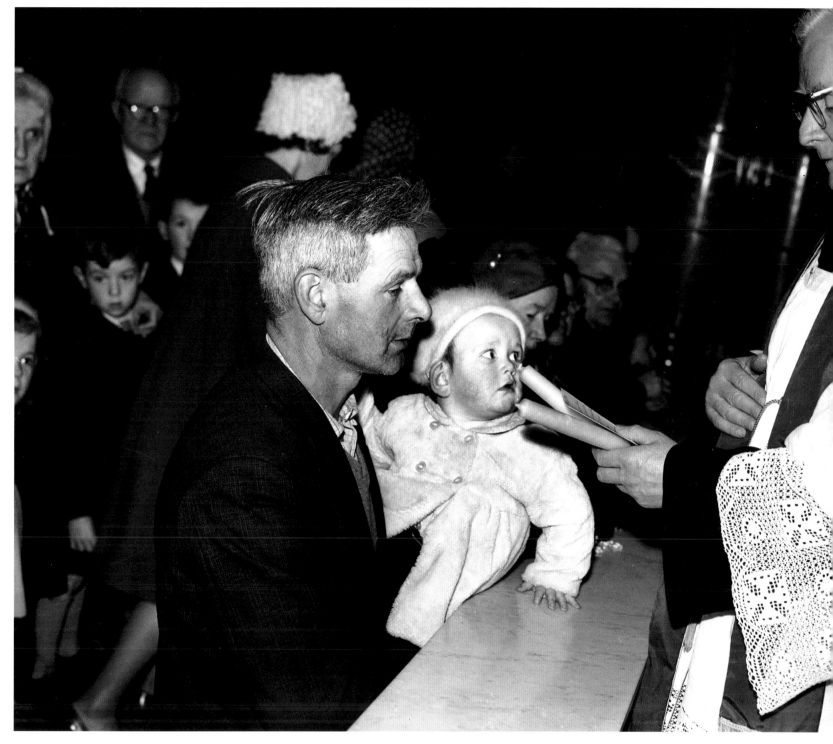

1964 Blessing of the throats being observed on the feast day of Saint Blaise, 3 February. *LL139*

1972 Cycling over Athlunkard Bridge with both St Mary's
Cathedral and St Mary's Church in the background. *LL138*

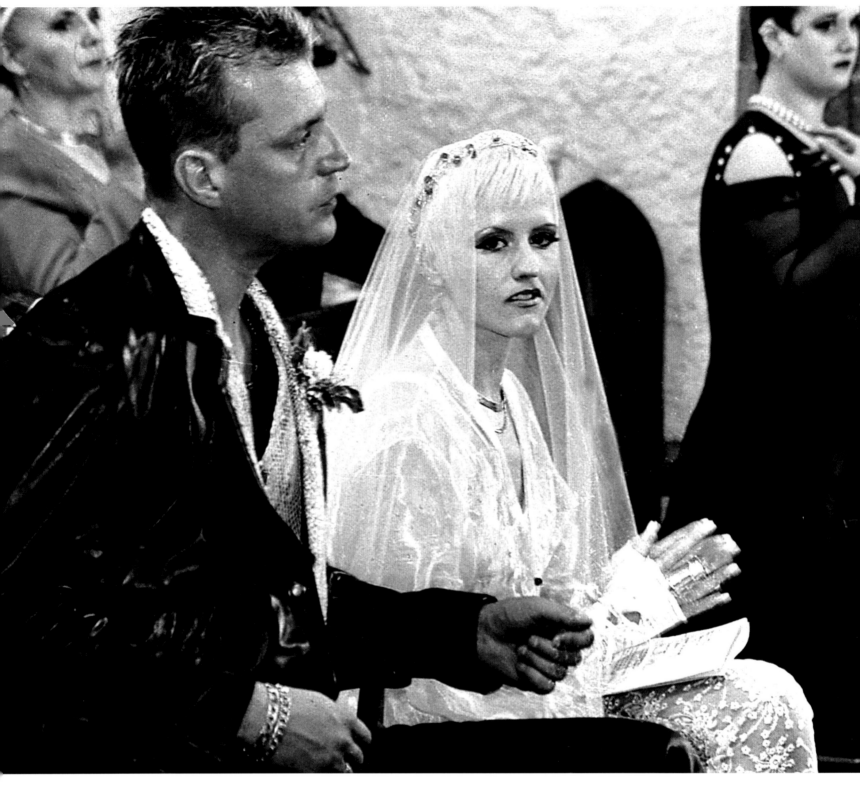

1994 The wedding of Cranberries star Dolores O'Riordan from Ballybricken and Don Burton at Holy Cross Abbey, Tipperary. *LL140*

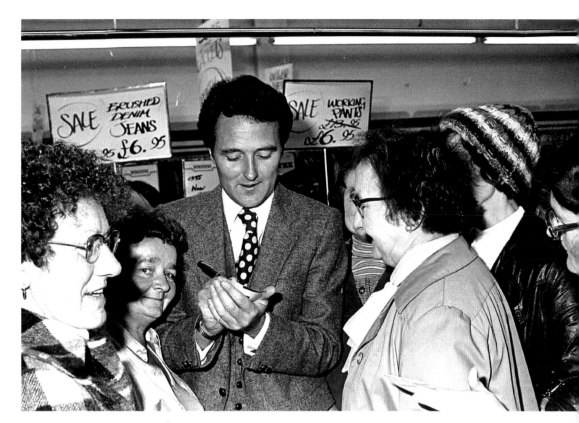

1980 Mike Murphy from RTÉ signs autographs at Winston's store, William Street. *LL141*

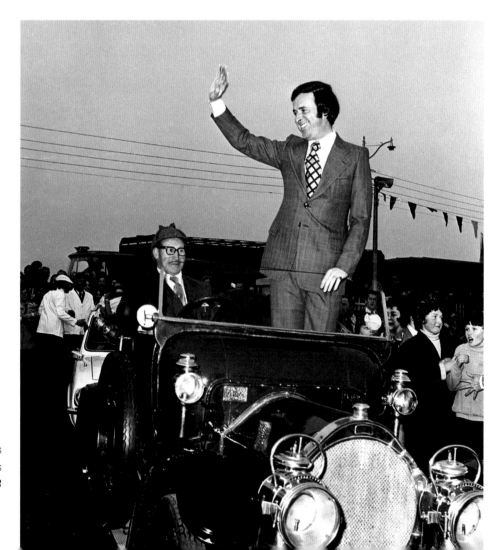

1974 Limerick man Terry Wogan salutes his admirers at the opening of Hypersales Furniture Store on the Ennis Road. *LL141B*

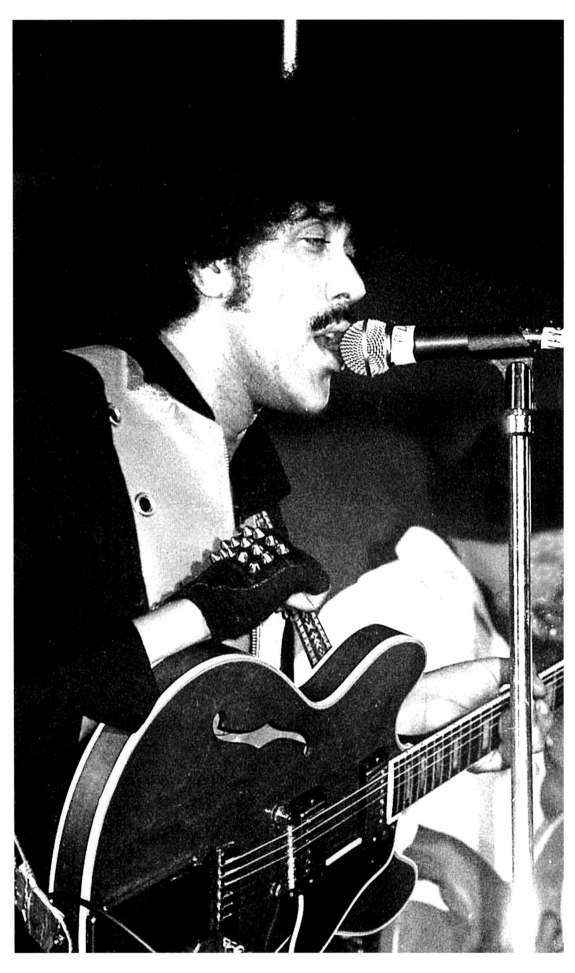

1983 Phil Lynott and Thin Lizzy perform at the Greenhill's Hotel, Limerick, January 1983, three years before his untimely death. *LL142*

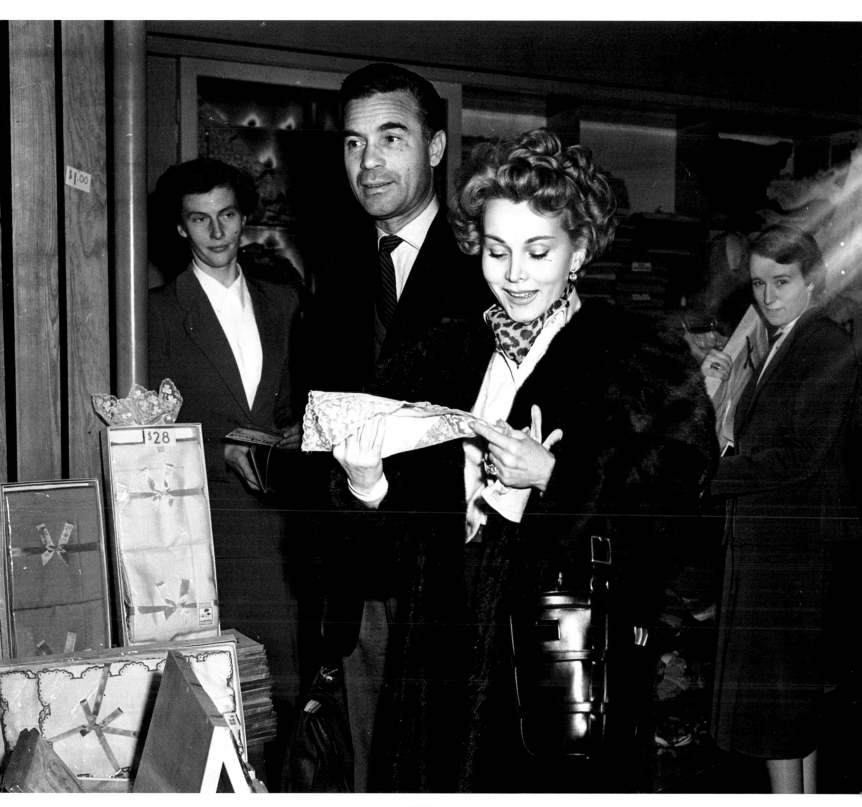

1954 Zsa Zsa Gabor with Porfirio Rubirosa making an impromptu stopover at Shannon Airport due to technical problems on a flight from Paris to New York. *LL143*

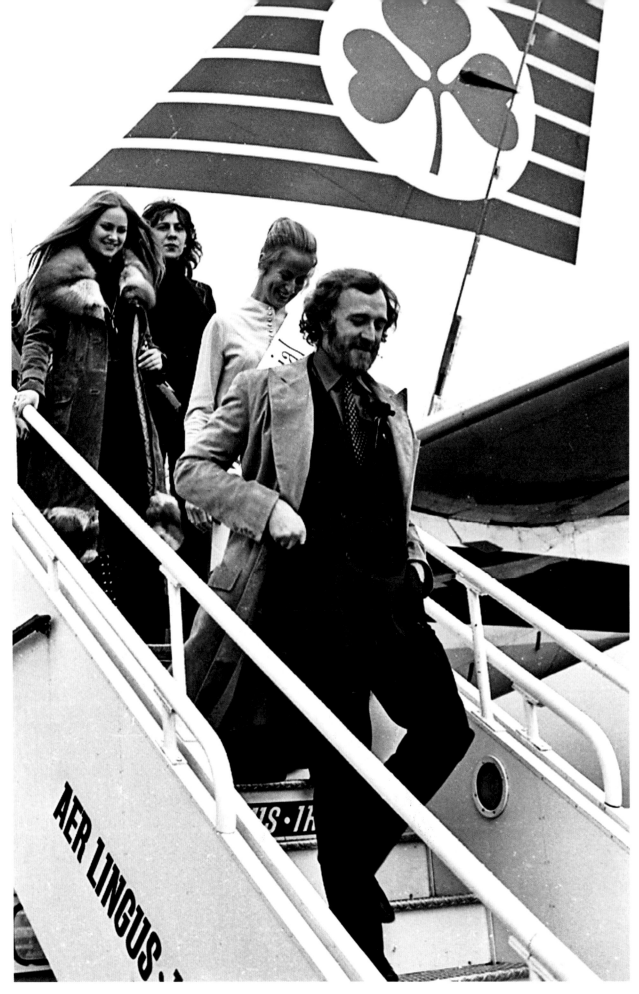

1970 Richard Harris arrives at Shannon Airport for the premiere of his new film, *Bloomfield*. *LL144*

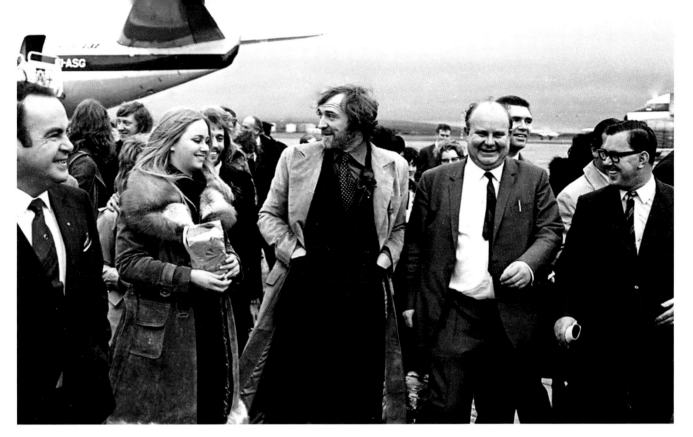

1970 Limerick's own Richard Harris gets a great welcome after flying in for the world premiere of his film, *Bloomfield*, which took place at the Savoy Theatre. Limerick chemist Dermot Foley is to his left, with *Leader* journalist Cormac Liddy one along, in glasses. Pop star Maurice Gibb, who composed some music for the film, is behind Harris's right shoulder. *LL145*

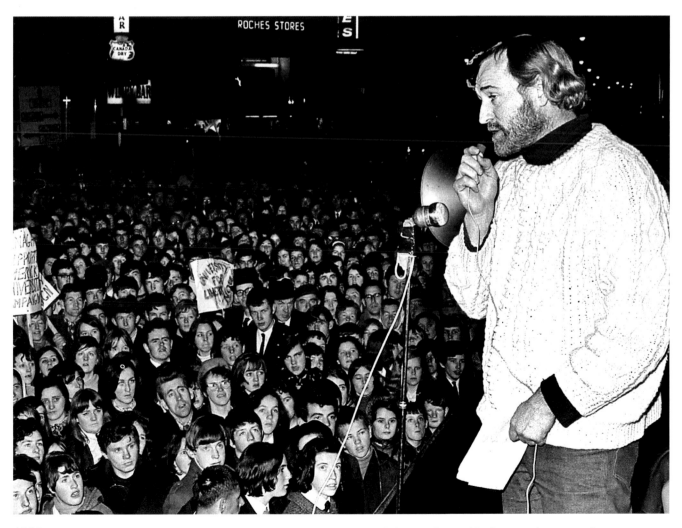

1969 Richard Harris addresses a Limerick University campaign rally on O'Connell Street. His fiery words were well received. Within a few years NIHE Limerick had been founded and it received university status in 1989. *LL145B*

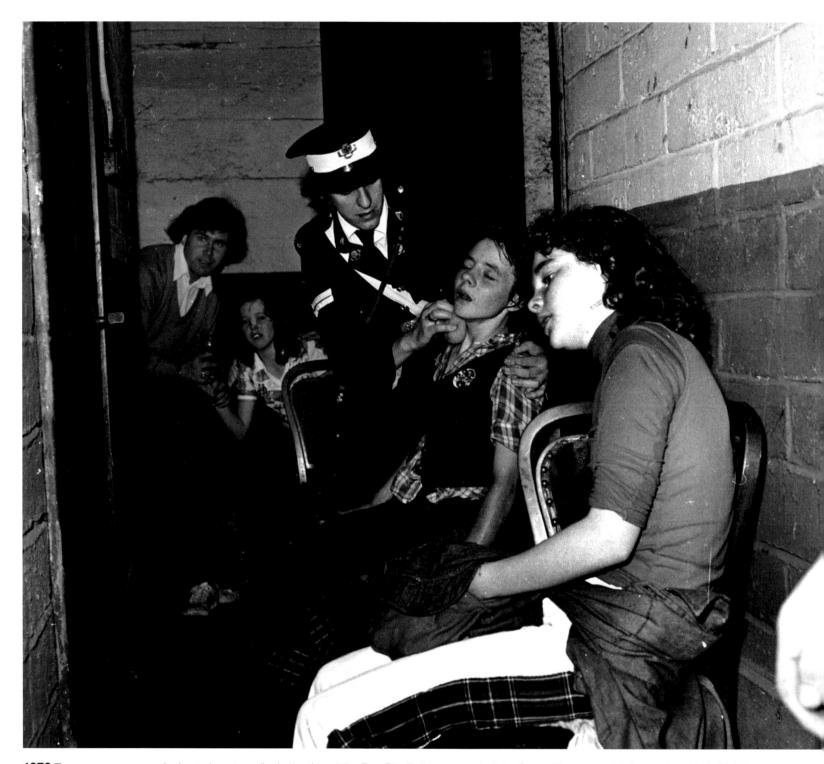

1976 Teenagers overcome by hysteria get medical attention at the Bay City Rollers concert at the Savoy Theatre on 30 September 1976. *LL146*

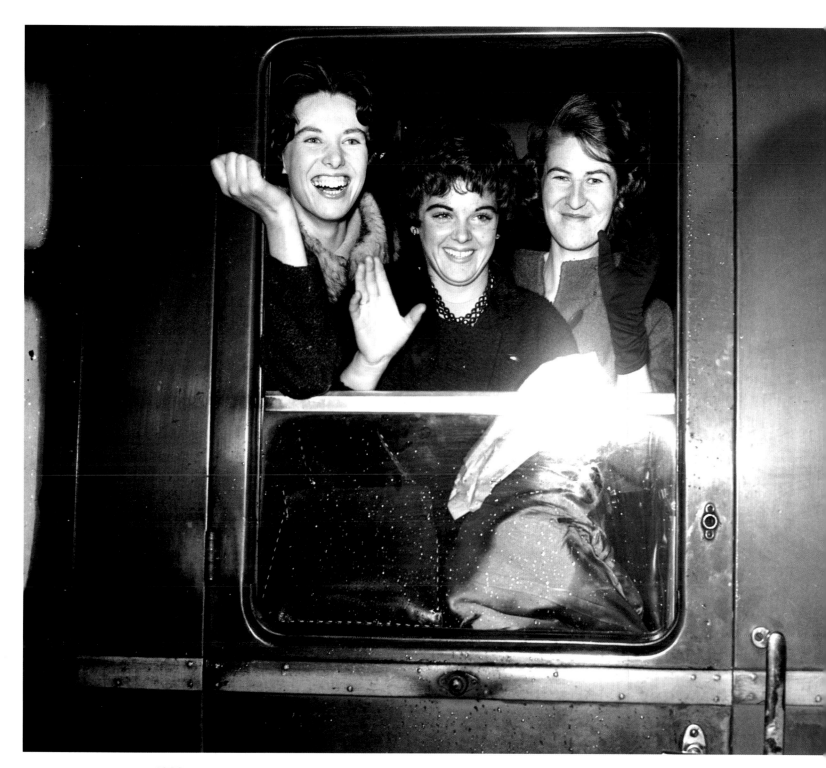

1962 Three emploees of Danus Clothing, for many years a major employer in the city, leave Colbert Station for London. Mary O'Brien, Una Quinn and Mary Sheahan were on a training trip, but London was a long way to go in those days! *LL147*

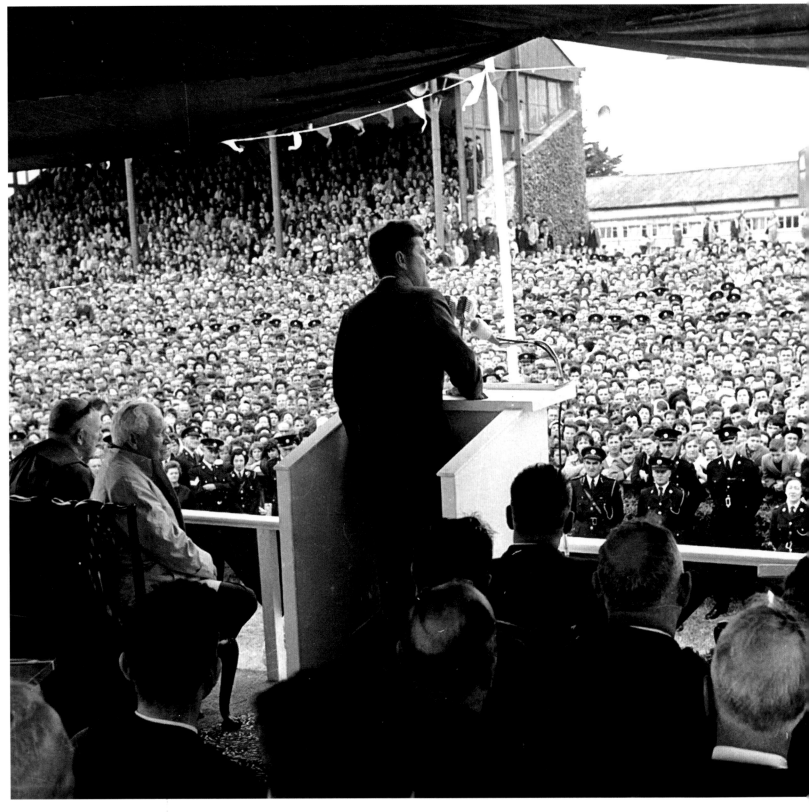

1963 President John F. Kennedy addresses the crowds at Greenpark Racecourse, Limerick, during his flying visit to the city on 29 June 1963. *LL148*

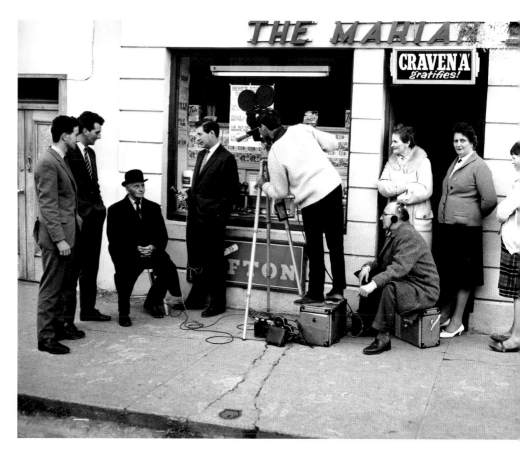

1963 Relatives of John F. Kennedy being filmed in Adare ahead of his visit to Limerick.
LL149

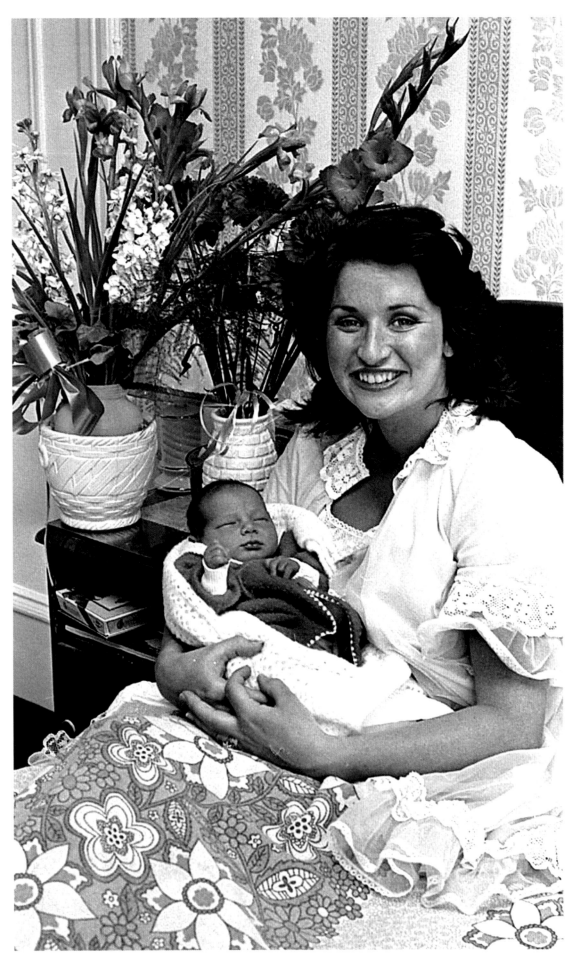

1974 Celia Holman Lee with her new baby Ivan Henry, born at the Marian Nursing Home. O'Connell Avenue. The top Limerick model, who later became one of the biggest names in Ireland's fashion world, was pictured by staff photographer Dermot Lynch. 'I am absolutely thrilled – and as for my husband Ger, well, he is walking on cloud nine,' Celia told the *Leader*. 'The birth didn't knock a feather out of me and I am looking forward to the fashion show at the Parkway on Monday night.' *LL150*

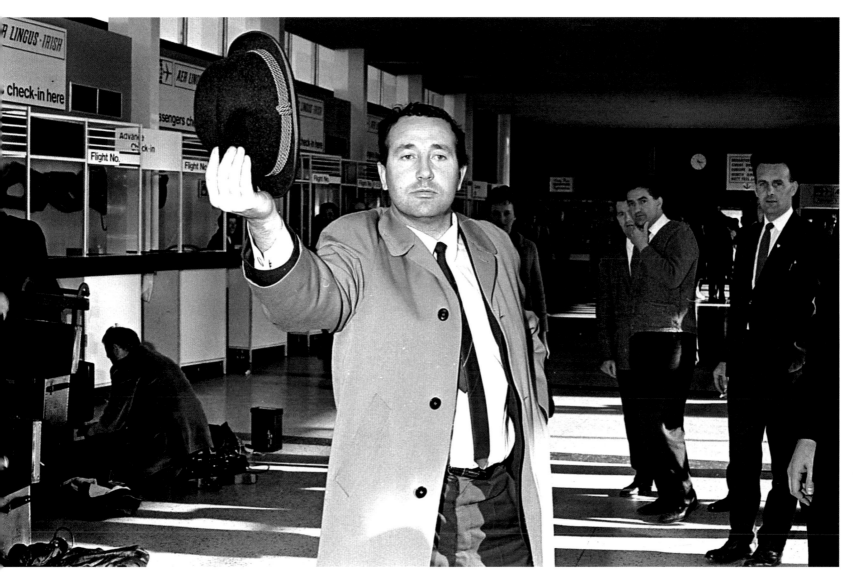

1968 Limerick native Seán Bourke, jailbreaker and author of *The Springing of George Blake*, arrives at Shannon Airport in typically flamboyant form. *LL151*

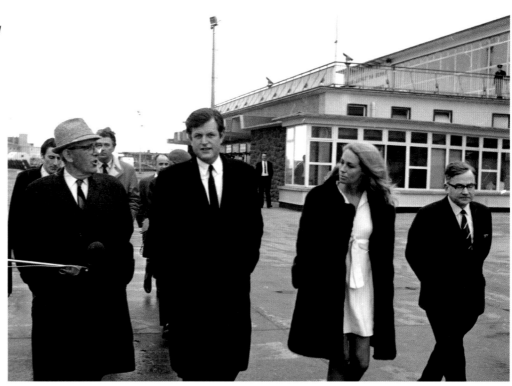

1970 US senator Edward M. Kennedy, at Shannon Airport. *LL151B*

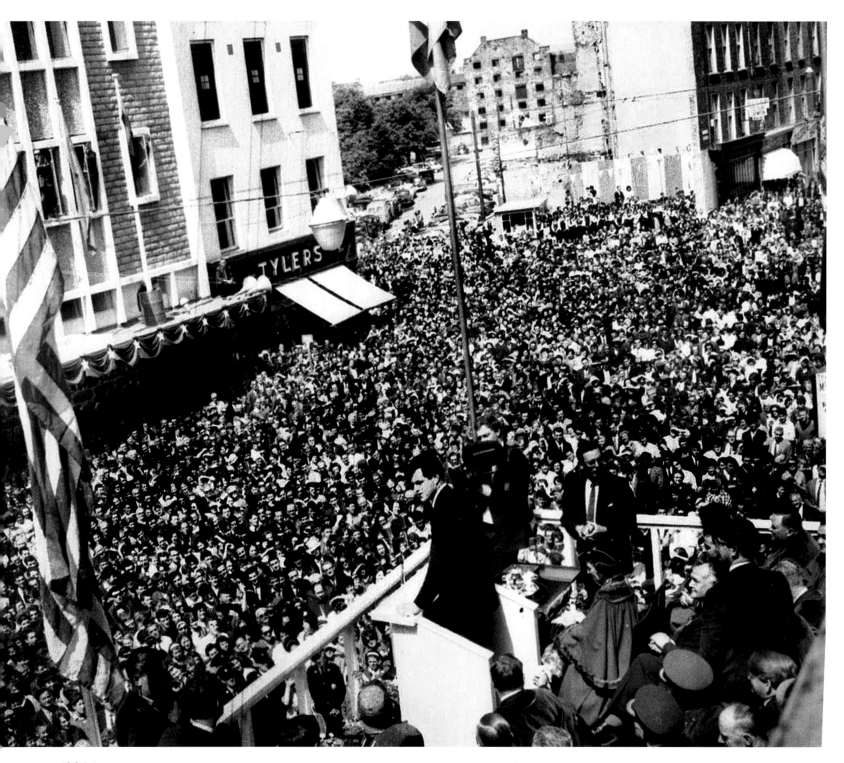

1964 Edward (Ted) M. Kennedy, brother of the late US President John F. Kennedy, drew a huge crowd in O'Connell Street on 30 May 1964. *LL152*

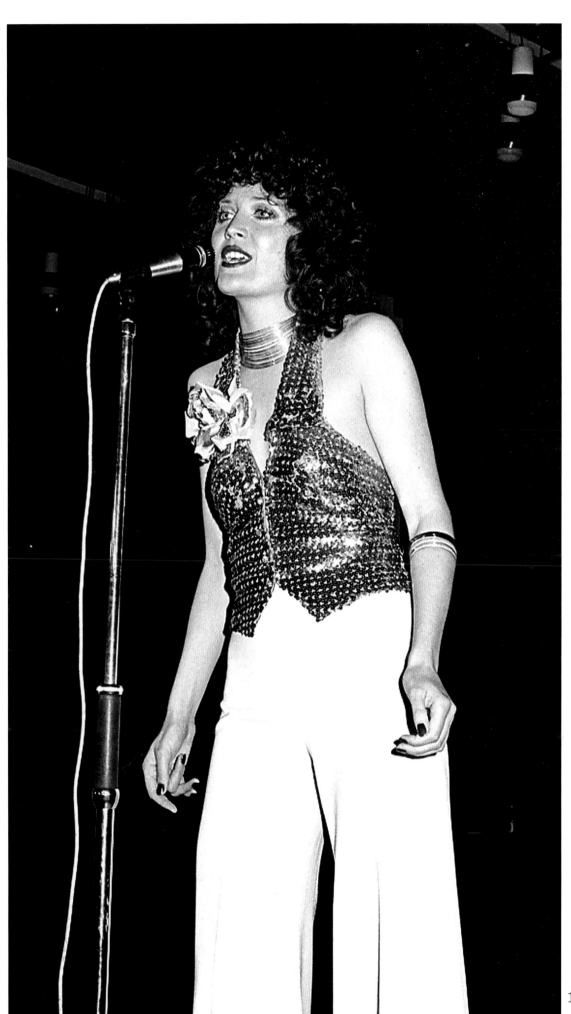

1975 Eurovision winner Sandie Shaw performs at the Parkway Motel. *LL153*

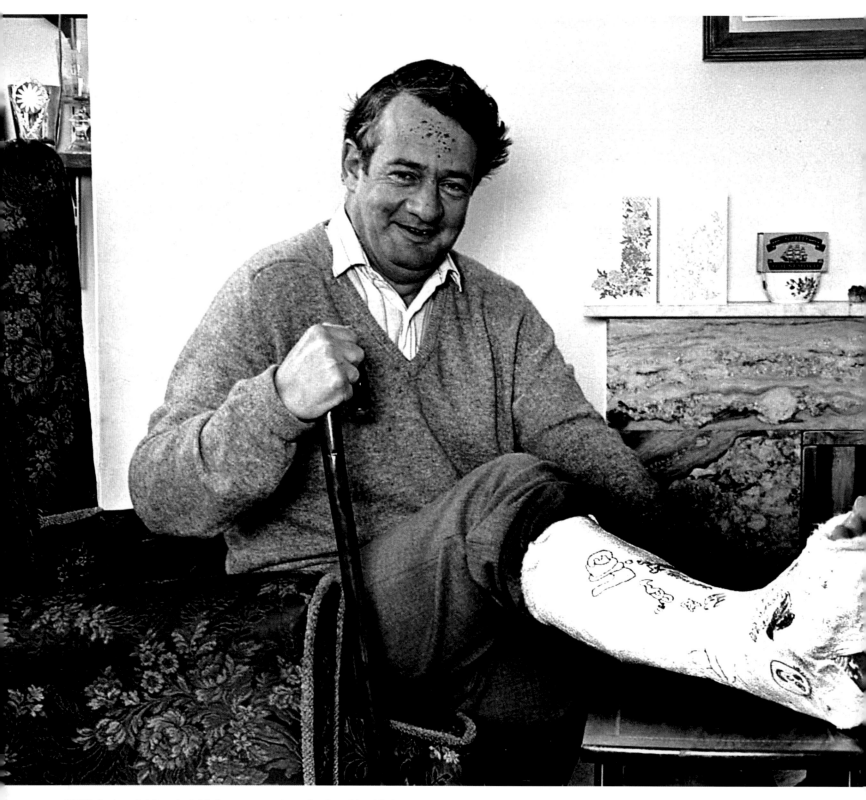

1985 A cheerful Dessie O'Malley recuperating after breaking his leg in a car crash, shortly before becoming leader of the Progressive Democrats. *LL154*

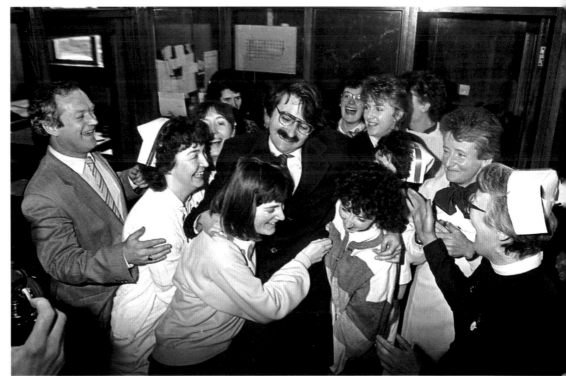

1971 Des O'Malley, Minister for Justice, lights up at the Scripto Lighters trade exhibition at the Ardhu Ryan Hotel, Ennis Road. *LL155*

1988 Willie O'Dea proving very popular after taking a stand in the Dáil over Barrington's Hospital, which cost him the Fianna Fáil whip. Alas, the hospital did not survive for much longer but a private medical facility is now on the same site. *LL155B*

155

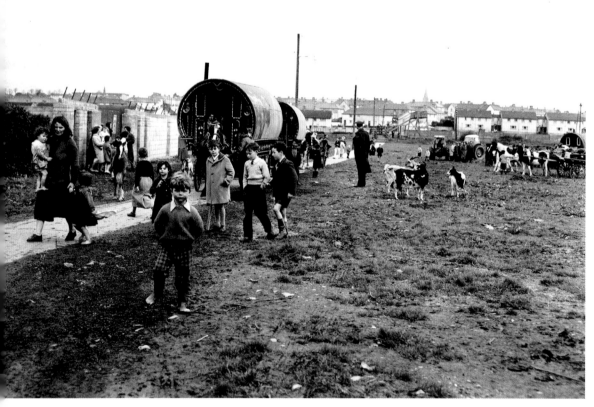

1965 Travellers being moved on from Janesboro. *LL156*

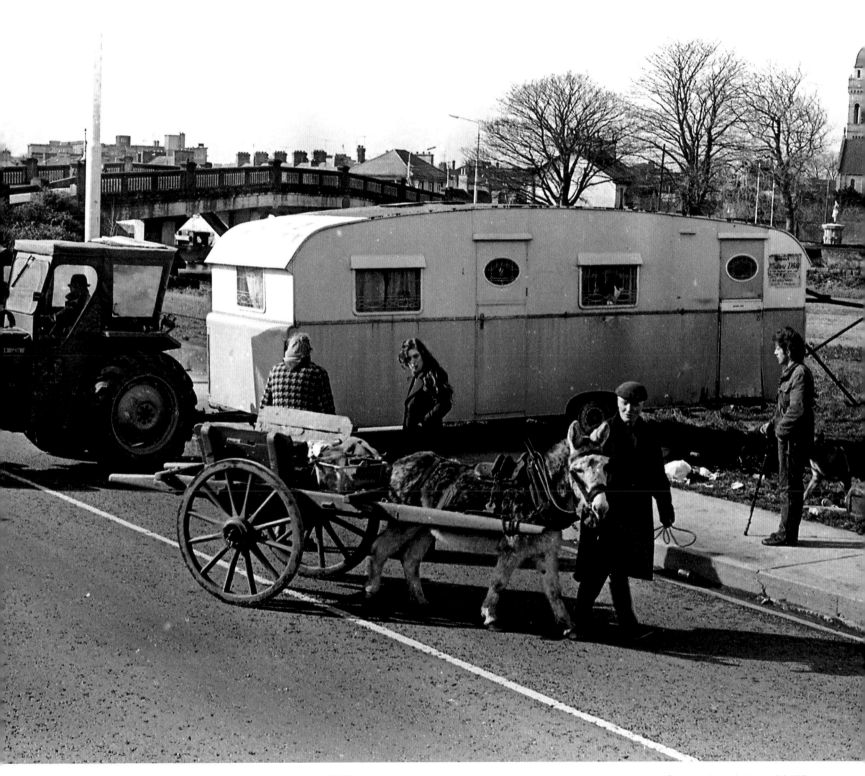

1976 Madame Leiza being moved on from the Abbey riverbank by Corporation workers. *LL157*

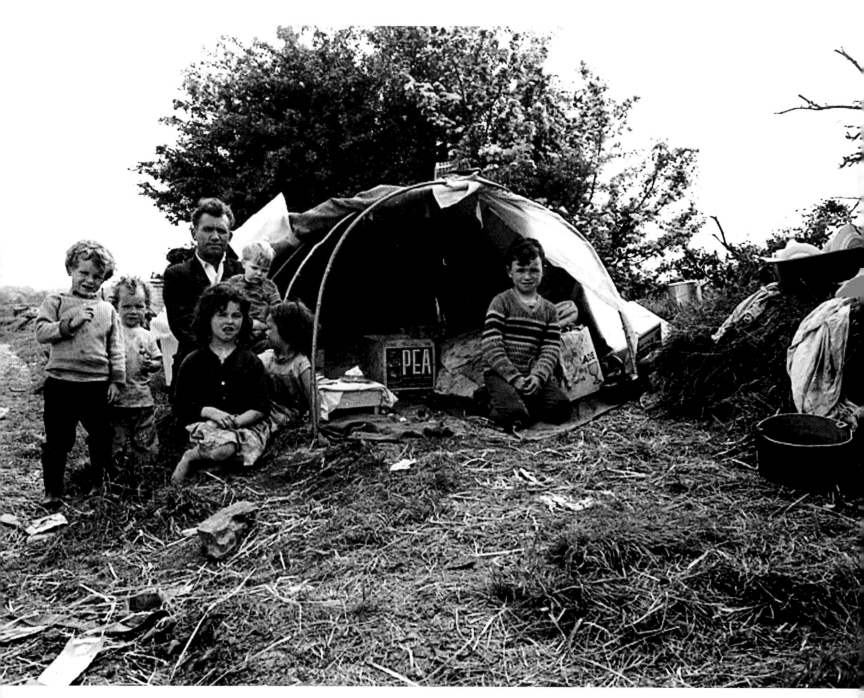

1970 The homeless family of Traveller Tom 'Goggles' O'Brien on the roadside near Abbeyfeale. The *Limerick Leader* reported that Tom and his young children – Thomas, Mary, Timothy, Eileen, Mikey and Christina – had lost their caravan and were being forced to live in a tent 'no bigger than a single household bed'. When this picture was taken, Tom's wife was in hospital expecting the couple's seventh child. 'When the baby arrives, the mother and her newly born will have to squeeze in among them,' reported the *Leader* on 13 June 1970. The Itinerant Settlement Committee in Abbeyfeale took up the family's cause, but was told by the County Council that there was 'no precedent in Co Limerick for the provision of a caravan for itinerants'. The *Leader* report added that Mr O'Brien 'finds work wherever he can, usually with considerate families around Abbeyfeale'. *LL158*

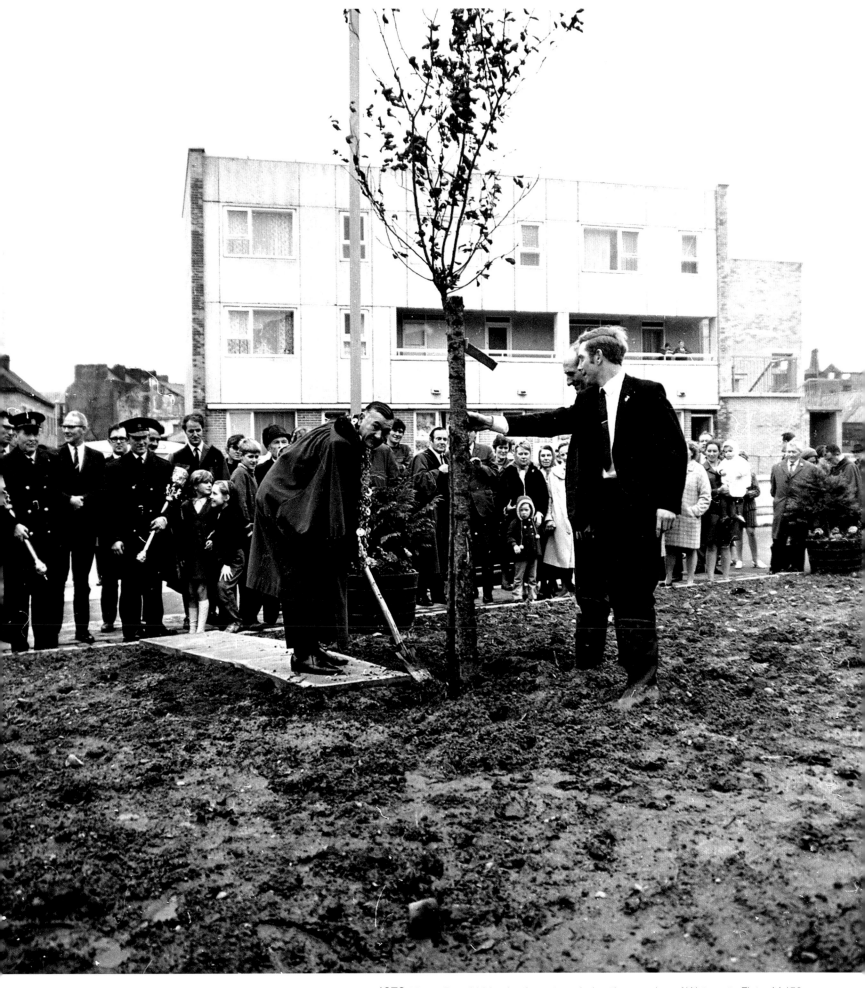

1970 Mayor Rory Liddy planting a tree during the opening of Watergate Flats. *LL159*

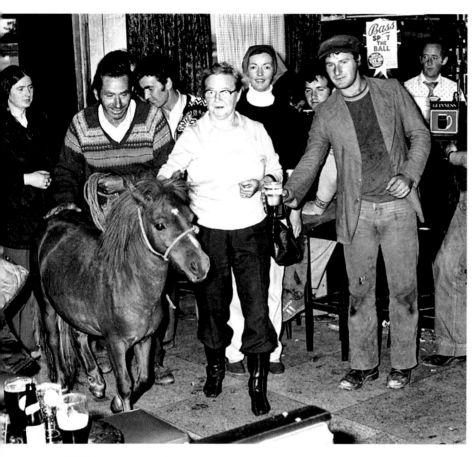

1979 It's not every day a pony pays a visit to a pub in Limerick. *LL160*

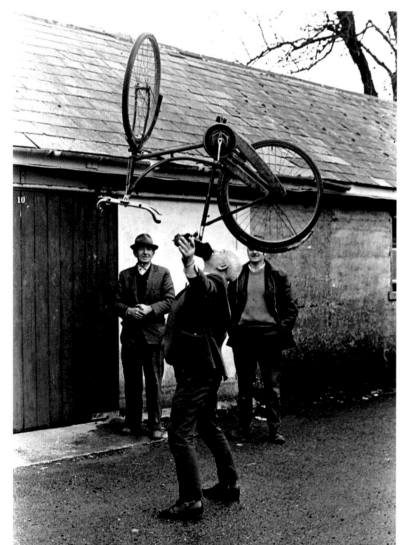

1974 Johnny Fitzgibbon of Kilmeedy doing his party piece in Abbeyfeale. *LL160B*

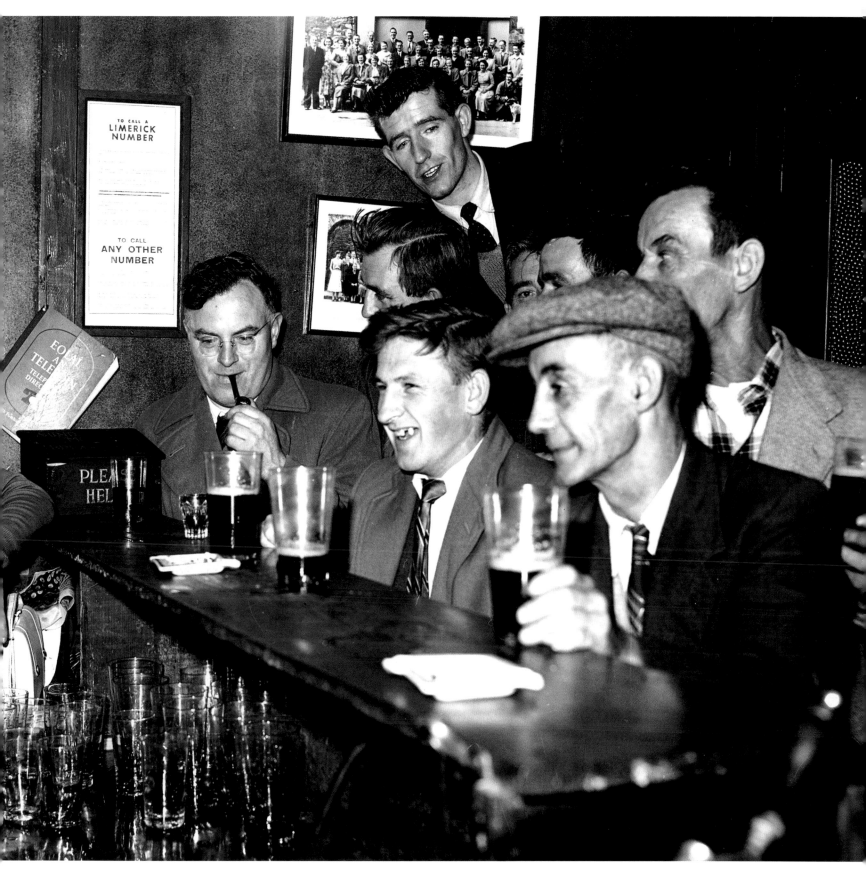

1957 A charming scene from John Doyle's public house. *LL161*

161

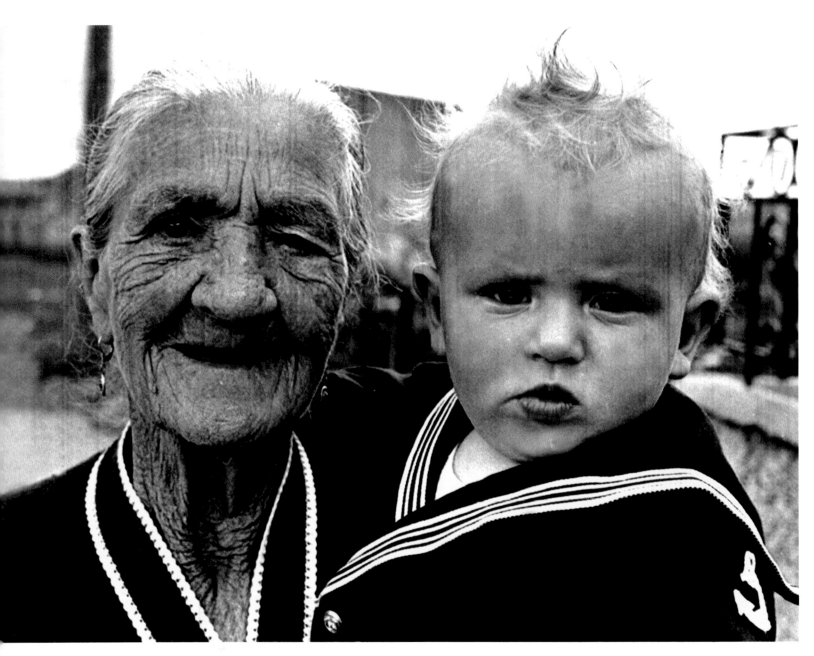

1986 Mrs Margeret Troy on her 86th birthday with her great-great-grandson Julian Collins. *LL162*

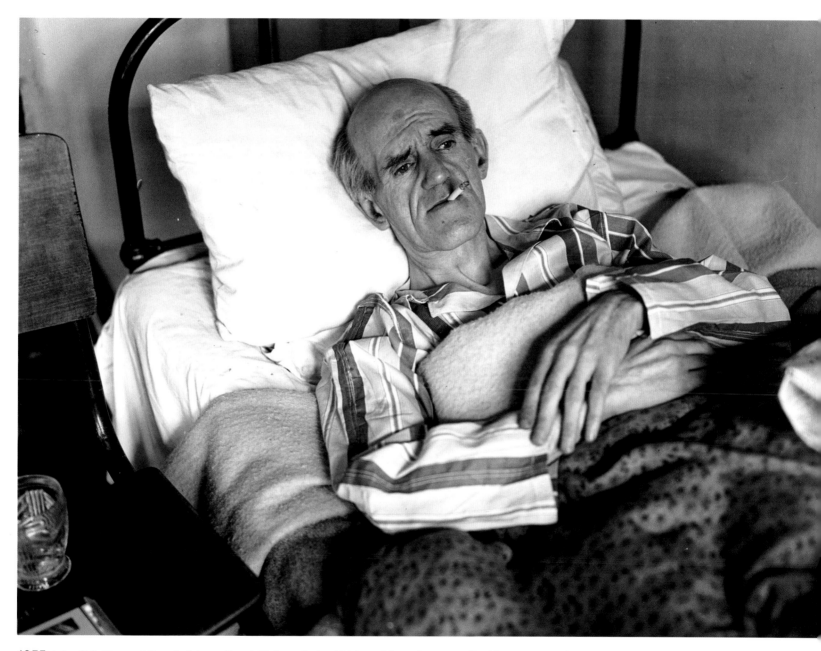

1955 John O'Sullivan, of Knockalisheen Road, Ballynanty, bedridden while on hunger strike. He was protesting against his suspension as a driver in the Post Office engineering department. He claimed he had been victimised because he 'upheld trade union principles'. In a letter to Con Cregan, the editor of the *Limerick Leader*, he wrote: 'I have fought so long against tyranny and the powers-that-be that there is very little further that they can do to me bar break my spirit and reduce me to the status of a serf. No set of administrative officers will ever succeed in doing that. It is common knowledge that I was made an example of for any "foolish" men who entertained any "foolish" ideas about the rights, security and dignity of the worker.' *LL163*

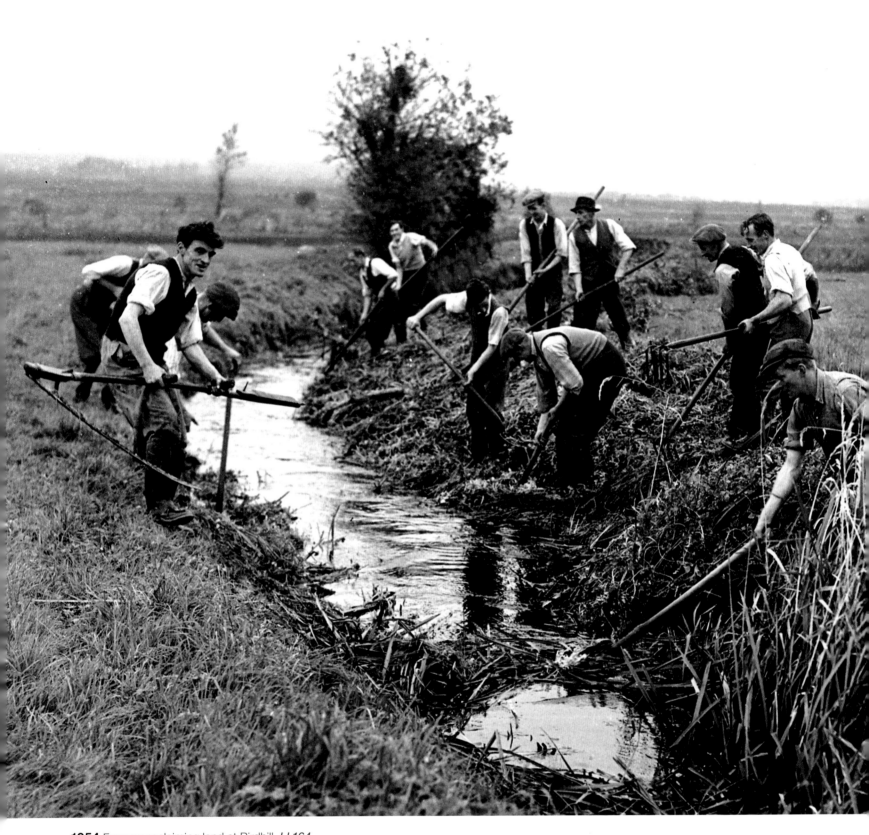

1954 Farmers reclaiming land at Birdhill. *LL164*

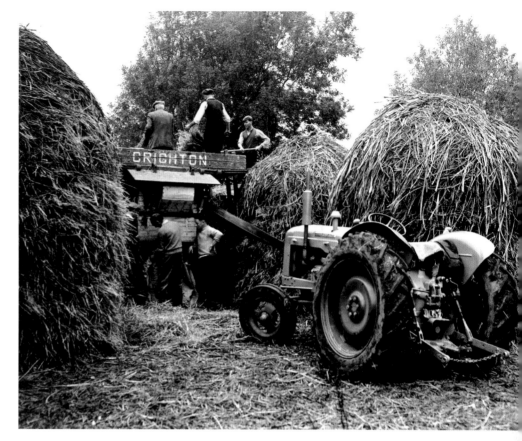

1962 Stacking hay in the county on a summer's day. *LL165*

1975 Working on the bog in near Glin. *LL167*

August 1963 There was snow in Abbeyfeale during August 1963 and
this man was pictured for the *Leader* taking it all in. *LL166*

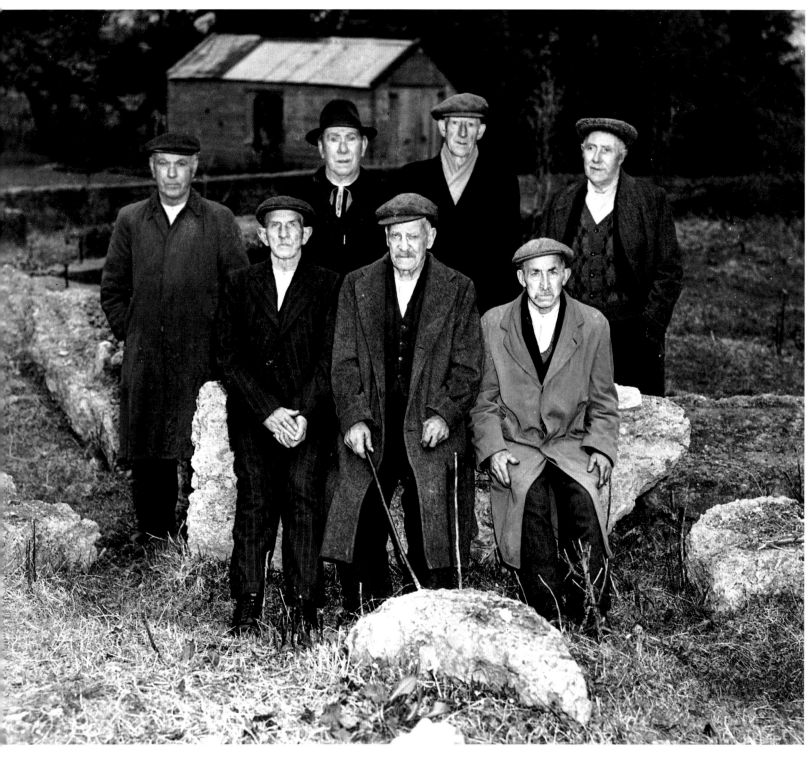

1954 These men built the Castleconnnell Peat Factory in 1904 and they were there 50 years later to mark its anniversary.

Back row (l–r) Martin Kelly, Jack Kelly, Thomas Joyce (Coolriree) and Thomas Joyce (Castleconnell).

Front row (l–r) William Tucker, Martin O'Sullivan, Malachy Ryan. *LL168*

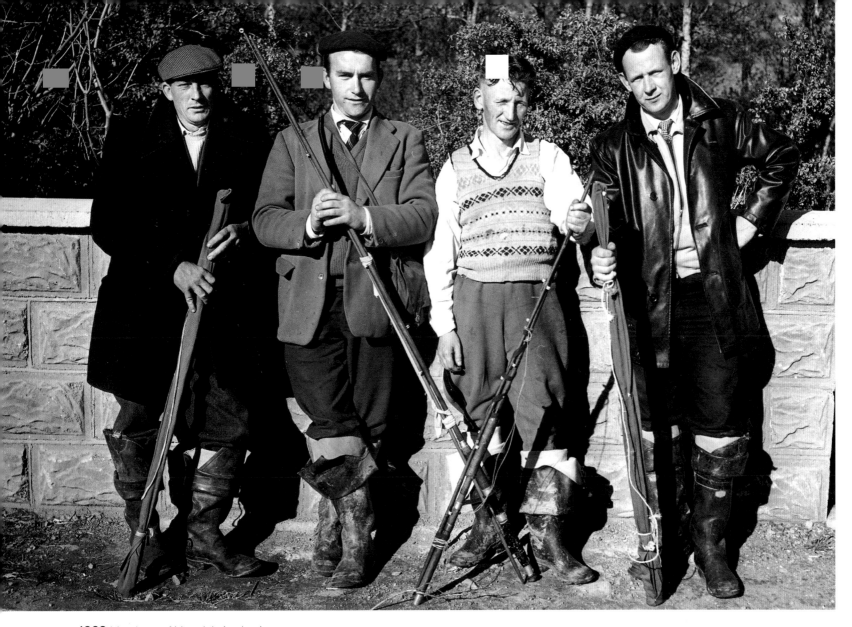

1962 Members of Limerick Anglers'
Association at Sixmilebridge. *LL169*

1965 Workers from Southern
Chemicals, Askeaton. *LL169B*

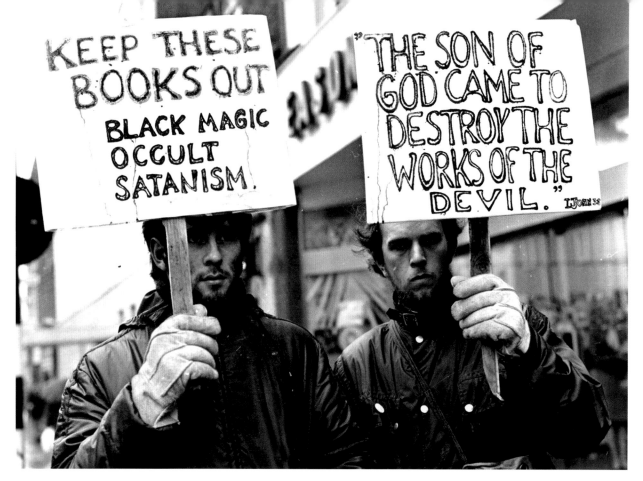

1972 Protesters outside Eason's bookshop, O'Connell Street. The *Leader* reported that David Ambury and Patrick Godfrey, who were living in Ballinacurra, where they held bible sessions, believed the black-magic books on sale had already affected Limerick children: 'These types of books have ruined England and will ruin this city. They are deadly. They must be destroyed.' *LL170*

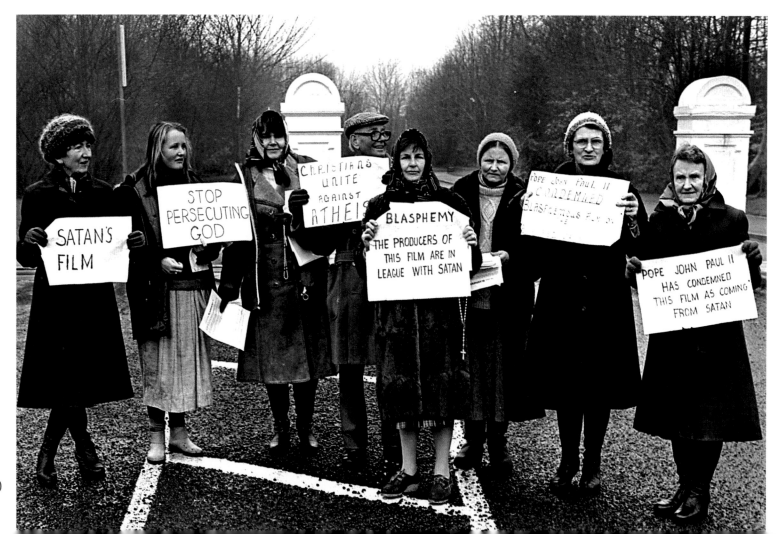

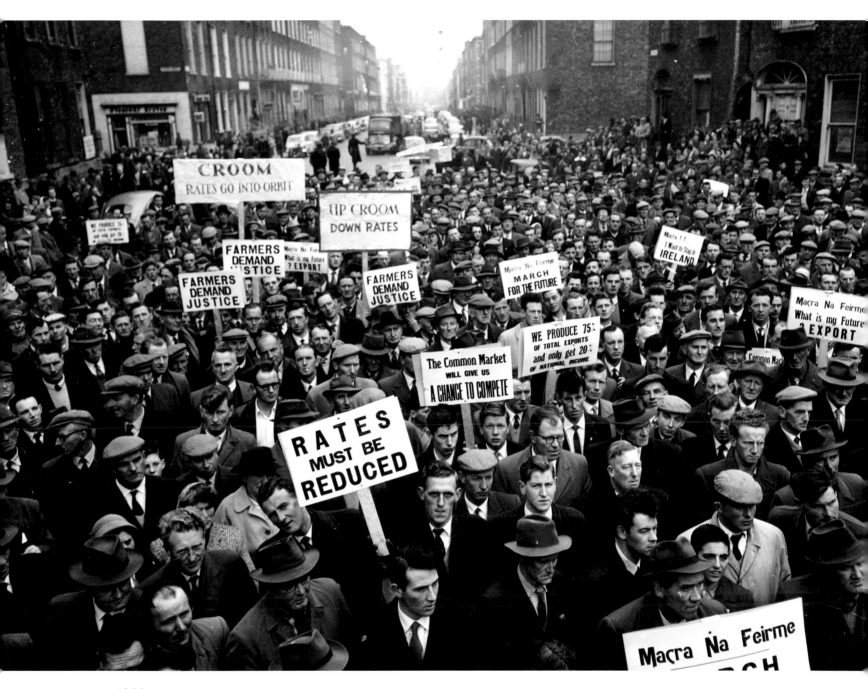

1963 Thirty thousand farmers protesting the plight of agriculture converge at the monument to Daniel O'Connell at The Crescent. *LL171*

1986 Protesters at the gates to the former NIHE, outraged at the showing of an allegedly blasphemous film *Je Vous Salue, Marie* by the French director Jean-Luc Godard. *LL170B*

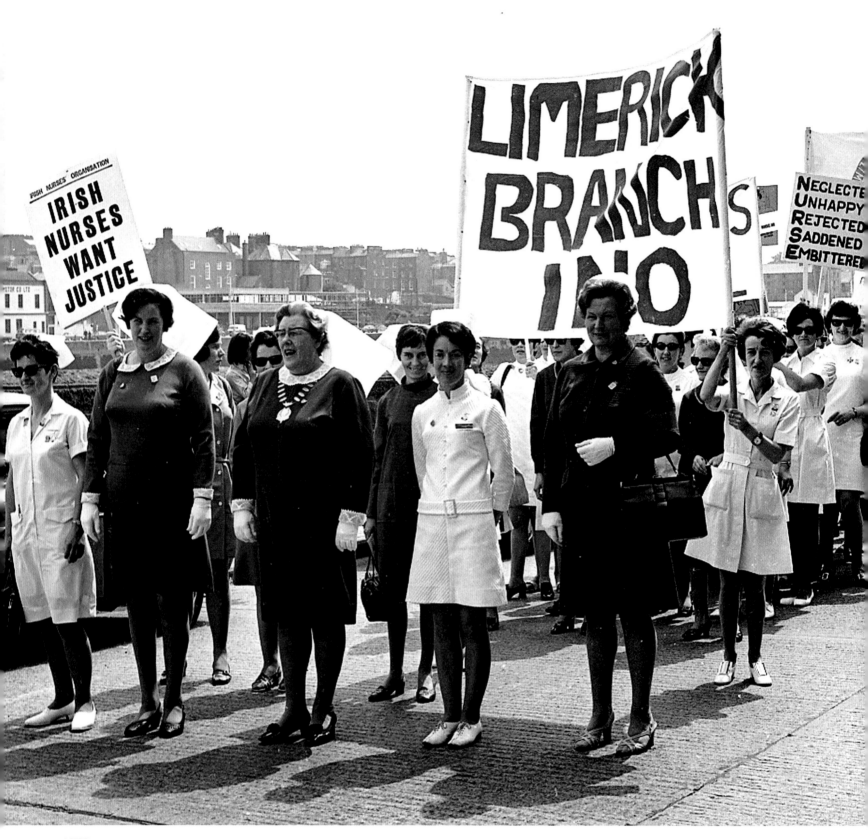

1970 Nurses' protest march on O'Callaghan Strand. *LL172*

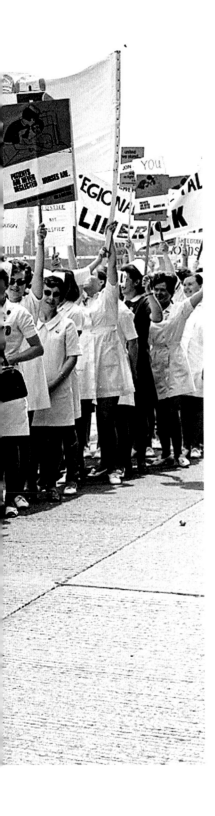

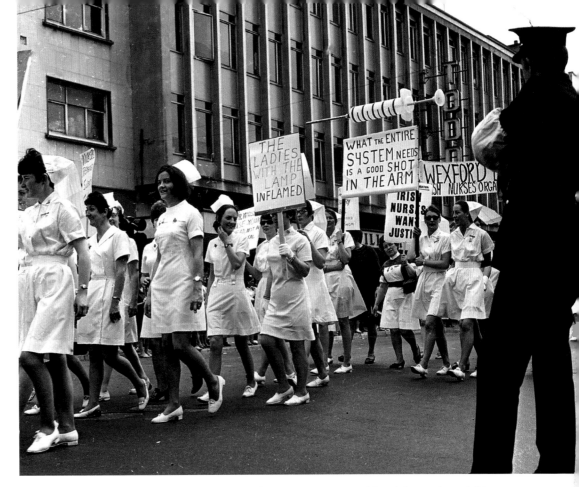

1970 Nurses and members of An Garda Síochána made up many a Limerick couple and this member of the force had his eyes peeled as a protest march came down O'Connell Street on 6 June 1970. *LL173*

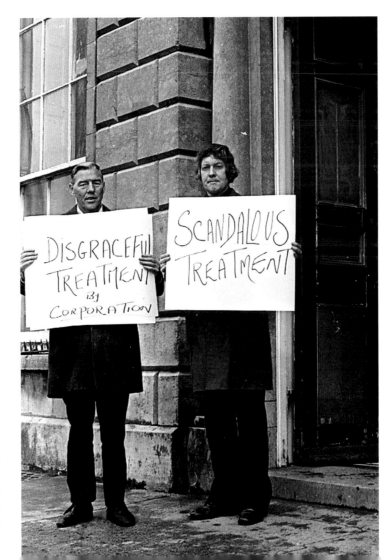

1975 Well-known sportsman, publican, politician and one of Limerick's great characters, Mick Crowe (right), and Fran Hayes, of Hogan Avenue, Kileely, picket the Town Hall, Rutland Street. *LL173B*

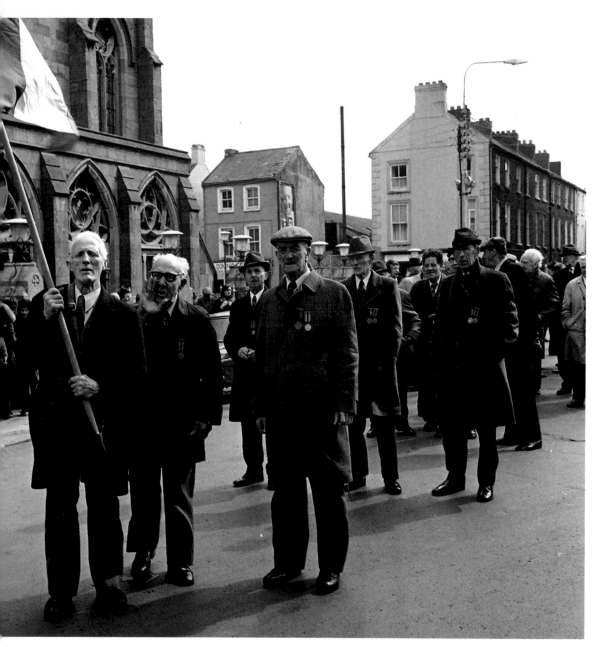

1977 Old IRA members parade in the city. *LL174*

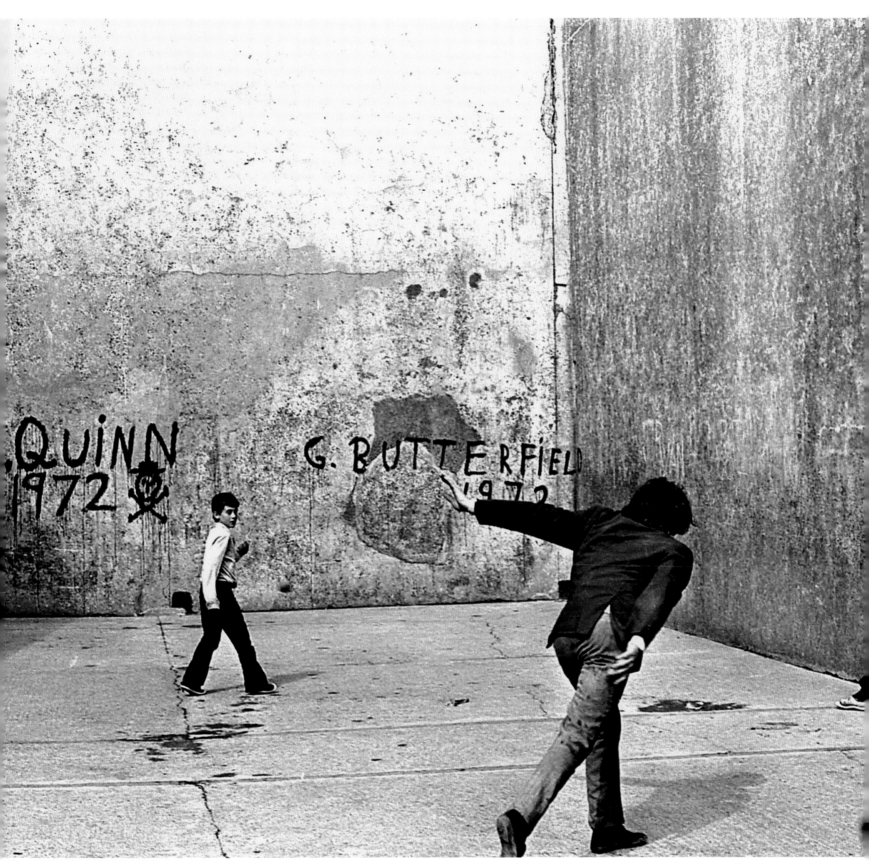

1973 Action in the handball alley at Prospect. *LL175*

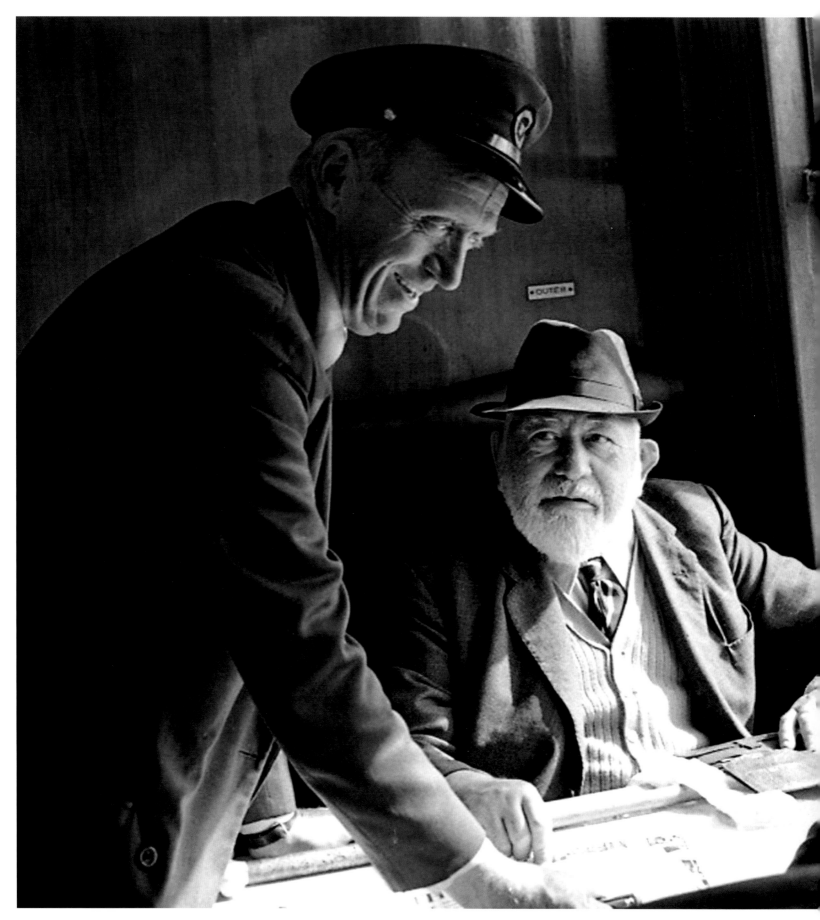

1976 Passengers on the last train from Limerick's Colbert Station to Claremorris were well looked after by cheerful CIÉ employee Mr M. Conway.
LL176

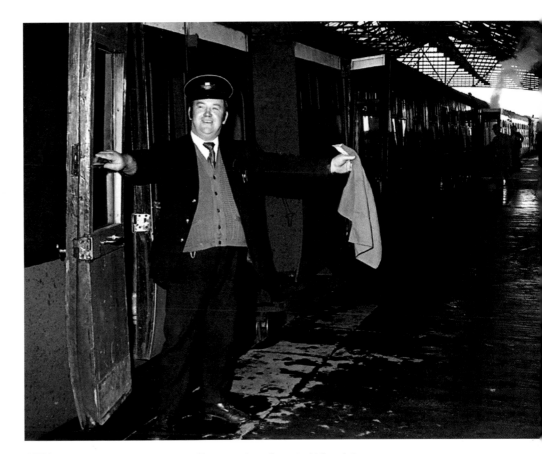

1976 All aboard! The last train to Claremorris pulls out of Limerick, flagged by CIÉ man Timothy Coughlan. *LL177*

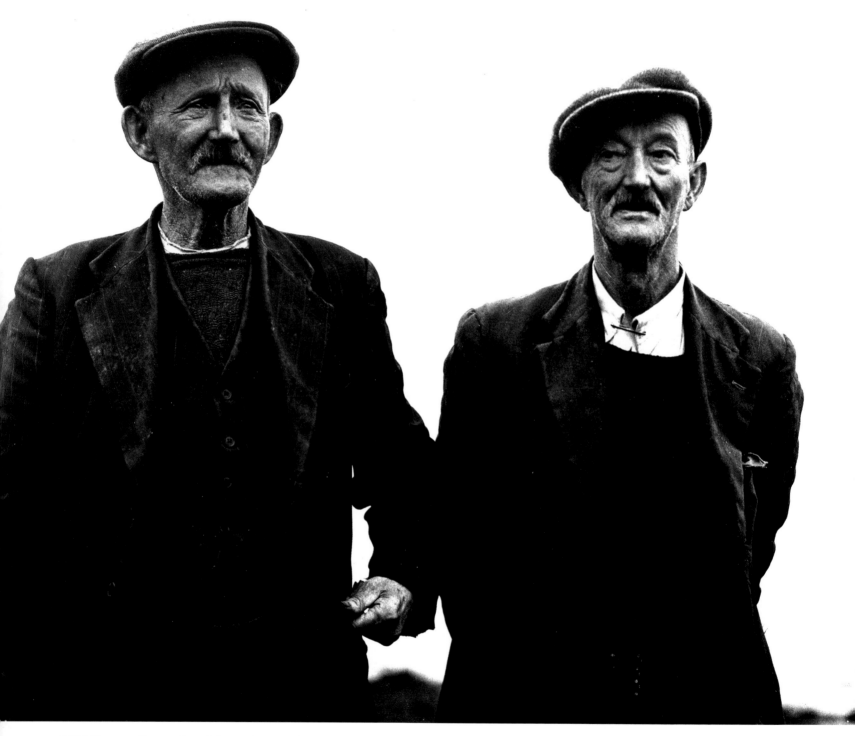

1955 Shannon Estuary lamplighters photographed for the *Leader*. Bill Fitzgerald, from Ringmoylan, Pallaskenry is on the left, alongside Jack McMahon. Bill was the last lighthouse keeper of the Horse Rock lighthouse between Ringmoylan Pier and Shannon Airport, which closed in 1954. *LL178*

1955 Give us a wave: lamplighters at Ringmoylan, on a structure which survived until the ferocious storm of February 2014 blew it away. *LL179*

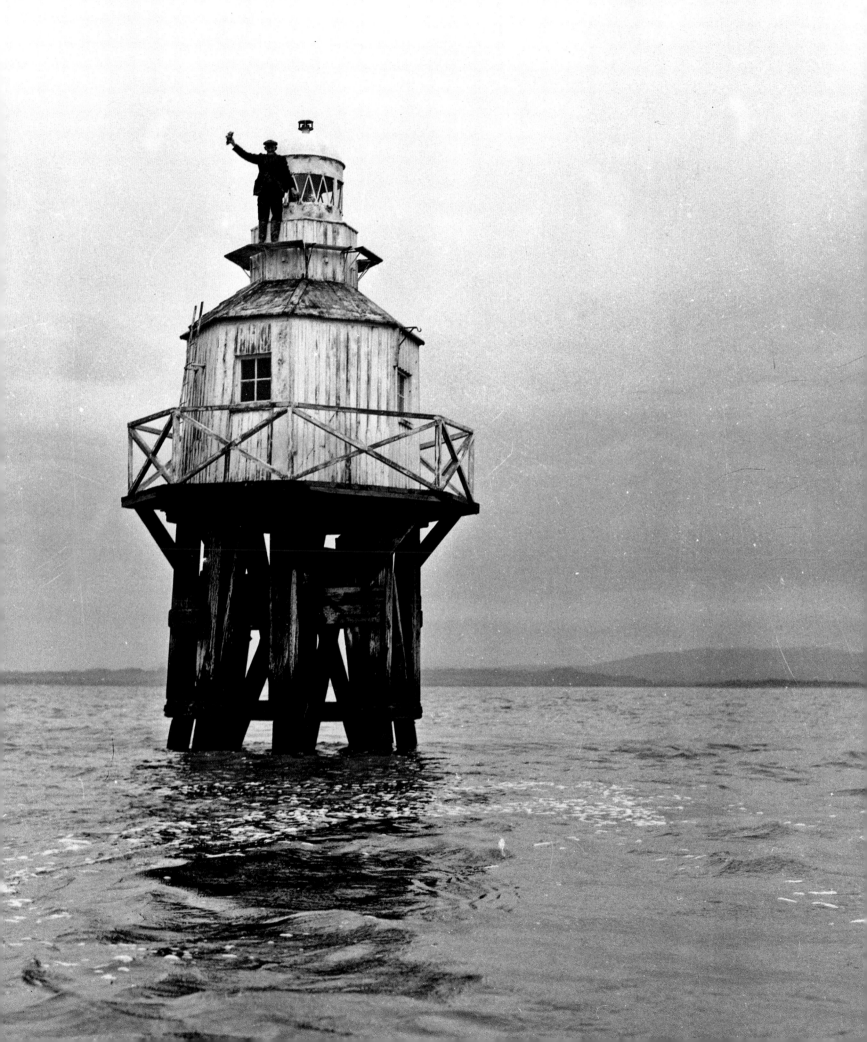

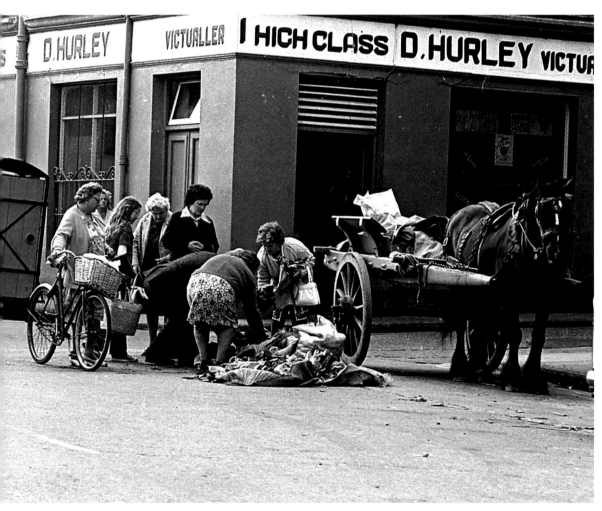

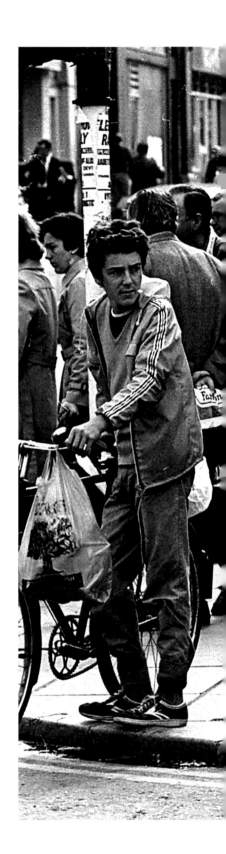

1977 Rummaging for a bargain outside Hurley's butchers. *LL180*

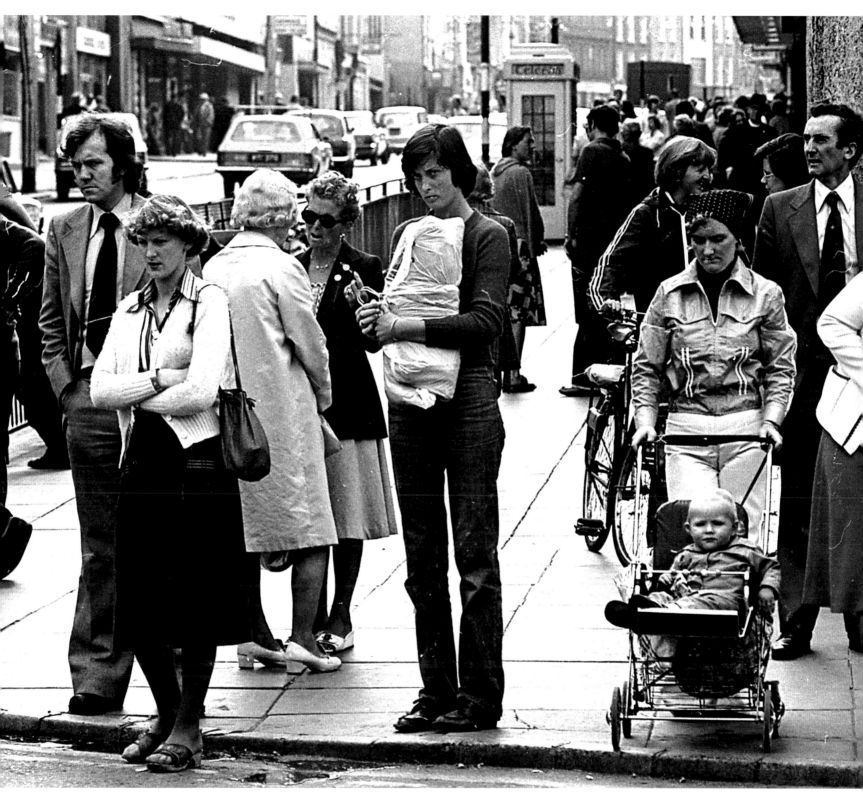

1977 This picture, taken in William Street in August 1977, shows the buzz in Limerick city centre that many will remember as an everyday occurrence. *LL181*

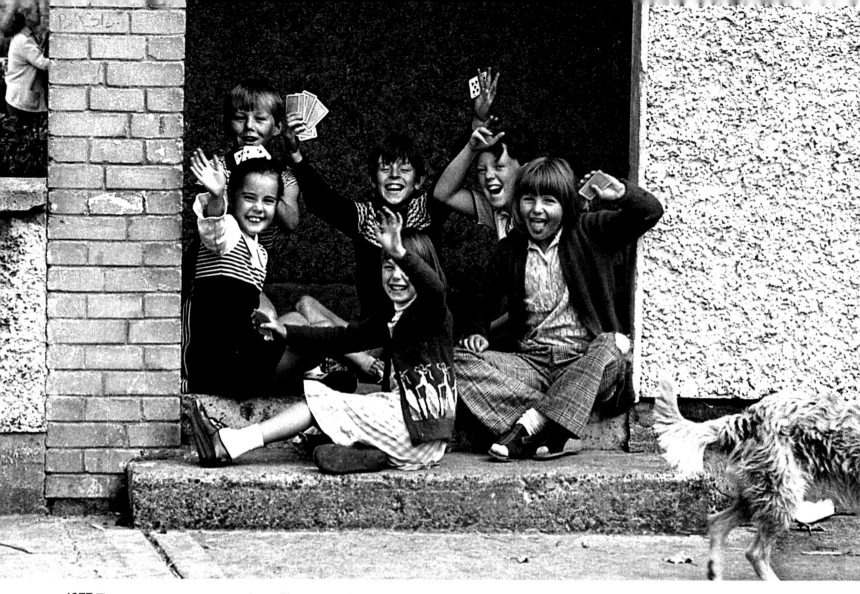

1977 These youngsters were more than willing to pose for the *Leader* photographer on a summer's day. The card players pictured outside the Watergate flats where they lived are (l–r): Lorraine Mullins, Michael Lawlor, Cathal O'Neill, Elsie Kenny, Catherine Hannon and Jacqueline Lawlor. *LL182*

1994 Children at St John's school in the city give the *Leader* photographer big thumbs-up on their first day at school. *LL182B*

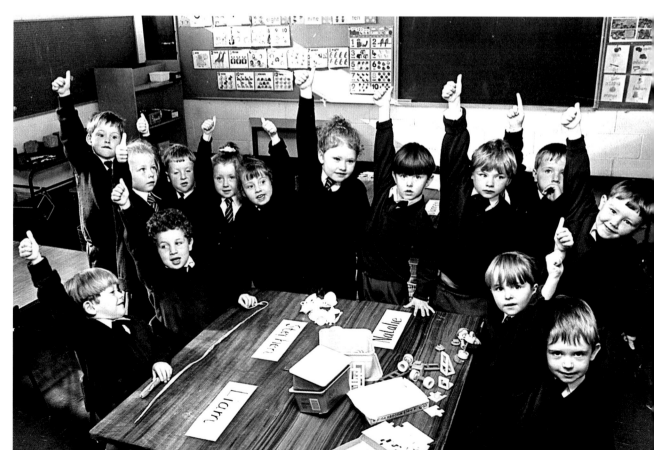

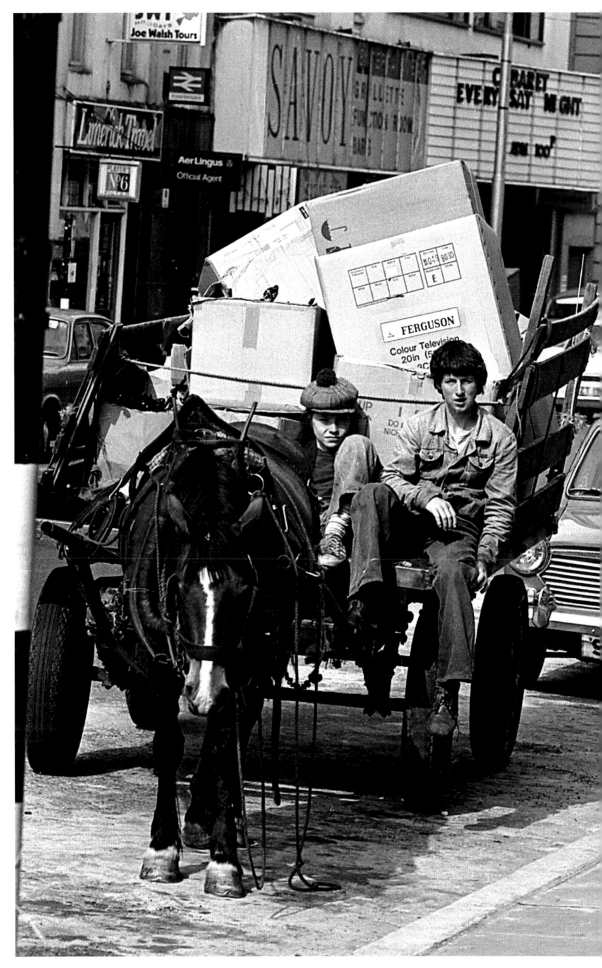

1977 The long-gone Savoy can be seen in the background of this picture taken in Bedford Row. *LL183*

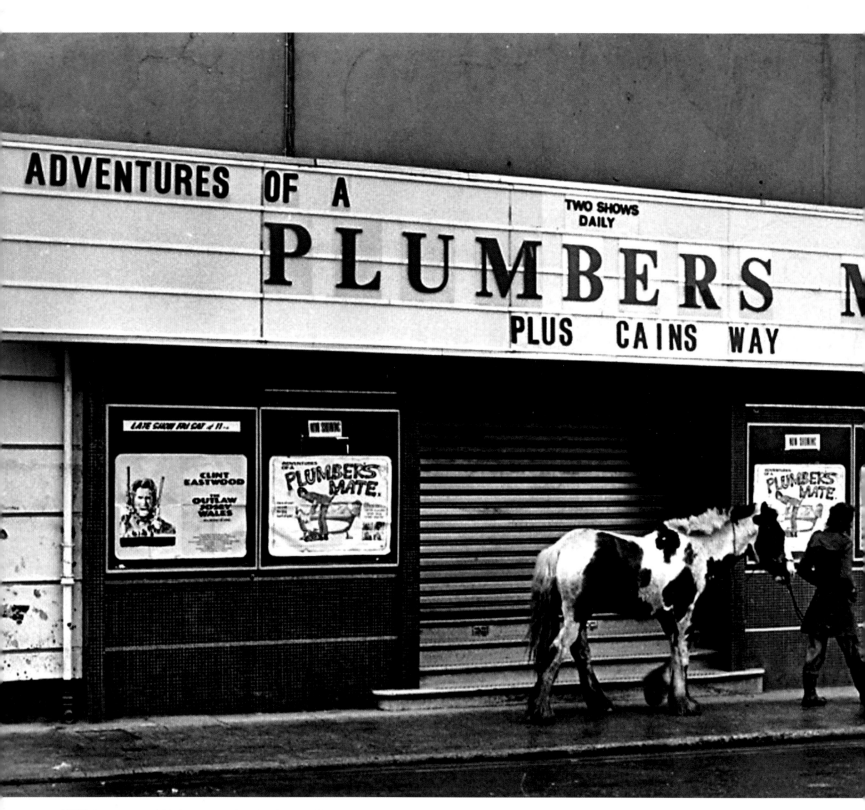

1978 One man and his horse passing the Carlton Cinema, now long demolished. *LL184*

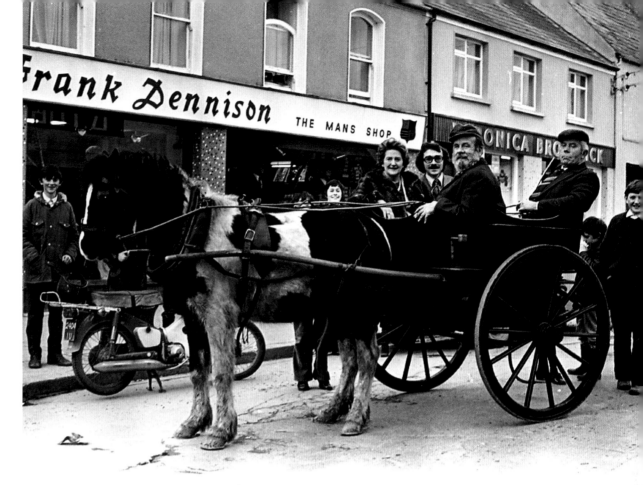

1974 Cast members from the popular RTÉ series *The Riordans* at the opening of Frank Dennison's shop in Abbeyfeale. *LL185*

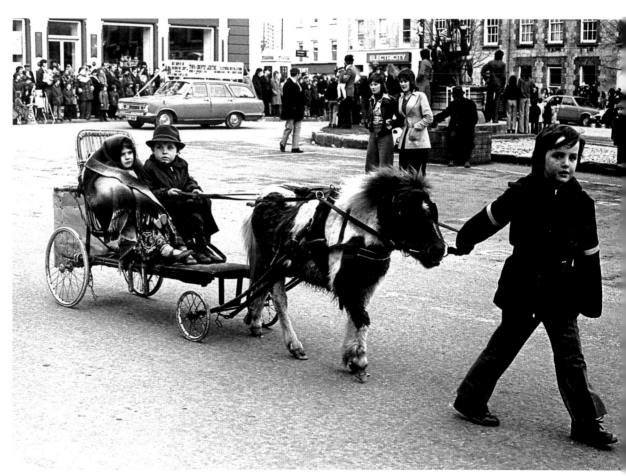

1977 A miniature horse and cart on show at the Newcastle West for the St Patrick's Day parade. *LL185B*

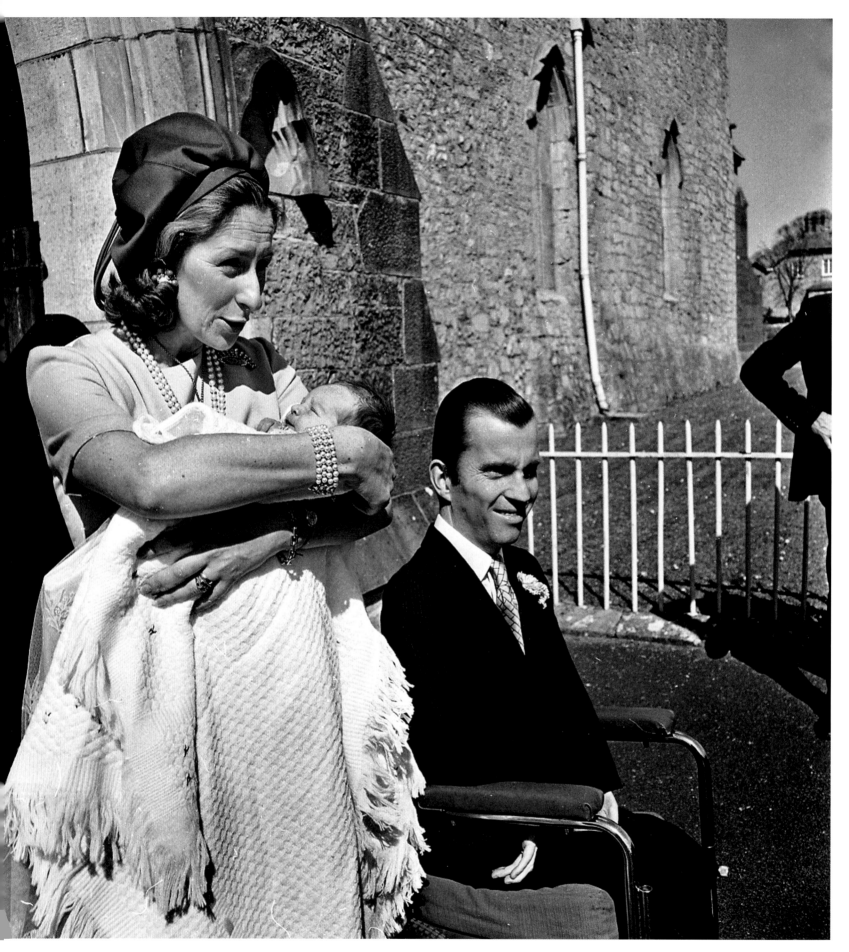

1972 The christening at St Nicholas Church, Adare, of Lady Ana Wyndham-Quin, only child of the seventh Earl of Dunraven and Mount Earl, Thady Wyndham-Quin, and his wife, Lady Geraldine. *LL186*

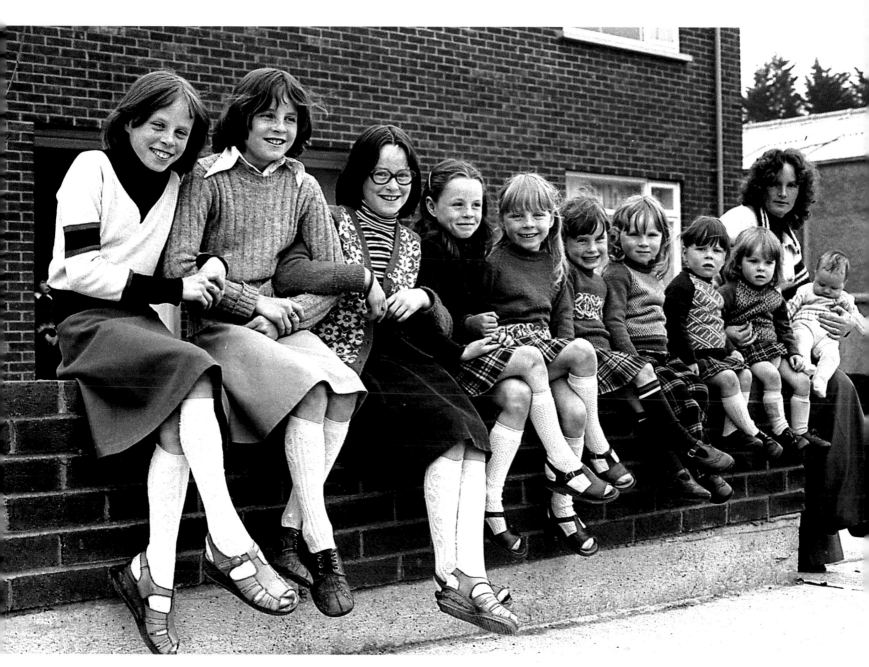

1978 Mrs Noreen Collopy, Cosgrave Park, Moylish. with her ten girls: Louise, Pauline, Loreinne, Antoinette, Teresa, Shirley, Collette, Helen, Georgina and latest arrival Virginia. *LL187*

1988 Sammy Benson at the newly built Shannon Bridge, when it became famous as the Whistling Bridge. The wind blowing though the gaps under it made an eerie sound, a unique feature that has long since been remedied. *LL188*

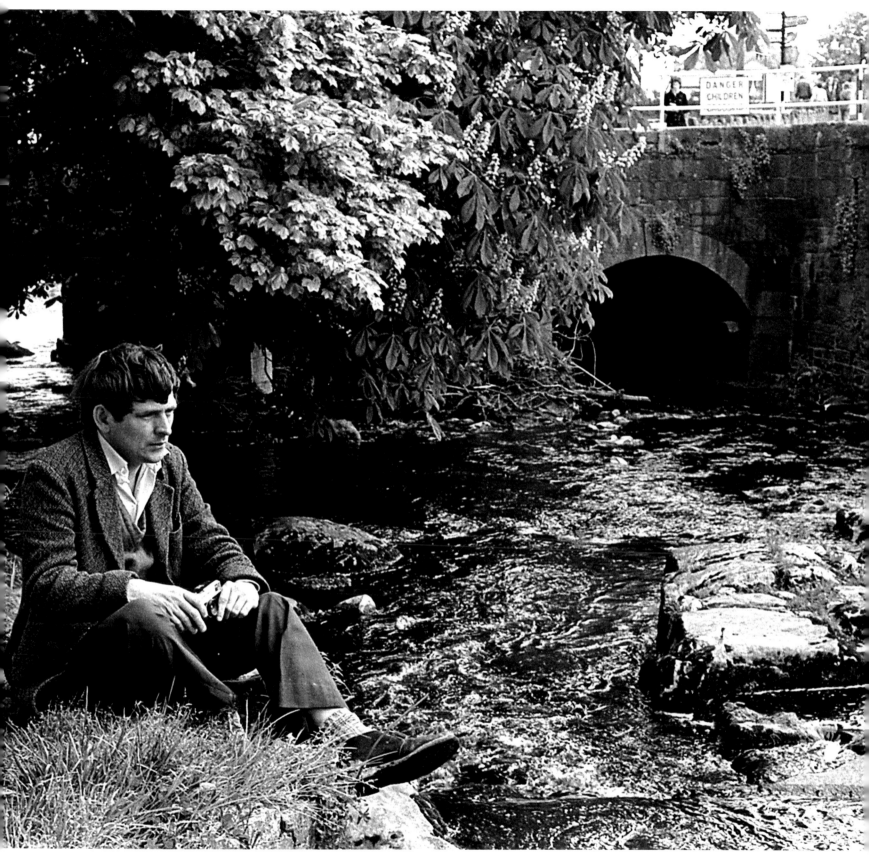

1975 West Limerick poet Michael Hartnett reflects by the River Arra in Newcastle West. *LL189*

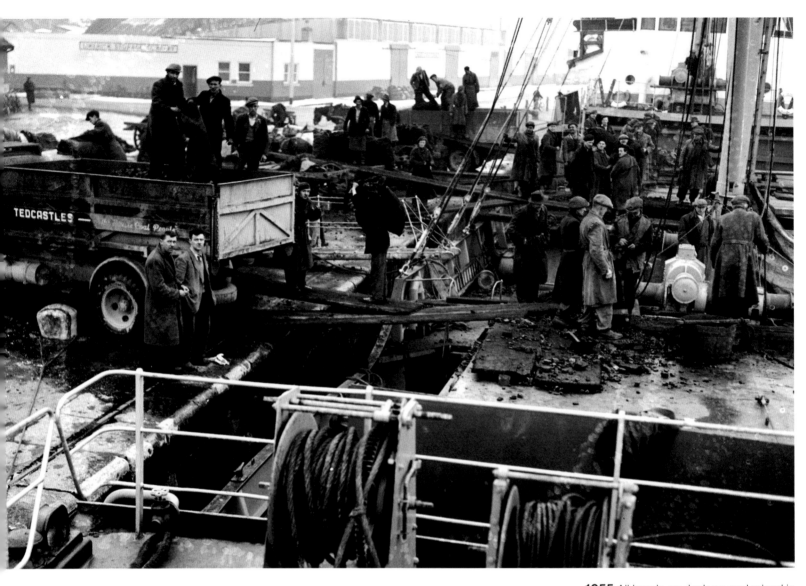

1955 All hands on deck as coal mined in Yorkshire is unloaded from the MV *Pearl* at Limerick Docks, having been delayed by severe weather. It was bound for the yard of Tedcastle McCormick, coal merchants. *LL190*

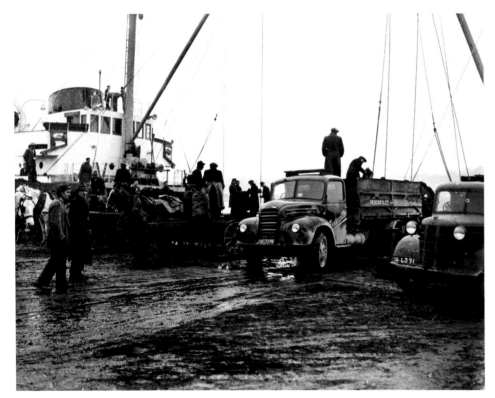

February 1955 Tedcastle's boat unloading coal at Limerick Docks. *LL190B*

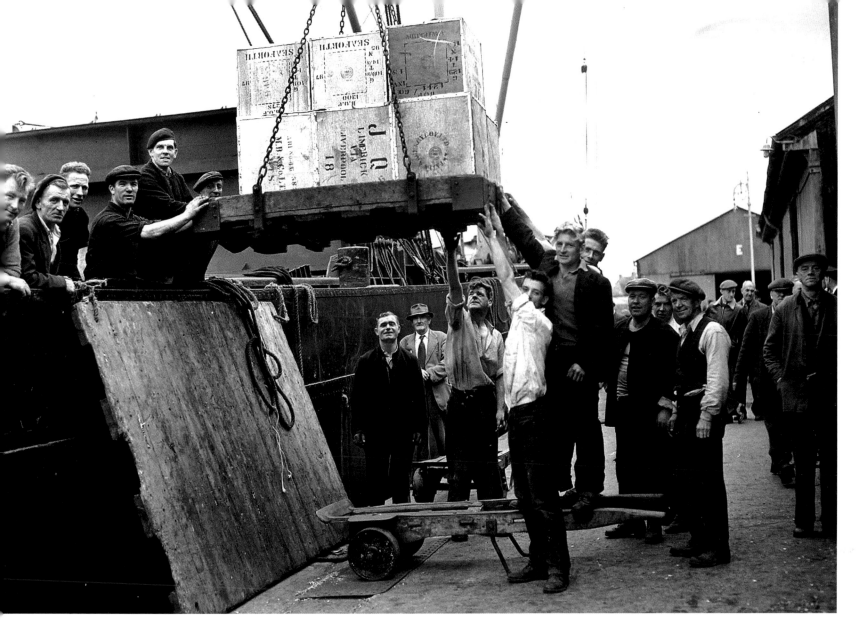

1958 Part of a consignment of tea being unloaded at Limerick Docks. It was imported from India by Messrs John Quin & Co. of Limerick, aboard the first steamer to bring a direct tea shipment to the city since 1939. In the edition of Wednesday, 17 September 1958, the *Leader* reported that the long-established Quin firm brought its first shipment of tea to Limerick 'over 136 years ago', thus around 1822. *LL191*

1972 Fishermen at Clancy Strand on the River Shannon. *LL191B*

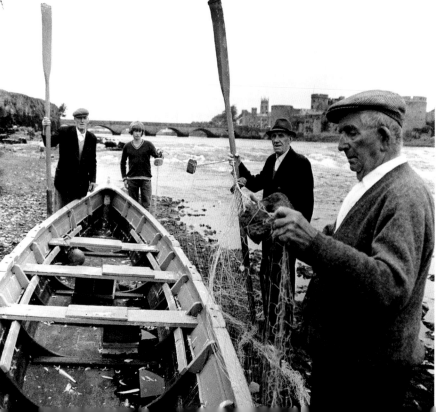

***Following pages:* 1955** *Irish Pine* ship at Limerick Docks. *LL192*

191

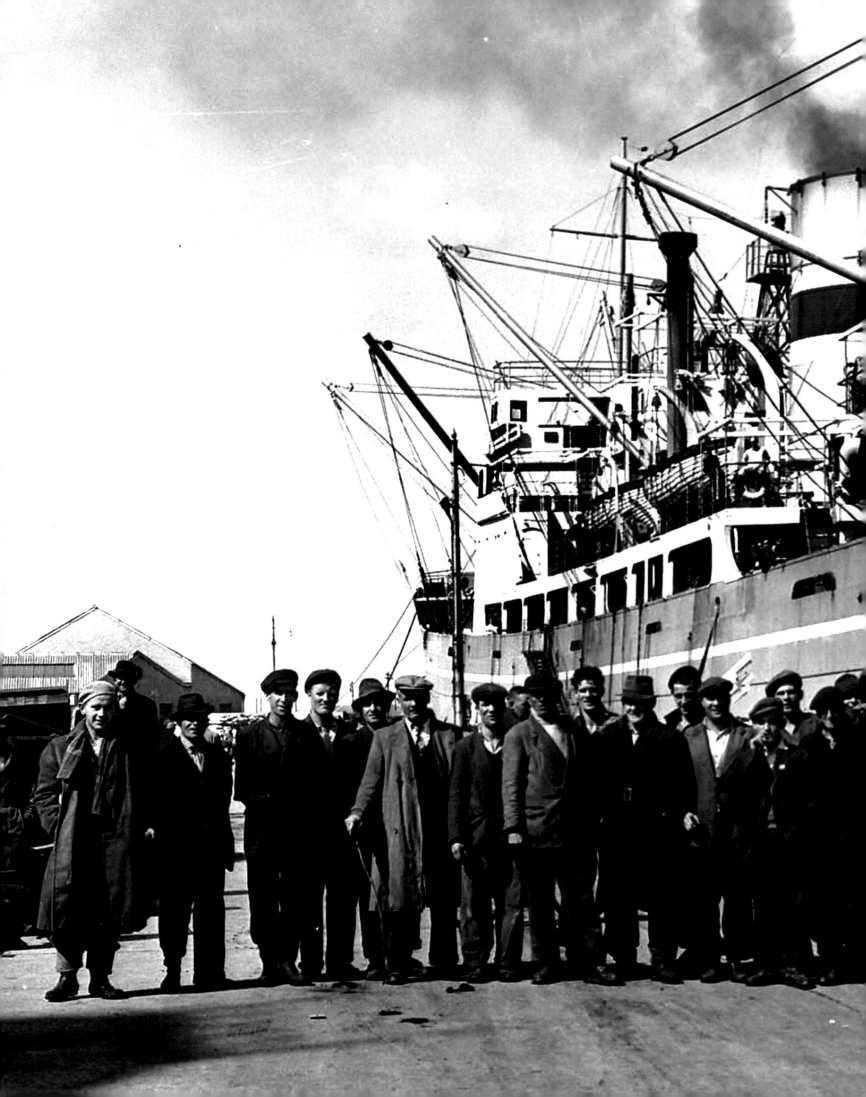

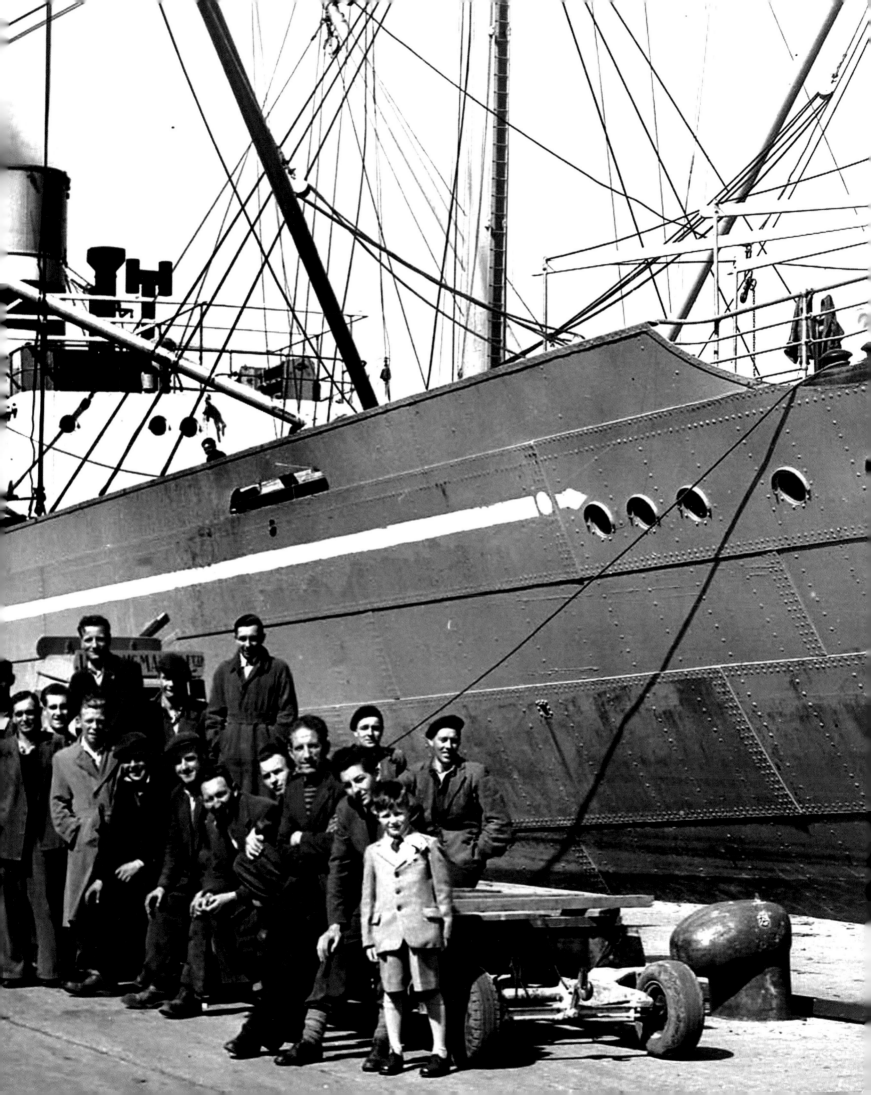

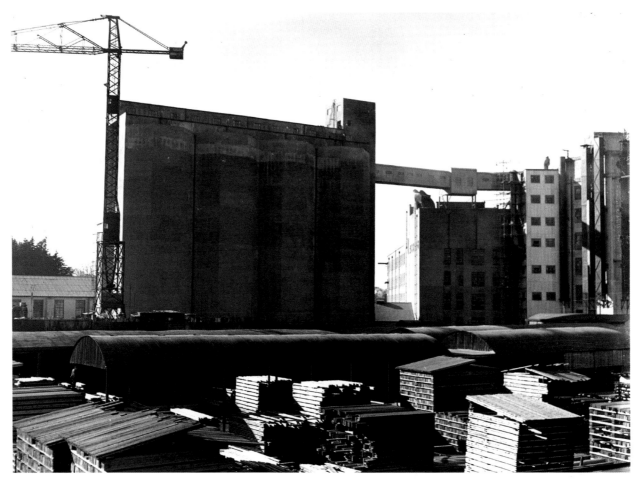

1954 Construction of the Ranks grain silo at Limerick Docks nears completion on 6 November 1954. *LL194*

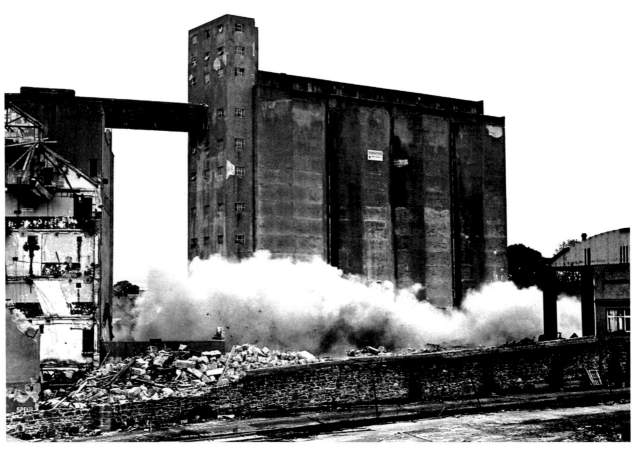

1989 The strong foundations of the Ranks grain silo at Limerick Docks survived this demolition attempt. *LL194B*

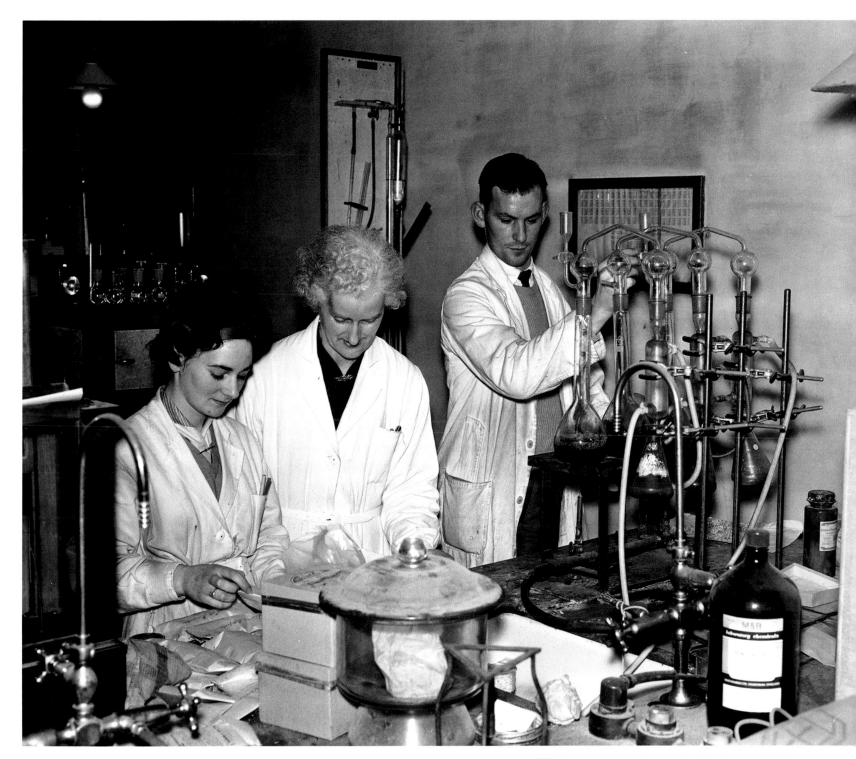

1961 Laboratory staff at work in Ranks Ltd. *LL195*

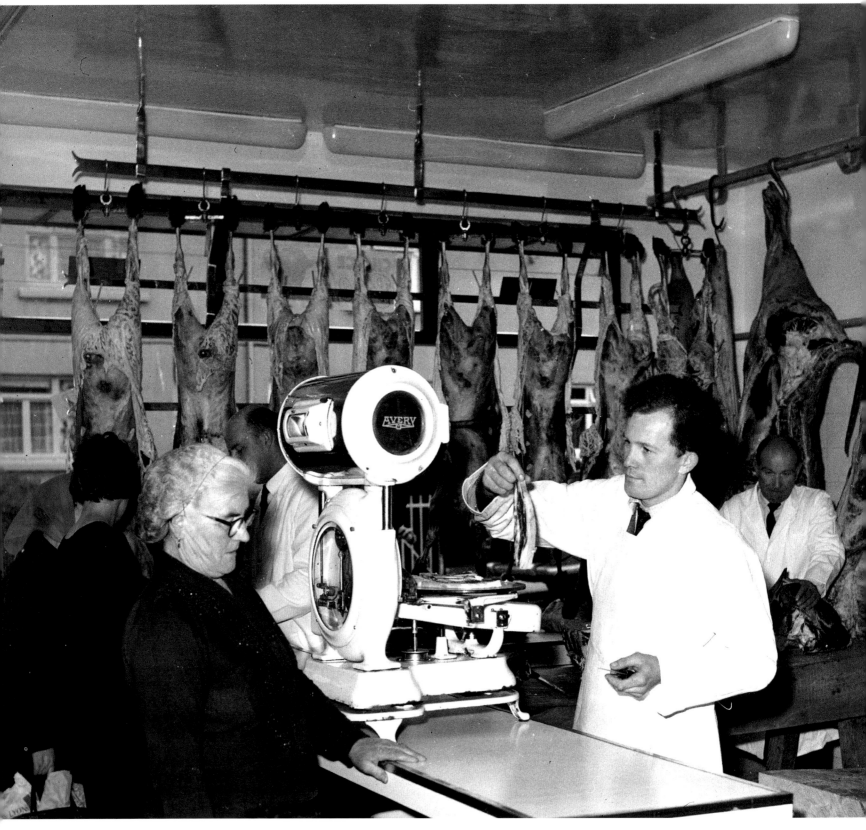

1965 Scene from Joyce Victuallers as another satisfied customer waits for the next dinnertime offering. *LL196*

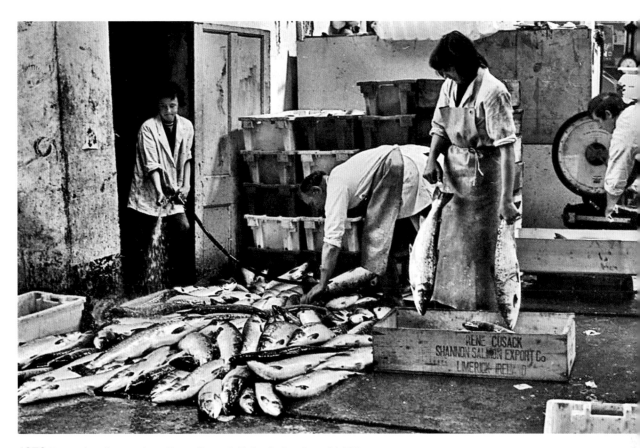

1973 Preparing the catch at Rene Cusack Fish wholesalers. *LL197*

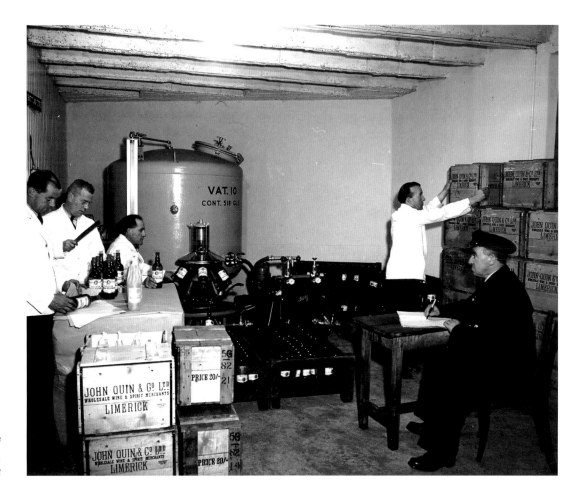

1959 Bottling wine at Quin's Wine
& Spirits Market, Ellen Street.
LL197B

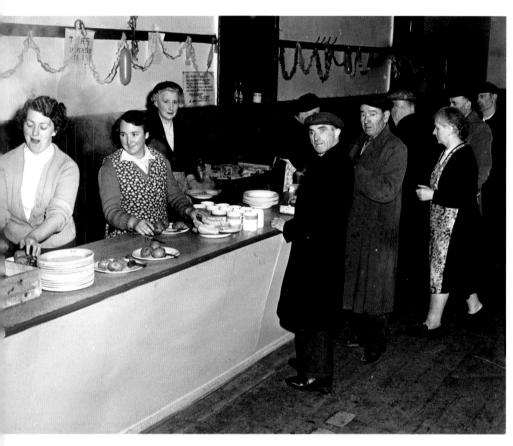

1954 Distribution of penny dinners in the city. *LL198*

1963 The staff at Kakes and Kandies,
O'Connell Street, with their tempting treats.
LL199

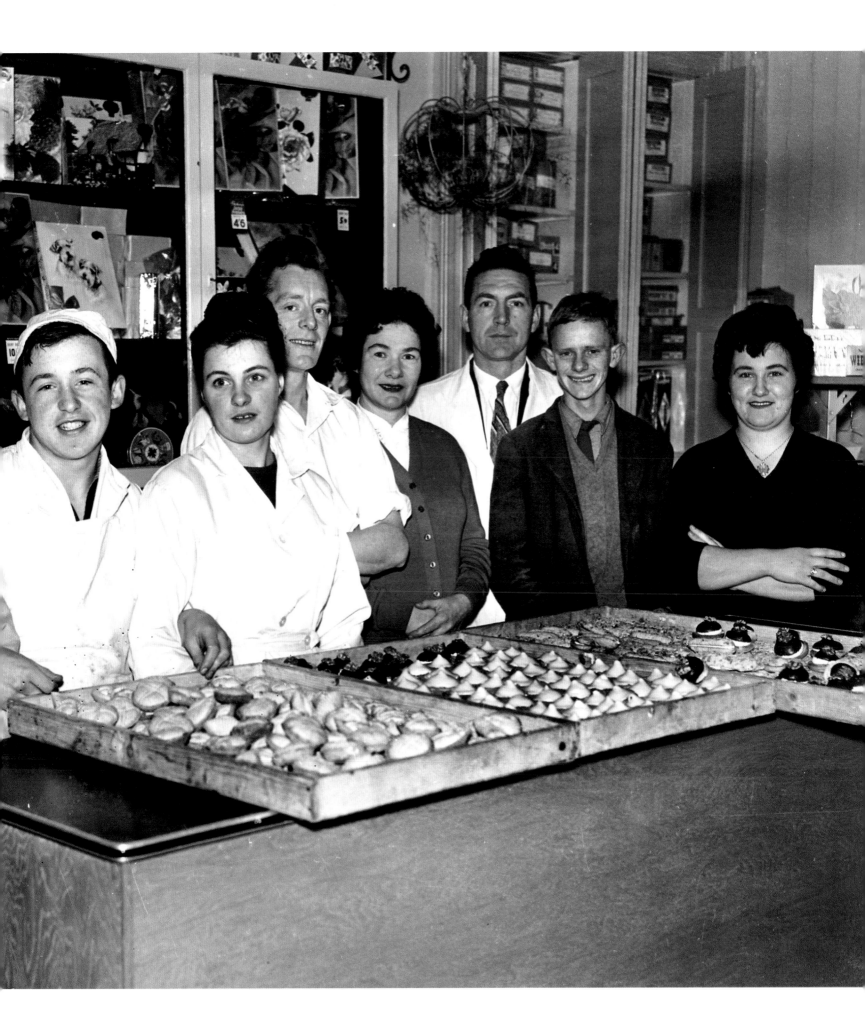

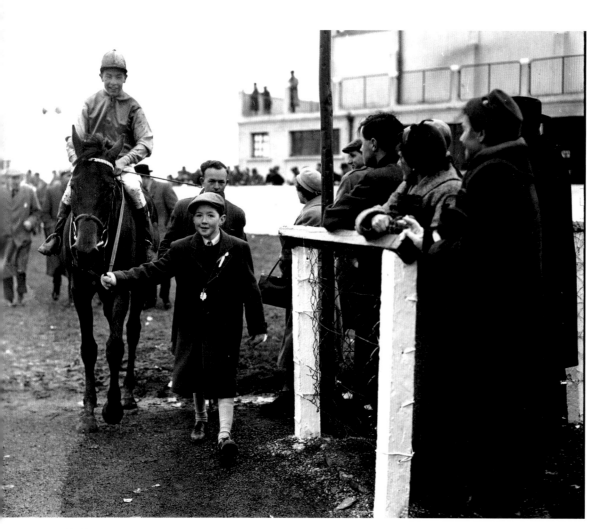

1958 St Patrick's Day Races at Greenpark. *LL200*

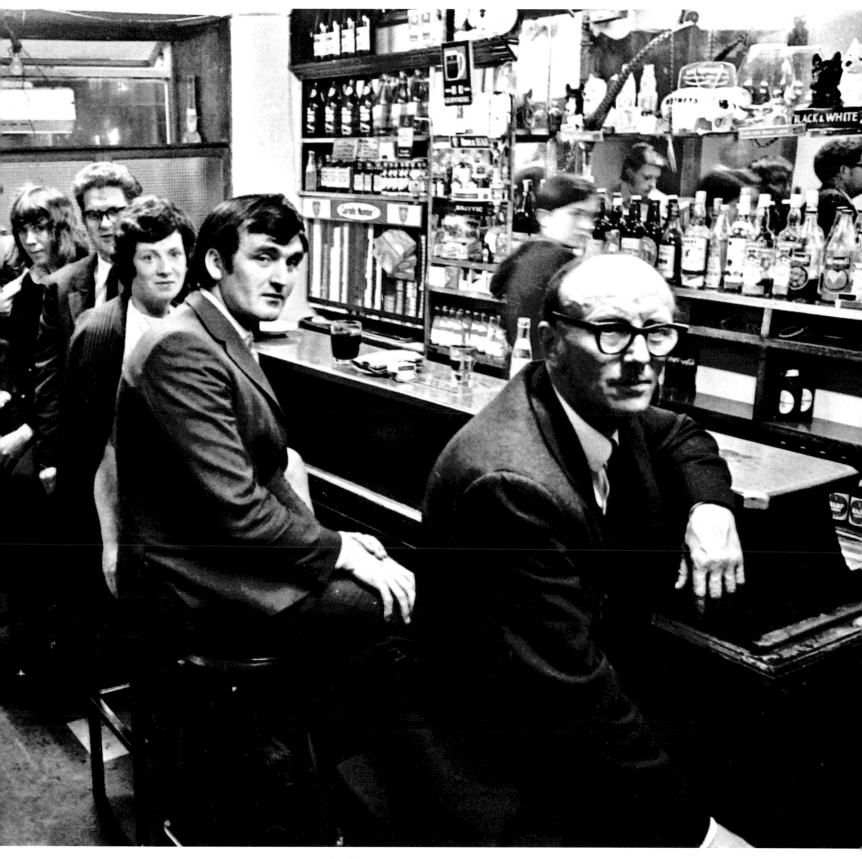

1973 Customers in Doon during the week of the All-Ireland Senior Hurling final. They looked a bit nervous but needn't have worried – Limerick famously beat Kilkenny. *LL201*

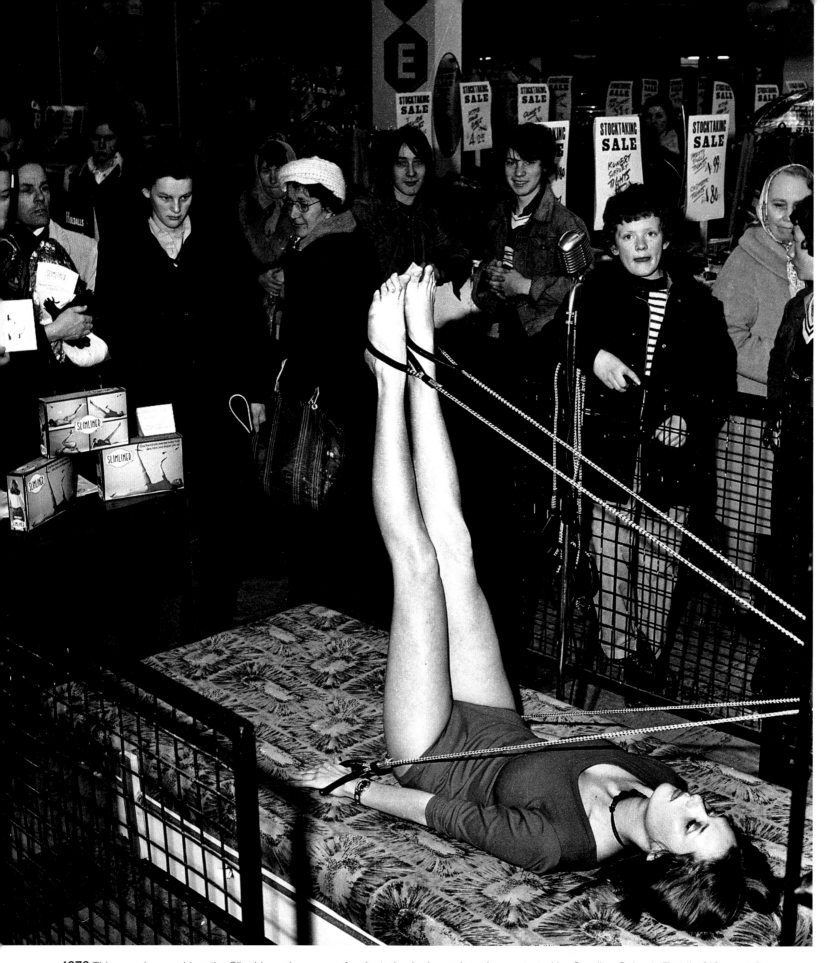

1976 This exercise machine, the Slim Liner, drew some fascinated onlookers when demonstrated by Caroline Going in Todd's O'Connell Street.
LL202

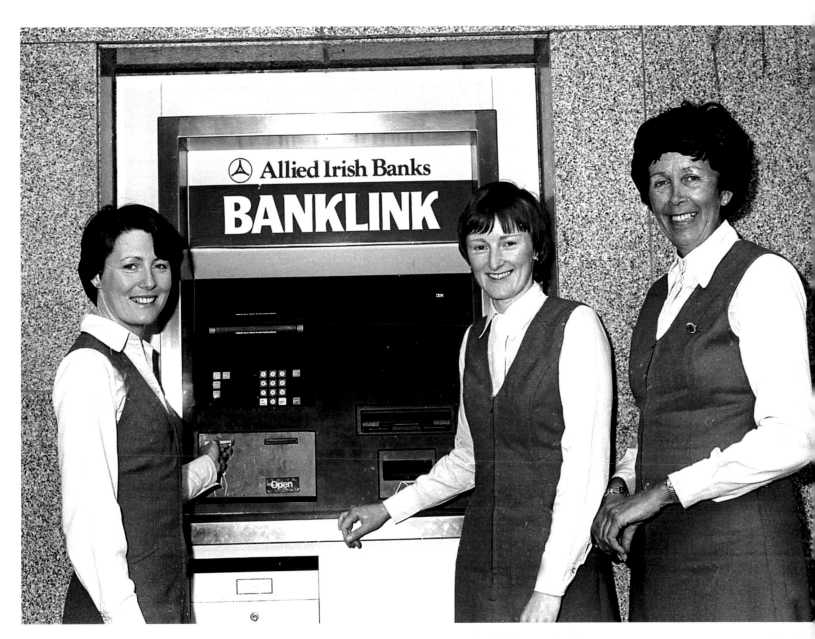

1981 Demonstrating Limerick's first ATM at AIB: (l–r) Eithne Ryan, Mary Shanahan and Evelyn Moriarty. *LL203*

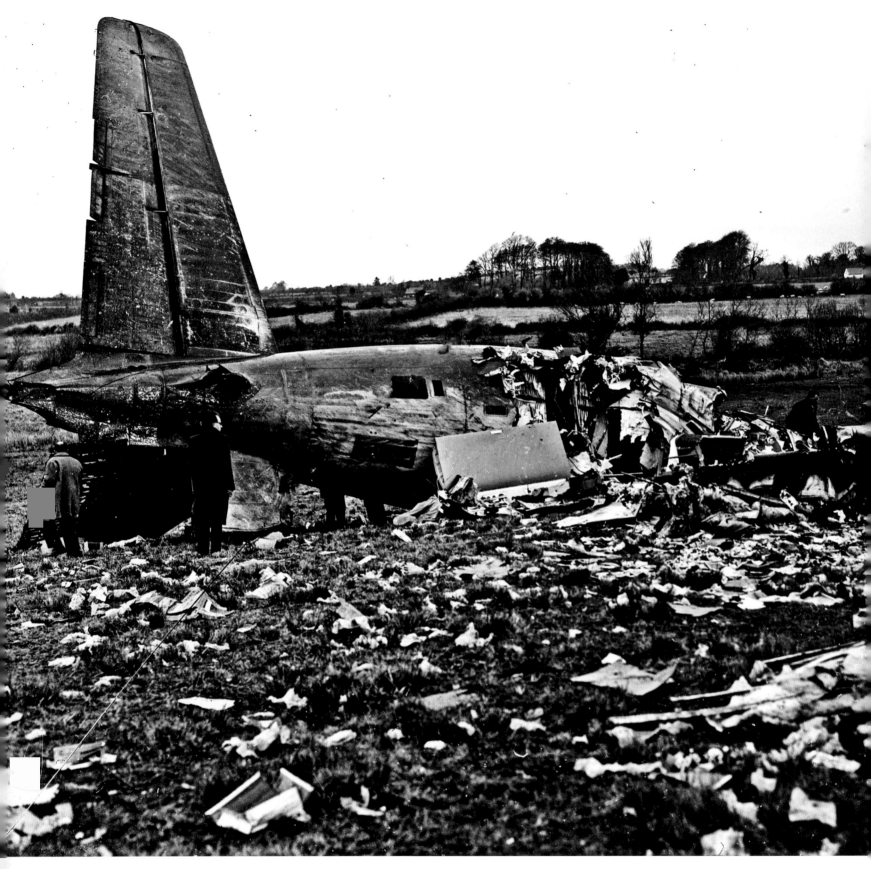

1963 The scene of an air crash near Shannon Airport. *LL204*

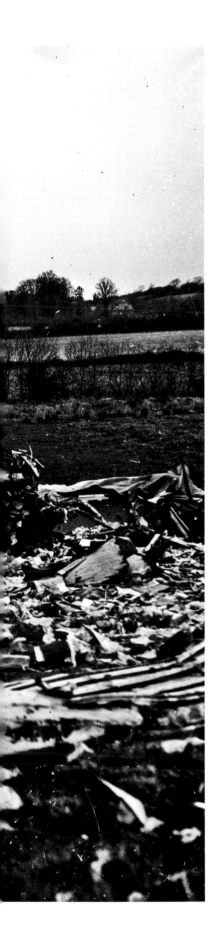

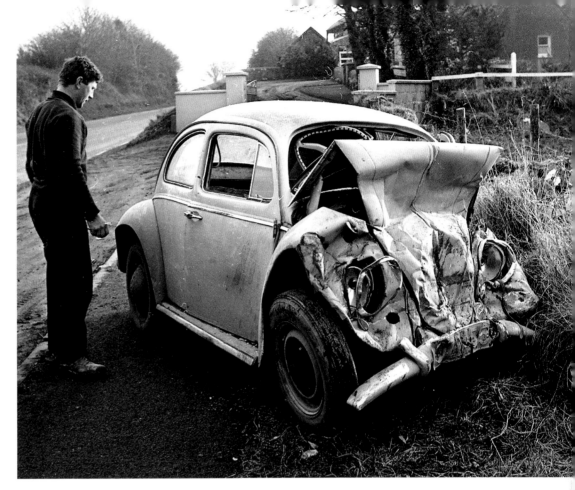

1971 A mechanic looks forlornly at a damaged VW Beetle, at Hurler's Cross. *LL205*

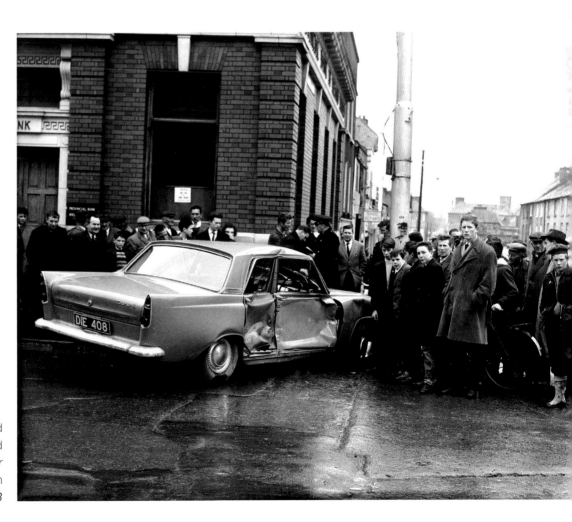

1964 Passers-by pose with a crashed vehicle on junction of William Street and Lower Gerald Griffin Street. The *Leader* was usually at the scene quickly when such incidents occurred. *LL205B*

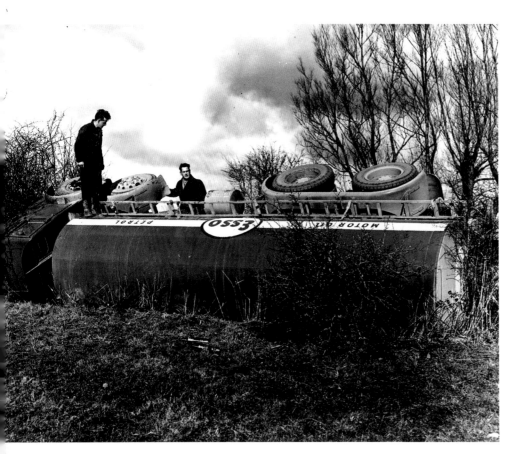

1955 An overturned Esso lorry on the main Ennis/Limerick road near Bunratty. *LL206*

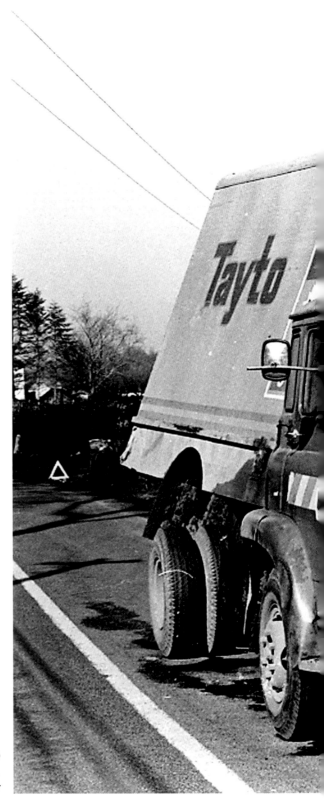

1975 This Tayto lorry crashed on a crisp morning near the Ferenka plant, Annacotty. *LL207*

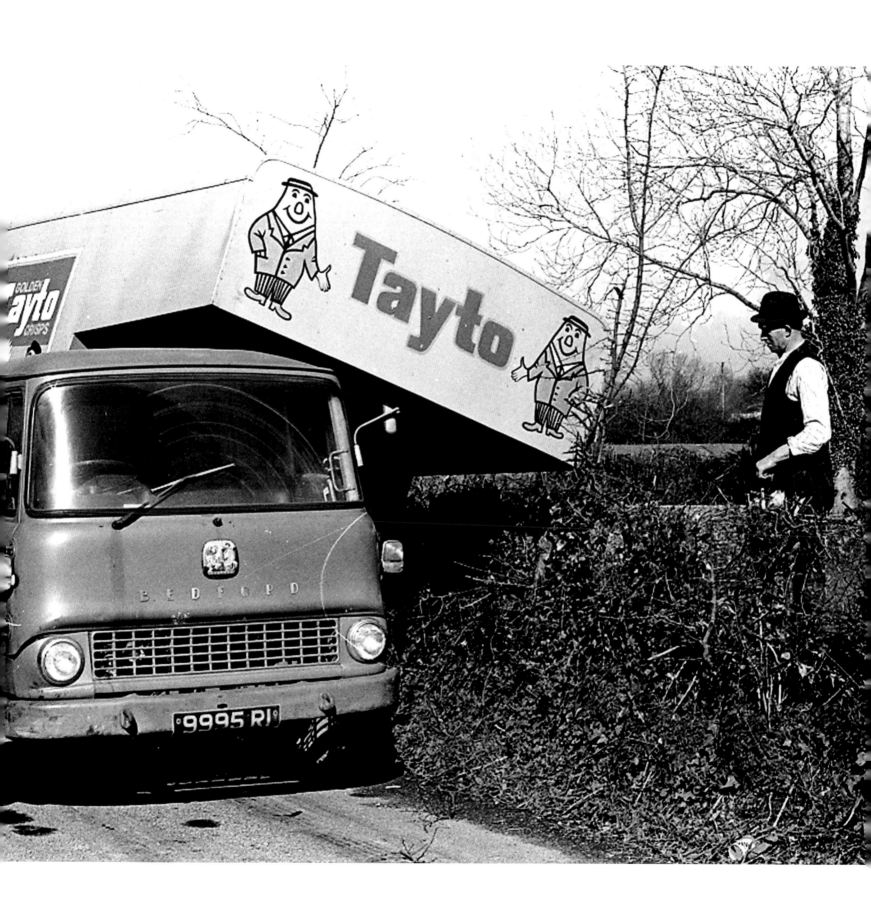

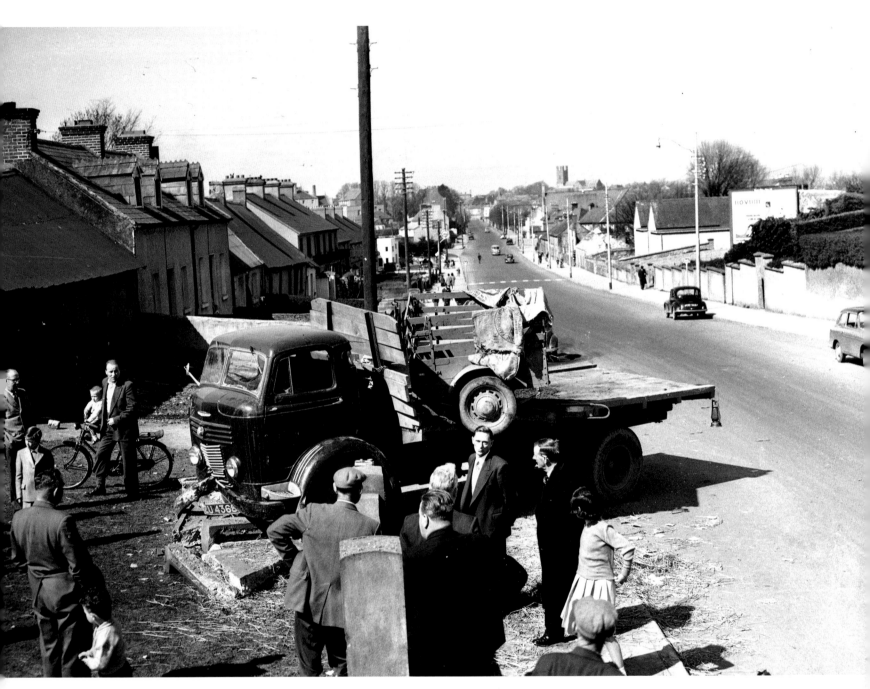

1960 The scene after a lorry lost control and collided with wall on the Dublin Road. *LL208*

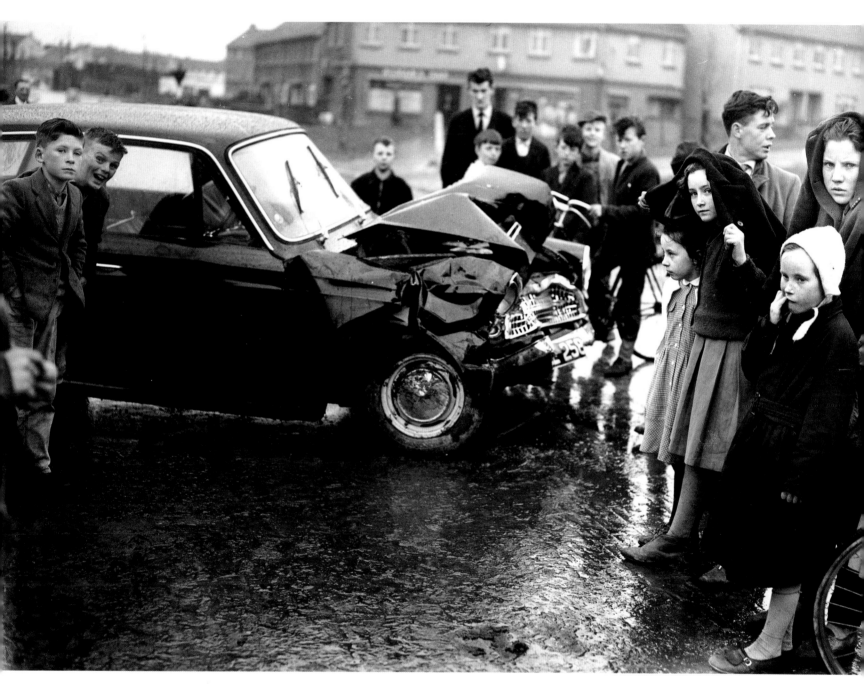

1966 Children inspect the crash damage at the junction of Hyde Road and Carey's Road. *LL209*

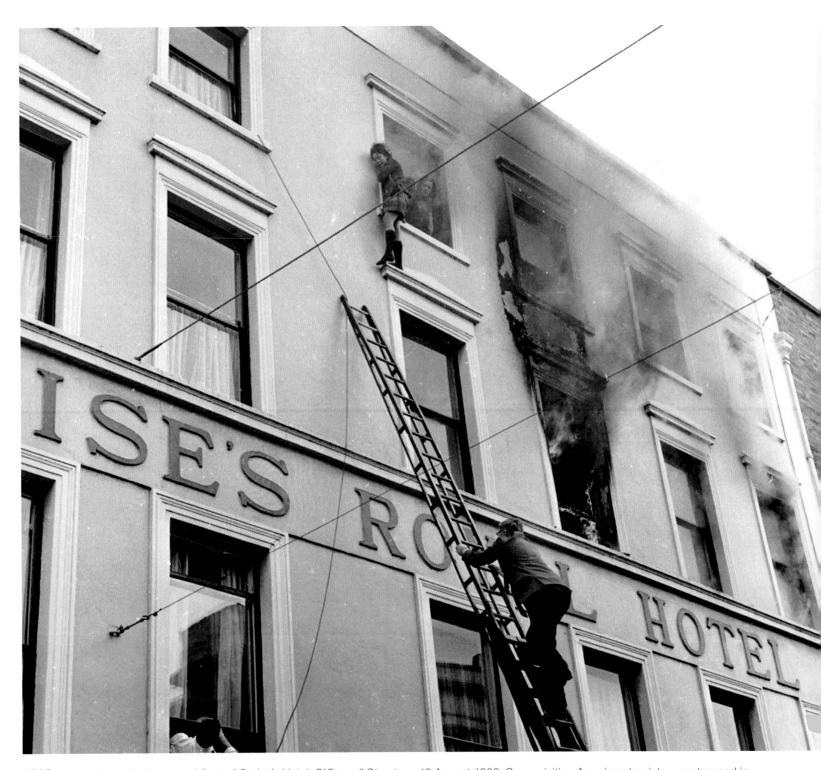

1968 Fire rips through the second floor of Cruise's Hotel, O'Connell Street, on 16 August 1968. Some visiting American tourists were trapped in their rooms, but thankfully escaped. In this dramatic picture by John F. Wright, local man Tom Roche mounts a ladder and goes to the rescue.
LL210

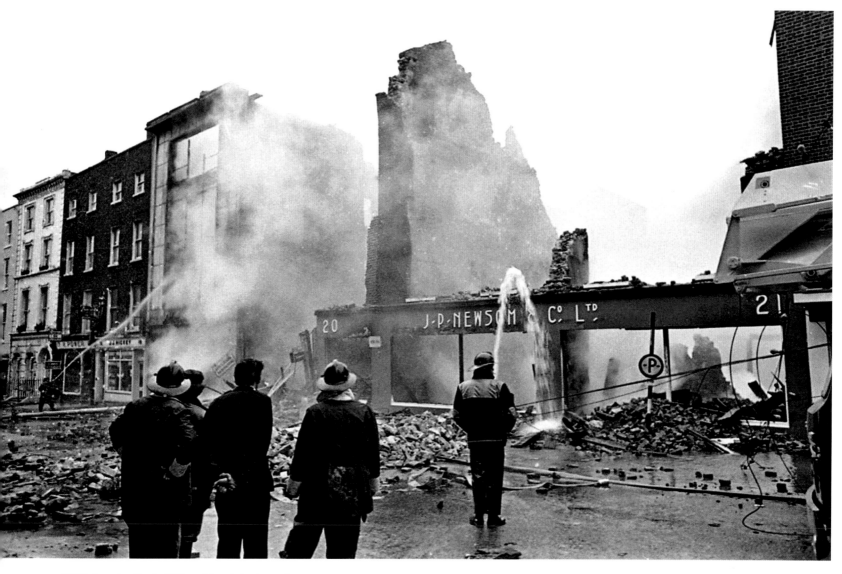

1974 A major fire in William Street destroyed Newsom's and McCarthy's on 9 December 1974. *LL211*

1963 A felled tree is cut for firewood at the People's Park, Pery Square, during a freezing winter. *LL211B*

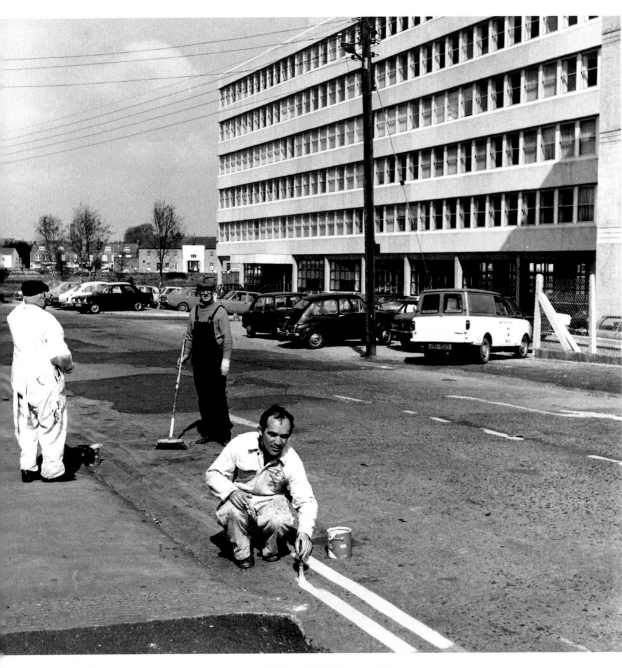

1976 Painting double yellow lines outside Sarsfield House. *LL212*

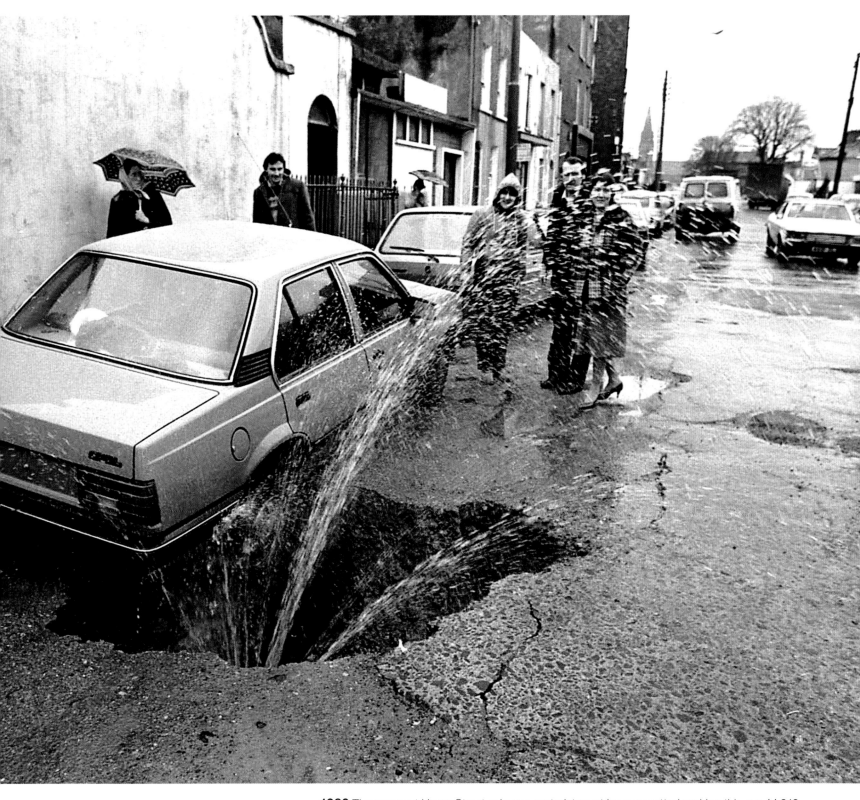

1982 The scene at Henry Street, where a motorist must have regretted parking this car. *LL213*

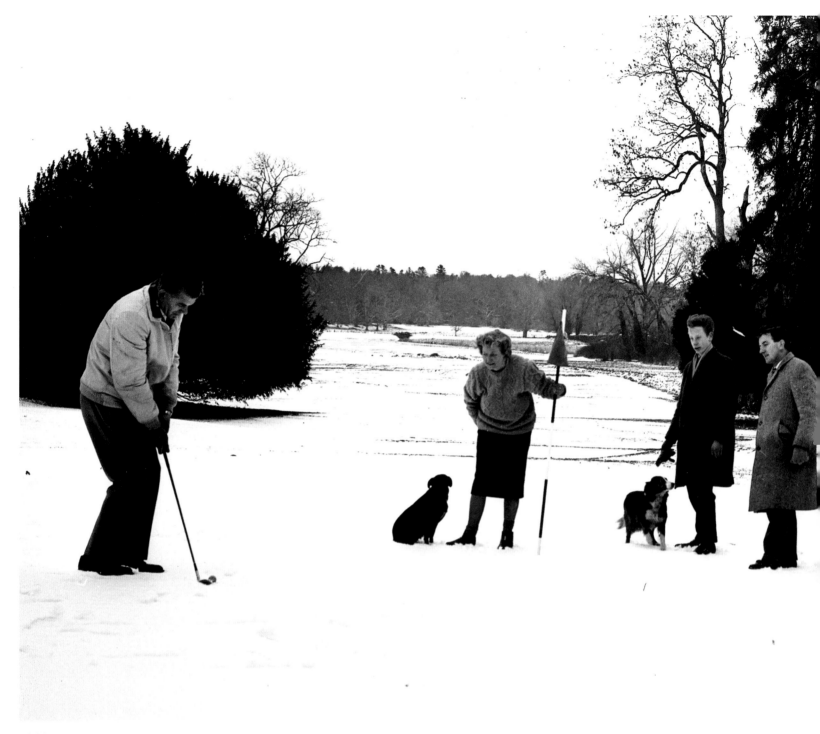

1963 All white on the green: the scene at Adare Manor Golf Club, where these keen members didn't let a bit of snow bother them. *LL214*

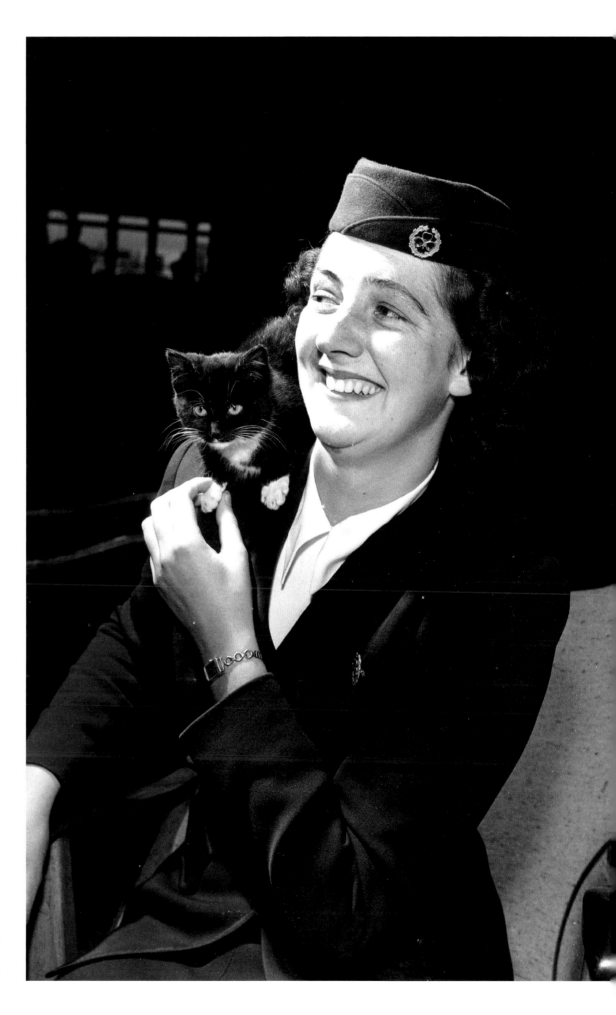

1954 Aer Lingus air hostess
Ms Neville and her feline friend.
LL215

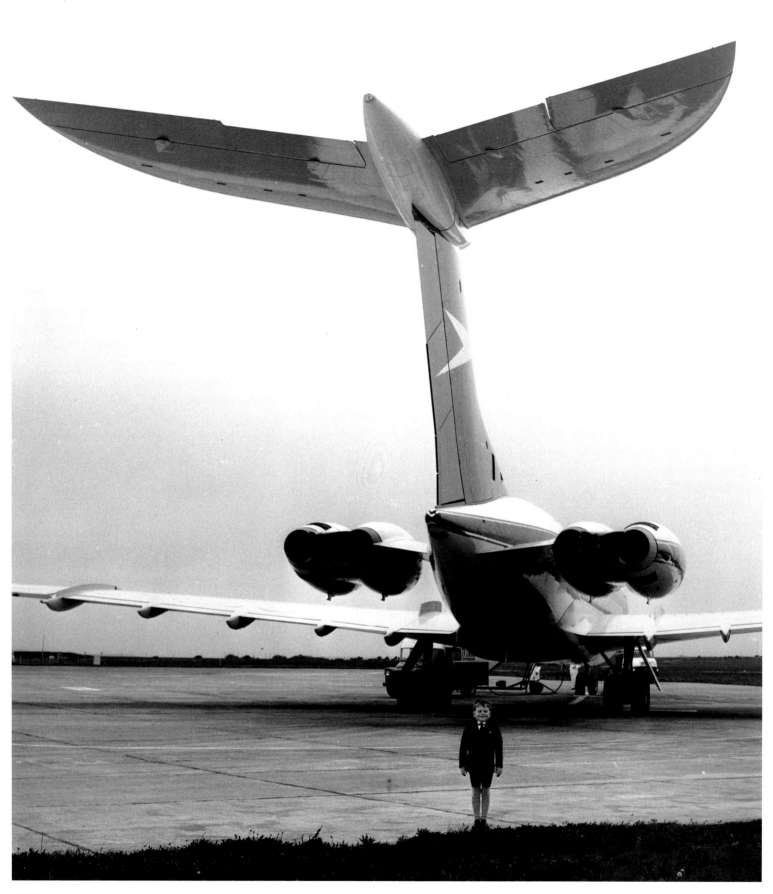

1964 A British-made VC10 on the runway at Shannon Airport, much to the excitement of this youngster. *LL216*

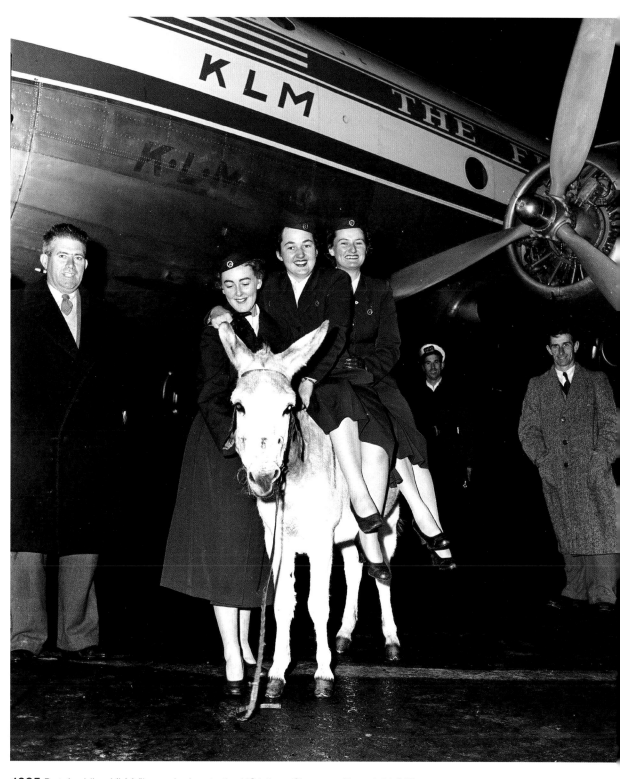

1985 Dutch airline KLM flies a donkey to the USA from Shannon Airport. *LL217*

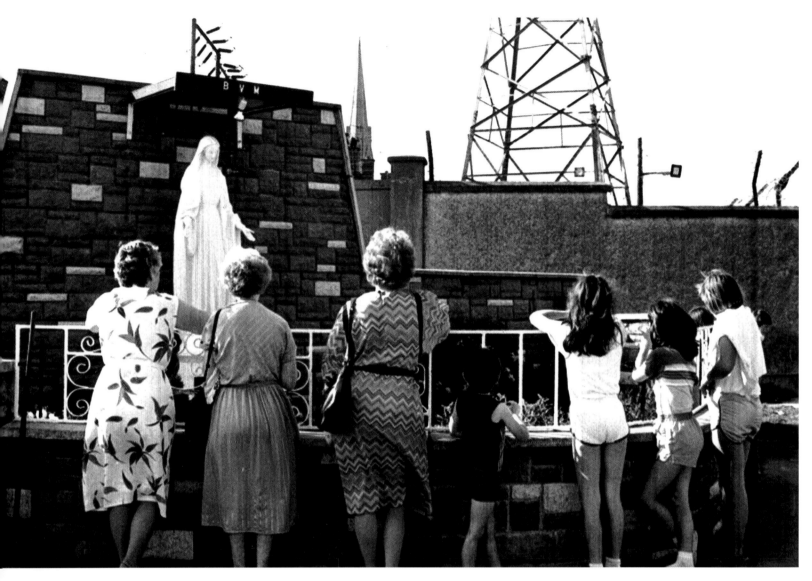

1985 Waiting for a miracle? It was the summer of the moving statues and these onlookers were hoping to see something happen in Garryowen. *LL218*

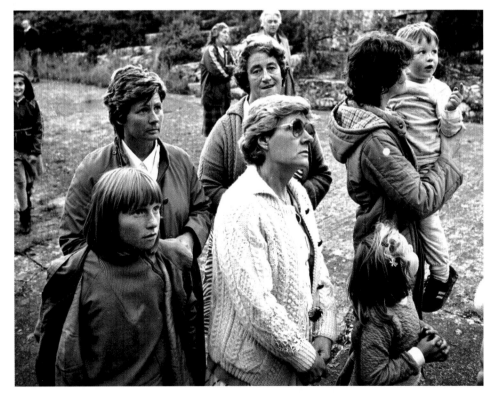

1985 A crowd waits to see a statue move in Cratloe. *LL218B*

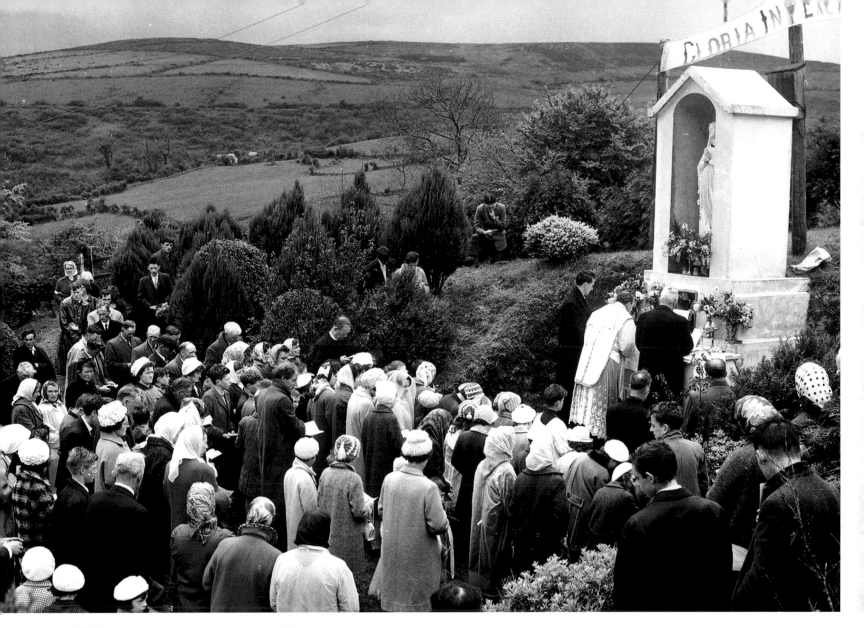

1965 An open air Mass on the mountainside at Ballyine, Carrigkerry. Around 200 parishioners were in attendance at the Marian shrine, before Rev M. O'Connor CC, Ardagh. *LL219*

1970 Mission at the Redemptorist Church, Mount St Alphonsus, South Circular Road. *LL219B*

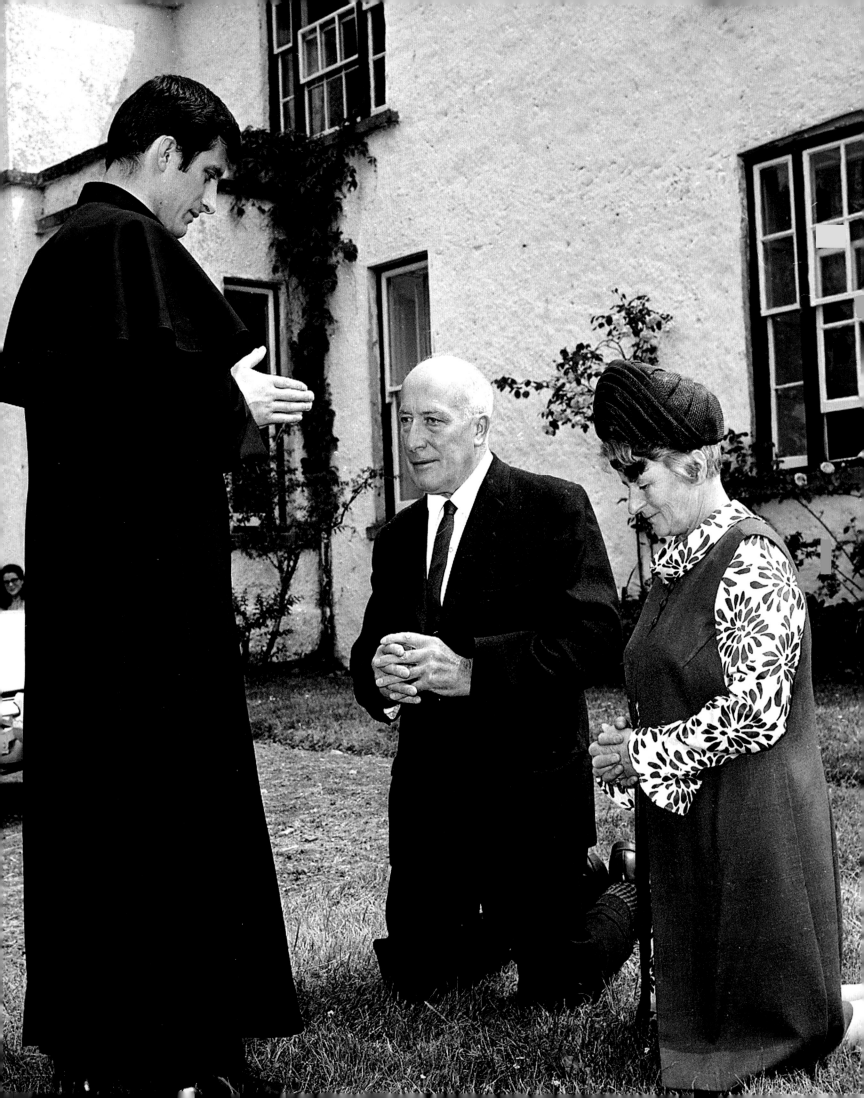

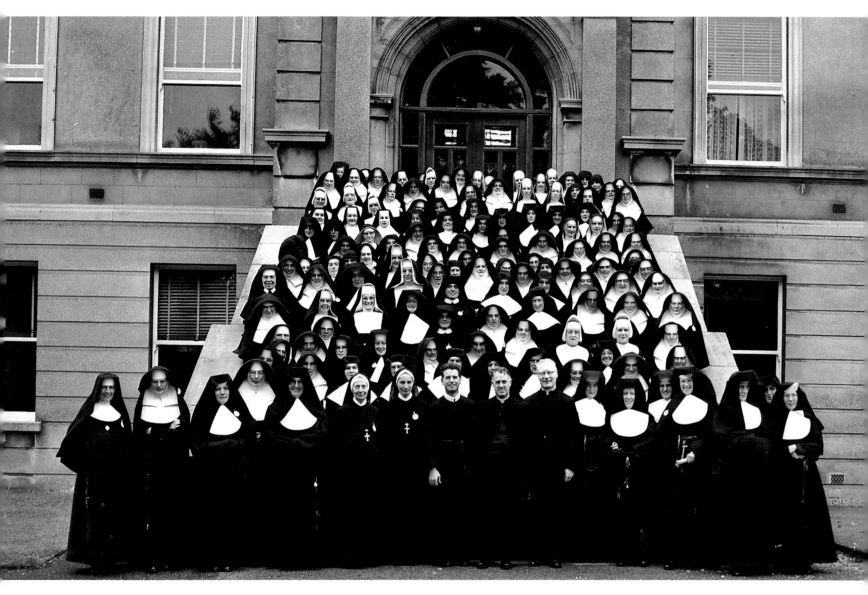

1962 Nuns in impressive numbers at Mary Immaculate College, South Circular Road. *LL221*

1970 Fr Edward Condra bestowing his first blessing on his parents,
Mr & Mrs T. J. Condra of Cahirnarry Glebe, County Limerick. *LL220*

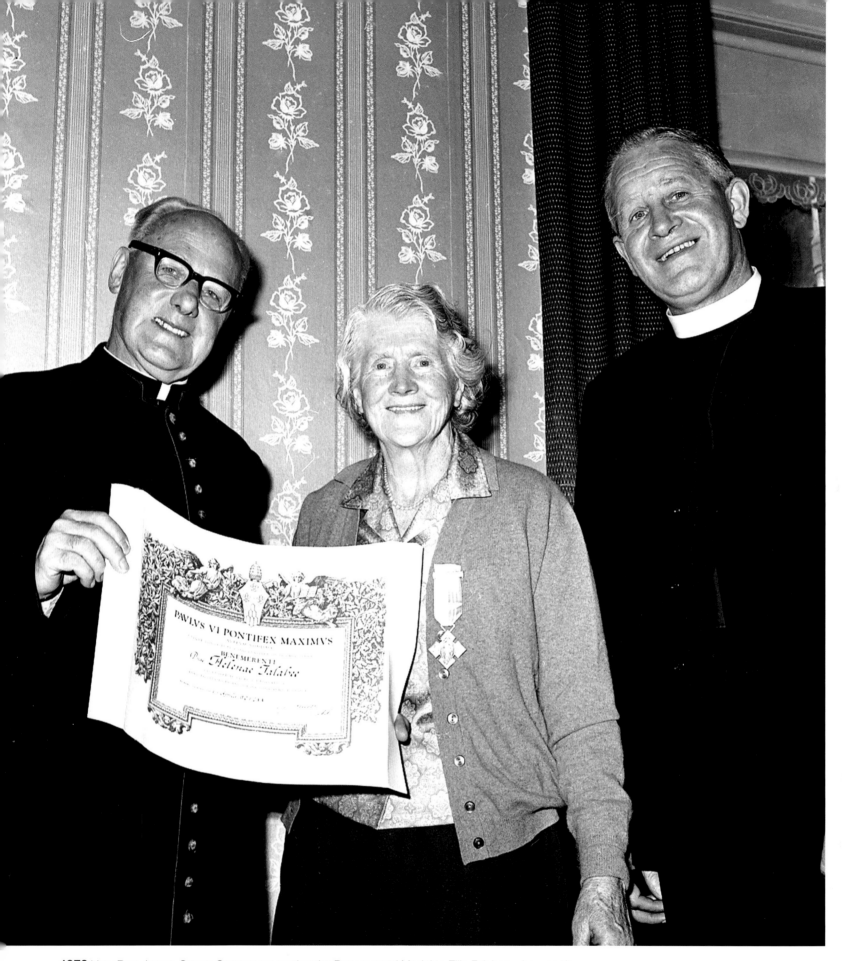

1970 Very Rev. James Canon Cowper presenting the Benemerenti Medal to Ellie Falahee who was the priests' housekeeper in Kilmallock for over 50 years. Also pictured is Rev. Eamonn Houlihan, CC. *LL222*

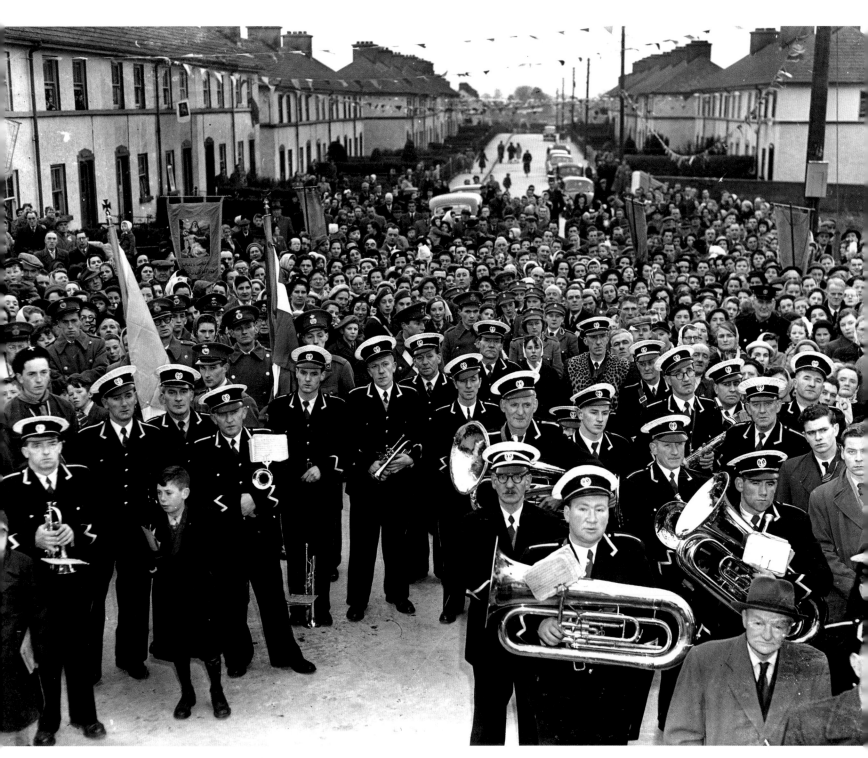

1954 It was Marian Year in Limerick and this picture was taken on New Year's Eve at the Fairgreen in the city. The St John's Brass and Reed Band were out in force to celebrate the erection of a Marian shrine. *LL223*

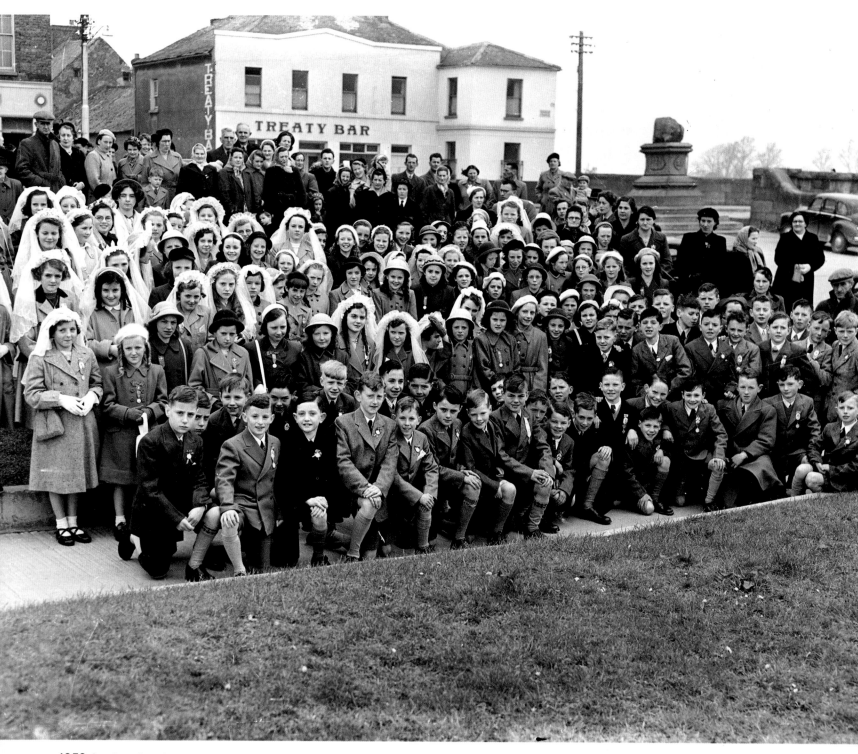

1959 Confirmation classes gather for their picture outside St Munchin's church. *LL224*

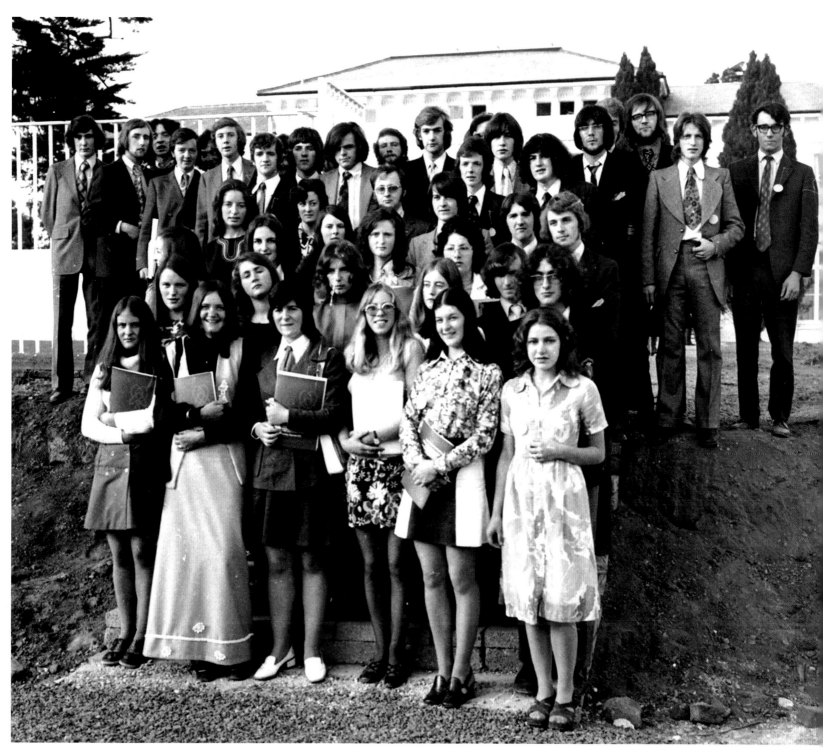

1972 Pioneers in education: the first students of the National Institute of Higher Education, Limerick, later University of Limerick. *LL225*

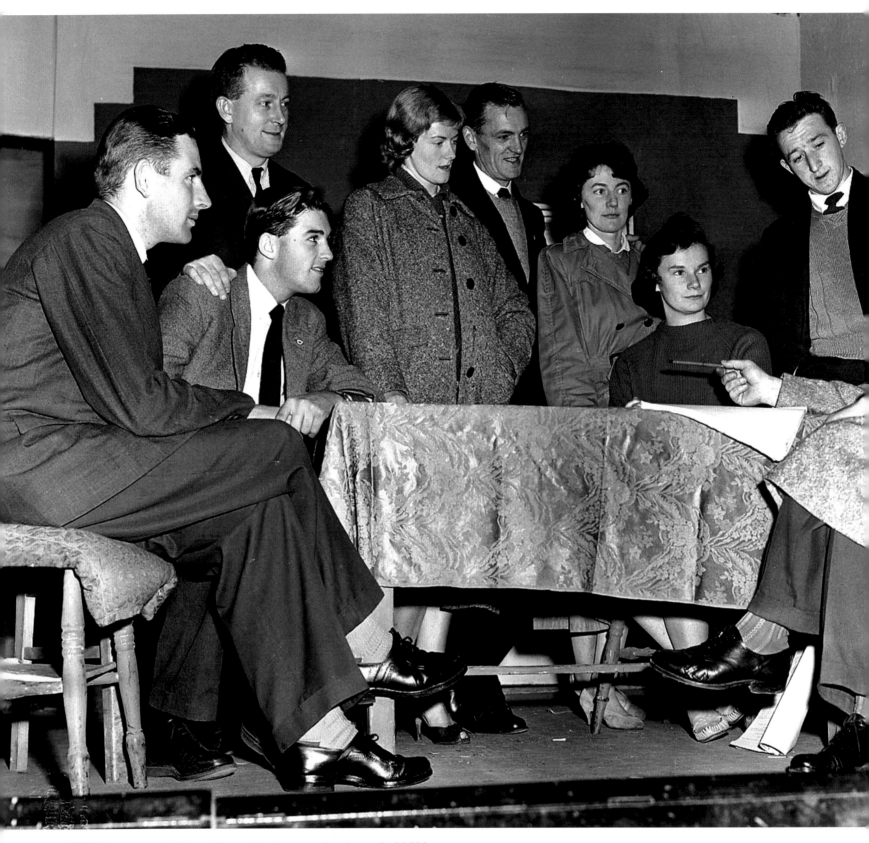

1964 The renowned College Players theatre group in rehearsals. *LL226*

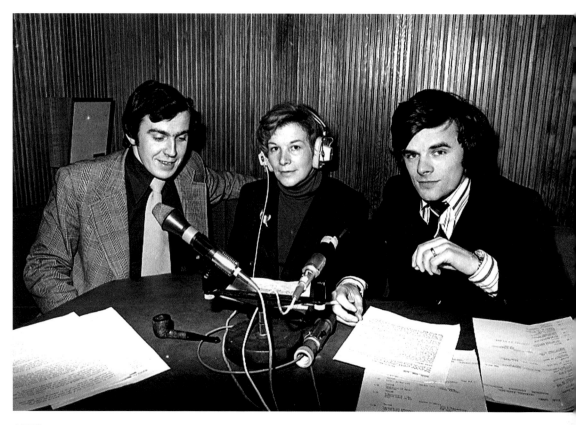

1976 Radio Luimní first broadcast from the attic of the old City Theatre building in March 1976. Mayor of Limerick Thady Coughlan (left) is seen here with future broadcasting star Michael McNamara (aka 'Mickey Mac') and Eileen Egan. *LL227*

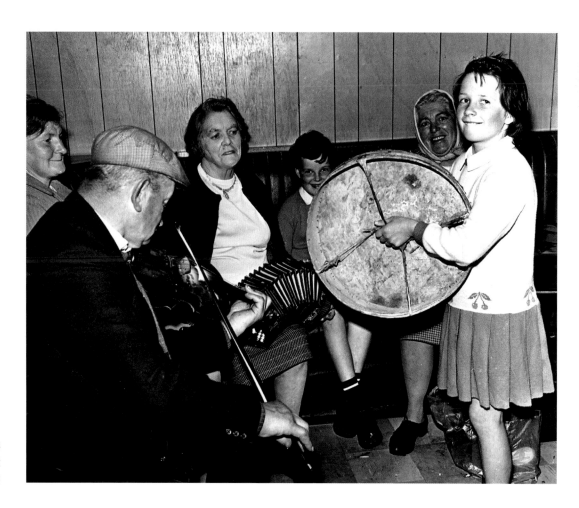

1971 Three generations of the Collins family play traditional music together at the Palace Inn, Abbeyfeale. *LL227B*

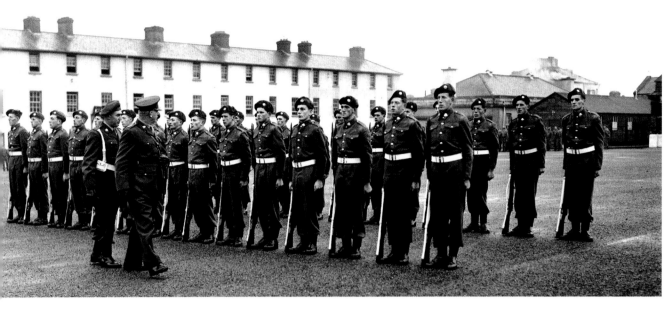

1965 Inspection at Sarsfield Barracks, Lord Edward Street. *LL228*

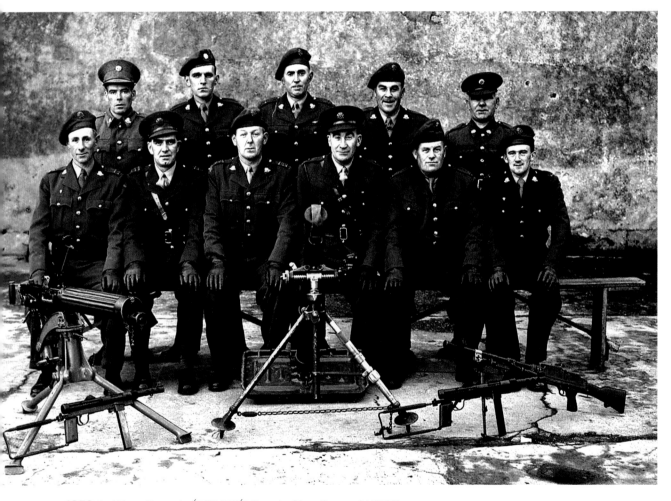

1959 An Fórsa Cosanta Áitiúil (FCÁ) County Clare Group. *LL228B*

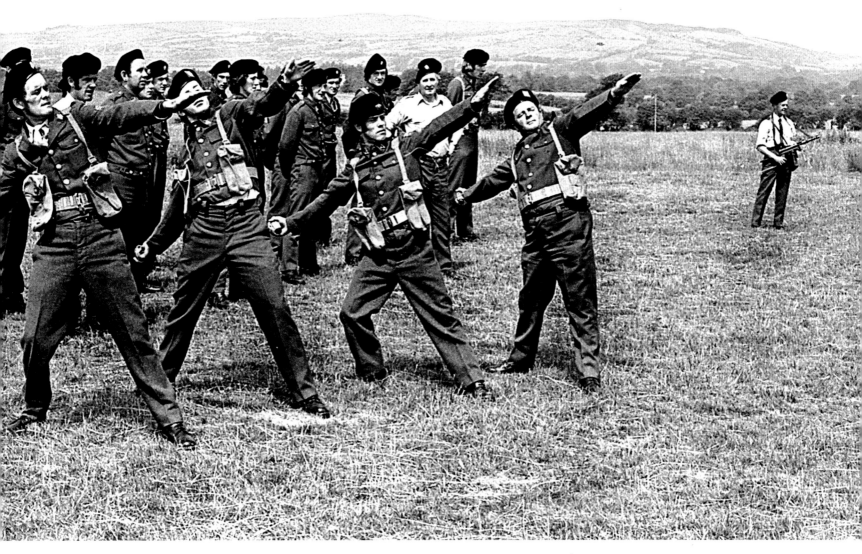

1975 Members of the FCÁ Limerick in training at Knockalisheen. *LL229*

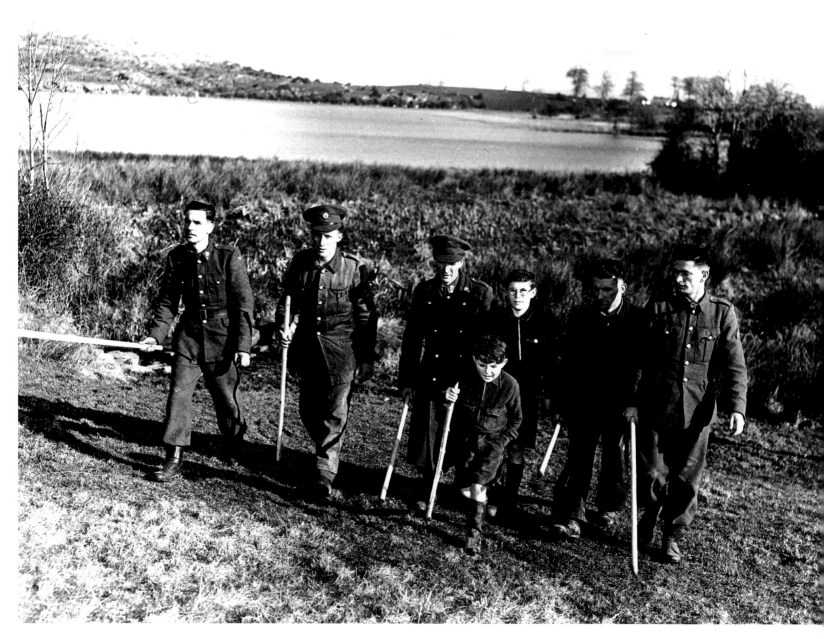

1955 Army members and a more youthful assistant search for a missing child near Killone Abbey, on 18 February 1955. *LL230*

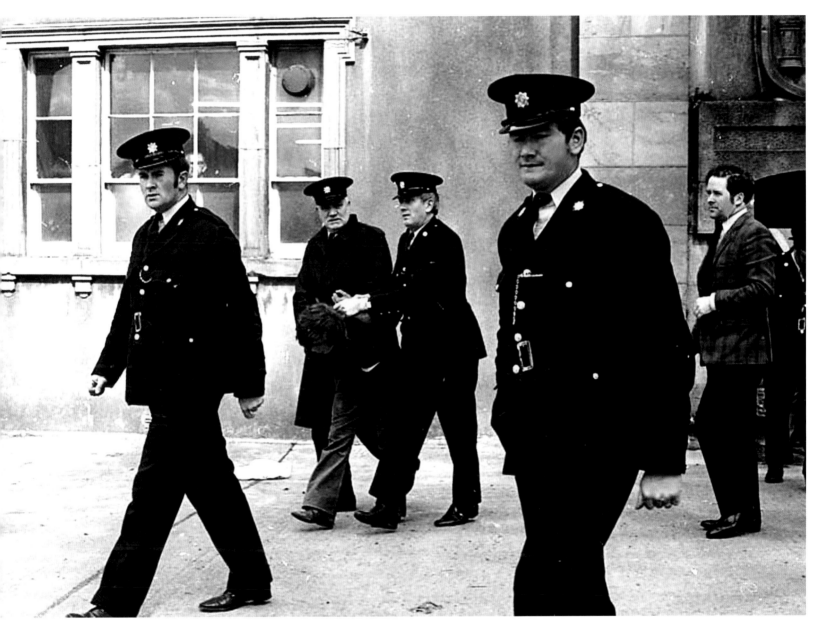

1972 Six prisoners were apprehended shorty after their escape: four in the attic of the nearby disused old City Jail, one in the grounds of Geary's Sweet Factory and one at George's Quay. These photographs were taken for the *Leader* by A.F. ("Foncie") Foley and first published on 13 May 1972. *LL231*

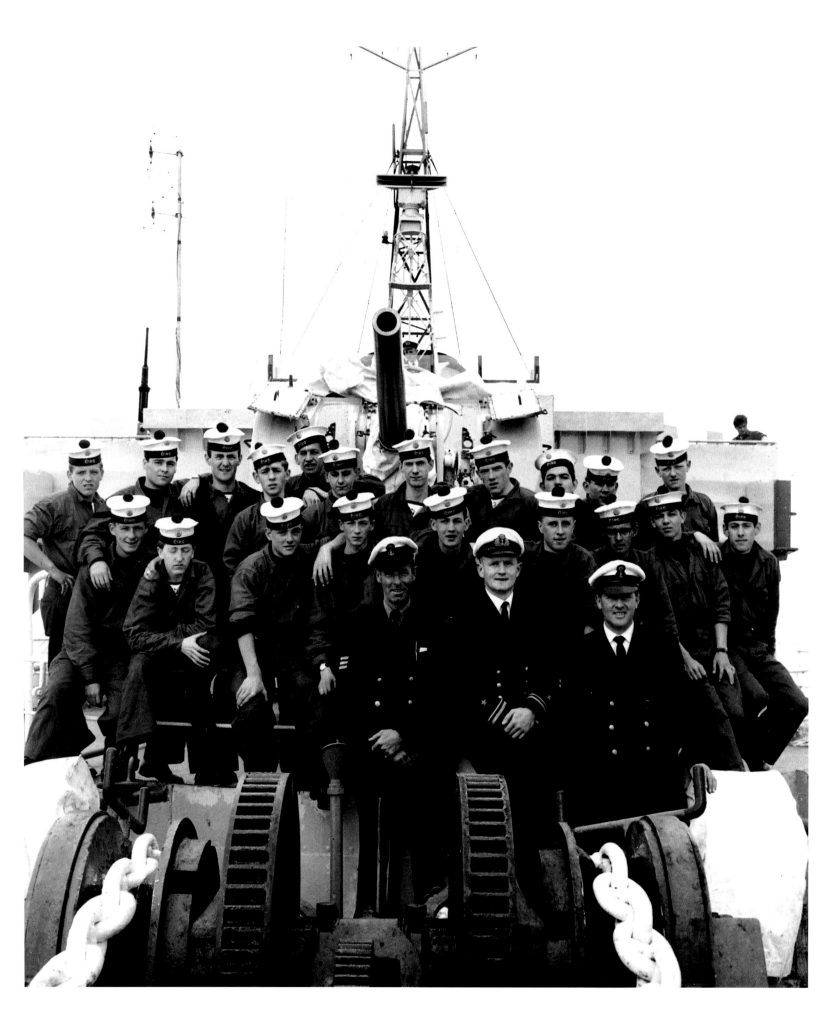

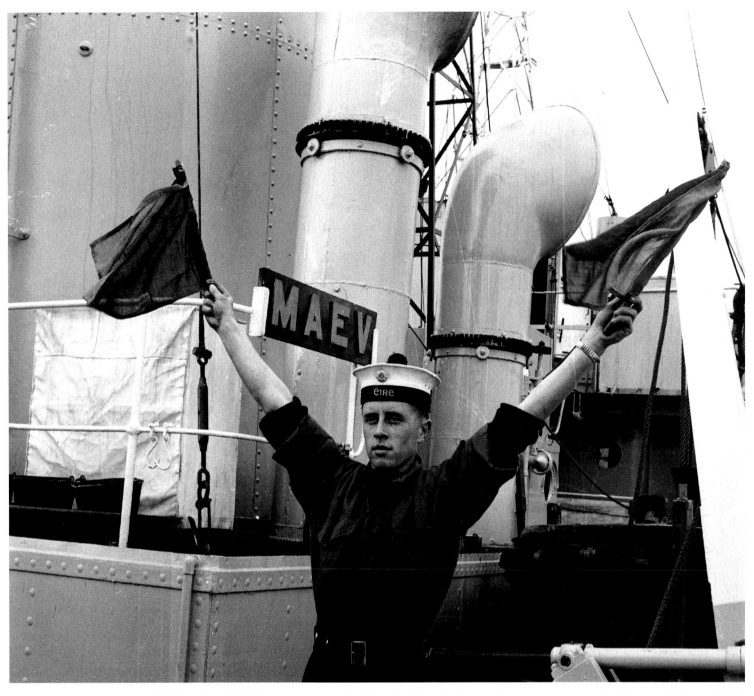

1964 An Slua Muirí (the forerunner of the Irish Naval Service Reserve) on manoeuvres at the Shannon Estuary. *LL233*

1964 An Slua Muirí members photographed
on a July day half a century ago. *LL232*

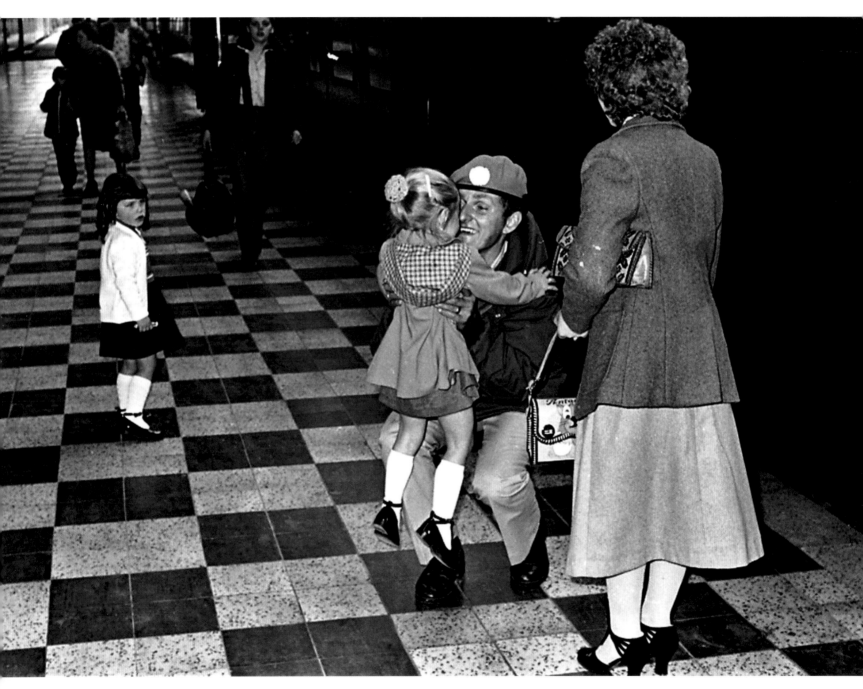

1979 Limerick troops home from the Lebanon arrive at Colbert Station. One little girl is thrilled to see her daddy, while another has to wait. *LL234*

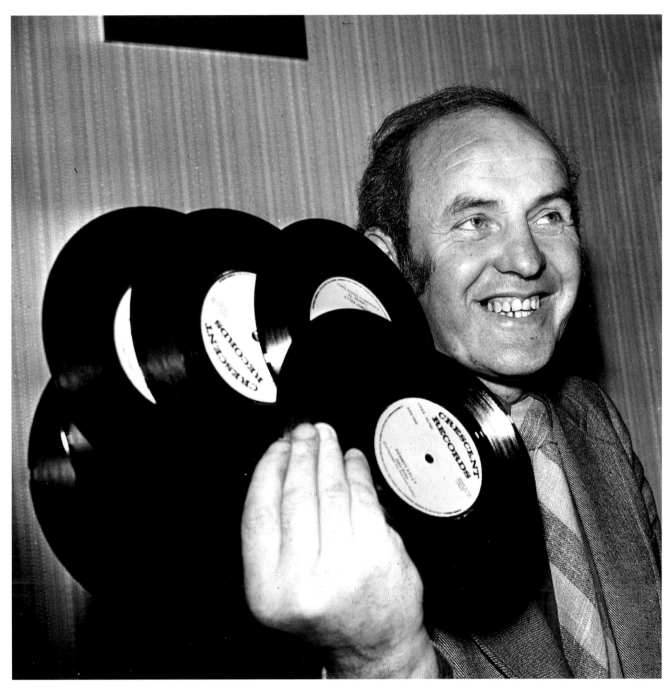

1975 Dermot Kelly, a bank official at the Roxboro Shopping Centre, with copies of his new record 'Limerick '73', a tribute to the All-Ireland winning hurlers released almost two years after their triumph. Dermot, a former hurler himself, launched the single at the Beamish & Crawford depot in Galvone. 'I think it will inspire this year's hurlers to another memorable victory at Croke Park,' he told the *Leader* – a little optimistically, as it proved. *LL235*

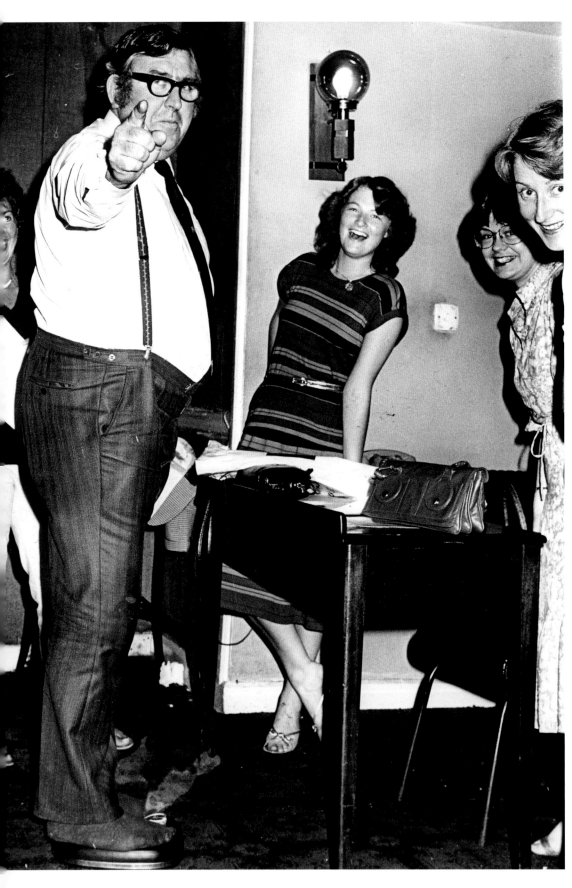

1982 The legendary Limerick politician Jim Kemmy makes a friendly point to the *Leader* photographer who captured this fine shot of him weighing in for a charity slim-in. *LL236*

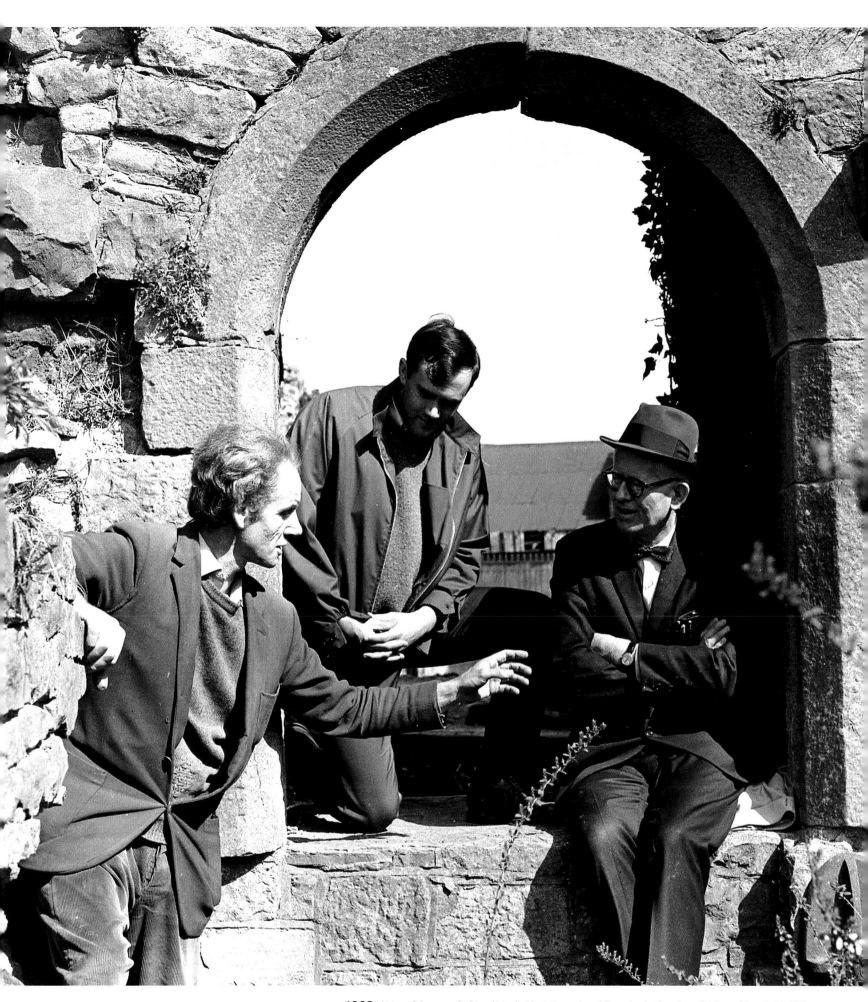

1969 Writer Séamus O Cinnéide (left) at the ruin of Fanning's Castle, off Mary Street. *LL237*

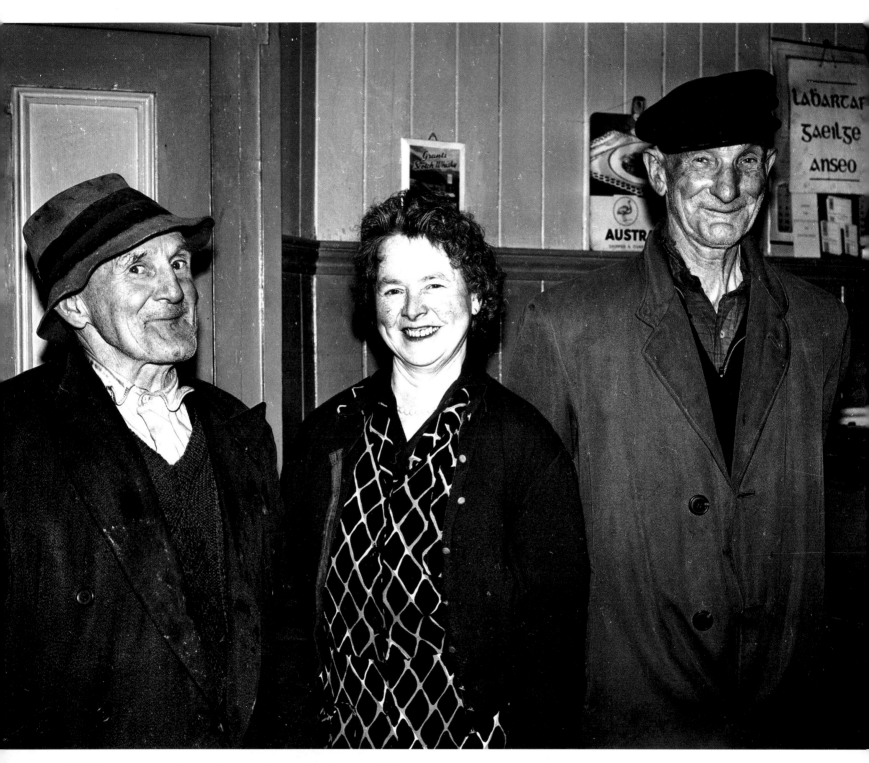

1966 Three locals in Mountcollins smile for their local paper. *LL238*

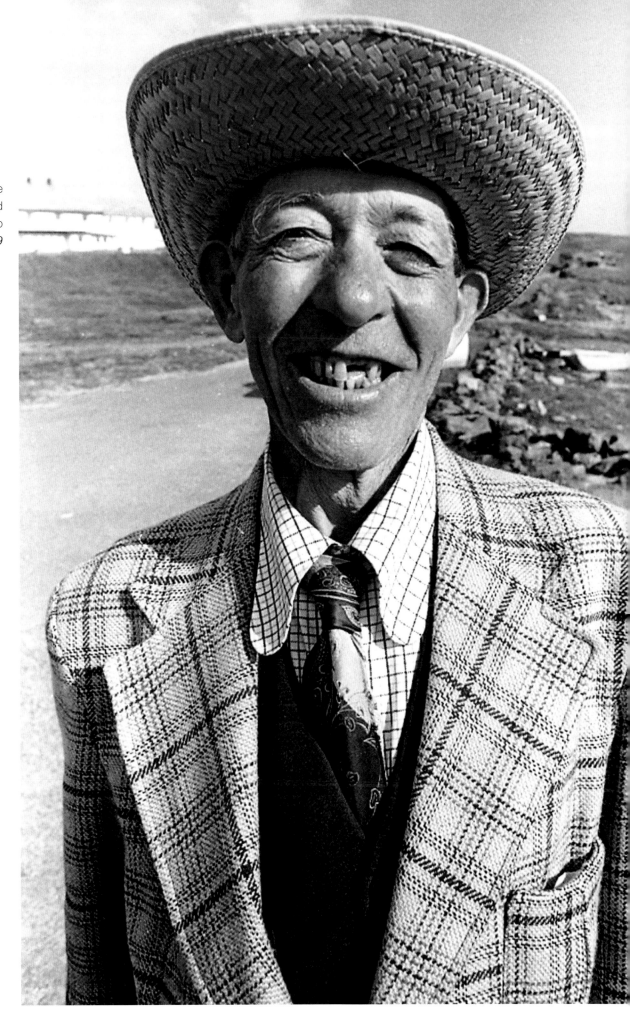

1978 I do like to be beside the seaside! Martin Sexton enjoyed the Newport old folks' outing to Spanish Point. *LL239*

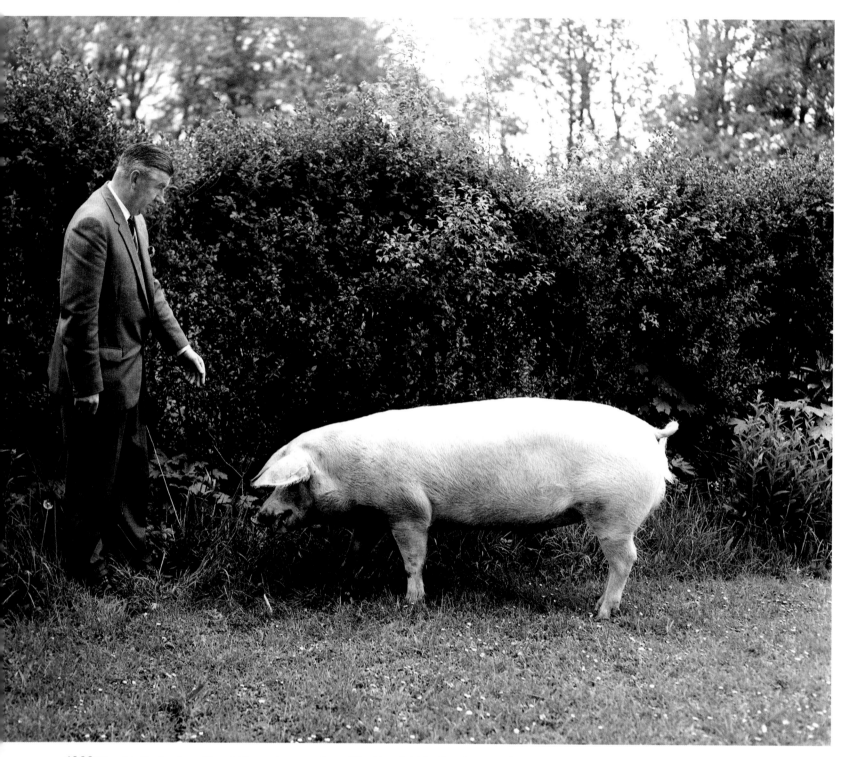

1962 Tony McCarthy from Mount Mungret, a member of the Limerick Pig Development Association, with his supreme champion boar, which was purchased for the top price of 170 guineas at the RDS Spring Show in Dublin. *LL240*

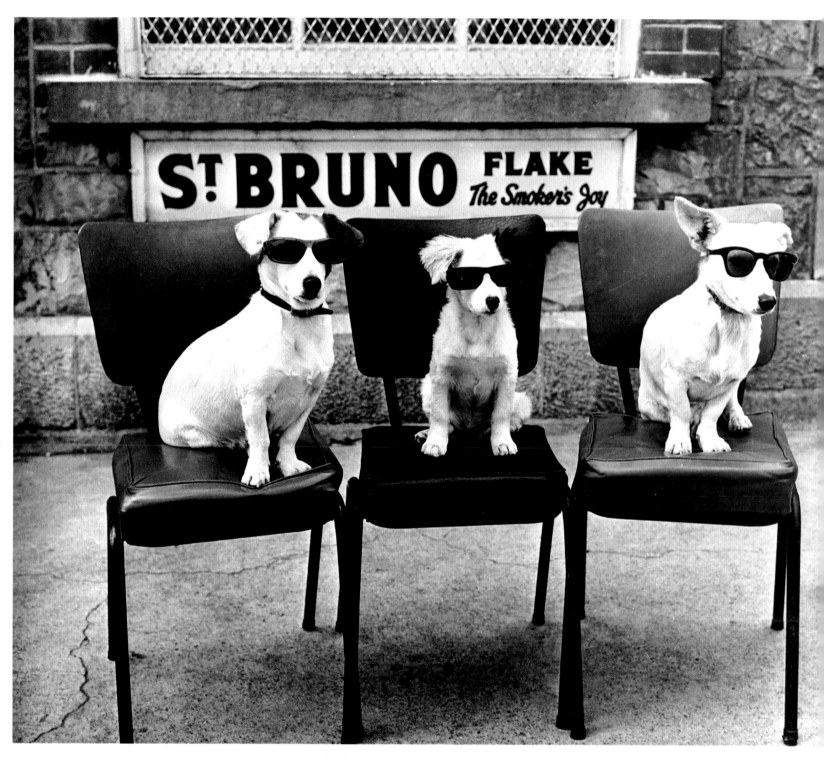

1971 Rex, Tiny and Pepper: three cool little dogs in sunglasses, from Bulgaden. *LL241*

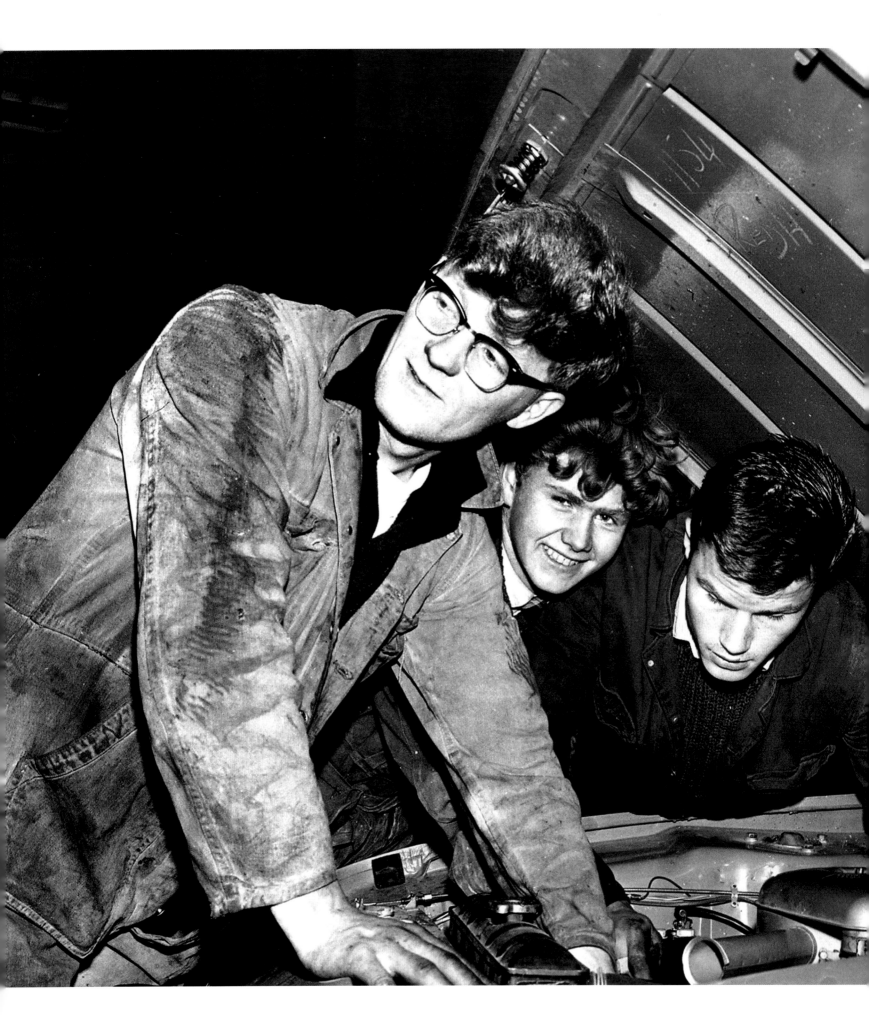

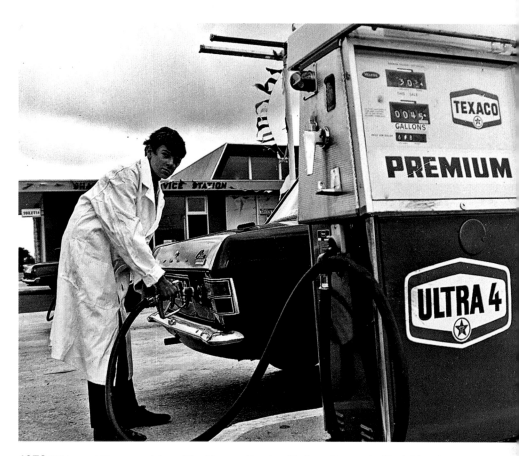

1970 Fill 'er up! The proprietor of the Texaco Service Station, Coonagh, Mark Murphy. *LL243*

1966 Mechanics at Limerick Motor Works, Mulgrave Street. (L–r): Ned Ryan, John Skehan and Paddy Walshe. *LL242*

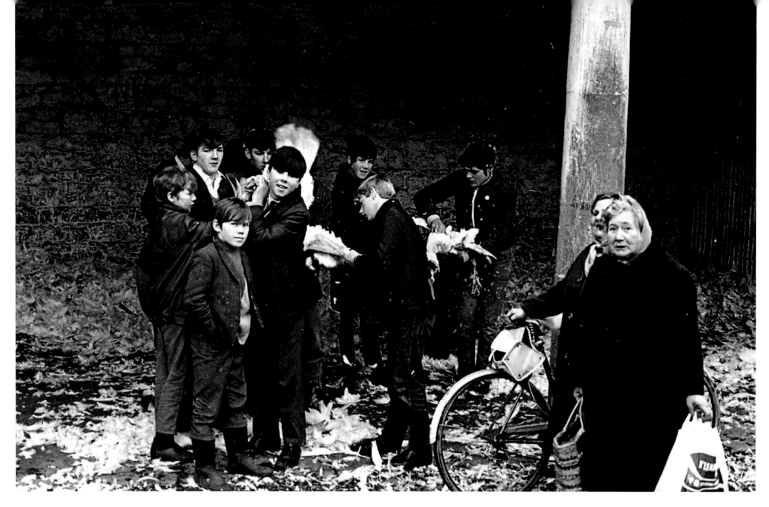

1971 Preparing fowl for Christmas, at the Milk Market, an ever-popular Limerick meeting place. *LL244*

1967 Plucking turkeys at the Milk Market. *LL244B*

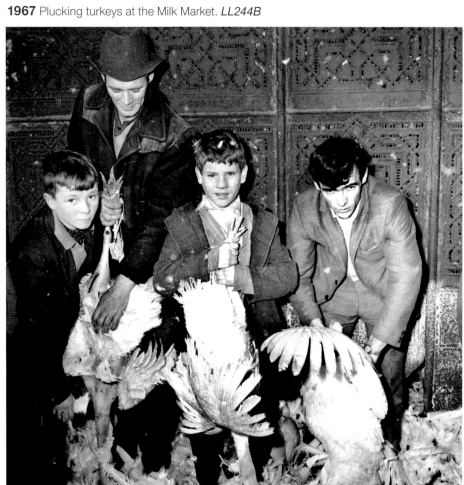

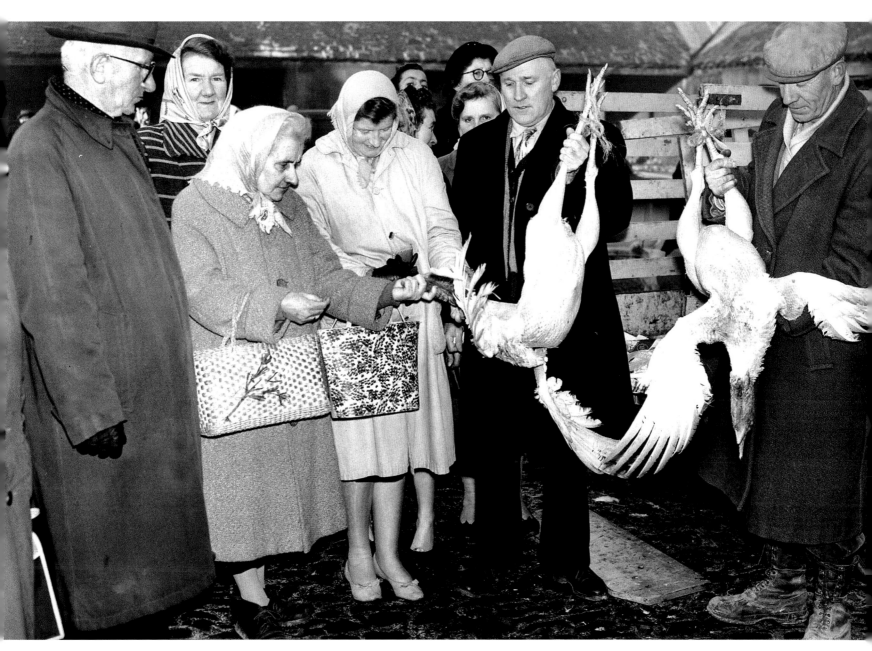

1961 Housewives assessing the options for Christmas dinner. *LL245*

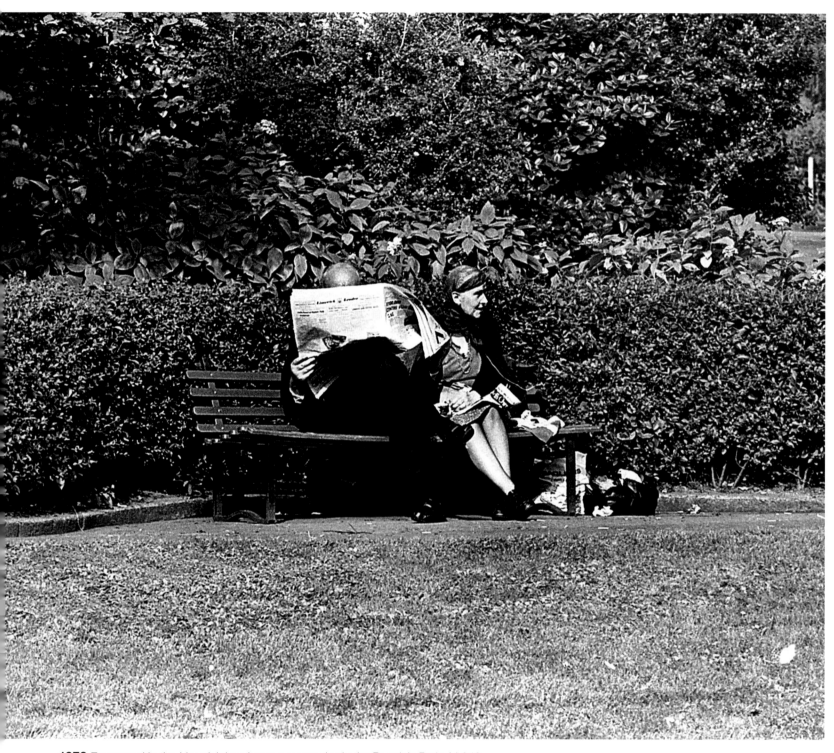

1973 Engrossed in the *Limerick Leader* on a sunny day in the People's Park. *LL246*

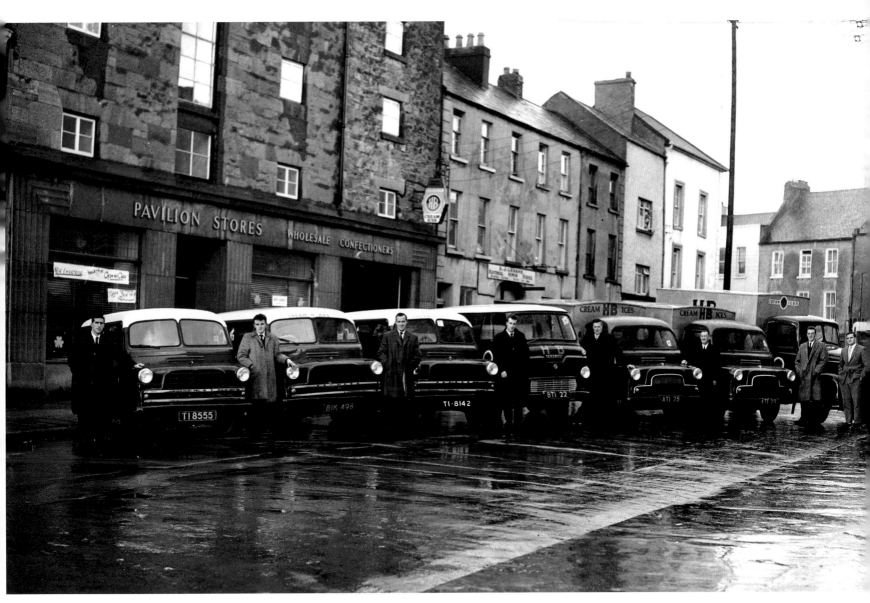

1963 Pavilion Stores, Roches Street. *LL247*

247

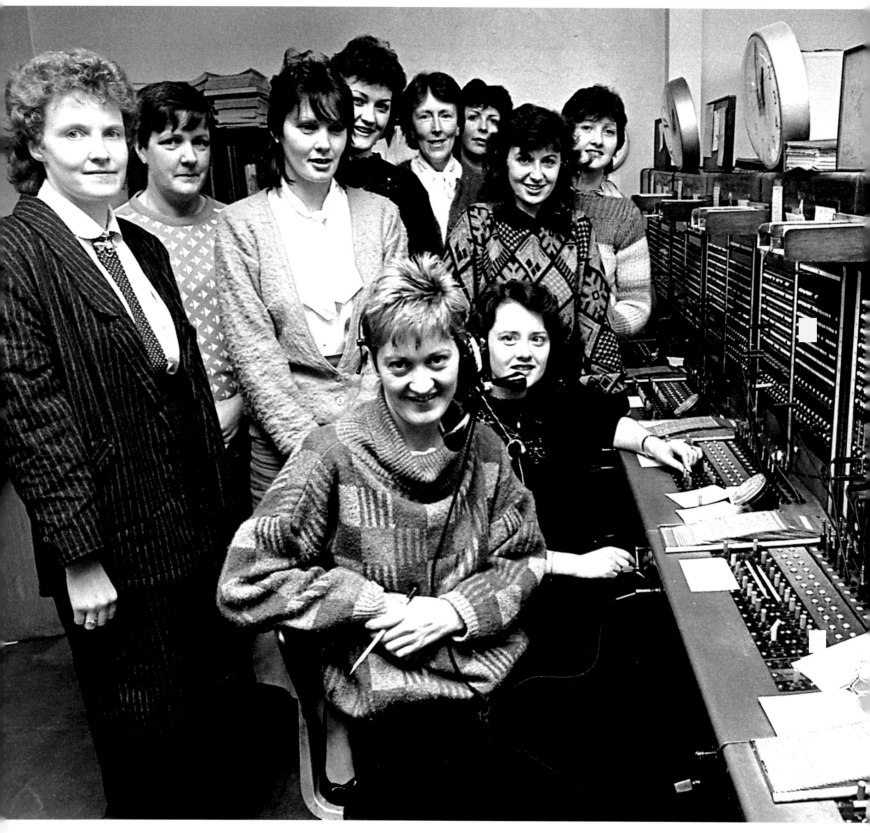

1987 Kilmallock telephonists on the last day before the exchange went automatic: Noreen Brown, Geraldine McCourt, Breda Barrett, Siobhan Kelly, Sarah Chawke, Pat Ryan, Mary Broderick, Helen Buckley, Kathleen Frazer, Ann Cagney and Bridget Hogan. *LL248*

1972 Workers on the production lines at Krups, Rathbane. *LL249*

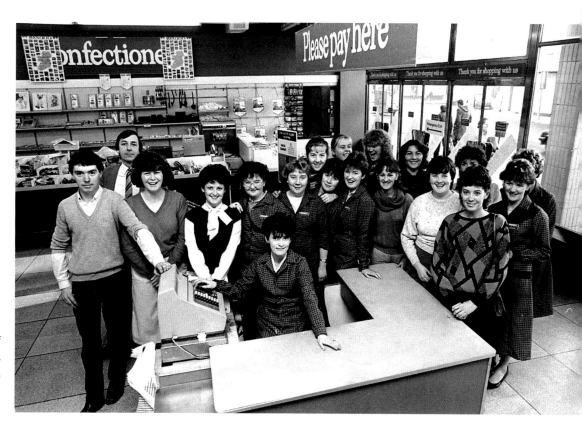

1984 Woolworths staff on the sad day of the O'Connell Street store's closure. HB Ice Cream vans and their drivers line up outside Pavilion Stores, Roches Street. *LL249B*

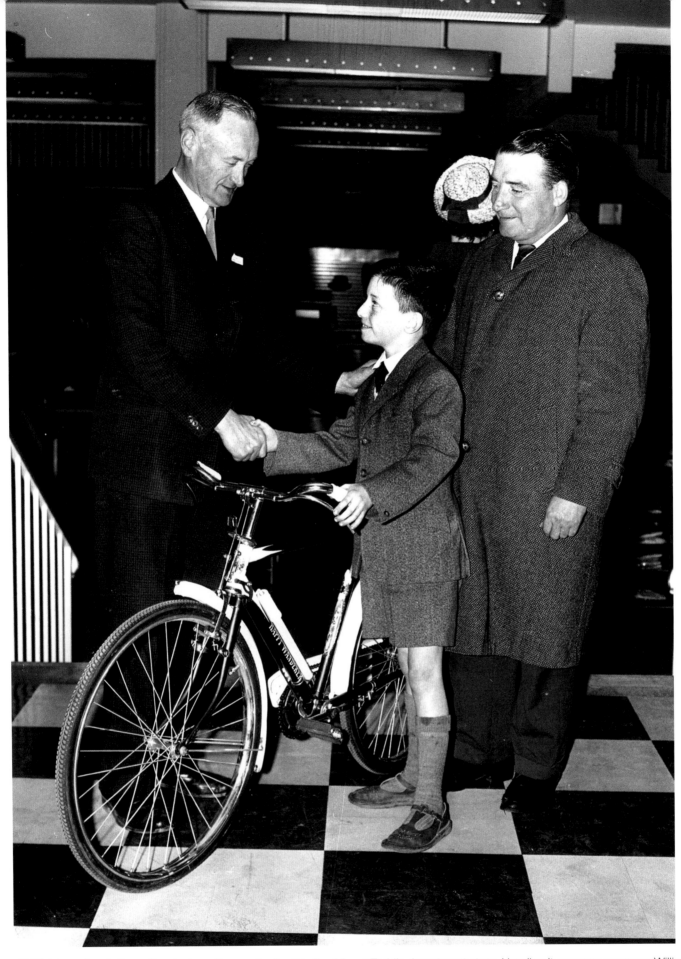

1967 A beaming Anthony Cronin, from Prospect, wins this fine bike at Todd's department store. Handing it over was manager Willie Hough and the *Leader* was on hand to capture the boy's big moment. *LL250*

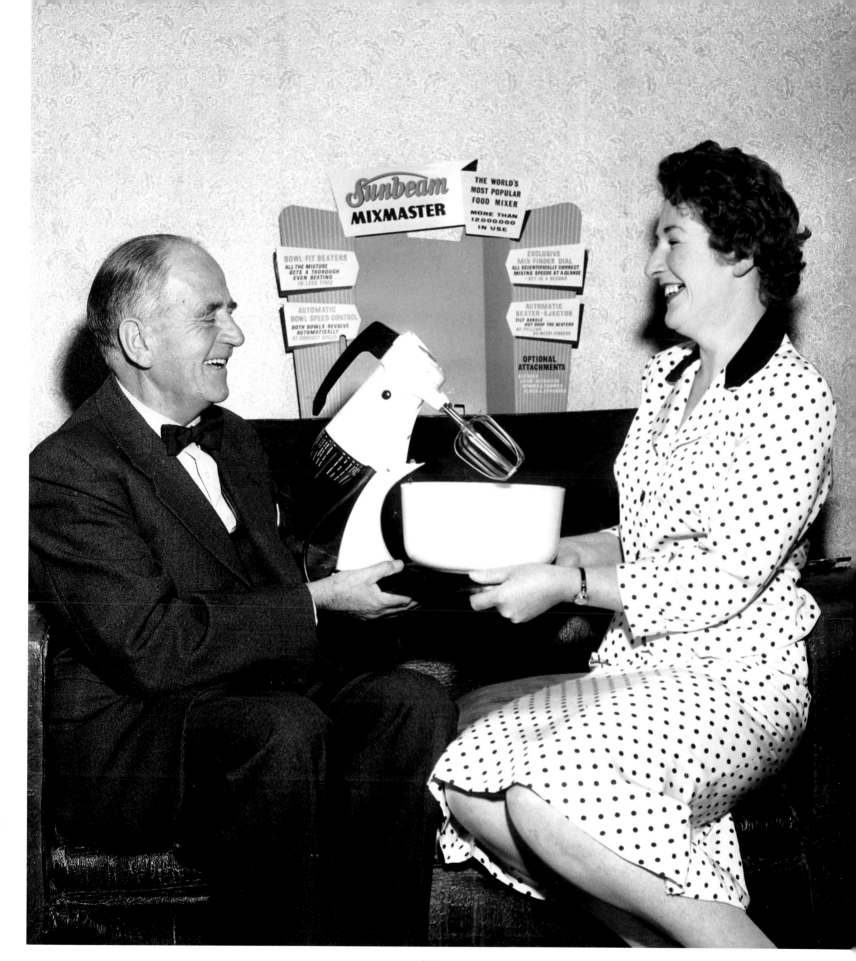

1963 A Mixmaster presentation to one impressed local housewife. *LL251*

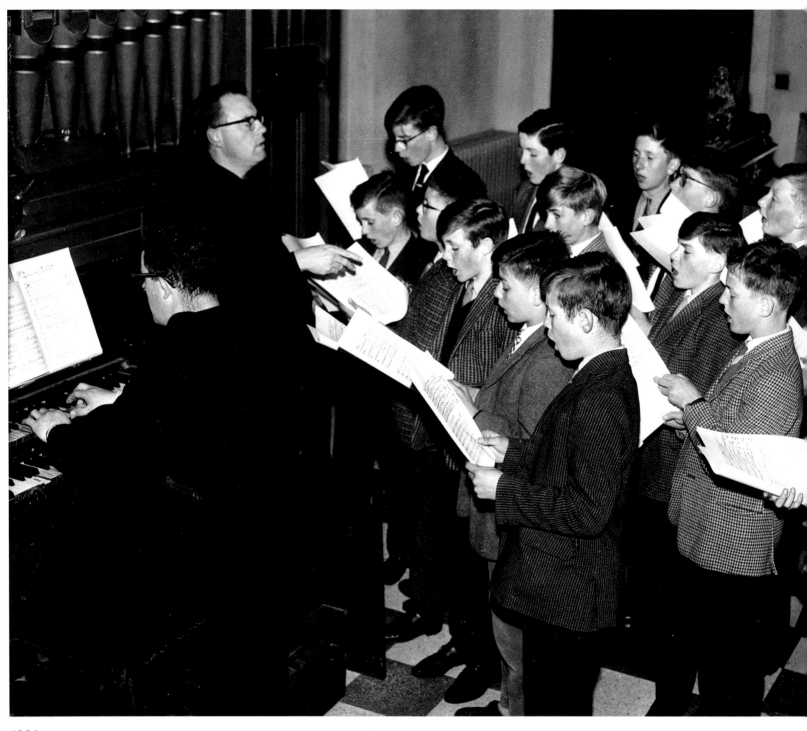

1964 Glenstal Abbey schoolboys during choir practice in Murroe. *LL252*

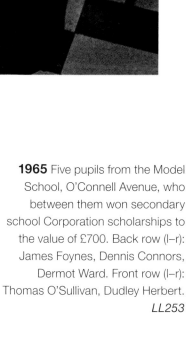

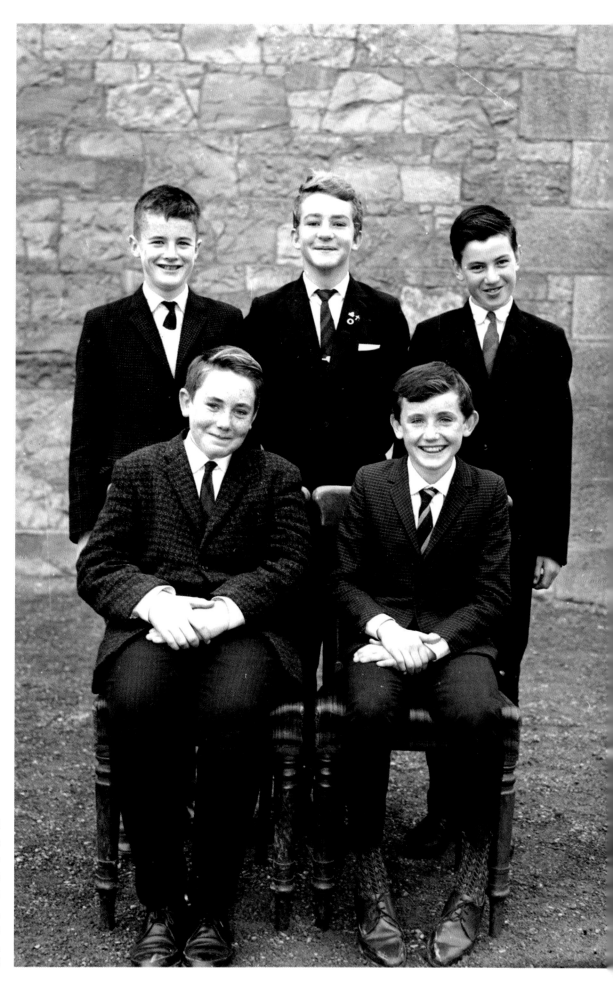

1965 Five pupils from the Model School, O'Connell Avenue, who between them won secondary school Corporation scholarships to the value of £700. Back row (l–r): James Foynes, Dennis Connors, Dermot Ward. Front row (l–r): Thomas O'Sullivan, Dudley Herbert.
LL253

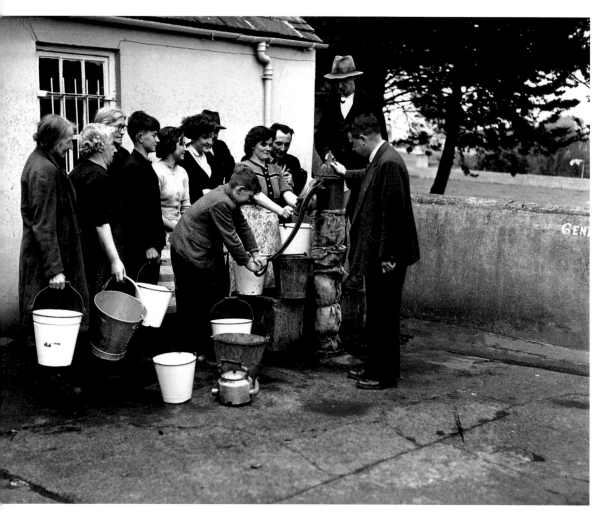

1954 The Pallasgreen water supply was in demand from these locals. *LL254*

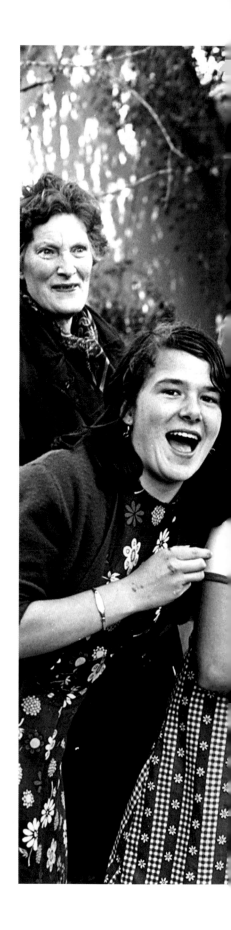

17 March 1926 *Limerick Leader* front page of St Patrick's day edition.

7 January 1991 Produced against the odds, the *Limerick Leader* front page featuring the catastrophic fire which destroyed the *Limerick Leader* printworks at O'Connell Street.

LIMERICK
THROUGH THE LENS

FIRST PUBLISHED IN 2014 BY
The Collins Press
West Link Park
Doughcloyne
Wilton
Cork

A CIP record for this book is available from the British Library.

ISBN: 978-1-84889-228-6

Design and typesetting by Fairways Design
Typeset in Helvetica Neue
Printed in Poland by Białostockie Zakłady Graficzne SA

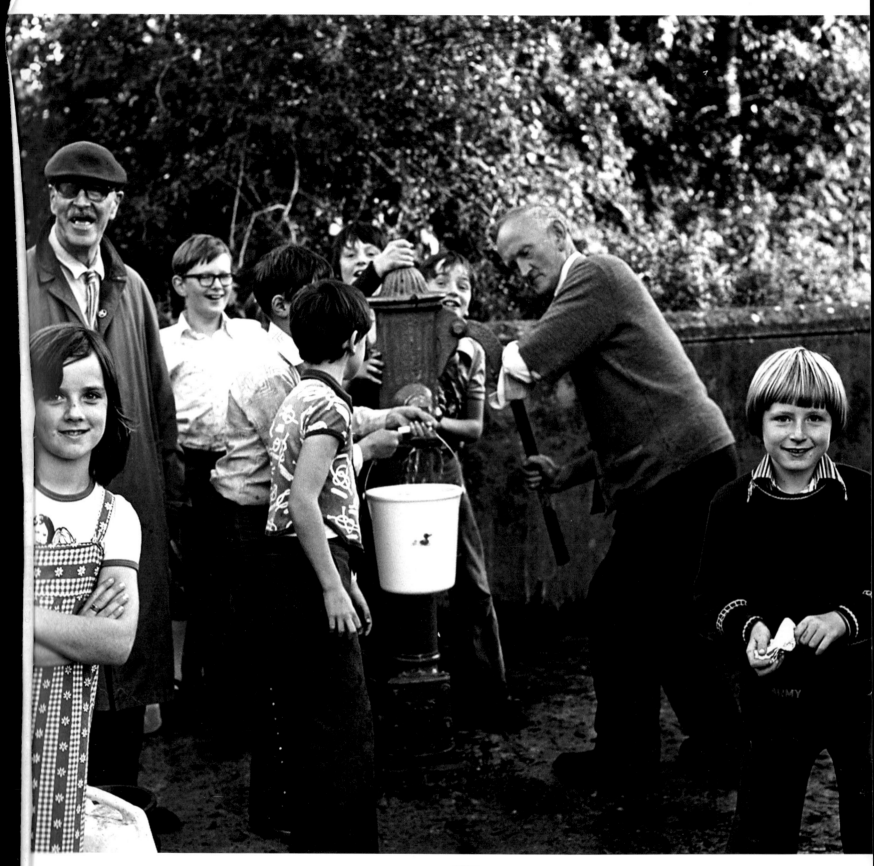

1977 Water shortage at Parteen during the long hot summer. *LL255*